The Art Commission *and*
the Municipal Art Society

GUIDE TO

# MANHATTAN'S
## OUTDOOR SCULPTURE

# The Art Commission and the Municipal Art Society

## GUIDE TO

# MANHATTAN'S
# OUTDOOR SCULPTURE

*Margot Gayle and Michele Cohen*

*Foreword by Mayor Edward I. Koch*

PRENTICE HALL PRESS
New York

*Published by Prentice Hall Press*
*A Division of Simon & Schuster, Inc.*
*Gulf + Western Building*
*One Gulf + Western Plaza*
*New York, NY 10023*
*Designed by Irv Perkins*

*Library of Congress Cataloging-in-Publication Data*

Gayle, Margot.
  The Art Commission and the Municipal Art Society guide to
Manhattan's outdoor sculpture.

  Bibliography: p.
  Includes index.
  1. Public sculpture—New York (N.Y.)—Guide-books.
2. Outdoor sculpture—New York (N.Y.)—Guide-books.
I. Cohen, Michele.   II. Art Commission of the City of New York.
III. Municipal Art Society of New York. IV. Title.
NB235.N5G38  1988            917.47'10443            88-4068
ISBN 0-13-620253-5

                    ISBN 0–13–620253–5

        Manufactured in the United States of America

# Contents

*Foreword by Mayor Edward I. Koch*                                    ix

*About the Art Commission and the Municipal Art Society*             xi

*Introduction*                                                       xiii

*Using This Guide*                                                   xvii

*Acknowledgments*                                                    xix

(A)    **FINANCIAL DISTRICT**                                         1
       Lower Manhattan south of Fulton Street, including Battery
       Park, World Trade Center, and Battery Park City

(B)    **DOWNTOWN**                                                   37
       Fulton Street to Houston Street, including City Hall Park,
       Municipal Building, Surrogate's Court, Chinatown, Lower
       East Side, Tribeca, and Soho

(C)    **THE VILLAGES**                                               69
       Houston Street to 14th Street, including the East Village
       and Greenwich Village, Washington Square, and
       Tompkins Square

(D)    **MIDTOWN SOUTH**                                              89
       14th Street to 34th Street, East and West Sides, including
       Union Square and Madison Square

(E)    **MIDTOWN EAST**                                               119
       34th Street to 59th Street, east of Fifth Avenue, including
       the United Nations

(F)    **MIDTOWN WEST**                                               145
       34th Street to 59th Street, west of Fifth Avenue,
       including Rockefeller Center, New York Public Library,
       Bryant Park, and Herald Square

(G)    **CENTRAL PARK**                                               187
       59th to 110th Streets and Fifth Avenue to Central Park
       West

(H)   **UPPER EAST SIDE**                                    *247*
      59th Street to 110th Street, east of Fifth Avenue,
      including Carl Schurz Park and John Jay Park

(I)   **UPPER WEST SIDE**                                    *261*
      59th Street to 110th Street, including Lincoln Center and
      Riverside Park

(J)   **UPPER MANHATTAN**                                    *293*
      North of 110th Street, including Columbia University,
      Morningside Park, and the College of the City of New
      York

*Checklist of Other Outdoor Sculpture in Manhattan*          *325*

*Selected Bibliography*                                       *329*

*Photo Credits*                                              *331*

*Index*                                                      *333*

# *Maps*

Sculpture Regions                          *xxi*

Financial District                          *2*

Downtown                                *38–39*

The Villages                              *70*

Midtown South                            *90*

Midtown East                            *120*

Midtown West                            *146*

Rockefeller Center                        *177*

Central Park                          *188–189*

Upper East Side                          *248*

Upper West Side                          *262*

Upper Manhattan                          *294*

# Foreword

As Mayor of New York City, I take great pride in sharing with you Manhattan's outdoor sculpture through this important guidebook. As you view the sculptures and browse through the pages, you will see our rich artistic heritage come to life. From *Still Hunt* in Central Park to the Henry Moore at Lincoln Center, from the *Sherman Monument* at Grand Army Plaza to *Nathan Hale* at City Hall Park, Manhattan holds varied and exciting examples of New York City's outstanding sculpture collection.

Each neighborhood holds a piece of our city's history. And one of New York's greatest pleasures is to suddenly find yourself in the presence of a notable work of art. Our plazas, parks, and open spaces are often sites where the history of a community and its culture can be learned through its public art.

The great social movements, personalities, and artistic styles that have shaped our city and society are vividly reflected in these works. Lively, amusing, sometimes touching, these sculptures attest to the civic and creative commitment of New Yorkers over two centuries.

My favorite way to experience the city is on foot, and I hope that you, too, will take to the streets and discover for yourself these wonderful cultural treasures which are part of our nation's legacy.

I extend my personal thanks to the Art Commission and to the Municipal Art Society for taking the initiative to make this book possible; to Margot Gayle and Michele Cohen for their superb, descriptive prose, providing a unique insight into public sculpture in Manhattan; to the many individuals, foundations, and corporations which helped to make this project possible. The private sector along with the city is responsible for the wonderful works described in the pages that follow. Thanks are due Prentice Hall Press, a division of Simon & Schuster, whose enthusiastic support was critical in this undertaking, and Susanne Lorenzo, whose support for this project never faltered.

The 300 works in this book are just a part of the more than 900 privately and publicly owned sculptures in all five boroughs of our city. And while the focus of this book is Manhattan, this is merely to whet your appetite for the feast of public art that awaits in the Bronx, Brooklyn, Queens, and Staten Island.

All the best.

EDWARD I. KOCH
*Mayor*

# About the Art Commission and the Municipal Art Society

Born of a need to uphold an esthetic standard for the City of New York, the **Art Commission** was established in 1898 as a regulatory agency with its mandate spelled out in the city Charter. Each year this 11-member body, consisting of art and architecture professionals, representatives of the mayor and cultural institutions, and three lay members, reviews hundreds of projects involving artworks, architecture, landscape architecture, and street furniture located on city property. The commisson's stamp of approval shapes the design and alteration of all city-owned structures and art.

Since its inception, the Art Commission has also sought to publicize the city's vast artistic holdings and oversee the maintenance of all city-owned works, many of which are in our parks. Toward this end, in 1909 the Art Commission published its first catalog of the city's art collection and in 1920 followed it with a supplement. Incredible as it seems, it has been almost 70 years since that catalog was updated.

Publication of this work was preceded by extensive efforts dating back to 1979 when, under the leadership of Mayor Edward I. Koch and Art Commission Administrator Annette Kuhn, a privately supported internship program was launched to survey the city's art collection. After reorganizing its extensive archives, the commission initiated surveys of the city's portrait, mural, and sculpture collections. Supervised by project directors, college interns and other volunteers are in the process of photographing and documenting every city-owned sculpture and mural. Presently, students are surveying sculptures in Brooklyn and will soon be working in the Bronx, Queens, and Staten Island.

The commission's surveys have enabled the City of New York to take stock of its outstanding art collection, sparking such preservation efforts as the Adopt-A-Monument program, a joint venture of the Art Commission, the Municipal Art Society, and the New York City Department of Parks & Recreation. This book furthers our shared goal of heightening public awareness of the city's sculptural legacy. The Art Commission believes that New York's public sculpture is as fascinating as it is historical, and we hope this guide will excite new interest in old treasures as well as draw attention to recent innovations.

EDWARD A. AMES  
*President*

PATRICIA E. HARRIS  
*Executive Director*

## Members of the Art Commission, December 1987

Edward A. Ames, lay member; Flora Miller Biddle, lay member; William H. Black, representative of the Brooklyn Museum; James Ingo Freed, architect; Warren Marr II, lay member; Eliot C. Nolen, representative of the Metropolitan Museum of Art; Lauren Otis, mayor's representative; Robert Ryman, painter; John T. Sargent, representative of the New York Public Library; John Willenbecher, sculptor; Philip N. Winslow, landscape architect.

Previous members who served on the Art Commission during the intern program from 1980–1985 include: Ernest Crichlow, Margot Gayle, Bradford M. Greene, Kenneth Halpern, Mary R. Morgan, Raquel Ramati, James Rossant, Muriel Silberstein-Storfer, Elizabeth A. Straus, and Norval White.

———————

The **Municipal Art Society** was founded in 1892 by a group of concerned citizens—architects, painters, sculptors, and civic leaders—who joined together to enhance New York City with public art: statues in parks, murals in public buildings, drinking fountains, and street lighting. Shortly after its inception, however, the society expanded its concerns.

Through the decades this organization's civic role has evolved into a more diverse and lively one, designed to educate New Yorkers and our visitors about all aspects of the built environment through exhibits, publications, and public programs. At the same time, an increasing membership and professional staff have advanced the society's advocacy efforts—identifying and supporting the best of New York's development that respects the essential ingredients of a livable and humane city. Like our colleagues in government, we recognize growth and change as a great city's hallmark and believe just as surely that such change need not come at the expense of esthetics, mobility, ethnic and demographic diversity, and light and air.

A brief look at some of the society's key accomplishments describes this evolution and expanding civic role. The society helped found the New York City Art Commission (1898); sponsored legislation for New York City which became the first zoning code in the United States to limit the bulk of buildings in relation to lot size (1916); fought the demolition of the Tweed Courthouse (1955); lobbied to institute the city's landmark law and its agent, the Landmarks Preservation Commission (1965); succeeded in urging the United States Supreme Court to uphold the landmark status of Grand Central Terminal, bringing to a victorious end a 12-year battle (1978); and most recently, initiated with the Art Commission and the New York City Department of Parks & Recreation the Adopt-A-Monument program, now being copied across the nation, to rescue public sculpture from pollution, vandalism, and neglect (1987).

In addition to its advocacy activities, the Municipal Art Society maintains the Urban Center in the landmark Villard Houses on Madison Avenue, where free public lectures, exhibits, and panel discussions are offered and walking tours are organized every weekend from April through October. The society also operates the Information Exchange, an urban studies reference and referral center, and shares its headquarters with the Urban Center Bookstore, the best shop in town for books on architecture, planning, urban design, and preservation.

We are gratified to co-sponsor this publication celebrating Manhattan's public sculpture. It reaffirms our commitment to education and preservation, allowing the society to share with New Yorkers and visitors its enthusiasm for Manhattan's outdoor art.

**KENT BARWICK**
*President*

**PAUL GUNTHER**
*Director of Development*

# Introduction

In keeping with the spirit of New York, a city of contrasts and a city of change, public sculpture in Manhattan is full of surprises. Serious and whimsical, flamboyant and reserved, it is a little of everything—a hero on horseback, a cube on point, or a vibrating neon arc. Its myriad forms reflect the nuances of New York's rich urban fabric, social history, and sculptural tradition, capturing the flavor of the city, past and present. Humanizing streets and plazas, Manhattan's public sculptures offer unexpected pleasure. And because they are on view free of charge 24 hours a day, they are a cultural legacy that belongs to everyone.

The changing forms of public sculpture in New York reflect the evolution of American sculpture during the last century and a half, illustrating shifts in style, taste, and technology. The first sculpture to be erected on Manhattan Island was placed in Bowling Green. A gilded lead equestrian statue of George III by the English sculptor Joseph Wilton, it met a violent end, toppled with ropes and melted into bullets by rebel colonists in 1776. As was true elsewhere in the country, the City of New York acquired few sculptures during the early days of the Republic. It was not until the mid-19th century, when artists began to favor bronze over marble, that New Yorkers began to erect outdoor sculpture. Henry Kirke Brown's equestrian statue *George Washington,* erected in Union Square in 1856, is the city's first outdoor bronze, and it exemplifies the simple and direct naturalism characteristic of America's first native school of sculpture.

About the time of the nation's Centennial in 1876, American artists began to study in Paris rather than as previously in Rome or Florence. As a consequence of this training, largely influenced by the Parisian École des Beaux-Arts, they abandoned neoclassicism and also the simplicity of mid-century naturalism, choosing instead a heightened realism, drama, and compositional complexity. Encouraged to collaborate with architects, French-trained American sculptors returned home with new skills and sensibilities. Augustus Saint-Gaudens, one of the first sculptors to import the Beaux Arts style to America, helped change the course of American monumental sculpture with his celebrated *Farragut Monument* of 1881 located in Madison Square. The majority of New York City's monuments and statues standing today were erected following the Centennial, during the period known as the American Renaissance (1876–1917).

By the 1920s, although abstract art was gaining acceptance, public sculpture in New York as elsewhere reiterated the themes and styles of an earlier era. Examples from this period include the *107th Infantry Memorial* at the edge of Central Park and Philip Martiny's two World War I memorials at Abingdon Square and Chelsea Park. Traditionally, urban outdoor sculptures

have functioned as symbol, marker, or reminder and works continued to be commemorative, celebrating historic events and artistic, political, military, and civic figures. The New Deal programs of the 1930s introduced federal patronage, but because materials for sculptures were expensive, New York acquired more WPA murals than outdoor sculptures. A rare exception is Frederick G. R. Roth's inventive limestone reliefs for the Central Park and Prospect Park Zoos.

The 1960s marked a new phase for public sculpture in New York, when large numbers of abstract pieces began to replace figurative monuments. Examples abound, including Alexander Calder's *Le Guichet* and Henry Moore's *Reclining Figure,* both at Lincoln Center, Theodore Roszak's *Sentinel,* and Tony Rosenthal's *Alamo.* Changing sculptural concerns, a glass-and-steel architecture shunning sculptural embellishment, and a society in which heroes seem elusive has caused abstract sculptures of imaginative forms and materials in large part to supplant traditional bronze and marble statuary. If no longer the expression of communal values, what is the function of today's nonobjective public sculpture? In an urban context, abstract sculpture can be viewed as a humanizing element. It may mediate between people and skyscrapers, identify a plaza, enhance a corporate image, or provide a public amenity. Much of the new public sculpture invites our participation, encouraging us to touch, to move through, around, or under it. The most recent trend leans toward an integration of public sculpture, architecture, and public amenities and is exemplified in Battery Park City at the southern tip of Manhattan where sculptors and architects have collaborated at the planning stages of the design of public spaces.

## SITES, PATRONS, AND THE PUBLIC

Unlike art displayed in a museum, a closed environment, outdoor sculpture in a city is part of an open arena and is subject to numerous forces. A site, a patron, and a public all play a role in shaping public sculpture.

Sites are selected for numerous reasons, sometimes because they mark the setting of historic events or merely because the space is available. Indeed, a city's growth limits where sculptures can be situated. The grid, which surveyors laid on Manhattan island in 1811, with its dearth of grand boulevards or circles, made suitable land for public sculpture there undeniably scarce and contributed to the penchant for placing sculpture in the city's parks, especially the wide, open spaces of Central Park. New York's more recent sculptures stand in newly built plazas. Many of these post-1961 sculptures came about because of a city zoning regulation which ruled that developers could increase the height of their buildings if they provided public plazas. Public sculptures followed.

Paralleling the changing nature of available sites, the sources of patronage have also changed. In New York during the 19th and early 20th centuries, patrons were most often civic groups, many of them associations based on a common national heritage. To pay for a monument, they formed a committee and launched a public subscription, inviting individual donations. Most city-owned works dating to this period were acquired as gifts. New York's most famous outdoor sculpture, the *Statue of Liberty,* was paid for by public subscription. Through this sharing of the cost of public sculpture, the public also shared a built-in appreciation and enthusiasm for new artworks. New York's varied immigrant populations, especially the Italians and the Germans, expressed their ethnic identities by sponsoring statues and busts of their homeland's heroes. Many are located in Central Park.

In the 20th century the corporate patron has emerged as a major sponsor of public sculpture. Inspired by the precedent set by Rockefeller Center, heralded for its extensive art program, such corporations as Chase Manhattan Bank and more recently the Equitable Life Assurance Society have assembled major art collections and commissioned prominent outdoor sculptures by Isamu Noguchi, Jean Dubuffet, and Scott Burton.

Like corporations, the city has also become an active patron, commissioning public art primarily through the Percent for Art Law, which was adopted in 1983 through the leadership of Mayor Koch and city legislators. This law requires the city to allocate for art 1% out of the first $20 million and 0.5% of the next $40 million spent on construction or renovation of an eligible city-owned structure.

Because the sculpture is public, it often elicits a spirited reaction. The appropriateness of the person or idea to be commemorated and the work's proposed site are often cause for debate. Once the basic concept gains acceptance, an artist, a design, and a specific site must be selected. The commission process varies among corporations and such public agencies as the Port Authority of New York and New Jersey and the Battery Park City Authority, while the city has its own review process. Generally, a proposed scheme has to receive the approval of one or more groups and undergoes several stages of review, for art placed in communal spaces bears a responsibility to a broad audience. The balance between artistic vision and the public may be elusive, but it is attainable.

## TEMPORARY SCULPTURES

Although this book focuses on permanent sculptures, an exciting assortment of temporary sculpture appears regularly on city streets. Temporary installations increase opportunities for artists and encourage the use of unusual sites and less practical and durable materials. Several organizations in New York sponsor temporary sculptures. The Public Art Fund, Inc., a nonprofit organization founded in 1977 by the late Doris C. Freedman, was one of the first to pioneer this approach, and PAF oversees many designated city-owned sites for alternating sculpture, including the Doris C. Freedman Plaza at the Fifth Avenue entrance to Central Park at 60th Street. Other New York City organizations committed to bringing innovative public art to the city, particularly in Manhattan, include Area, Artists in the Gardens, Cityarts Workshop, Creative Time, the Department of Transportation, the Lower Manhattan Cultural Council, MTA's Arts for Transit, New York City Department of Parks & Recreation, Organization of Independent Artists, and the Port Authority of New York and New Jersey. With the city as an urban gallery, both the public and artists benefit, for artists can be more experimental and the public can experience a greater variety of art forms.

# Using This Guide

Designed for the native New Yorker and the visitor, the layman and the scholar, this guide to Manhattan's outdoor sculpture features celebrated masterpieces and lesser-known gems. The book began as an inventory of the City of New York's sculpture collection and evolved into a comprehensive guide to both privately and publicly owned works. To encourage self-guided walking tours, the sculptures are arranged into geographic regions and are keyed onto maps of these regions. We have tried to include all permanent works, but recognize the difficulty in doing so in a city that is constantly changing. To make this guide as complete as possible, we have compiled a checklist of additional works on view in Manhattan. But let the reader be warned that we omit most architectural sculptural ornamentation and ecclesiastical sculptures, subjects which merit books of their own.

**Code Number:** Every entry is identified by a letter followed by a number. Readers should refer to the area maps marked with the entry's letter to locate the work, represented by a number on the appropriate map.

Each entry lists the following information, when available:

**Title, date:** Refers to the date inscribed on the sculpture or the period during which it was made; "ca." precedes the date to indicate that it is an approximation.

**Sculptor and life dates, designer of pedestal:** Refers to the sculptor, and the person, generally an architect, who designed a sculpture's pedestal.

**Architect:** Refers to the person or firm that designed a building or structure of which a sculpture is a part.

**Media and size:** Refers to the materials the sculpture is made of and its approximate dimensions.

**Location:** Gives the address and placement of the sculpture.

**Dedication:** Refers to the date of the sculpture's official unveiling.

**Signed and dated:** Refers to the signature and date inscribed by the artist on the sculpture. Not always precisely transcribed.

**Dated:** Refers to just a date inscribed on the sculpture.

**Foundry mark:** Refers to the information that a foundry inscribed on a bronze to document where it was cast. Not always precisely transcribed.

**Fabricated by:** Refers to the firm that assembled a welded metal sculpture.

**Commissioned by:** Refers to the individual or organization that initiated a project for a designated site.

**Collection of:** Refers to the sculpture's owner.

# *Acknowledgments*

This book would not have been possible without Mayor Edward I. Koch's leadership, interest, and commitment. We are also indebted to Patricia E. Harris, Executive Director of the Art Commission, whose energy and insights were vital to its completion. Municipal Art Society representatives Kent Barwick, Paul Gunther, Jane McCarthy, and the late Tucker Ashworth, who helped conceive this guide, and our agent Susanne Lorenzo worked to make this book a reality. We also appreciate the contributions of the Mayor's Chief of Staff Diane M. Coffey, former Art Commission Administrator Annette Kuhn, and all the members, staff, and interns of the Art Commission.

Our thanks to Steven Murphy, President of Prentice Hall Press Trade Division, and editors Marilyn Wood and Gloria McDarrah and the many people at Prentice Hall Press who worked with us. We are indebted to Marlene Park, Professor at John Jay College of Criminal Justice and CUNY Graduate Center, for her unfailing guidance; to Nanette M. Smith for her commitment and superb work; to Blanche Kahn and Benedict O'Looney for their research assistance; to Lisa Chalif for her research on Rockefeller Center; and most of all to William Penny for his unwavering support and patience.

We wish to acknowledge the generous gifts of: Edward A. Ames; the Associates of the Art Commission; the AT&T Foundation; Banker's Trust Company; Flora Miller Biddle; William H. Black; Doubleday and Co., Inc.; the Horace W. Goldsmith Foundation; the Cecil Howard Charitable Trust; the J.M. Kaplan Fund; the Samuel H. Kress Foundation; Mary R. Morgan; The New York Community Trust; New York State Council on the Arts; Park Tower Realty; John T. Sargent; Joan C. Schwartz Philanthropic Fund; the John Sloan Memorial Foundation; and the Norman and Rosita Winston Foundation.

We appreciate assistance from: Battery Park City Authority; Adrian Benepe; Joseph Bresnan; Phyllis Samitz Cohen; Alan Cox; Jennifer McGregor Cutting; William J. Dane; Department of General Services; Department of Parks & Recreation; Susan K. Freedman; Stephen Garmey; Roberta Glasser; Jane Gullong; Estelle Haferling; John and Peg Hammond; Besse Hirschberg; David Kahn; Mayor's Central Messenger Service; Ronay Menschel; Kate D. Levin; Theodora Morgan; Joel Moskowitz; Municipal Archives, Department of Records and Information Services; Museum of Modern Art Library; New York Public Library Art Division staff; Percent for Art Program; New York City Law Department; Henry Hope Reed; Susan Rosenberg; Rudin Management Corporation; Marie Sarchiapone; Lewis I. Sharp; Stephen C. Swid; John Tauranac; Bobby Vincent; Dan Wolf; all the artists, galleries, institutions, and others too numerous to mention who provided information, photographs, and granted interviews.

For photographic assistance special thanks to John Podracky for expertly printing our negatives; also to Edmund V. Gillon, Jr.; Landmarks Preservation Commission; Judith Leynse; Gerard Malanga; Don Manza; Peter Mustardo; the Port Authority of New York and New Jersey; United Nations Photo Library.

Lastly, we want to thank all the organizations and individuals who have funded sculpture conservation in New York through the Adopt-A-Monument program. To date they are: American Conservation Associates, William F. Beinecke, the Broadway United Church of Christ, descendants of Henry Ward Beecher, the Columbus Citizens Foundation, Inc., the Commonwealth Fund, Cooper Union, French-American Chamber of Commerce, Jeffrey Glick, Grand Marnier Foundation, International Herald Tribune, Lincoln Savings Bank, Dan Neale, New York Telephone Co., The Poltzer Foundation, Queens Civic Association, and Shelby White. Thanks also to all the other people who throughout the years have contributed to the preservation of New York City's public art.

Margot Gayle
Michele Cohen

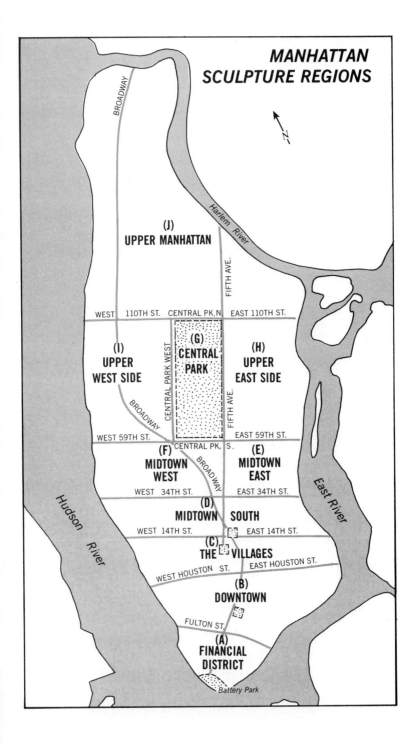

# (A)
# FINANCIAL DISTRICT
*Lower Manhattan south of Fulton Street*

———————

Battery Park, at the southern tip of the island, was named for the battery of cannons that the first Dutch settlers erected at what is today State Street, then the water's edge. In the 18th century the area served as a military parade and training ground, then as a battlefield during the Revolutionary War, and finally as the city's first public park. Abutting the harbor, it affords the best land view of the *Statue of Liberty*.

The sculptures in Battery Park commemorate early explorers, the first European settlements on Manhattan, naval battles, and immigration. A walk through Battery Park is a walk back to the origins of the City of New York.

North a few blocks at Pine and Nassau Streets, the sprawling, raised plaza of Chase Manhattan Bank's skyscraper headquarters comes into view. It is the site of Jean Dubuffet's fantastic *Group of Four Trees* and Isamu Noguchi's serene sunken garden.

At the westernmost part of the district, the recently developed Battery Park City stands on 92 acres of landfill along the Hudson River. Quiet and spacious with a glorious esplanade, it is a model of urban planning. The complex includes majestic office buildings and handsome, low-rise residential structures and some of Manhattan's most innovative and ambitious public sculpture.

Just east of Battery Park City is the World Trade Center, famous for its 110-story twin towers, containing abstract monumental sculptures by an international roster of artists. Unlike Battery Park City, where sculptors collaborated with architects to sculpturally define spaces, here artists fit their works into preexisting spaces. Nowhere else in New York is monumental sculpture so challenged by monumental architecture.

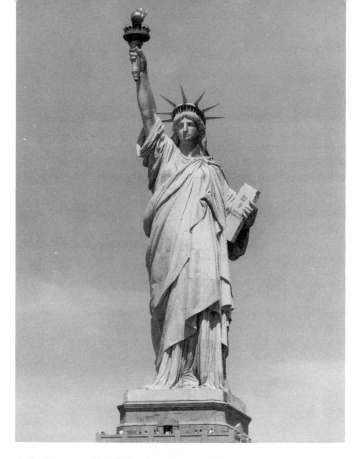

## A-1 Statue of Liberty, 1875–1884

**Sculptor:** *Frédéric-Auguste Bartholdi (1834–1904).* **Pedestal by:** *Richard Morris Hunt.* **Engineer:** *Gustave Eiffel.* **Media and size:** *Hammered sheet copper on iron skeleton, 151 feet high; granite pedestal.* **Location:** *Across the Upper Bay from Battery Park on Liberty Island, formerly Bedloe's Island.*

Patriotic emblem, tourist logo, Pop Art symbol, the *Statue of Liberty* is America's most famous public sculpture. A celebration marking the centennial year of its dedication was a televised three-day jubilee. Visitors are impressed by Liberty's interior mysteries, explained with great clarity during the Statue's repair, and of course by its awesome size. Its resonant symbolism strikes new chords in successive generations of Americans.

First known as "Bartholdi's Statue" or "Liberty Enlightening the World," the *Statue of Liberty* was presented to the United States by France to symbolize the two countries' friendship. French sponsors intended the gift to mark our nation's centennial, but it was not dedicated until a decade later. The French people paid for the statue and United States citizens raised money for the pedestal.

Beneath the veil of international diplomacy, the *Statue of Liberty* also served a propagandistic purpose for French republicans. This political faction conceived the plan for a colossus during the Second Empire, a period when the government restricted the expression of democratic ideas. Limited in their ability to campaign openly for liberty within France, republican leaders used the example of American liberty to criticize domestic policy. They

hoped that a public subscription for the *Statue of Liberty* would engender a nationwide campaign for the principles the sculpture embodied.

Subsequent events soon obscured for Americans the original significance of the monument. The plight of immigrants entering New York Harbor during the second half of the 19th century inspired Emma Lazarus to write "The New Colossus." The poem's words, "Give me your tired, your poor, your huddled masses yearning to breathe free," have come to express the meaning of Bartholdi's torchbearing "lady in the harbor," replacing the icon of French republicanism with the image of America as the land of opportunity.

Bartholdi derived the *Statue of Liberty* from two artistic traditions, uniting the colossal with the allegorical. The ancient Colossus of Rhodes, a mythic, giant figure that straddled the entrance to the Harbor of Rhodes, inspired Bartholdi to choose Bedloe's Island in New York Harbor for his colossus. Following Roman tradition, Bartholdi conceived a robed, female figure. He replaced the scepter, signifying sovereignty, with a torch signifying enlightenment, the Phrygian bonnet with a seven-pointed nimbus representing the seven continents, and the book of Faith with a Masonic tablet inscribed July 4, 1776.

Although the exterior of the colossus exemplifies 19th-century academic sculpture, the interior frame embodies 19th-century technology. Gustave Eiffel, designer of the Eiffel Tower (1889), constructed an iron skeleton to support the 88 tons of sheet copper. Ingeniously connecting the copper to spring-like iron elements attached to the central skeleton, Eiffel designed a flexible structure that could withstand severe winds. The noted engineer also designed an unprecedented double stair, one stair for climbing up, another for walking down, providing additional interior support and facilitating traffic movement inside.

The *Statue of Liberty* was restored over a three-year period with the combined skills of French and American engineers, architects, and conservators in preparation for its rededication on July 4, 1986. Now another message has been added to its earlier political and ideological content. The colossus has come to symbolize the problems of urban outdoor sculpture and the need to preserve our artistic heritage.

**Dedicated:** *October 28, 1886.* **Collection of:** *National Park Service. Statue, gift of French citizens; pedestal, gift of United States citizens.*

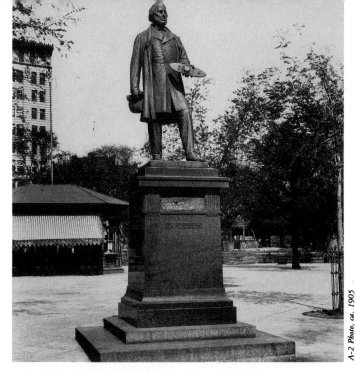

A-2 Photo, ca. 1905

## A-2 John Ericsson, 1902

**Sculptor:** *Jonathan Scott Hartley (1845–1912).* **Media and size:** *Bronze statue, over life-size; each of four bronze relief tablets 12 inches by 27½ inches long, recast in 1952; granite pedestal.* **Location:** *Battery Park, southwest end of Eisenhower Mall.*

When the noted inventor and engineer John Ericsson (1803–1889) died, the New York State legislature authorized the City of New York to raise $10,000 through city taxes to erect a monument to his memory. An appointed committee of 14 selected an artist and approved a design. They chose Jonathan Scott Hartley, a leading portraitist, whose work the turn-of-the-century sculptor and art historian Lorado Taft described as "a synonym for the most precise and authentic characterization possible."

The Swedish-born Ericsson is best known for his creation of the screw propeller and the ironclad, turreted fighting ship *Monitor,* a model of which he holds here. He attained national prominence during the Civil War after his *Monitor* battled the *Merrimac* at Hampton Roads, Virginia. The clash of the two ironclads changed the nature of naval warfare, making wooden battleships obsolete.

After the Ericsson statue had been in the park for ten years, the sculptor replaced it at his own expense in 1902 with a new and what he considered better version. The bas-reliefs, chronicling Ericsson's major achievements, were part of the original monument. They depict *The Princeton,* the first screw-propelled war vessel, the battle between the *Merrimac* and the *Monitor,* an assortment of Ericsson's inventions and mechanical devices, and the use of the steam fire engine, for which Ericsson won a medal in 1840.

**Dedicated:** *April 26, 1893.* **Signed and dated:** *J. S. Hartley 1902.* **Foundry marks:** *Gorham Mfg. and Founders (statue); Roman Bronze Works, Inc. (tablets).* **Collection of:** *City of New York; purchase.*

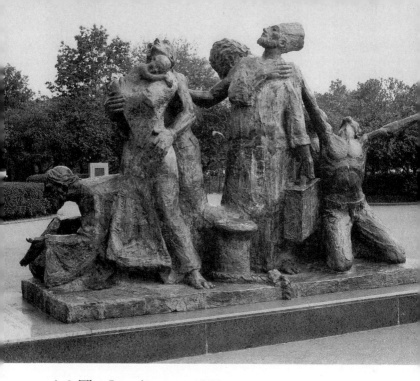

## A-3 The Immigrants, 1973

Sculptor: *Luis Sanguino (1934– )*. **Media and size:** *Bronze group over life-size; granite pedestal.* **Location:** *Battery Park, south end of Eisenhower Mall.*

Between 1855 and 1890 some 7.7 million immigrants entered America through the Immigrant Landing Depot, now Castle Clinton. Originally built as a fort and later transformed into a concert hall, this immigration station became overcrowded and notorious for its administrative abuses, causing the federal government to close it and move immigration processing to the nearby Barge Office (1890) and then over to spacious new facilities on Ellis Island (1892).

*The Immigrants* is placed directly in front of this former immigration station, reminding us of that unhappy period in Castle Clinton's history. Conceived as a processional of new arrivals, the sculpture includes references to different ethnic groups and types of people. An Eastern European Jew bent forward in supplicant prayer leads a family, a priest, a worker, and an African, depicted as a freed slave. The artist's stereotypical figures reflect the ethnic and class mixture of New York City rather than documenting actual immigrants. Throughout, Sanguino employs anatomical distortions, dramatic gestures, and coarse textures in an attempt to convey the struggles and aspirations of those seeking a better life.

Figurative public sculpture executed in the last two centuries typically glorifies a public figure, a military hero, or an artistic genius. In contrast to that individualistic interpretation of history, *The Immigrants* draws on social history, calling attention to ethnic antecedents.

**Dedicated:** *May 4, 1983.* **Signed:** *Sanguino.* **Collection of:** *City of New York; gift of Samuel and May Rudin.*

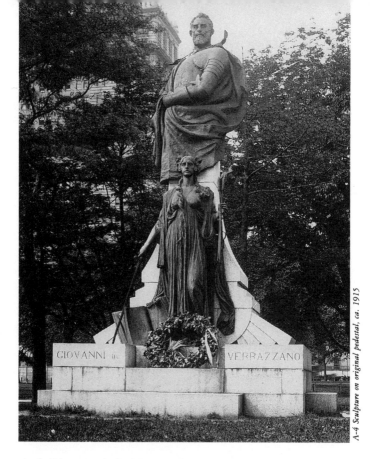

A-4 Sculpture on original pedestal, ca. 1915

## A-4 Giovanni da Verrazzano, 1909

**Sculptor:** *Ettore Ximenes (1855–1926).* **Media and size:** *Bronze bust, 5 feet high; female figure, 9 feet high. Granite pedestal substituted for original in 1951.* **Location:** *Battery Park, east of Castle Clinton.*

This monument has had a strange history and looks quite different from its original design. Due to vandalism, in 1951 the Parks Department replaced the pedestal pictured here with two granite slabs set at right angles to each other. At the same time, the part of Verrazzano's cloak that draped over the stepped base was removed. As a result, sculptor Ximenes' design now lacks its original unity. There seems little connection between the very large bust of the explorer and the allegorical figure, Discovery. Her right hand holds a sword while the book at her feet is an allusion to history. Her left hand once held a torch.

In 1909, when the Hudson-Fulton Celebration honored Hendrick Hudson as the discoverer of the Hudson River, the editor of *Il Progresso*, Charles Barsotti, aroused the Italian community to contend that Verrazzano was the river's true discoverer in 1524. He gave this monument to the city in the name of New York Italians and timed its dedication to coincide with the Hudson-Fulton celebration.

**Dedicated:** *October 6, 1909.* **Signed and dated:** *Ximenes 1909.* **Foundry mark:** *Roman Bronze Works, N.Y. 1909.* **Collection of:** *City of New York; gift of Charles Barsotti in the name of the Italians of New York.*

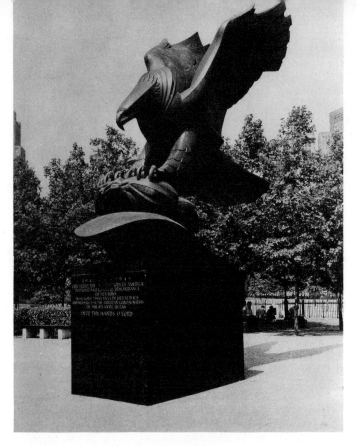

## A-5 East Coast Memorial, 1961

**Sculptor:** *Albino Manca (1898–1976).* **Architect:** *Gehron and Seltzer.*
**Media and size:** *Bronze eagle, 18½ feet high; eight granite slabs, each 19 feet high.* **Location:** *Battery Park, north of Dewey Promenade.*

Commemorating 4,596 servicemen who lost their lives in the Atlantic Ocean during World War II, the *East Coast Memorial* is the counterpart to the *West Coast Memorial* erected at the Presidio of San Francisco. The names of the deceased, whose bodies were never recovered, are inscribed in three columns on the two rows of tall granite slabs. The bronze eagle symbolically lays on a wave a wreath woven from the arrows and branches of the Great Seal of the United States. This signifies an official act of mourning at the servicemen's ocean grave. In recognition of the national scope of the monument, President John F. Kennedy spoke at its dedication.

**Dedicated:** *May 23, 1963.* **Signed and dated:** *Albino Manca 1961.*
**Foundry mark:** *Bedi-Rassy Art FDY NY.* **Collection of:** *U.S. Government; placed on city-owned land.*

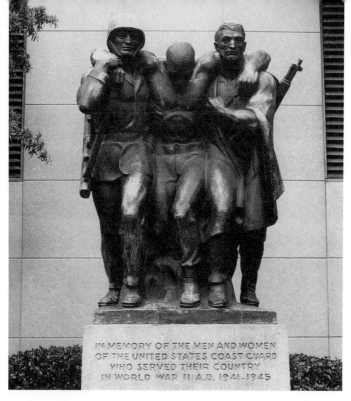

## A-6 Coast Guard Memorial, 1947

**Sculptor:** *Norman M. Thomas (1915– ).* **Media and size:** *Bronze group, over life-size; granite pedestal.* **Location:** *Battery Park, east of* East Coast Memorial.

One of Parks Commissioner Robert Moses' minor confrontations with city officials occurred over the *Coast Guard Memorial.* Although Moses had given the United States Coast Guard his support when they first submitted their design to him, the Art Commission rejected it, criticizing the sculpture's weak modeling and underdeveloped conception. In response to the commission's disapproval, Moses threatened to overrule that body by arguing that the work would be sited close to the Federal Barge Office Building and would therefore fall outside the jurisdiction of the Art Commission. Although Moses used publicity and the purported backing of the Federal Arts Commission as leverage, he did not succeed in pushing the project through in 1945, and the plans for the memorial remained dormant until the Art Commission accepted an improved design in 1954.

A combat veteran and painter, Thomas had never done a monumental sculpture. He won the commission solely on the basis of a sketch depicting a rescue scene that he had witnessed. The work may lack sophistication, but Thomas did succeed in conveying his primary message. Rather than glorify war, he wanted to show its negative impact on human lives. Accordingly, the wounded soldier with his sagging weight and outstretched arms can be viewed as a Christ-like martyr, a sacrifice to war's brutality.

**Dedicated:** *May 30, 1955.* **Signed and dated:** *Norman M. Thomas 1947.* **Foundry mark:** *Capital Products Inc. L.I.C. N.Y. Founders.* **Collection of:** *City of New York; gift of the United States Coast Guard.*

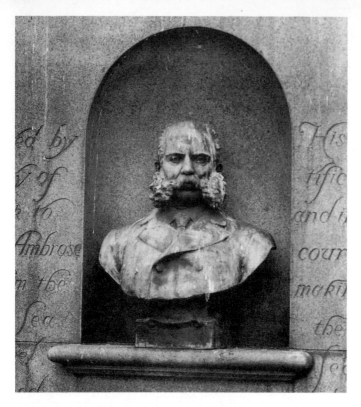

## A-7 John Wolfe Ambrose, ca. 1899

**Sculptor:** *Andrew O'Connor, Jr. (1874–1941).* **Pedestal relief by:**
*Frederick G. R. Roth (1872–1944).* **Setting designed by:** *Aymar Embury
II.* **Media and size:** *Bronze life-size bust; granite slab.* **Location:** *Battery
Park, south wall of Concession Building*

Engineer John Wolfe Ambrose (1838–1899) fought for more than 40 years
to obtain congressional endorsement for his plan to widen the channel into
New York Harbor. His plan cut the distance into port by six miles, and the
wider, deeper channel allowed access by the largest ships. Today, Ambrose
Channel bears his name, attesting to the important role he played in
developing New York as a sea port.

Shortly after Ambrose died, a group of friends presented the bust by
O'Connor to his children who, 30 years later, presented it to the City of New
York for a public memorial. Instead of a simple pedestal, a more interesting
architectural setting was devised to hold the bust which the sculptor had
intended for an indoor location. It is set in a niche in an upright granite slab
and, in the smooth stone beneath the bust, a map of the Ambrose Channel
and surrounding coastline is incised in thin gold lines. At the base of the slab
a border of stylized waves is carved in low relief.

**Erected:** *June 3, 1936, against the wall of the New York Aquarium, then
relocated in the 1950s to the outside wall of the Concession Building.*
**Collection of:** *City of New York; gift of Mrs. George F. Shrady.*

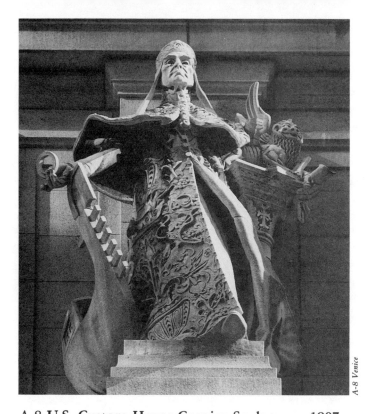

*A-8 Venice*

## A-8 U.S. Custom House Cornice Sculptures, 1907

**Sculptors:** *See text.* **Architect:** *Cass Gilbert (1859–1934).* **Media and size:** *Twelve limestone statues, over life-size.* **Location:** *Bowling Green, between State and Whitehall Streets.*

For the base of the Custom House, architect Cass Gilbert envisioned four large statuary groups symbolizing the four continents. Then to round out the sculptural program for New York's new center of international trade, for the attic story he planned a series of single figures representing various countries.

The Custom House's 12 cornice statues symbolize ancient and modern seafaring and commercial powers. Sculpted by eight different artists, each figure wears an elaborate national costume and seems to compete for our attention. From left to right they are *Greece* and *Rome* by Frank Edwin Elwell (1858–1922), *Phoenicia* by Frederick Wellington Ruckstull (1853–1942), *Genoa* by Augustus Lukeman (1871–1935), *Venice* and *Spain* by Mary Lawrence Tonetti (1863–1945), *Holland* and *Portugal* by Louis St. Gaudens (1854–1913), *Denmark* by Johannes Gelert (1852–1923), *Belgium* (entitled Germany before World War I) by Albert Jaegers (1868–1925), and *France* and *England* by Charles Grafly (1862–1929). Crowning the central portico is Karl Bitter's cartouche depicting the United States seal, embellished by an eagle on the top, and personifications of Peace and Strength standing at left and right respectively. The lavish statuary aligned with the columns accentuates the building's architectural rhythms. The whole ensemble is a Beaux Arts tour de force, a sumptuous display of architecture, sculpture, and ornament.

**Collection of:** *U.S. General Services Administration.*

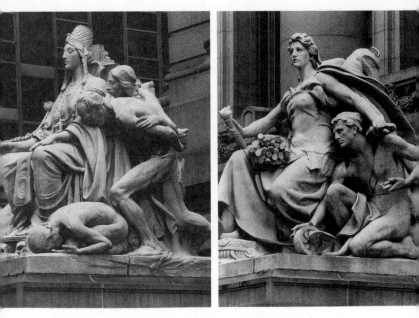

## A-9 The Four Continents, 1903–1907

**Sculptor:** *Daniel Chester French (1850–1931).* **Architect of the Custom House:** *Cass Gilbert (1859–1934).* **Media and size:** *Four marble groups, over life-size.* **Location:** *United States Custom House, Bowling Green between State and Whitehall Streets.*

Daniel Chester French, best known for his *Lincoln Memorial* (Washington, D.C.; 1911–1922) and the *Minute Man* (Concord, Mass.; 1871–1875), received accolades during his lifetime for the "abstract serenity" of his allegorical inventions. Of his three major monuments in Manhattan (see G-26 and J-2) *The Four Continents* is the most celebrated. French greatly valued the commission, confiding to Cass Gilbert, the architect of the Custom House, that his offer interested him "more than anything else almost I ever had to do, and I am willing to make great sacrifices in order to be permitted to execute them."

As one faces the Custom House, the allegorical groups from left to right are Asia, America, Europe, and Africa. Conceived as pyramidal forms to be viewed from all sides, an idealized seated female figure is the focal point in each group. French successfully created a new iconography for a theme that has appeared in art since the end of the 15th century. Each continent fits into a coherent program and is differentiated from the others by subtle changes in figure type, pose, and secondary elements. The sculptures, however, convey meaning beyond their stated allegorical purpose. By the placement of each group in relationship to the building, by the gestures of the figures, and by their attributes, *The Four Continents* reveal underlying cultural values. They can be viewed as an index of turn-of-the-century American attitudes, reflecting America's perception of the world at large and her role in it.

Asia and Africa are at the periphery of the building, distanced from the center of activity. The artist represents Asia as the "mother of religion," a Buddha-like figure absorbed in a meditative trance. She holds a sacred lotus flower with a serpent wrapped around the stem in her right hand, a statuette of a Buddha rests on her lap, and her feet rest on a footstool supported by human skulls. The sculptor contrasts the figure's composure and voluptuous

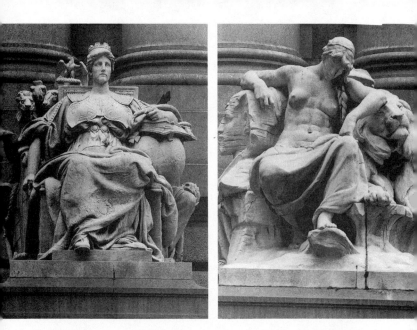

forms with the emaciated body of the man bent forward in supplication and the prostrate youth at her feet. French implies that spiritual salvation, as defined by Buddhist philosophy, falls short of human sustenance.

Africa, veiled in the mysteries of sleep and darkness, is shown as an exotic land. Massive, slumbering, and semi-nude, Africa rests one arm on a sphinx, evoking ancient Egypt, and the other on a lion, typically associated with the "dark continent." The personification of Africa suggests that French and his public perceived the continent as a passive land, characterized by untapped resources and unawakened potential.

America and Europe occupy the central positions in the series, indicative of their active role in international affairs. Of all the figures, America assumes the most dynamic posture, with her torso turned and her left arm stretched out in a forceful diagonal. Critics at the time interpreted the figure as an "ideal woman of the New World," associating her with America's pioneer women and colonial settlers. In her right hand she holds a torch, symbolic of liberty and enlightenment, while an abundant sheaf, representing material prosperity, balances across her lap. A robust figure of Labor turns the wheel of progress, a straightforward reference to America's growing industrial power at the beginning of the 20th century. As America looks to the future, an Indian crouching behind her right shoulder is a reminder of her past and by his position implies a tacit acceptance of the "march of progress."

French depicts Europe, America's counterpart, as the regal continent and disseminator of knowledge. Enthroned, crowned, and clothed in a Grecian gown, she sits upright. Her left arm rests on a book placed over a globe and her right arm leans against a ship's prow. The Parthenon frieze carved on the throne and her Grecian garb evoke Classical Greece and the imperial eagle over her right shoulder recalls ancient Rome. Behind Europe is Ancient History, depicted as an old woman holding a laurel-crowned skull reading a scroll.

**Signed:** *D.C. French Sc. / A.A. Weinman Asst.* **Collection of:** *U.S. General Services Administration.*

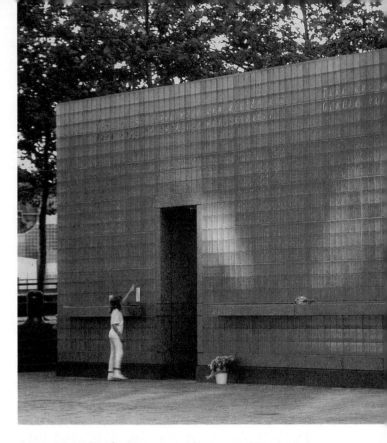

## A-10 New York Vietnam Veterans Memorial, 1984–1985

**Architects:** *Peter Wormser (1952– ) and William Fellows (1953– ).*
**Writer:** *John Ferrandino (1948– ).* **Media and size:** *Glass blocks and granite, 14 feet high by 70 feet wide.* **Location:** *Vietnam Veterans Plaza (formerly Jeannette Park) at 55 Water Street between Coenties Slip and Broad Street.*

"The purpose of the New York Vietnam Veterans Memorial is not to express or imply approval or disapproval of the war. . . . Rather it is to express reconciliation and an awareness of the enduring human values which are reflected in the conflicting experiences of the Vietnam War." These guidelines, set by the New York Vietnam Veterans Memorial Commission for its open competition, shaped this unusual memorial.

New York's Vietnam War monument is a translucent wall of greenish glass blocks engraved with writing by and about Vietnam vets. It is pierced by two portals, and on either side are granite shelves for wreaths, flowers, and candles. For some it evokes Jerusalem's "Wailing Wall," while others see it as a window on the past.

The power of the memorial stems from the engraved words, portions from letters, diaries, poems, and news dispatches which re-create the impact of the war on individuals and the tenor of the times. Richie writes Marie, ". . . I'm getting pretty used to getting shot at. At first I was scared, but now it's like an everyday thing. . . ." Ten months later, on November 16, 1968, he was

killed in action. Howie's letter to his mother says ". . . I worry more about the war back home than I do about my own life over here. What good is the peace we accomplish here if we don't have peace in our own back yards?" The letters embody a range of feelings, touch on universal concerns, and reveal the emotions aroused by the war. Arranged to conform to the architectonic structure of the memorial, the variously sized inscriptions engage the viewer at different distances. The best time to view the memorial is at dusk, when interior lights illuminate the memorial from within, adding to the fading natural light.

The effort to erect a New York memorial began in 1982 when Mayor Koch established the Vietnam Veterans Memorial Commission to organize a memorial competition and create a job-training program for unemployed Vietnam veterans. Twelve hundred applicants entered the open competition, which not only produced the memorial but also resulted in the book *Dear America,* a collection of Vietnam War veterans' letters.

Veterans of an unpopular war, returning Vietnam War soldiers came home without fanfare, and it took a veteran to organize a campaign to erect a national memorial in Washington, D.C. In 1982 the dedication of Maya Lin's chevron-shaped granite wall, cut into the earth and inscribed with the names of the men and women who died, introduced a new approach to commemorative sculpture. Its formal presence and conceptual power may have affected the designers' approach to New York's Vietnam memorial.

**Dedicated:** *May 6, 1985.* **Collection of:** *City of New York; gift of the New York Vietnam Veterans Memorial Commission.*

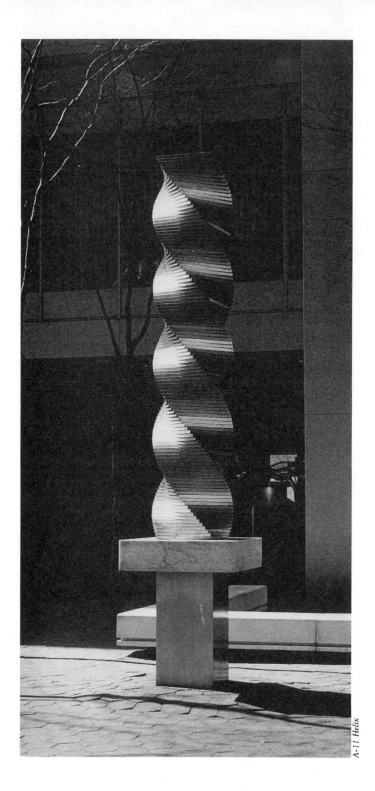

A-11 Helix

# A-11 Sculptures at 77 Water Street, 1970

**Sculptors:** *Rudolph de Harak (1924– ) and William Tarr (1925– ).*
**Designed by:** *Overall scheme designed by Melvyn Kaufman, architect Emery Roth and Sons, designers Corchia, de Harak, Inc., and landscape architects A. E. Bye Associates.* **Location:** *Water Street between Gouverneur Lane and Old Slip.*

Developers Melvyn and Robert Kaufman are known for their imaginative approach to office building design. Completed in 1970, 77 Water Street was their first major Wall Street project and its playful aspect challenged the staid character of New York's financial district.

This glass-and-steel high-rise is surrounded by a multilevel, open plaza which is a series of foot bridges and water pools. Describing the plaza's conception, Melvyn Kaufman explained that his objective "was to make the building disappear. . . . The scale of any large office building is impossible for a human being to relate to. Our plaza is inviting, exciting, warm, and friendly. It makes people forget they're at an office building."

A sculpture or design element marks each of the plaza's four corners, and an old-fashioned candy store and heat lamps called *Heat Trees* by Howard Brandston draw visitors toward the building's entrance. On the northeast corner is Victor Scallo's polished stainless-steel *Cityscape,* opposite Rudolph de Harak's *Helix.* This handsome curving columnar sculpture, 13 feet 9 inches high, consists of 120 one-inch-thick stainless-steel squares, overlapping slightly so as to form the rigidly poised endless curve of a spiral. On the south side of the building are George Adamy's *Month of June,* a series of cylindrical concrete seats backed by orange and yellow Plexiglas circles, and William Tarr's *Rejected Skin,* conceived by Melvyn Kaufman as a joke on the art world: 8 feet high, it is made from rejected, imperfect aluminum panels intended for the skin of 77 Water Street. Compressed in a junk compactor, the crushed aluminum mixed with the red body of a junked ambulance forms three blocks; one hangs suspended by its point from the plaza's ceiling and the other two, one resting on the other, lie beneath it on the ground.

In addition to the works on the street level, there is a sculpture on the building's roof which is visible from surrounding skyscrapers. Upon the suggestion of Rudolph de Harak, the William Kaufman Organization commissioned sculptor William Tarr to create *Sopwith 1919,* a replica of a World War I Sopwith Camel fighter plane, probably the Allied forces' most famous airplane. Like his earlier motorcycle, Tarr fashioned his make-believe aircraft with a 28-foot wing spread from scrap metal and found objects. It sits on an Astroturf runway designed by Rudolph de Harak.

**Collection of:** *The William Kaufman Organization.*

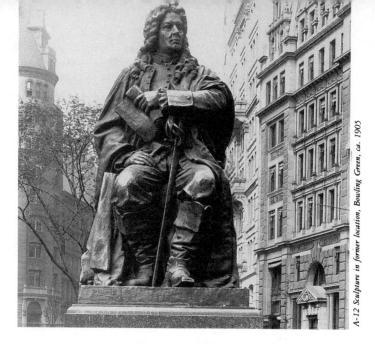

## A-12 **Abraham De Peyster, 1896**

**Sculptor:** *George Edwin Bissell (1839–1920).* **Media and size:** *Bronze statue, over life-size; granite pedestal (replica of original pedestal installed in 1976).* **Location:** *Hanover Square, at the juncture of Pearl and Hanover Streets.*

Abraham De Peyster, born into a New Amsterdam family in 1657 shortly before the colony became New York, was a rich merchant who in his 63 years filled almost every local government office, serving as alderman, mayor, chief justice, member of the king's council, acting governor, and colonel of militia. John Watts De Peyster, his great-great-great-grandson, commissioned this statue. It originally stood in historic Bowling Green opposite the house at 3 Broadway where the younger De Peyster was born. In 1972 the city redesigned Bowling Green and moved the seated bronze figure to Hanover Square.

Bissell produced this work in his Mount Vernon, New York, studio, then had it cast in Paris where he also worked. He sought a convincing likeness as well as accuracy in the period clothing. The seated, self-assured man wears high boots, a voluminous cloak, and a wig of cascading curls. The rich textures, deep undercuts, and details of his garments do not overshadow the strength and intelligence reflected in his face.

Turn-of-the-century Chicago sculptor and historian Lorado Taft said of Bissell that he "imagines a vast amount of character" into his subject. Bissell's colleagues admired the De Peyster work, and in a 1902 contest to determine New York's most noteworthy sculptures many local artists included the portrait of De Peyster among their selections.

John Watts De Peyster also commissioned Bissell to sculpt a portrait statue of his grandfather, John Watts, put in Trinity churchyard in 1890.

**Signed and dated:** *Geo. E. Bissell / Sculptor 1896.* **Foundry mark:** *E. Gruet Jne. Fondeur / Paris.* **Collection of:** *City of New York; gift of John Watts De Peyster.*

# A-13 Untitled, 1973

**Sculptor:** *Yu Yu Yang.* **Media and size:** *Two-piece stainless-steel sculpture, 16 feet high.* **Location:** *Orient Overseas Building, 88 Pine Street.*

This intriguing steel sculpture by Taiwanese artist Yu Yu Yang engages the viewer in a visual game. Set upright on the sidewalk space, it consists of a matte-finished L-shaped slab pierced by a circular cut-out, and a separate, highly polished disk. The two parts appear to fit together. The 12-foot-high, 4,000-pound disk stands at a slight angle to the "parent" element, which, when viewed from the north, frames it. The relationship of the steel components and the resolution that they suggest lend the work an internal tension. In addition, the disk's mirror finish dissolves this solid form into myriad reflections, creating an illusion of deep space. The technological perfection of the work, which is assembled without seams, increases its visual impact.

On a building wall adjacent to this participatory sculpture, a plaque commemorates the *Queen Elizabeth I,* destroyed by fire in Hong Kong harbor in 1972. Morley Cho, owner of the Orient Overseas Building, was the last owner of the ill-fated luxury ocean liner.

**Signed and dated:** *Yu Yu Yang '73.* **Fabricated by:** *Otis Allied Bronze Division.* **Commissioned by:** *C. Y. Tung of the Orient Overseas Association.*

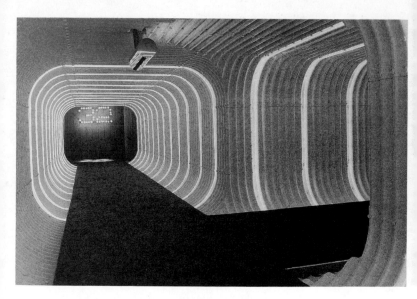

# A-14 127 John Street, 1971

**Architect:** *Emery Roth & Sons. Lobby and plaza designed by Rudolph de Harak.*

This 1971 office building near the South Street Seaport has been enhanced by its owners, the William Kaufman Organization, with even more playful elements than was their first downtown office property at 77 Water Street (see A-11). Several artists turned their talents toward creating here an environment at once practical and enjoyable. One entire wall functions as a huge digital clock, useful and entertaining to passersby in cars or on foot. At lunchtime, workers flock to the comfortable, colorful, outdoor seats shaded by awnings and climbable scaffolding. To enter the building one must pass through a neon-lit, corrugated-metal tunnel, probably unique in the world. It was designed by Rudolph de Harak, who created the ground-floor spaces as well as the brightly painted love seats and the hanging fish sculpture outside the building.

In addition, two sculptures decorate the open lobby. In the vein of *Sopwith 1919* on the roof of 77 Water Street, Albert Wilson created *The Busted Bike* and *Comet* (1972), a scrap-metal bicycle and motorcycle chained to a bicycle rack. In a corner near the corrugated-steel tunnel is a group of painted plastic dolls called *Homage to Lewis Carroll* (1972) by Mary Lomprey. The fanciful ensemble represents the Queen, Bishop, and Castle, three of the animated chess pieces from Lewis Carroll's *Through the Looking Glass*.

**Commissioned by:** *The William Kaufman Organization.*

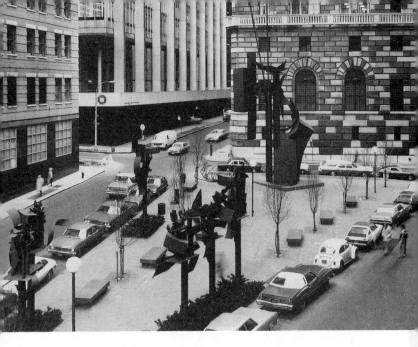

## A-15 Shadows and Flags, 1977

**Sculptor:** *Louise Nevelson (1900–1988).* **Media and size:** *Seven Cor-Ten steel constructions painted black; largest piece, 40 feet high.* **Location:** *Louise Nevelson Plaza, at the intersection of Maiden Lane and William and Liberty Streets.*

When she was commissioned to create a group of works for this mini-park, which came into being as a barren oversize traffic island resulting from street widening, Louise Nevelson sought to encompass the whole space, named in her honor. She did not, however, design the paving, benches, and tree locations which were provided by an active business community. After she had studied the area looking down from nearby office buildings, Nevelson decided to place the sculptures on poles so that they would appear to "float like flags" along the periphery of the plaza.

In *Shadows and Flags* Nevelson incorporates curling pieces of steel, cylinders, planes, and four-sided boxes. She balances the forms, suspending what appears to be massive weight. The most effective of the all-black painted series is the large work, with its jagged contours, its gestural, thin cylinders angling out of the mass, and its dramatic empty interior spaces. When seen from the ground under the bottomless box cantilevered into space, the work takes on a menacing character. In the smaller works, the clusters of curving planes suggest organic growth, a theme which Nevelson had explored in her *Tropical Gardens* of the late 1950s.

Concerned with total environments, Nevelson explained in an interview with gallery owner Arnold B. Glimcher: "I visually anchor my piece and feel that it has a backdrop to react against or it gets lost." In Louise Nevelson Plaza, the largest work interacts with the structures around it, but the other black works drift into the larger visual field of trees, traffic, and buildings.

**Dedicated:** *April 14, 1977.* **Fabricated at:** *Lippincott, North Haven, Connecticut.* **Collection of:** *City of New York; gift of the Mildred Andrews Fund.*

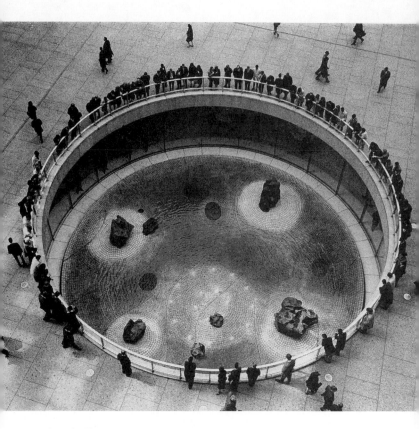

## A-16 Chase Manhattan Bank Plaza Sunken Garden, 1961–1964

**Sculptor:** *Isamu Noguchi (1904– ).* **Media and size:** *Granite and basalt rocks, largest 6 feet high; pool, 60 feet in diameter.* **Location:** *1 Chase Manhattan Plaza, between Nassau and Liberty, William and Pine Streets.*

The Japanese-American artist Isamu Noguchi is one of the most versatile and inventive sculptors of his generation—indeed, of our century. He has produced a diverse body of work in stone, metal, ceramics, and wood that draws on ancient art and modern technology, Oriental spiritualism and Western rationalism. Noted as a sculptor of spatial relationships, Noguchi devised stage sets for dancer Martha Graham and also pioneered new garden and playground designs. His continued interest in these sculptural forms flows from both his fascination with Japanese ceremonial landscapes and his desire "to bring sculpture into a more direct involvement with the common experience of living."

Noguchi has completed 14 significant gardens in America, Japan, France, and Israel. He developed the idea for the *Chase Manhattan Bank Plaza Sunken Garden* when Gordon Bunshaft of Skidmore, Owings & Merrill, the architects of the Chase Manhattan tower, asked him to design the plaza. To help humanize the space, Noguchi proposed a circular, sunken garden, a meditative refuge, which would be visible from both the plaza level 16 feet above it and the banking facilities level on which it rests. Enclosed by glass,

the large circular hole piercing the plaza would also bring daylight to the lower level.

Noguchi shaped the ground of the lower level into mounds and depressions, creating an undulating landscape, evocative of an ocean floor. Covering the contoured earth are concentric patterns of paving, curving lines that accentuate the rolling forms of the ground and suggest the raking used in Japanese gardens and the stylized sea waves of Chinese art. The visual focus of the design is seven basalt rocks, taken from the bed of the Uji River in Kyoto. The rocks' veined surfaces, eroded by sand-laden water, are smooth and their silhouettes intricate. Precisely positioned, they are in equilibrium with the various-size depressions surrounding them. The fountain near the center of the pool can produce a variety of sprays, and the water covers enough of the floor to suggest the effect of rocks rising out of the sea.

In his writings Noguchi emphasizes the importance of rocks in his sculptured gardens, citing their prominence in Japanese gardens and their historic place in Japanese worship. But here Noguchi's usage differs from Japanese precedents. "The chief feature in this Garden," he elucidates, "is the use of rocks in a nontraditional way. Instead of being a part of the earth they burst forth, seeming to levitate out of the ground." In traditional Japanese gardens the rocks are sunk into the earth.

The *Chase Manhattan Bank Plaza Sunken Garden* combines the randomness of nature with artifice and logic. Without water, it looks like a lunar landscape—bleak, austere, and mysterious. Impossible to enter, Noguchi's shaped space is as cerebral as it is physical, a palpable imaginary landscape.

**Collection of:** *Chase Manhattan Bank.*

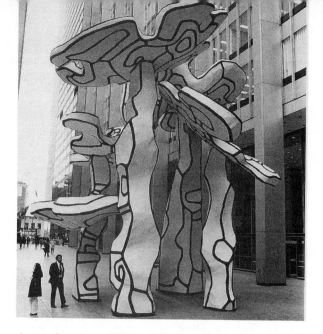

## A-17 Group of Four Trees, 1972

**Sculptor:** *Jean Dubuffet (1901–1985).* **Media and size:** *Epoxy paint on fiberglass resin skin over a cellular aluminum core, 42 feet high.* **Location:** *1 Chase Manhattan Plaza, between Nassau and Liberty, William and Pine Streets.*

This whimsical invention is one of New York's most delightful and successful public sculptures. Like a cluster of giant, pulsating mushrooms, Dubuffet's *Group of Four Trees* establishes a mood of fantasy. Architectural in scale, the undulating vertical and horizontal elements lack straight edges, and the sculpture as a whole contrasts with the taut curtain wall of the Chase tower. The white surface, covered with thick curving black lines, is like a continuous membrane wrapped around a structural core.

At the sculpture's dedication, the French-born Dubuffet remarked that his "unleashed graphisms" are not painted sculptures, but rather "drawings which extend and expand in space." They evolved from a series, called the "L'Hourloupe" cycle, begun in 1962, the product of doodles with a ballpoint pen. Dubuffet explained that the "L'Hourloupe" works, in various media, are meant "to erase all categories and regress toward an undifferentiated continuum."

Skidmore, Owings & Merrill completed 1 Chase Manhattan Plaza in 1961, but it took another decade to select a work of art for the plaza. According to David Rockefeller, the bank's art committee felt that the 2½-acre plaza "needed a vertical counterpoint to stand against the assertive personality of the Chase building" and soften the severity of "the immediate architectural landscape." Giacometti was originally considered for the job, but the noted Surrealist sculptor died before he could complete the project. Eventually Alfred H. Barr, Jr., former director of the Museum of Modern Art, suggested Dubuffet.

**Dedicated:** *October 24, 1972.* **Collection of:** *Museum of Modern Art; donated by David Rockefeller on his retirement in 1981 as chairman of Chase Manhattan Bank.*

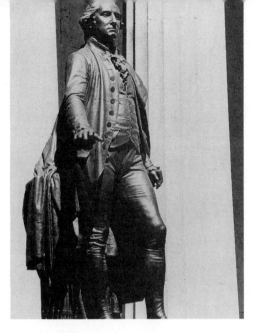

## A-18 George Washington, 1883

**Sculptor:** *John Quincy Adams Ward (1830–1910).* **Pedestal by:** *Richard Morris Hunt.* **Media and size:** *Bronze statue, over life-size; granite pedestal.* **Location:** *Federal Hall National Memorial at Wall and Nassau Streets.*

Caught up in the centennial celebrations that swept over the country, the Chamber of Commerce of the State of New York organized a subscription for this statue of Washington to commemorate his inauguration as the first president of the United States. It is positioned on the spot where Washington took the oath of office in 1789 on the balcony of New York's second City Hall, an earlier building that was the seat of government when New York served as the nation's first capital between 1789 and 1800. Inside the present Greek Revival temple, which replaced that structure in 1842, is the actual stone Washington stood on for the occasion.

Ward shows Washington lifting his hand from the Bible as he completes the swearing-in ceremony. The composition of a figure standing next to a draped fasces, signifying national unity, and Washington's features and dress recall the French sculptor Jean-Antoine Houdon's full-length marble portrait made from life in 1786, on which Ward relied for historical accuracy. A bronze cast of Houdon's marble, which is located in Richmond, Virginia, can be seen in the lobby of City Hall.

The solid forms, minimal detail, and solemn gesture make Ward's statue a noble monument to the father of his country. Its scale is compatible with the financial district and also with the massive columned façade of Federal Hall. One of the small plaster models Ward made for this statue belongs to the City of New York and is located at Gracie Mansion.

**Dedicated:** *November 26, 1883.* **Signed and dated:** *J. Q. A. Ward / 1883 Sculptor.* **Foundry mark:** *The Henry & Bonnard / Bronze Manuf'g Company / New York 1883.* **Collection of:** *National Park Service; gift by public subscription.*

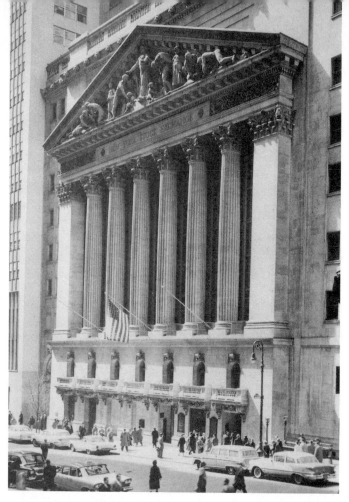

## A-19 New York Stock Exchange Pediment, 1903

**Sculptor:** *John Quincy Adams Ward (1830–1910), assisted by Paul Wayland Bartlett (1865–1925).* **Architect:** *George B. Post.* **Media and size:** *Marble pediment, 110 feet long.* **Location:** *New York Stock Exchange, 8 Broad Street between Wall Street and Exchange Place.*

"Integrity Protecting the Works of Man," the pediment of the New York Stock Exchange, suits its location stylistically and conceptually. The relief symbolically represents the Stock Exchange as a reflection of national wealth. With open arms, Integrity stands in the center where, as the critic Russell Sturgis explains, "she holds the center of the world's business." Agriculture and Mining, symbols of the earth's riches, are at her left; Mechanical Arts, Electricity, Surveyors, and Builders, emblems of technological production, are at her right. The corner groups, representing miners and builders, are artfully compressed in the angled spaces.

Correspondence between Ward and the architect of the building, George B. Post, indicates that Post devised the program for the relief. Ward carried it out with the help of the young Paul Bartlett, who was perhaps also responsible for the final modeling. Getulio Piccirilli, a member of the family of expert Italian stone cutters, translated the relief into marble.

In 1936 the marble figures were replaced with lead-coated copper replicas.

## A-20 The Red Cube, 1967

**Sculptor:** *Isamu Noguchi (1904– )*. **Media and size:** *Painted welded steel and aluminum, 28 feet high; also known as* Rhombohedron. **Location:** *Marine Midland Building Plaza, 140 Broadway.*

Noguchi's bright-red cube plays against the dark, impenetrable glass façade of the Marine Midland Bank's tower, creating with the building an abstract composition of color and form. Balanced on a point, toward the left side of the building, the cube and its architectural backdrop suggest a giant exclamation mark. The hole in the work's center adds complexity to the design. It seems to hold a magnetic attraction for the viewer.

Subtle distortions intensify the impact of the sculpture. Elongated on its vertical axis, the cube is more precisely a rhombohedron, a six-sided figure whose opposite sides are parallel at oblique angles. Noguchi once commented: "If you have complete harmony, nothing happens; whereas if you have an element of disharmony, energy enters as a disequalibrizing factor."

Shortly before the Marine Midland commission, Noguchi designed the marble sculpture court for the Beinecke Rare Book and Manuscript Library at Yale University, and *The Red Cube* recalls the cubic element in that garden, where he assigned each sculptural form a symbolic meaning. He equated the cube on its point with chance, "like the rolling of dice," a metaphor for the human condition.

The success of *The Red Cube* is not Noguchi's alone. The commission is one of several collaborative ventures with architect Gordon Bunshaft of Skidmore, Owings & Merrill. For the Marine Midland Plaza, Noguchi originally proposed a cluster of primitivistic monoliths, rejected because they were too expensive. Bunshaft suggested an alternative approach, and eventually sculptor and architect settled on this precariously balanced brightly colored cube.

**Installed:** *March 1968.* **Commissioned by:** *140 Broadway Company.*

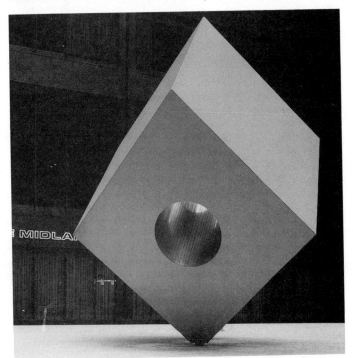

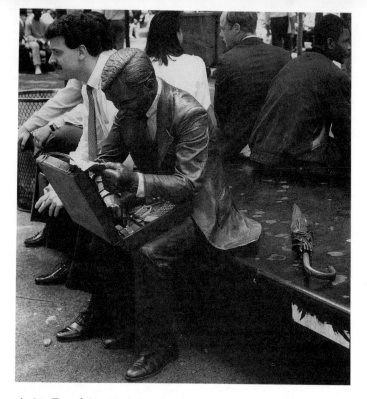

## A-21 Double Check, 1982

**Sculptor:** *J. Seward Johnson, Jr. (1930–  ).* **Media and size:** *Bronze life-size statue; placed on metal bench.* **Location:** *1 Liberty Plaza, on Liberty Street between Broadway and Church Street.*

Inconspicuous among the metal benches, pedestrians, and trees of Liberty Plaza, a seated bronze businessman bends over an open briefcase and studies a memo. Whether depicting the executive, tennis player, teenager, or restaurant patron, Johnson's realistic, life-size sculptures honor the ordinary American. Placed in convincing settings, they fool the passerby, who often chuckles after delayed recognition.

Johnson's style of realism is literal, and he uses actual clothing, artifacts, and color to create his illusionary bronzes. He begins with a 12-inch clay maquette, which his assistants then enlarge to a life-size clay nude. Other workers drape the life-size clay manikin in actual clothes that a seamstress then stitches to plaster castings. A stiffening resin transforms the pliable material into permanent folds. Johnson fashions the figure's semi-naturalistic head and hands and the sculpture is cast into bronze by means of the lost-wax method. Finishers employ various chemicals to achieve a colored patina on the figure's hair, clothes, and accessories.

Commissioned by Merrill Lynch, Johnson tailored this work to reflect his patron. The businessman reads a memo on Merrill Lynch letterhead, reviewing information as the title "Double Check" implies, before attending a meeting across the street at Merrill Lynch headquarters. His briefcase contains a stapler, calculator, tape recorder, pencils, and sometimes an actual sandwich, provided by passersby.

**Installed:** *1982.* **Cast at:** *The Johnson Atelier, New Jersey.* **Collection of:** *Merrill Lynch.*

# A-22 Sphere for Plaza Fountain, 1968–1971

**Sculptor:** *Fritz Koenig (1924– ).* **Media and size:** *Bronze, 25 feet high.*
**Location:** *Austin J. Tobin Plaza at the World Trade Center, between Church and West, Vesey and Liberty Streets.*

This colossal sphere dominates the center of the World Trade Center Plaza. Bulbous growths and geometric incisions rupture the globe's sleek surfaces, suggesting both cosmic forces and cellular life as the sculpture seems to rise on its own volition out of the pool of water.

Koenig's sculpture closely resembles the cut-away spheres by Italian sculptor Arnoldo Pomodoro and its bold geometries reflect Koenig's interest in African carvings. The World Trade Center work is the largest of Koenig's commissions.

This bronze fountain sculpture is one of six major public artworks at the World Trade Center. In 1969 the Port Authority of New York and New Jersey established an admirable art-in-architecture program, allocating up to 1% of the construction costs of a Port Authority facility toward the purchase of art. To oversee the acquisition of works, the Port Authority created an Art Committee, formed during the construction of the World Trade Center. Before the committee met, the architect of the twin towers, Minoru Yamasaki, had planned sites for four exterior sculptures, one interior sculpture, and one tapestry by Miró, at 2 World Trade Center; he had commissioned Masayuki Nagare to execute the entrance plaza sculpture and Fritz Koenig to execute this bronze centerpiece for the fountain. When the Art Committee convened, members reviewed the work of 50 prominent sculptors and selected James Rosati for the third plaza sculpture and Alexander Calder and Louise Nevelson to create the remaining exterior and interior sculptures, respectively. Although sculptors adjusted the scale of their works to the site, the immense World Trade Center towers still minimize their "monumentality."

**Collection of:** *The Port Authority of New York and New Jersey.*

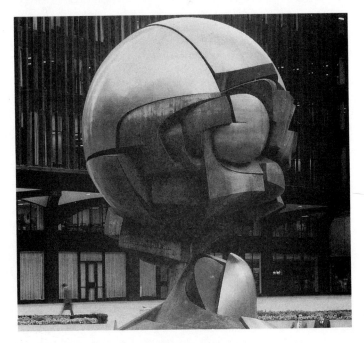

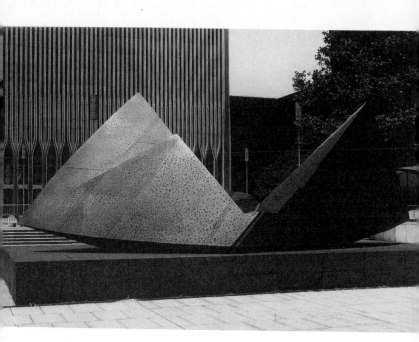

## A-23 World Trade Center Plaza Sculpture, 1967–1972

Sculptor: *Masayuki Nagare (1923– )*. **Media and size:** *Black Swedish granite over steel armature, 14 feet high by 34 feet wide by 17 feet deep; low, platform base.* **Location:** *World Trade Center, at the Church Street entrance to the Austin J. Tobin Plaza.*

Recognized by American critics as one of Japan's leading sculptors, the self-taught Nagare draws inspiration from traditional Japanese arts and crafts, Shintoism, and Buddhism. Merging nature with artifice, Nagare's quiet granite studies reflect Japanese cultural attitudes and strike a balance between the inherent beauty of raw materials and the crafted object. Nagare's New York gallery representative, George W. Staempfli, says that the sculptor's works, "are all 'stones' rather than sculptures made of stone. They are sensuous, alive, and seem to be breathing."

*The World Trade Center Plaza Sculpture,* one of the largest free-standing stone carvings of modern times, unites two asymmetrical pyramids, buoyantly rising from a center gully. The polished finish of the primary planes contrasts with the sculpture's rough underside and gully, which critic John Canaday has likened to "a dry, rocky stream bed." Incised grooves, filled with putty, form a pattern of lines over the surface, and pockmarks randomly cover the entire piece, whose sensuous, varied textures invite the viewer to touch. Although it appears monolithic, this sculpture consists of approximately 40 granite pieces, carved and fitted together over a metal frame.

Retaining the warmth of the midday sun and providing a wall to lean against, Nagare's sculpture helps humanize the World Trade Center plaza. It is a meditative focal point in the midst of downtown's bustle.

**Unveiled:** *1974.* **Signed:** *Nagare.* **Collection of:** *The Port Authority of New York and New Jersey.*

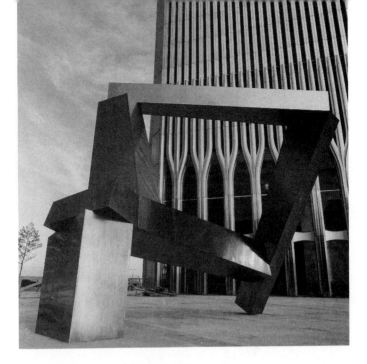

## A-24 Ideogram, 1967–1973

Sculptor: *James Rosati (1912–  ).* **Media and size:** *Stainless steel, 23 feet 6 inches high by 19 feet 6 inches wide by 28 feet 6 inches deep.* **Location:** *Austin J. Tobin Plaza at the World Trade Center, between Church and West, Vesey and Liberty Streets.*

The stainless-steel *Ideogram* appears to be in constant motion, in search of an equilibrium, contracting and expanding with each shift in the viewer's vantage point. Avoiding the vertical, the horizontal, and the static, Rosati built his monumental construction from angled geometric elements, reminiscent of beams. Tilted on diagonals and balanced on points, the sculpture's parts form window-like openings that frame views of the World Trade Center and nearby buildings. Reflected light accentuates the sculpture's movement through space. Its shimmering surfaces dissolve and reappear, for *Ideogram* is as ephemeral as it is solid.

In 1969 the Port Authority Art Committee commissioned Rosati's sculpture, selecting it from a group of models dating from 1962. The committee also chose this location in the vast Austin J. Tobin Plaza, where the sleek sculpture alternately blends with and plays against the aluminum striations of the World Trade Center towers.

**Signed and dated:** *Rosati / 67–73.* **Collection of:** *The Port Authority of New York and New Jersey.*

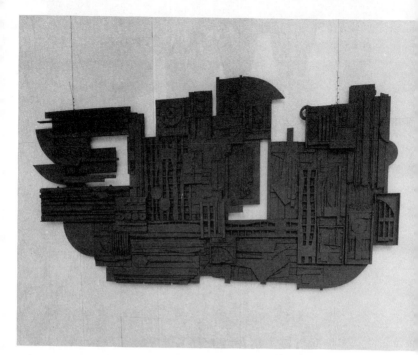

## A-25 Sky Gate, New York, 1977–1978

**Sculptor:** *Louise Nevelson (1900–1988).* **Media and size:** *Black-painted wood relief, 17 feet high by 32 feet wide by 12 feet deep.* **Location:** *Lobby of 1 World Trade Center.*

The celebrated sculptor Louise Nevelson is best known for her stacked, wood boxes filled with pieces of molding, furniture, and crates. Here she also uses the technique of assemblage, arranging an assortment of found objects into a compartmental structure. By painting her works a uniform color, generally black, white, or gold, she conceals the objects' original identities and establishes a new totality. Called an "architect of shadow," she creates both an architectonic pattern of lights and darks and a composition that resonates with external references.

*Sky Gate, New York* combines finials, chair slats, parts of balustrades, newel posts, and barrel staves. The work is subtle and requires the viewer's active curiosity to draw out its nuances. Within a structure of horizontal and vertical planes, Nevelson shapes striations and blocks of shadows, played against disks and curving edges. To modulate the contrast between light and dark, the sculptor creates intricate layerings. In the center box-like grid, for example, Nevelson inserts small disks, which both reflect light and throw their own crescent-shaped shadows, echoing the larger disks on the relief's surface. At the dedication ceremony, Nevelson described it as a "a night piece," and said that it represents the "windows of New York."

Drawing upon the Cubist and Constructivist traditions, manifest in the geometric structure and planar organization of space in her works, Nevelson adds a note of poetic mystery to the activity of the World Trade Center lobby.

**Dedicated:** *December 12, 1978.* **Collection of:** *The Port Authority of New York and New Jersey.*

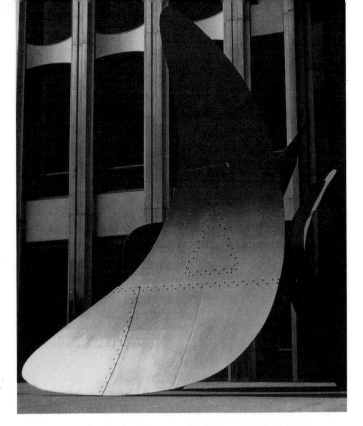

## A-26 World Trade Center Stabile, 1970–1971

**Sculptor:** *Alexander Calder (1898–1976).* **Media and size:** *Abstract steel construction painted red, 25 feet high.* **Location:** *7 World Trade Center on the Vesey Street overpass.*

Buoyant and bright red, the three biomorphic elements comprising the *World Trade Center Stabile* suggest the wings of a giant bird. Ribs and rivets strengthen the powerful, curving plates and, as critic Sam Hunter has observed, "contribute to an intensified material and formal presence." In a 1969 interview Calder explained how he made his stabiles: "How to construct them changes with each piece; you invent the bracing as you go, depending on the form of the object." The Port Authority Art Committee commissioned Calder to enlarge an existing stabile, *Three Wings.* The sculptor proposed enlarging it to a height of 150 feet, but the architect Yamasaki proposed 14 feet; they compromised at a height of 25 feet. Calder had previously done a giant 60-foot stabile, which straddled a street in Spoleto, Italy.

For his World Trade Center piece, the sculptor insisted on a site outside the World Trade Center plaza, where sculptures appear miniaturized in the shadow of the towers. He agreed to a location on West Street, but in 1979, because of construction on the West Side Highway, Port Authority officials moved the work to the corner of Church and Vesey Streets. Criticized as being too large for that site, the sculpture has recently been relocated to the front of 7 World Trade Center, where it can be seen on the overpass.

**Collection of:** *The Port Authority of New York and New Jersey.*

## A-27 The Upper Room, 1984–1987

**Sculptor:** *Ned Smyth (1948– ).* **Media and size:** *Cast concrete, glass, stone, mosaic, 40 feet high by 75 feet long by 20 feet wide.* **Location:** *Battery Park City, on Albany Street at the Esplanade.*

In keeping with the overall vision of Battery Park City, designed by Cooper-Eckstut on 92 acres of landfill, a Fine Arts Program was established in 1982 to integrate art into the complex. Planners wanted to encourage artists to collaborate with architects in sculpturally defining a space. Traditionally, sculptors have been asked to provide ornamental objects for a preexisting location, rather than working with architects during the crucial planning stages.

Matching artists to sites, an advisory committee selected six locations for artworks, two at the north and south coves and a third in the southernmost part of the development. An additional three sites lead onto the Battery Park City Esplanade. All of the sculpted spaces will provide public amenities and maximize waterfront views.

Ned Smyth's *Upper Room* is the first of the six works to be completed. It links Albany Street with the pleasing esplanade and the river beyond, drawing you in as it unfolds toward the water. It offers a wonderful view of the sunset, framed by its five arches. Near the center of the space a gazebo enshrines a column. There is also a long table inlaid with chess boards and surrounded by 12 stationary concrete stools. From the table's center rises a slender cypress-shaped column covered in mosaics. The carefully orchestrated courtyard of pink aggregate and pebbles offers many sitting places and is a favorite spot for lunch, encouraging both sociability and meditation.

Since the 1970s Ned Smyth has been inventing hybrid architectural forms, embellishing them with colorful mosaics and imbuing them with

spiritual content. The design here recalls a Roman atrium and echoes the papyrus columns of Ancient Egypt as well as the rhythmic arches of a Renaissance arcade. The name *The Upper Room* reflects the artist's intent to create a "space of respect," where people can transcend themselves and the realities of urban life. The spiritual symbolism is reiterated in the ritualistic altar and in the long table and 12 stools, suggesting the Last Supper.

The decorative element in Smyth's work, the emphasis on texture and color, coincides with a similar trend in architecture, evident in the surrounding post-modern buildings of Battery Park City.

The other works commissioned for the Battery Park City esplanade are a metal gateway for the eastern entrance to Rector Park by R. M. Fisher and Anderson/Schwartz Architects, and a "public environment," including lighting, plantings, and six pieces of park furniture made of various materials for the entrance to West Thames Street Park by Richard Artschwager.

Designs for the larger cove sites are the most complex of the group. On the waterfront plaza at the base of the World Financial Center sculptors Siah Armajani and Scott Burton have collaborated with architect Cesar Pelli and landscape architect M. Paul Friedberg to create a series of spaces joining lower Manhattan with the waterfront area. For the three acres of waterfront park at Battery Park City's South Cove, sculptor Mary Miss, working with architect Stanton Eckstut and landscape architect Susan Child, has devised an elaborate structure juxtaposing organic elements with a lookout, bridge, and circular jetty. The last commission for the South Park site was awarded to Jennifer Bartlett, Alexander Cooper, and David Varnell.

**Collection of:** *The Battery Park City Authority and the City of New York.*

# (B)
# DOWNTOWN

*Fulton Street to Houston Street*

---

This region encompasses the heart of civic New York, a stately assembly of government and court buildings arrayed around downtown's architectural jewel, City Hall. In keeping with the function of the buildings they adorn and in the tradition of public sculpture, many of the works here symbolize judicial and governmental ideals.

A shimmering, golden silhouette, *Civic Fame* dominates the skyline above the Municipal Building. Below her a more sedate *Justice* presides over City Hall, opposite the fabulously decorated Beaux Arts Surrogate's Court. To the south stretches City Hall Park, a significant green space in the downtown district and one of the city's oldest parks. Originally part of the Commons, it assumed its present size in 1785 when the Common Council designated its boundaries. During the last two centuries City Hall Park has undergone many changes. From 1869 to 1939 it rested in the shadow of Alfred B. Mullett's overpowering 1876 post office erected on its southern end. Under Parks Commissioner Robert Moses the park was redesigned in the 1930s, at which time the post office was demolished. In 1941 the marble group *Civic Virtue* was moved to the new Queens Borough Hall. During the mid-1970s M. Paul Friedberg and Partners restructured the southern tip around the new Delacorte Fountain. Today City Hall Park is the tree-shaded setting for the statues of the patriot Nathan Hale and the journalist Horace Greeley. In addition, its lawns are a showcase for rotating exhibitions of contemporary public sculpture, presented by the Public Art Fund.

To the northeast of City Hall Park, Chinatown bustles at the foot of the Manhattan Bridge, marked by a grand sculptured entranceway. Nearby is the Lower East Side where one can find monuments to New York favorites Gov. Alfred E. Smith and Mayor Fiorello La Guardia.

EAST HOUSTON ST.

LOWER
EAST SIDE

STANTON ST.

NORFOLK ST.

ATTORNEY ST.

RIDGE ST.

PITT ST.

COLUMBIA ST.

RIVINGTON ST.

ELDRIDGE ST.

SUFFOLK ST.

CLINTON ST.

DELANCEY ST.

WILLET ST.

LEWIS ST.

BROOME ST.

ORCHARD ST.

LUDLOW ST.

GRAND ST.

Seward
Park

JACKSON ST.

LITTLE
ITALY

HESTER ST.

CHRISTIE ST.

FORSYTHE ST.

ALLEN ST.

ESSEX ST.

EAST BROADWAY

JEFFERSON ST.

CLINTON ST.

MONTGOMERY ST.

GOUVERNEUR ST.

BOWERY

ELIZABETH ST.

19  20

RUTGERS ST.

23

LaGuardia
Houses

CHERRY ST.

WATER ST.

East River

MOTT ST.

MULBERRY ST.

BAYARD ST.

FLORENCE ST.

DIVISION ST.

PIKE ST.

RUTGERS
SLIP

PELL ST.

18

DOYERS ST.

HENRY ST.

MARKET ST.

PARK ST.

17

Chatham
Sq.

CATHERINE ST.

MADISON ST.

CHINATOWN

OLIVER ST.

BAXTER ROW

JAMES ROW

21

22

MARKET SLIP

ST. JAMES PL.

CATHERINE SLIP

Gov. Smith
Memorial Park

F.D.R. DRIVE

MANHATTAN BRIDGE

N

FRANKFORT ST.

DOVER ST.

FERRY ST.

PECK SLIP

BROOKLYN BRIDGE

BEEKMAN ST.

WATER ST.

FRONT ST.

PEARL ST.

DOWNTOWN
(REGION B)

DOWNTOWN  39

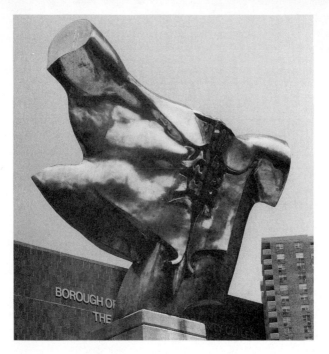

## B-1 Icarus, 1976

**Sculptor:** *Roy Shifrin (1933– ).* **Media and size:** *Bronze torso, 9 feet high by 14 feet wide by 4 feet deep; granite pedestal.* **Location:** *In the plaza at the entrance to Borough of Manhattan Community College, 199 Chambers Street, near West Street.*

According to Greek mythology, Icarus was the son of Daedalus, architect of King Minos' Labyrinth. When Daedalus helped a captive escape from it, the king spitefully imprisoned both Daedalus and Icarus in the maze. Seeking freedom, Daedalus fashioned two pairs of wings, warning Icarus not to fly too close to the sun because the wax holding the feathered wings might melt, but the youth, infused by the joy of flight, disregarded the warning; Icarus lost his wings and dropped into the sea.

Artists and writers have presented various interpretations of the myth of Icarus. Shifrin, long interested in the Icarus theme, explains, "For me, Icarus represents the uncertainties of our age." To express that idea, he has tried in his sculpture to combine the sensations of flying and falling, liberation and earth-bound captivity.

Here, Icarus appears as a male torso, whose spine and thorax are fused with the concave expanse of wings. *Icarus* conveys a sense of anguish; yet Shifrin also wanted the sculpture to appear as if soaring, suggesting optimism.

In designing *Icarus,* Shifrin carefully evaluated the problems of reflective surfaces in an outdoor environment, aware that too much reflected light dissolves sculptural mass. The highly polished front and back surfaces activate the simplified forms with passing reflections, but the sides of the torso are only moderately reflective. The artist compares his sculpture to a "knife-edge" form.

**Cast at:** *Foundry Villa Valls Spain, 1976.* **Collection of:** *City of New York; purchase.*

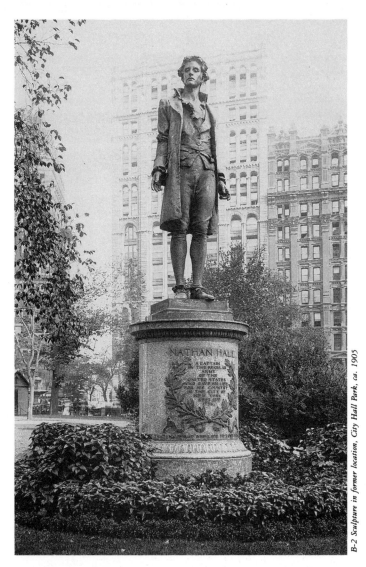

## B-2 Nathan Hale, 1890

Sculptor: *Frederick MacMonnies (1863–1937)*. Pedestal by: *Stanford White*. Media and size: *Bronze statue, over life-size; granite pedestal.* Location: *City Hall Park, Broadway at Murray Street.*

Sculptor Frederick MacMonnies depicts 21-year-old Captain Hale (1755–1776) before his execution, the day after his capture by British troops. The young patriot is portrayed as he concludes his historic speech with the memorable words, "I only regret that I have but one life to lose for my country." MacMonnies attempted to convey the magnitude of Hale's self-sacrifice. "I wanted to make something that would set the bootblacks and little clerks around there thinking," he recalled, "something that would make them want to be somebody and find life worth living." Having no portrait of Hale, MacMonnies imagined his subject as a romantic hero, heightening the figure's dramatic effect with an open ruffled collar, noble bearing, and gesturing, bound arms. Hale wears the costume of a schoolmas-

ter, the disguise he assumed to infiltrate British lines. The deep undercuts, textured surfaces, particularly in the area of the stockings, and the creased garments reflect MacMonnies' brilliant handling of his medium.

MacMonnies was only 26 when he entered the Nathan Hale Memorial Competition in 1889 upon the recommendation of his former teacher, Augustus Saint-Gaudens. His winning clay model brought him recognition in New York City, and two years later his full-scale plaster model won him a medal at the Paris Salon. The finished statue was also warmly praised. In 1893 Henry Marquand, president of the Metropolitan Museum of Art, declared the *Nathan Hale* to be "among the finest works we have ever produced in this country." The statue of America's martyred spy has since been critically acclaimed as an exemplary Beaux Arts monument.

The sculpture was unveiled in City Hall Park on November 25, 1893, the 110th anniversary of the evacuation of British troops from New York City. It has often been said that Nathan Hale died in City Hall Park (previously The Commons), but the British hanged him in Artillery Park, the British military ground, today the area near Third Avenue and 66th Street.

**Dedicated:** *November 25, 1893.* **Signed and dated:** *Frederick MacMonnies Paris 1890.* **Foundry mark:** *Jaboeuf & Bezout fondeurs à Paris.* **Collection of:** *City of New York; gift of the Sons of the Revolution of New York.*

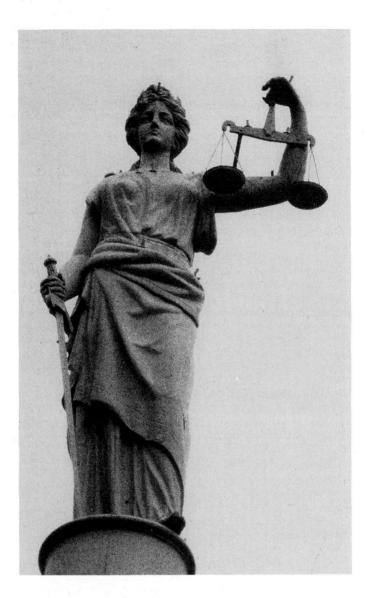

## B-3 Justice, 1887

**Sculptor:** *Unknown.* **Media and size:** *Copper statue, painted white, 9 feet 6 inches tall.* **Location:** *On cupola of City Hall.*

Crowning New York's beautiful 1812 City Hall is a stately figure of Justice, the third to occupy that position. The figure is constructed much like the *Statue of Liberty.* It is composed of formed pieces of sheet copper soldered together into a smooth shape. Supported on an internal armature it is painted white to give the appearance of carved stone. Nearby, *Civic Fame* (see B-15), at the top of the tower of the Municipal Building, was built on the same principle but is gold leafed, whereas the *Statue of Liberty,* which has been allowed to develop the characteristic copper patina, has taken on a green appearance.

Unlike either of these other statues which were individually created by famous sculptors, *Justice* is a mass-produced sculpture, a fine example of the skills of 19th-century manufacturers of large metal architectural sculptures. *Justice* was fabricated for $600 in Salem, Ohio, at the William H. Mullins, Co. studio, which made countless figures for public buildings, world's fairs, and expositions. The Mullins workshop also custom-made such famous pieces as Saint-Gaudens' lovely copper Diana weathervane that graced the tower of the original Madison Square Garden and is now at the Philadelphia Museum of Art.

Mullins employed several European-trained sculptors and carvers who worked anonymously. "Justice" was a favorite subject for early courthouses, and was an appropriate choice for New York's City Hall because in its earliest days the structure housed city courts as well as virtually all city departments and officials.

City Hall's very first figure of Justice had been commissioned by its architects while the building was still under construction. Drawings for that first Justice, depicted without a blindfold, can be seen at the New-York Historical Society along with other architectural drawings for the building. The sculptor was John Dixey, Dublin born, London trained, and an outstanding member of New York's art circle in the early 1800s. Dixey received $310 for carving the graceful wooden Justice with scales and sword that adorned City Hall from 1813 until the fire of August 18, 1858, caused by fireworks set off on the roof of City Hall to celebrate the laying of the Atlantic Cable. When the roof and cupola burned, so did the wooden figure, which crashed through the dome and into the central stairwell of City Hall.

In May of 1860 a new wooden Justice appeared on the rebuilt cupola. No clear picture of this figure is known, but distant views of City Hall indicate that one hand was raised, presumably to hold scales, while the other was lowered as if holding a sword. A flagpole with flapping American flag stood immediately behind her. City records show that on May 10, 1860, $525 was paid to Mary Stratton, who signed the receipt in an uncertain hand "Mrs. Joseph Stratton." A Stratton family of ships' carvers had been in business on South Street where the big sailing ships docked.

At any rate, that wooden Justice seemed before long to suffer from rot and the Department of Public Works reported in mid-1887 that it had become "insecure." So after about 25 years atop City Hall, the second wooden statue of Justice was replaced by the present 170-pound Justice of lightweight copper.

**First Justice:** *Wooden, carved by Dixey; placed on City Hall about 1813; burned 1858.* **Second Justice:** *Wooden, carved by Stratton; placed on City Hall May 1860.* **Third Justice:** *Copper on armature, fabricated by William H. Mullins Co.; placed on City Hall November 3, 1887.*

*B-4 Photo, ca. 1905*

## B-4 Benjamin Franklin, ca. 1872

**Sculptor:** *Ernst Plassmann (1823–1877).* **Media and size:** *Bronze statue, over life-size; granite pedestal.* **Location:** *Printing House Square, Nassau Street and Park Row.*

Benjamin Franklin (1706–1790), statesman, scientist, and journalist, here assumes the role of an ambassador and a newspaperman. Depicted at the age of 70 and dressed in the garments of an 18th-century diplomat, he extends his right hand in an oratorical gesture and holds a copy of his first newspaper, the *Pennsylvania Gazette,* in his left. A very popular retired Hudson River steamboat commander, Albert DeGroot, presented *Benjamin Franklin* as a tribute to New York's printers and press, placing it in this public space in front of the former *Times* and *Tribune* offices. At the sculpture's unveiling, Mr. Savage, president of the New York Typographical Society, noted: "It is appropriate that this statue should be erected in this center of our trade, in the very midst of our craft-work, instead of Central Park; for Franklin's life was devoted to practical hard work rather than to ornamental and recreative."

The dedication of the Franklin statue was a major event. Horace Greeley, editor of the *Tribune,* made the principal address and the "star spangled robe" that hid the statue was unveiled by the elderly Samuel F. B. Morse, like Franklin a great inventor and in an earlier period of his life a leading artist. The day's public unveiling was followed by a banquet that evening at Delmonico's restaurant. All in all, it was a memorable occasion.

A replica of the Franklin statue and a similar statue of Johannes Gutenberg, also by sculptor Ernst Plassmann, stand in the lobby of the High School of Graphic Arts at 439 West 49th Street. These works originally adorned the façade of the office building of the German-language newspaper *Staats-Zeitung,* present site of the Municipal Building.

**Dedicated:** *January 12, 1872.* **Foundry mark:** *G. Fisher Bronze Foundry, New York City.* **Collection of:** *City of New York; gift of Capt. Albert DeGroot.*

# B-5 Pace University Sculpture

**Location:** *Pace Plaza, off Park Row and just south of the Brooklyn Bridge.*

A variety of public sculptures enhance this new campus of Pace University, completed in 1970. A welded metal relief entitled *Brotherhood of Man* by Henri Azaz (1923) marks the university's main entrance on Printing House Square. It consists of a series of metal strips embellished with figures punched into the surface, which when viewed from the south are identifiable but from other angles look like abstract geometric shapes.

In the center of the university buildings is a peaceful sculpture garden with greenery and trickling water. Although it is closed to the public, one can peer in from the street.

Inside are sculptures by Peter Anthony Chinni (1928– ) and Ralph Joseph Menconi (1915– ).

Behind the university on Gold Street are two bronzes entitled *Acrobat in the Ring* and *Heaven and Earth,* by Chaim Gross (1915– ). This sculptor, best known for his wood carvings, has another similar work at Fordham University (see I-3).

**Collection of:** *Pace University.*

## B-6 Horace Greeley, 1890

**Sculptor:** *John Quincy Adams Ward (1830–1910).* **Pedestal by:** *Richard Morris Hunt.* **Media and size:** *Bronze statue, over life-size; granite pedestal.* **Location:** *City Hall Park, northeast of City Hall.*

John Quincy Adams Ward's outstanding portrait of Horace Greeley (1811–1872), founder of the *New York Tribune,* not only records the journalist's appearance and facial features but also suggests his personality. The sculptor revealed to reporters that he was aided by a death mask he had made of Greeley. "By means of this," he explained, "I was enabled to reproduce the peculiar structure of his head that photographs would never have shown. The great difficulty was in giving the features the expression of childlike simplicity, together with the strength of a philosopher which was peculiar to him." Ward also wanted to capture Greeley's idiosyncratic gestures, particularly the inquiring side look he would give visitors to his office, and here portrays the editor with his head cocked toward an unseen person and the *Tribune* across his knee. Rumpled clothing, his tie looped under his chin whiskers, and a bulky figure complete this probing study of one of New York's most powerful newspapermen.

Whitelaw Reid, Greeley's successor as the *Tribune's* editor, invited Ward to execute the memorial some nine years after Greeley's death. Reid and the Tribune Association supplemented funds collected from donors nationwide.

Ward designed the sculpture for a sidewalk niche in the façade of the Tribune Building, the famous early skyscraper on the northeast corner of Nassau and Spruce Streets across from City Hall Park, in what is now the bed of the exit from the Brooklyn Bridge. Unfortunately, the sculpture projected beyond the building line. In 1915 the president of the Borough of Manhattan mandated that all street obstructions be removed, so the statue on its granite pedestal was relocated to City Hall Park, near the place where Greeley had labored throughout his life. The Tribune Building, designed in 1873 by Richard Morris Hunt, was demolished in 1966.

**Dedicated:** *September 20, 1890.* **Signed and dated:** *J.Q.A. Ward / 1890.*
**Foundry mark:** *Cast by the Henry-Bonnard Bronze Co. / New York 1890.*
**Collection of:** *City of New York; gift of the Tribune Association.*

## B-7 Surrogate's Court Façade Sculpture, 1903–1908

**Sculptors:** *Philip Martiny (1858–1927) and Henry Kirke Bush-Brown (1857–1935).* **Building designed by:** *John Rochester Thomas.* **Architect:** *Horgan and Slattery.* **Location:** *Surrogate's Court (formerly Hall of Records), 31 Chambers Street.*

The Surrogate's Court is a building of great elegance, strongly influenced by French Second Empire architecture. Designed in the 1890s but not completed until 1907, it is free-standing and occupies an entire small city block. All four of its sides are ornamented. The main façade on Chambers Street is a skillfully balanced composition that gracefully displays sculpture. There is an uninterrupted view of it from across the street at the edge of City Hall Park, and as the strongly modeled façade receives sunlight all day long, it is a photographer's delight.

Sculptor Philip Martiny was commissioned to carry out the full sculptural program, a total of 42 sculptures. He handled the major pieces himself and turned over to Henry Kirke Bush-Brown all work on the imposing mansard roof. Martiny also did two dignified seated female figures, named *Justice* and *Authority,* which were relocated from the Centre Street entrance to the New York County Courthouse at 60 Centre Street when that thoroughfare was widened in 1959.

The figures on the courthouse are either historical or allegorical and were intended to edify the public. Among the allegorical subjects represented are the four seasons, intellectual and artistic pursuits, and industry and commerce, a reflection of the turn-of-the-century American preoccupation with material and artistic progress.

Martiny did the parade of full figures standing along the cornice line above the fifth floor. On the Chambers Street façade, a mixed bag of New York officials, mostly mayors, spans some 300 years. From left to right across the building the figures represent the following: *David Pietersen De Vries* (17th

century), patroon of the colony of Staten Island about 1640; *Caleb Heathcote* (1665–1721), mayor of New York, 1711–1714; *De Witt Clinton* (1769–1828), governor of New York, 1817–1823, 1828; mayor of New York, 1803–1807, 1809–1810, 1811–1815; *Abram Stevens Hewitt* (1822–1903), Mayor of New York, 1887–1888; *Philip Hone* (1781–1851), mayor of New York, 1825–1826; *Peter Stuyvesant* (1592–1672), director-general of New Netherlands, 1647–1664; *Cadwallader David Colden* (1769–1834), mayor of New York, 1818–1821; *James Duane* (1733–1797), mayor of New York, 1784–1789.

On the Centre Street façade's cornice the eight female figures by Martiny represent *Chemistry, Medicine, Industry, Commerce, Navigation, Industrial Art, Music,* and *Architecture*. On the Reade Street cornice are Martiny's eight male and female figures representing *Justice, Electricity, Printing, Force, Tradition, Iron Age, Painting,* and *Sculpture*.

The roof sculpture, like that on the façades, is visually an extension of the architecture. The attic pieces by sculptor Henry Kirke Bush-Brown on the Chambers Street façade are *Childhood,* left and right side of the attic window; *Spring, Summer, Winter, Autumn,* four caryatids grouped around the upper part of the round window; *Philosophy* (left) and *Poetry* (right), semi-reclining male figures; and *Maternity* (left) and *Heritage* (right), seated sculptures on either side of the triple window, which allude to the record keeping and judicial activities within the building.

For the Reade Street façade, around the central window on the attic roof Bush-Brown did four male figures, two semi-reclining and two seated representing intellectual pursuits, which culminate in the law as represented by the bearded old man. The statues are *Instruction,* upper right; *Study,* upper left; *Law,* lower right; and *History,* lower left. On the Elk Street façade, around the central window in the attic roof, *Industry,* a male, is on the left and *Commerce,* the female figure, on the right.

**Collection of:** *City of New York; purchase.*

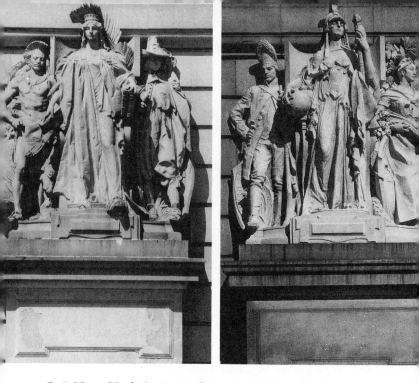

## B-8 New York in Its Infancy *and* New York in Revolutionary Times, 1907

Sculptor: *Philip Martiny (1858–1927).* **Media and size:** *Granite statuary groups, over life-size; granite pedestals.* **Location:** *Entrance to Surrogate's Court, 31 Chambers Street.*

Philip Martiny studied in French ateliers, where he mastered the Beaux Arts style of ornamental sculpture. When he immigrated to the United States in the 1880s, he worked as an assistant to Saint-Gaudens then went on to become this country's leading practitioner of architectural sculpture.

Among Martiny's 28 sculptures for the Surrogate's Court, this pair of sculptural groups flanking the main entrance on Chambers Street best illustrates his poetic use of light, shadow, and line. *New York in Revolutionary Times,* at the left, and *New York in Its Infancy,* at the right, are pyramidal groups, animated by deep undercuts, graceful and abundant folds of drapery, and an irregular play of shadows. In both compositions the standing figure personifying New York dominates two smaller ones on either side. The New York of early times wears a crown, connoting colonial rule. On her right stands an Indian; on her left a Dutch settler. The New York of revolutionary times wears a Phrygian cap, connoting the struggle for liberty. On her right is a man in colonial military uniform balanced by a female settler on her left, holding a scythe and flowers.

Lorado Taft, turn-of-the-century sculptor and art historian, regarded Philip Martiny as the consummate decorative sculptor, writing: "Mr. Martiny works with incredible rapidity and apparently with little reflection, yet with such an instinct for the right thing, decoratively considered, that he seldom fails to produce a beautiful result."

**Collection of:** *City of New York; purchase.*

# B-9 Tilted Arc, 1981

**Sculptor:** *Richard Serra (1939– )*. **Media and size:** *Cor-Ten steel, 12 feet high by 130 feet wide.* **Location:** *26 Federal Plaza, off Centre Street.*

Not a monument, not a statue, but an active force that redefines its space, Serra's controversial curving arc of rusted steel challenges our definition of sculpture and public art. Serra is one of the leading innovators of 20th-century sculpture, noted for his eloquent manipulations of lead and steel plates, organized around the principles of weight and balance. Also concerned with a work's whole context, he designs his sculptures for a particular place, making them "site-specific." Integrally connected to their locations, whether they be urban plazas or grassy meadows, Serra's sculptures affect the way we perceive their surroundings, and by extension, ours. *Tilted Arc,* at once a solid mass and a line, segments the plaza and establishes two distinct volumes—one concave and one convex—which emerge as the viewer traverses the space. As Serra explains, "The work, through its location, height, length, horizontality, and lean, grounds one into the physical condition of the place. The viewer becomes aware of himself and of his movement through the plaza."

*Tilted Arc* was commissioned by the General Services Administration as part of the federal government's Art-in-Architecture program. Championed by some as an enhancement of the site, others have viewed the sculpture as an obstruction. Four years after its erection the Regional General Services Administrator conducted a three-day hearing to determine whether or not

*Tilted Arc* should remain at 26 Federal Plaza. It generated 654 pages of public transcript, attracted 1,737 letters, and petitions carrying over 7,000 signatures.

Serra and his supporters argue that the work is site-specific, and to remove it is to destroy it. They also contend that its removal would be a breach of contract and a dangerous precedent for other artists commissioned by the government. The work's detractors, primarily employees who work in the adjacent buildings, argue that the sculpture prevents them from using the plaza and interferes with their vision and passage across the space. As a result of the March 1985 hearing, the panel recommended that the sculpture be removed. However, that recommendation is subject to review by the administrator of the General Services Administration. Meanwhile, Serra, who has continually maintained that relocation of the sculpture would violate his First Amendment rights, filed a lawsuit against the G.S.A., but in July of 1987 the Federal District Court ruled against Serra on those grounds. Since the court ruling, and at the request of the G.S.A., an advisory committee appointed by the National Endowment for the Arts was formed to evaluate alternative sites for *Tilted Arc*. In December of 1987 the committee indicated that there are no appropriate alternative sites, upholding Serra's contention that to relocate the Cor-Ten steel arc is to destroy it. If the G.S.A. accepts the panel's recommendation, the agency will have to leave the sculpture in situ or else place it in storage. The fate of *Tilted Arc*, the decade's most controversial public sculpture, is still undecided.

**Commissioned by:** *U.S. General Services Administration.*

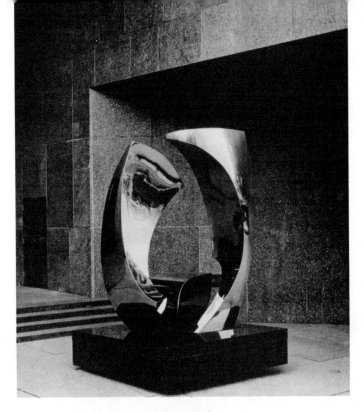

## B-10 **Three Forms, 1972–1976**

**Sculptor:** *Roy Gussow (1918– ).* **Media and size:** *Polished stainless steel, 10 feet high; black granite pedestal.* **Location:** *Family Court Building, 60 Lafayette Street at Leonard Street.*

Gently twisting in space, three hollow, stainless-steel forms interlock in a cluster. By repeating curves and orchestrating the ensemble into rhythmic solids and voids, sculptor Gussow creates a unified composition that is effective from all angles. Although the abstract shapes have no literal meaning, Gussow explains, "I strive for a lyrical equilibrium among distinctly different elements, and I like to think I am suggesting optimism, beauty, and a well-being."

Gussow's seamless stainless-steel sculptures attain a crafted sleekness. Set against a very somber building of dark granite, the highly burnished, reflective surfaces mirror the environment and each other, and from certain vantage points, the forms dissolve under a liquid light.

Gussow won this commission in a closed competition, organized by the Fine Arts Federation. As a result of an executive order issued by Mayor Robert F. Wagner, suggesting funds be allocated for works of art in new public buildings, money for this sculpture came from construction costs of the Family Court Building.

Brooklyn-born Gussow first studied landscape design. Then, after World War II, under the GI Bill he studied sculpture in Chicago under Alexander Archipenko. After teaching design in the school of architecture at the University of North Carolina in Raleigh, he returned to New York to pursue his consuming interest in metal sculpture.

**Installed:** *November 24, 1976.* **Collection of:** *City of New York; purchase.*

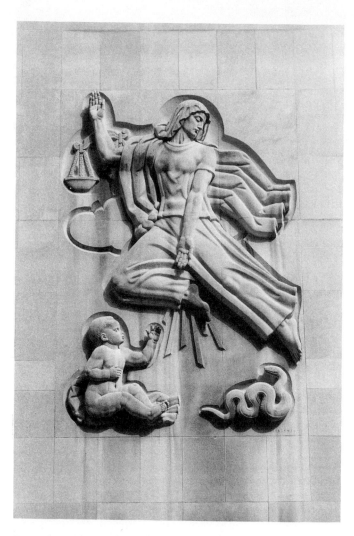

## B-11 Justice, 1960

**Sculptor:** *Joseph Kiselewski (1901– ).* **Media and size:** *Limestone bas-relief, 18 feet high.* **Location:** *Civil and Municipal Court Building, 111 Centre Street, on the Lafayette Street façade.*

In contrast to Zorach's more realistic narrative representing Law, on the east façade of this court building Kiselewski presents a modern allegory of Justice. A stylized female figure wearing flowing pants and shirt, draped with a cloak over one shoulder, appears to float in a dance-like posture. The traditional iconographic emblem, scales, occupies the carved-out space below her right hand. With her left arm she gestures to the baby sitting below her bent right knee, suggesting that justice will protect the child from harm, represented as a snake. The relief's precise detail and sharp edges are typical of Kiselewski's style.

**Dedicated:** *1961.* **Signed:** *J. Kiselewski.* **Collection of:** *City of New York; purchase.*

# B-12 Law, ca. 1959

Sculptor: *William Zorach (1887–1966)*. Media and size: *Limestone bas-relief 18 feet high*. Location: *Civil and Municipal Court Building, 111 Centre Street, on the Centre Street façade*.

A leading figure in the American school of direct carving, William Zorach is best known for his primitivistic stone figures depicting mothers and children. Advocating "truth to materials," Zorach explained in 1926 that "real sculpture is something monumental, something hewn from a solid mass, something with repose, with inner and outer form; with strength and power."

The relief on the east façade of the Civil and Municipal Courthouse is one of Zorach's last public works, commissioned shortly after he completed a façade sculpture (1952–1953) for the Mayo Clinic in Minnesota. Although this relief is not one of the sculptor's best pieces, it adds visual interest to the blank, austere wall, and its theme suits the function of the building. Instead of depicting Law as an allegorical figure, Zorach presents a contemporary family in the context of legal proceedings. Four family members cluster around a central, stoic figure of a judge, solemnly taking an oath. A mother and baby sit on the lower left, turned in profile toward Wisdom, a young woman who holds an open book in her lap and reaches out to comfort the mother with her other arm. Above and behind the judge are two male figures who face in opposite directions and raise their arms in an oath. Behind the figures is an abstracted cityscape, composed of geometric buildings, houses, and bridges, suggesting New York City. Rounded forms and stylized details, evident in the treatment of the figures' hair and facial features, characterize the relief. The sculpture's implied message, law's power to assist the ordinary family, coupled with its generalized forms, recalls artworks commissioned for public buildings during the New Deal, when Zorach's fame was at its height.

Signed and dated: *Zorach / 1960*. Collection of: *City of New York; purchase*.

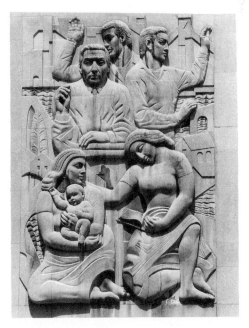

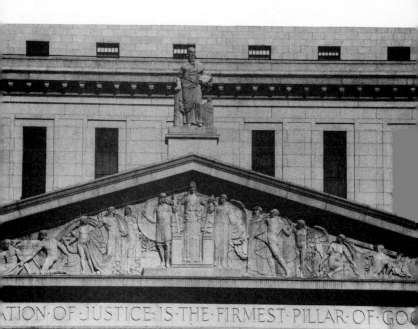

ATION·OF·JUSTICE·IS·THE·FIRMEST·PILLAR·OF·GOO

## B-13 New York County Courthouse Pedimental Sculpture, ca. 1924

**Sculptor:** *Frederick Warren Allen (1888–1961).* **Architect:** *Guy Lowell.*
**Media and size:** *Granite pediment, 140 feet long.* **Location:** *60 Centre Street, at Foley Square, recently renamed Thomas Paine Square, between Pearl and Worth Streets.*

Above the massive, columned portico of the temple-like New York County Courthouse are 14 stone pedimental figures and three gigantic roofline sculptures, *Law, Truth,* and *Equity.* The sculptural program, conceived in a Beaux Arts manner tinged with Art Deco, represents the ideals of a court of justice. Within the pediment, *Justice* occupies the center with the warrior, *Courage,* on her right and *Wisdom* on her left. Three figures next to *Courage* are the forces of Evil and three figures next to *Wisdom* are the forces of Good. In the small triangular spaces at the ends of the pediment are appropriately *Guardians of the Records,* for within this building are priceless historic New York records. The designer of the work, Frederick Warren Allen, a teacher of sculpture at Harvard and at the Boston Museum, had the granite blocks carved at the site from full-scale plaster models.

**Collection of:** *City of New York.*

# B-14 Authority *and* Justice, 1906

**Sculptor:** *Philip Martiny (1858–1927).* **Media and size:** *Granite statues, over life-size.* **Location:** *Niches on either side of the entrance to New York County Courthouse, 60 Centre Street.*

On the columned porch at the top of a long sweep of stone steps sit two granite female figures representing *Authority* and *Justice*. Each in her own niche, *Authority*, on the left, balances her right hand on a fasces, Roman emblem of official power, and holds a scroll in her left hand. Her associate, *Justice*, steadies a shield in her left hand and grasps a scroll in her right. Both of these idealized figures appear dreamy-eyed and withdrawn, a characteristic of turn-of-the-century female personifications in sculpture and painting.

Martiny's majestic figures were originally on either side of the Centre Street entrance to the Surrogate's Court (Hall of Records). When the city widened Centre Street in 1959, the sculptures were relocated to the New York County Courthouse.

**Collection of:** *City of New York; purchase.*

B-14 Authority

# B-15 Civic Fame, 1913–1914

Sculptor: *Adolph Alexander Weinman (1870–1952)*. **Media and size:** *Sheet copper on a steel frame, 25 feet tall.* **Location:** *On the tower of the Municipal Building, Centre and Chambers Streets.*

Gold-leafed *Civic Fame,* the largest statue in Manhattan, gleams at the very top of the 40-story Municipal Building. Like the *Statue of Liberty,* this female figure is of sheet copper, formed in numerous sections that are soldered together into a smooth sculptural surface. It is supported by an interior skeleton, a steel inner post from which steel branches extend to hold the thin copper skin in position and firm against wind and storm.

*Civic Fame* wears flowing drapery and a laurel headdress, and stands on a sphere. In her right hand is a shield and laurel branch, in her left a crown with five turrets symbolic of the city's five boroughs.

After the five boroughs came together in 1898 to form the greater city, a competition was held for a large structure adjacent to City Hall to house additional administrative offices. The architectural firm of McKim, Mead and White won with a design recalling both a Roman triumphal arch and Bernini's colonnade at St. Peter's Square. The architects commissioned sculptor Adolph Weinman to create the new building's entire sculptural program, which included a gilded finial at its top and ornamental relief panels in the classical Renaissance manner on lower levels.

The Chambers Street archway has granite relief carvings: spandrel figures *Guidance* (left) and *Executive Power* (right), and also figurative groups *Civic Duty and Progress* (left) and *Civic Pride and Prudence* (right). Second-story bronze relief panels to the right of the archway depict *The Comptroller, Water Supply, Elections* and *Licenses, Civil Service* and *Sheriff, Records and Accounts, Correction and Building Inspection, Public Service Commission,* and *Board of Estimate.* Bronze medallions contain coats-of-arms of the state, county, and city. All are repeated in reverse order to the left of the archway.

In 1974 the city's Department of Public Works undertook to regild *Civic Fame* for the nation's Bicentennial. The interior surfaces were brushed clean (even a bird's nest removed), then primed and protectively painted. Finally the 2,800 square feet of outer copper skin surface were prepared for the new covering of hand-burnished gold leaf to give *Civic Fame* a durable protective coating as well as her original elegant appearance.

**Collection of:** *City of New York; purchase.*

*B-15 Model, ca. 1914*

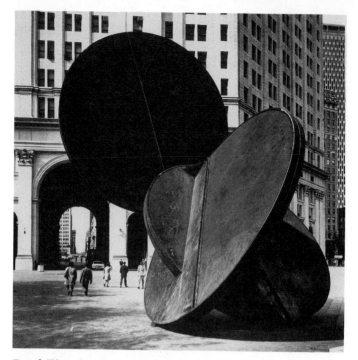

## B-16 Five in One, 1971–1974

**Sculptor:** *Bernard (Tony) Rosenthal (1914– ).* **Media and size:** *Cor-Ten steel, 30 feet high each of five disks, 20 feet in diameter.* **Location:** *Police Headquarters Plaza, east of the Municipal Building just north of the Brooklyn Bridge.*

The 75-ton *Five in One* consists of five disks, sloping, slicing, and interlocked. Although it was conceived as an abstraction, the sculpture has come to symbolize the five boroughs of New York City. Sculptor Rosenthal designed the piece as a participatory sculpture, intending viewers to walk through it as they traverse the plaza, and he chose the large scale so that the work would be visible from the Police Building and the Federal Building. It is seen to best advantage from the east or west, framed by the mammoth arch of the Municipal Building.

In his original design, selected in a closed competition, Rosenthal had envisioned the piece as a bright-red burst in the center of a monotone plaza, but the Art Commission rejected his plans primarily because of the expense that frequent repainting would entail. Cor-Ten steel, at the time a new material for sculpture, was selected because it was thought to be maintenance-free. Still, in spite of compromises, *Five in One* won first prize in the Design in Steel Awards of the American Iron and Steel Institute.

In 1987 the Art Commission approved improvements for the expansive Police Plaza, the locale of *Five in One,* notably a new pavement pattern by Valerie Jaudon, funded through the Percent for Art program. Aiming to unify the site, she proposed an environmental site-specific artwork that in her words will "preserve the public and monumental character of the plaza, but change the scale of the pedestrian traffic passages to a more human one."

**Signed and dated:** *Rosenthal / 1971–74.* **Fabricated by:** *Milgo.* **Collection of:** *City of New York; purchase.*

# B-17 Kimlau War Memorial, 1962

**Architect:** *Poy G. Lee (1900–1968).* **Media and size:** *Granite, structural steel, and cement; 18 feet 9 inches high, 16 feet wide, and 2 feet deep.* **Location:** *Chatham Square, at the head of Oliver Street.*

Evoking a triumphal arch, the *Kimlau War Memorial* is a simple granite structure composed of two shafts and a lintel, capped with a narrow overhang. Two features—the three concentric grooves carved into the top of the columns above the lintel, and the pagoda-like overhang—are inspired by Oriental motifs. The American Legion erected the monument in memory of Chinese-Americans who have died in the armed services of the United States.

**Built by:** *De Nigris Monument Co.* **Collection of:** *City of New York; gift of the American Legion, Lt. B. R. Kimlau Chinese Memorial Post 1291.*

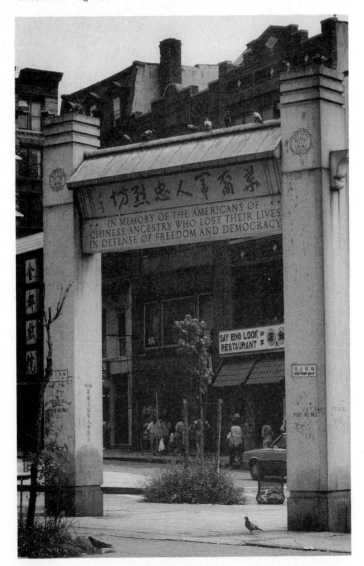

# B-18 Confucius, ca. 1977

**Sculptor:** *Liu Shih.* **Media and size:** *Bronze statue, over life-size; concrete pedestal faced in green marble.* **Location:** *Bowery and Division Streets.*

The Chinese philosopher Confucius (c. 551–479 B.C.) founded one of the world's great ethical systems. Based on the principles of "right living," Confucianism presents logical arguments, teaching followers love and respect for fellow human beings. The disciples of Confucius recorded his teachings and sayings in the *Analects of Confucius*.

The Chinese community presented this statue of Confucius by the Taiwanese sculptor Liu Shih to the City of New York on the occasion of the United States Bicentennial. Standing calmly in elaborate, flowing robes which fall in symmetrical folds, the philosopher clasps his hands across his chest. The traditional headdress, long beard, and moustache are characteristic of portraits of the venerated sage. In 1983, in honor of the anniversary of Confucius' birthday, the Chinese community had the plain concrete pedestal faced with green marble and erected marble bollards with chains to surround the sculpture.

**Collection of:** *City of New York; gift of the Chinese Consolidated Benevolent Association.*

## B-19 Spirit of Commerce *and* Spirit of Industry, ca. 1914

Sculptor: *Carl A. Heber (1874–1956).* **Media and size:** *Granite statuary, over life-size.* **Location:** *North and south piers of the Manhattan Bridge, between Canal Street and the Bowery.*

The Manhattan Bridge was the last of the three Manhattan–Brooklyn bridges to be built across the East River. It followed the Brooklyn Bridge (1870–1883) and the Williamsburg Bridge (1901–1903). A suspension structure, it combines modern engineering with Beaux Arts accessories, evident in the elaborate monumental approach, including a heavily ornamented triumphal arch and a colonnade reminiscent of Bernini's colonnade for St. Peter's.

Statuary decorates the piers of the entrance arch to the bridge. *Spirit of Industry,* on the north, depicts a winged female figure who dramatically grasps a sprig of laurel in her upraised left hand as she stretches out her right arm. Leaning diagonally toward her left, she conveys motion and energy. Two figures, one of which holds a hammer, kneel on either side of her, forming the bottom of a pyramid.

On the opposite pier is the complementary *Spirit of Commerce.* This group depicts Mercury, a nude and winged male figure wearing Greek sandals who raises in his right hand a caduceus, the staff carried by the messenger of the gods. Leaning forward with his left leg bent behind him, he hurries forth to carry his message of progress. Below him, on his right, is a seated female figure holding a basket of fruit and leaning on a globe. On his left a kneeling male figure grasps a small bale of goods.

Above the sculptural groups are two vertical, richly ornamented, high reliefs, patterned on war trophies containing flags, heraldic motifs, hunting weapons, instruments, vegetative ornament, fasces, a lion head, and an eagle—an assemblage indicating commercial and industrial success.

**Collection of:** *City of New York; purchase.*

## B-20 Buffalo Hunt, 1914–1916

**Sculptor:** *Charles Cary Rumsey (1879–1922).* **Media and size:** *Stone frieze, 6 feet high by 40 feet long.* **Location:** *Manhattan Bridge, frieze on monumental entrance arch.*

Far and away the most unusual sculpture on the Manhattan Bridge, this frieze depicting a buffalo hunt surmounts its monumental archway. Sharply undercut figures of four Indians on horseback dramatically lunge and twist with spears and bows and arrows as they charge into a herd of buffalo. Positioned in a slightly undulating curve, the figures rhythmically move across the narrow strip. The semi-naturalistic forms of men and beasts are flattened, angular, and taut, recalling Greek archaic sculpture. The severe contours and simplified surfaces also increase the frieze's visibility from a distance.

There is no obvious connection between the theme of the frieze, a buffalo hunt, and the bridge itself. In 1909 the bridge's architect, Thomas Hastings, had commissioned Rumsey to execute a similar panel for a private home he had recently designed. This project undoubtedly gave Hastings the idea for the Manhattan Bridge frieze.

**Collection of:** *City of New York; purchase.*

## B-21 **Governor Alfred E. Smith Memorial, 1946**

**Sculptor:** *Charles Keck (1875–1951).* **Pedestal by:** *Eggers and Higgins.* **Media and size:** *Bronze statue, over life-size; bronze relief on back of the granite pedestal.* **Location:** *Governor Smith Memorial Park, at the intersection of Catherine and Cherry Streets.*

A realistic bronze figure of Governor Smith (1873–1944) stands in front of a granite wall which serves as the support for the bas-relief on its back entitled "The Sidewalks of New York." The sculpture is designed low to the ground so viewers can walk right up to it. Smith's characteristic brown derby rests on the low wall, and the bas-relief, depicting children at play, is a nostalgic view of street life.

Smith never forgot his roots in New York's Lower East Side and campaigned for social issues throughout his political career. Elected governor in 1918, Smith held the post for four terms. His friends wanted to remember him as the workingman's legislator, so they sponsored a memorial to him in his old neighborhood, next to the Governor Alfred E. Smith Houses, a state public housing project then under construction. The New York City Housing Authority provided the land for the memorial.

**Dedicated:** *June 1, 1950.* **Signed and dated:** *Charles Keck Sculptor, 1946.* **Collection of:** *City of New York; gift of the Governor Alfred E. Smith Memorial Committee.*

## B-22 Alfred E. Smith Memorial Flagpole Base, 1946

**Sculptor:** *Paul Manship (1885–1966).* **Media and size:** *Bronze group, 6 feet 3 inches high; octagonal granite pedestal.* **Location:** *Governor Smith Memorial Park, at the intersection of Catherine and Cherry Streets.*

The *Alfred E. Smith Memorial Flagpole Base* is part of the whole memorial scheme that includes the Governor Smith Memorial Park, statue, playground, benches, and landscaping. A whimsical invention, it contains stylized animals typical of Manship's earlier works, particularly the Paul Rainey Gates at the Bronx Zoo and the Osborn Gates erected in Central Park (see entry G-35.)

The pedestal is a sophisticated arrangement of solids and voids which are divided into three tiers. A bear, framed by a pair of scrolls, lumbers through the center. Above him an owl and a beaver serve as finials, and below the bear a parade of deer in high relief with delicate, spindly limbs encircle the cylindrical base. Parks Commissioner Robert Moses invited Manship to do the flagpole base, and suggested that the sculptor depict animals found in New York in pre-colonial times. In its theme and composition, the work is an original conception for a flagpole pedestal. America's foremost sculptor of the 1920s and '30s, Paul Manship continued to sculpt until the end of his life, often recombining old themes and motifs in new ways.

**Signed and dated:** *Paul / Manship / Sculp 1946.* **Foundry mark:** *Capitol Products Inc. Long Island City, N.Y.* **Collection of:** *City of New York; gift of the Governor Alfred E. Smith Memorial Committee.*

## B-23 Fiorello Henry La Guardia, 1934

**Sculptor:** *Jo Davidson (1883–1952).* **Pedestal and niche by:** *Eggers and Higgins.* **Media and size:** *Bronze bust, life-size; high granite pedestal.* **Location:** *Off the central mall of La Guardia Houses near Madison Street, between Clinton and Jefferson Streets.*

The American sculptor Jo Davidson, sometimes called a "plastic historian," modeled busts of the world's great political, military, and cultural figures during the period between the World Wars. Fascinated by the personalities of his illustrious sitters, who included Gertrude Stein, Mahatma Gandhi, Franklin Delano Roosevelt, and James Joyce, Davidson produced penetrating, animated portraits. Loose modeling, simplified form, and textured surfaces characterize his portraiture, described by one critic as "... psychological biographies in tangible form."

In 1934, soon after former Congressman Fiorello La Guardia (1882–1947) became mayor of New York, a post he held for three terms, Davidson arrived in City Hall to model his bust. The sculptor wrote in his autobiography that as he modeled, La Guardia conversed with a steady stream of visitors in four languages and that he "was too preoccupied in his job to be interested in his bust."

The bronze portrait of "the little flower," as La Guardia was called, was in Davidson's collection at the time of the sculptor's death in 1952. Later that year, the La Guardia Memorial Committee purchased it for a monument honoring one of New York's most distinguished mayors.

**Dedicated:** *1957.* **Collection of:** *City of New York; gift of the La Guardia Memorial Committee.*

## B-24 Juan Pablo Duarte, 1978

**Sculptor:** *Nicola Arrighini*. **Media and size:** *Bronze statue, over life-size; granite pedestal.* **Location:** *Duarte Plaza, Avenue of the Americas and Canal Street.*

Juan Pablo Duarte (1813–1876) appears as a 19th-century statesman, holding a scroll in his right hand and a cane in his left. In the tradition of earlier New York City statues honoring Central and South American leaders, Duarte stands on Avenue of the Americas. In celebration of the American Bicentennial, the government of the Dominican Republic presented this statue of Duarte to the City of New York. Regarded as Father of the Dominican Republic, Duarte led the society La Trinitaria in rebellion against the Republic of Haiti, and helped engineer the Santo Domingo coup of February 27, 1844.

**Dedicated:** *January 26, 1978.* **Signed:** *Scultore / Nicola Arrighini / Pietrasanta.* **Dated:** *1978.* **Collection of:** *City of New York; gift of the Government of the Dominican Republic.*

# (C)
# THE VILLAGES
## *Houston Street to 14th Street*

---

This part of Manhattan, particularly Greenwich Village, still bears the imprint of the small residential enclaves and winding streets already in existence when the city commissioners laid a grid street pattern over the island in 1811. Two parks, Washington Square in the west and Tompkins Square in the east, provide open space and greenery, and are natural locations for outdoor sculptures. Unlike Midtown and lower Manhattan, where corporate headquarters are a strong visual presence, here New York University and Cooper Union are the recognizable institutions and sponsors of some of the region's most distinctive public sculptures, including Picasso's *Sylvette* and Saint-Gaudens' *Peter Cooper*.

Washington Square, located at the beginning of Fifth Avenue near 8th Street, is the older of the two parks, and like many others in Manhattan, it began as a potter's field. It even had a gallows. In 1826 it became a parade ground and two years later the Common Council officially designated it "Washington Square." New York University's first buildings were erected on its eastern edge beginning in 1830, and soon after, wealthy New Yorkers were building houses along its periphery, making it one of the city's most desirable residential districts, described so well by Henry James in his 1881 novel *Washington Square*. Its centerpiece is the handsome marble *Washington Arch,* a favorite Village landmark constructed in 1892.

Tompkins Square, between East 7th and 10th Streets and Avenues A and B, was officially opened in 1834. Named after Gov. Daniel Tompkins and patterned on Washington Square, it was intended to be the center of a fashionable district, but its peripheral location engendered a working-class neighborhood. A steady stream of immigrant populations, first the Irish and Germans, later the Polish and Ukrainians, settled along its edges. The park's monuments and plaques document the area's social history.

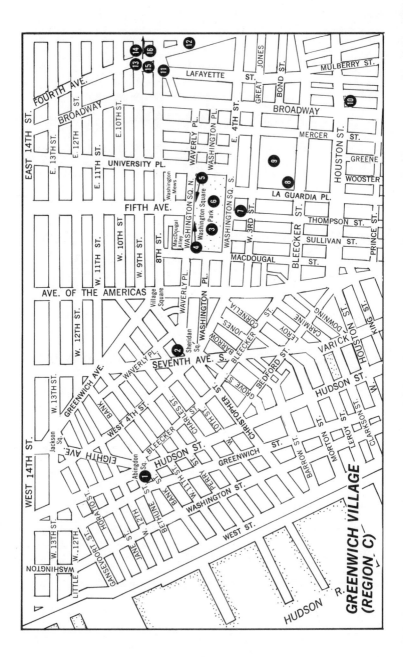

GREENWICH VILLAGE
(REGION C)

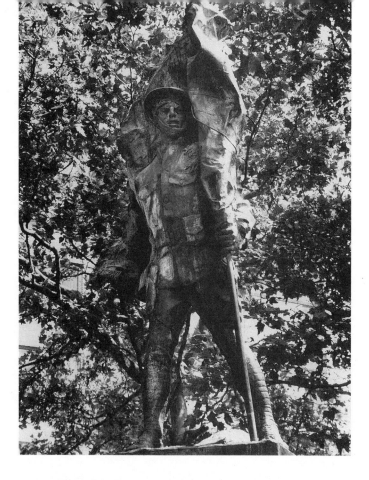

## C-1 Abingdon Square Memorial, ca. 1921

**Sculptor:** *Philip Martiny (1858–1927).* **Pedestal by:** *William A. Hewlett.* **Media and size:** *Bronze statue, over life-size; granite pedestal.* **Location:** *Abingdon Square Park, at the intersection of West 12th Street, Eighth Avenue, and Hudson Street.*

Sculptor Philip Martiny depicts here a World War I soldier planting an American flag with his right hand, the voluminous folds all but engulfing him, while in his left hand he holds a pistol to defend it. The figure of the solitary soldier with feet braced and head turned to the left is not unlike the statue he created for the *Chelsea Park Memorial* (see D-25), a little farther uptown, which shows a man in a windblown coat holding a rifle across his thighs. They are clearly individualized as the bases are different and they were cast in different foundries, and both exemplify his skill in animating his figures. Still, one wonders if this was not one way Martiny could hold down costs for neighborhood commemorations.

In many locations throughout the city are found memorials to local men lost in action in World War I. This was given by the nearby Jefferson Democratic Club and dedicated in 1921.

**Dedicated:** *1921.* **Foundry mark:** *Bureau Bros. / Bronze Founders / Phila Penna.* **Collection of:** *City of New York; gift of the Jefferson Democratic Club.*

## C-2 General Philip Henry Sheridan, ca. 1936

**Sculptor:** *Joseph P. Pollia (1893–1954).* **Media and size:** *Bronze statue, over life-size; granite pedestal.* **Location:** *Christopher Street Park, adjoining Sheridan Square.*

In the middle of the Depression, members of the Grand Army of the Republic and the General Sheridan Memorial Association unveiled this life-size, full-length portrait statue and resurrected the memory of one of the Civil War's most powerful generals. Philip Henry Sheridan (1831–1888) had been dead for 64 years when, in 1924, John B. Trainer, former secretary of the Armory Board of New York City, founded an association to commemorate the Union officer with a statue in this city. An impressive equestrian statue of Sheridan had been erected earlier in Albany, Sheridan's birthplace.

Sheridan was a cavalry officer and is typically presented on horseback, not only in Albany, but also as in Gutzon Borglum's monument in Washington, D.C. Here he stands without his mount. Dressed in the Union uniform, Sheridan wears boots with spurs and clutches a sword at his side. A victorious general in the Civil War, his most brilliant maneuver transformed a sure defeat into a victory when on October 19, 1864, the commander rode to his army, demoralized at Cedar Creek, and rallied his troops to win this decisive battle. Sheridan's supporters officially unveiled the statue on October 19, 1936, to symbolically celebrate this victory.

**Dedicated:** *October 19, 1936.* **Signed:** *J. Pollia.* **Foundry mark:** *Roman Bronze Works.* **Collection of:** *City of New York; gift of the General Sheridan Memorial Association, Inc.*

# C-3 Alexander Lyman Holley, 1889

**Sculptor:** *John Quincy Adams Ward (1830–1910).* **Pedestal by:** *Thomas Hastings.* **Media and size:** *Bronze bust, over life-size; limestone pedestal.* **Location:** *Washington Square, west of the central fountain.*

Alexander Lyman Holley (1832–1882) is considered "the father of modern American steel manufacturing," and his career is inseparable from the development of steel production in this country. As a metallurgist, engineer, inventor, prolific writer, editor, and lecturer he recognized the great breakthrough achieved by the new English Bessemer process of making steel. Hastening to England, he acquired the American patents to the process for a firm in Troy, New York, and in 1865 built the first Bessemer plant in America. In quick succession he built Bessemer works and rolling mills in Chicago, Joliet, and Pittsburgh.

Holley died at the early age of 49, and shortly thereafter the Institute of Mining Engineers commissioned a memorial to him. They chose the popular sculptor John Quincy Adams Ward, whose vibrant bronze portrait bust of Holley, modeled with an intense and purposeful gaze and the suggestion of a smile, is mounted on the central pillar of a highly decorated tripartite limestone pedestal. Several years later the well-known architect Thomas Hastings, co-designer of the New York Public Library, was invited to create the pedestal. Although quite unusual, the monument successfully combines architecture, sculpture, and carvings in Beaux Arts style. Central Park commissioners declined the offer of the memorial, possibly because Holley was not sufficiently known, so park authorities placed it in Washington Square.

**Dedicated:** *October 2, 1890.* **Signed and dated:** *J.Q.A. Ward / sculptor / N.Y. 1889.* **Foundry mark:** *Cast by the Henry-Bonnard Bronze Co. / New York 1889.* **Collection of:** *City of New York; gift of Engineers of Two Hemispheres.*

*C-3 Photo, ca. 1905*

## C-4 Washington Arch, 1889–1892

**Architect:** *Stanford White (1853–1906).* **Media and size:** *Marble arch, 77 feet high.* **Location:** *Washington Square, at the beginning of Fifth Avenue.*

Celebrations marking the nation's Centennial occurred throughout the 1870s and 1880s. New York City's participation in the jubilee culminated in a three-day festival, held in honor of George Washington's inauguration, from April 29 through May 1, 1889. A highlight of the celebration was the reenactment of George Washington's arrival by boat from New Jersey, re-created by President Benjamin Harrison and a crew of rowers. To heighten the drama of that presidential entrance and the forthcoming parades, the city erected four temporary wooden triumphal arches.

Stanford White designed a wooden arch that was built a little to the north of Washington Square. It immediately drew critical and public acclaim, and when the celebrations ended, a committee was formed to raise funds for a permanent arch. In the stone version White modified his original plan, most notably by widening the piers and relocating the arch to the northern edge of the park.

This classicizing monument, erected during the height of the City Beautiful movement, was intended to add dignity and order to the urban scene. Remarks made at the laying of the cornerstone on May 31, 1890, reveal how a symbol of Imperial Rome came to emblemize democracy. Waldo Hutchins, president of the Park Board declared: "Our arch is erected by no one man to his own glory. It is erected by the voluntary contributions of the people of this republic to perpetuate the memory of the first step in the great experiment, momentous to mankind, of government by the people and for the people."

**Dedicated:** *May 4, 1895.* **Collection of:** *City of New York; gift of the Washington Arch Committee.*

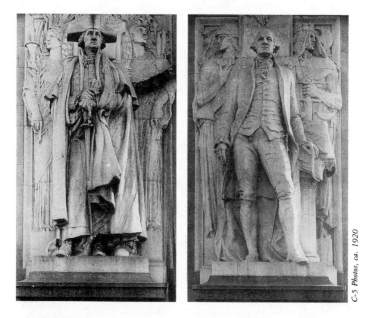

C-5 Photos, ca. 1920

## C-5 Washington as Commander-in-Chief, Accompanied by Fame and Valor, 1914–1916 *and* Washington as President, Accompanied by Wisdom and Justice, 1917–1918

**Sculptors:** *Herman MacNeil (1866–1947) and Alexander Stirling Calder (1870–1945).* **Media and size:** *Marble statues and two high reliefs, over life-size.* **Location:** *East and west piers of the Washington Arch.*

White's original designs for the permanent *Washington Arch* included an elaborate sculptural scheme, which was never carried out, probably for lack of funds. The architect projected a grandiose approach including two curved sidewalks, terminating in four free-standing Corinthian columns, capped by eagles standing on spheres. Frederick MacMonnies was supposed to have executed the pier sculpture, but he only completed the designs for the spandrel panels, War, Peace, Fame, and Posterity.

Twenty years elapsed between the dedication of the *Washington Arch* and the installation of the pier sculptures. MacNeil represents Washington as a military leader and as a political leader, showing him as commander-in-chief of the army (east pier), and Calder represents him as president (west pier). Although by two different artists, the works are compositionally and stylistically similar. In each group, a naturalistic statue of Washington stands in the center, flanked by symmetrical, allegorical figures in relief. The sculptors differ most in their treatment of the secondary figures. Calder's more stylized Wisdom and Justice on the west pier are flatter, less detailed, and more sharply contoured than are MacNeil's Fame and Valor. Calder combines a profile view of the heads with a frontal view of the torsos, incorporating aspects of archaic art, then in vogue, whereas MacNeil employs a more traditional figurative style. Both marble groups suffer from severe erosion, particularly evident in the coarsened features of Washington.

**Collection of:** *City of New York; gift of the Washington Arch Committee.*

*C-6 Photo, ca. 1905*

## C-6 Giuseppe Garibaldi, ca. 1888

**Sculptor:** *Giovanni Turini (1841–1899).* **Media and size:** *Bronze statue, over life-size; granite pedestal.* **Location:** *Washington Square, east of the central fountain.*

The Italian-born sculptor of this statue, Giovanni Turini, had personally met General Garibaldi when he was a volunteer in the latter's Fourth Regiment in 1866. Undoubtedly deeply impressed by the indomitable Garibaldi, Turini strove to convey the drama of his life in this commemorative sculpture, an almost melodramatic figure shown in the act of drawing his sword.

An Italian patriot and guerrilla general, Garibaldi crusaded for the unification of Italy and became a legend in his own time. The son of a sailor and a sailor himself, Garibaldi joined Mazzini's Young Italy society and in 1834 fought in his first republican uprising in Genoa. After a period of years as a guerilla leader in South America, Garibaldi returned to Italy to support Mazzini and his short-lived Roman Republic. Upon its collapse, the patriot left Italy for America, living for a period with a friend on Staten Island. Today his memory is kept alive in the cottage (now a small museum) at 420 Tompkins Avenue where he eked out a livelihood making candles from 1851 to 1853. Almost a decade later, the fiery Garibaldi directed a volunteer army in a series of brilliant maneuvers and captured Sicily and Naples (1859–1862). This victory led to the unification of Italy under King Victor Emmanuel.

**Dedicated:** *June 4, 1888.* **Foundry mark:** *Lazzari & Barton / Woodlawn, New York.* **Collection of:** *City of New York; gift of Italian-Americans.*

## C-7 Untitled Abstract Sculpture, 1960

**Sculptor:** *Reuben Nakian (1897–1986).* **Media and size:** *Aluminum plates and steel supports, 28 feet by 45 feet by 6 feet.* **Location:** *Façade of Loeb Student Center on Washington Square South between Thompson Street and La Guardia Place.*

When New York University built a student center on the south side of Washington Square, the building presented to the park a large brick façade without windows which was the wall of an auditorium. Its architects, Harrison and Abramovitz of Rockefeller Center fame, set up a closed competition in order to select a façade sculpture. Five sculptors participated. Reuben Nakian, well known for his abstract expressionist constructions in plaster, bronze, and other metals, won the competition with an unusual approach that employed clusters of twisting aluminum plates randomly placed in a diagonal line. The plates curl away from the wall in various directions providing an open composition that recalls Nakian's contemporaneous constructions of bent steel plates suspended in metal pipe armatures.

For Nakian this sculpture is a metaphor for the university and its fledgling students, who "once they are educated and civilized . . . fly away," for education is "the freeing of the spirit."

Also on the N.Y.U. campus in front of nearby Tisch Hall at 40 West 4th Street is Jean Arp's glistening, stainless steel abstraction, *Seuil Configuration* (1959). It is on extended loan from the Metropolitan Museum of Art and was officially unveiled on this site on October 26, 1987.

**Installed:** *May 17–19, 1961.* **Collection of:** *New York University.*

## C-8 Time Landscape, 1965–1978

**Sculptor:** *Alan Sonfist (1946– ).* **Media and size:** *Trees, grasses, plants, flowers, 45 feet wide by 200 feet.* **Location:** *At La Guardia Place (West Broadway) and Houston Street.*

What at first glance looks like a patch of vegetation growing in the middle of concrete is in fact a piece of land layered with meaning. Conceived by environmental sculptor Alan Sonfist, *Time Landscape* is "a redefinition of the public monument, a monument of natural history rather than human history." It is a living sculpture, consisting of a variety of trees, shrubs, wild grasses, flowers, and plants that thrived on Manhattan Island before its colonization. Here Sonfist shows three stages of a forest's growth—grasses, saplings, and mature trees—as well as the topography that existed at this site over 200 years ago. What appears to be random was actually carefully researched and planted with the help of a botanist, an ecologist, and a historian.

Manhattan's memorial to natural history is Sonfist's first poetic forest, and since it was planted in 1978 the artist has created 15 similar works around the world. Each draws on the local history, geography, and vegetation of its site. New Yorkers warmly welcomed their *Time Landscape.* In a letter to the artist written when the work was dedicated, Mayor Edward I. Koch, long a supporter of the project, called it "fresh and intriguing."

Sonfist defines himself as an environmental sculptor, but unlike the earth movers Robert Smithson and Michael Heizer, he works in an urban setting for a community rather than in remote uninhabited places, and his pieces are often autobiographical. Sonfist recalls the virgin forests of Bronx Park where he played as a child and then his horror years later when most of the park was destroyed. Wanting to preserve his childhood memories, he rescued remnants of the forest and transplanted them. Some of those saplings are now thriving in *Time Landscape.*

**Collection of:** *City of New York; gift.*

## C-9 Bust of Sylvette, 1968

**Sculptor:** *Pablo Picasso (1881–1973).* **Executed by:** *Carl Nesjar and Sigurd Frager.* **Media and size:** *Sandblasted concrete and basalt, 36 feet high by 20 feet wide by 12½ inches deep.* **Location:** *At the University Plaza and the Washington Square Southeast Apartments, 100–110 Bleecker Street and 505 La Guardia Place, between La Guardia Place and Mercer Street.*

Folded into planes, this colossal sculpture combines a profile and frontal view of a young woman's head, neck, and shoulders. The outlines of Sylvette's features, bangs, and ponytail emerge through the textured surfaces on both sides of the flat, concrete slabs. Although the Cubistic sculpture is composed of two-dimensional elements, it has no front or back; rather it is a series of angles and fractured viewpoints. In its original form as a small, painted sheet-metal maquette, the sculpture had a more playful aspect. In sandblasted concrete it is unquestionably monumental, suiting its architectural context, but less spontaneous.

The unchallenged giant of 20th-century art, Pablo Picasso created a prodigious oeuvre which spanned the course of modern art. Working closely with Georges Braque in the first decade of the century, Picasso invented Cubism, essentially a new pictorial order in which painted objects dissolve into planes and space becomes a function of form. Although Picasso was primarily a painter, he explored various technologies and media, seeing

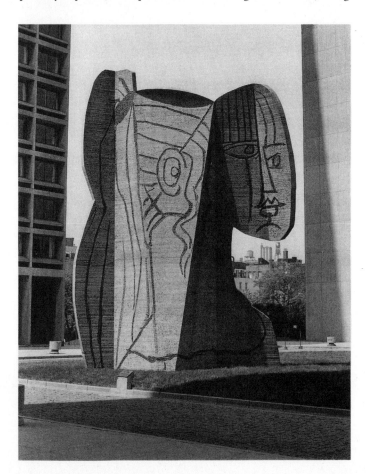

expressive potential in paint, ceramics, graphics, found objects, and last, concrete, as illustrated here.

In 1956 the Norwegian Carl Nesjar approached Picasso and introduced him to the technique of sandblasting concrete, called "Betograve." In "Betograve" sculpture a colored aggregate stone is tightly packed around a metal armature and placed in strong wooden box forms. A cement grout is then pumped into the wooden boxes where it hardens in between and around the aggregate, forming a "skin." Next, drawings made on the concrete surface are sandblasted to reveal the colored aggregate underneath, producing a permanent drawing.

A decade after Picasso and Nesjar embarked on their first collaborations, the internationally famous architect I. M. Pei had a chance encounter with the Norwegian and determined "to have a monumental Picasso work for one of my projects." He explained to Nesjar: "I have long thought about monumental sculpture in scale with modern architecture, and I recognize the possibilities of the concrete technique." Pei, architect of the three residential towers here, chose the Washington Square Center, then under construction, and Picasso suggested enlarging one of the painted metal constructions from his Sylvette series, inspired by Sylvette David, a young woman whom Picasso had met in 1954; Pei agreed and selected *Bust of Sylvette*.

**Dedicated:** *December 9, 1968.* **Collection of:** *New York University; gift of Mr. and Mrs. Allan D. Emil.*

## C-10 Untitled, 1973

**Sculptor:** *Forrest Myers (1941– ).* **Media and size:** *Wall sculpture, channel iron and aluminum, 72 feet high by 65 feet wide by 4 feet deep.* **Location:** *North wall of 599 Broadway, fronting Houston Street at the southwest corner.*

Striking a balance between surface and structure, the northern wall of 599 Broadway is both a mural and a sculpture. A series of 42 equally spaced aluminum bars project from 42 channel irons, six rows across and seven down. The brick wall is painted deep sea blue and the metal elements are painted turquoise, a color contrast that lends the wall a strong visual presence without overpowering the rest of the street. When the morning sun strikes from the east, the aluminum projections cast diagonal, regularly spaced shadows across the façade.

This bare wall, like many others on Houston Street, was exposed after city planners widened that thoroughfare by razing buildings along its southern edge. To provide additional support to newly exposed building façades, they bolted in channel irons. Sculptor Myers first noticed the brick face of 599 Broadway in the mid-1960s and observed that the equally spaced iron bars functioned as a grid on a plane. They suggested the regularity and industrial anonymity characteristic of Minimal art, then a dominant artistic movement.

The mural movement of the early '70s prompted Myers to pursue his idea for a wall sculpture on the Houston Street site. In 1973, in search of a sponsor for his sculptural mural, Myers approached Doris C. Freedman, president of City Walls, a nonprofit organization founded to promote outdoor murals by contemporary artists. Envisioning a subtle play of color and shadow, Myers proposed adding four-foot-long aluminum pieces to the existing channel irons. He then painted the projecting bars gray and the wall a pale blue. A decade later the building changed ownership and Myers devised the present, brighter color scheme, which in his view, lacks the "mysterious, industrial feeling" of the original work.

**Signed and dated:** *fm 82 ©.*

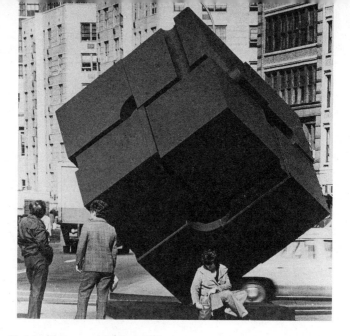

## C-11 Alamo, 1966–1967

**Sculptor:** *Bernard (Tony) Rosenthal (1914– )*. **Media and size:** *Cor-Ten steel painted black, 10 feet high*. **Location:** *Astor Place at the intersection of Lafayette and 8th Streets*.

A rotating cube balanced on a point, *Alamo* is a neighborhood landmark which lends form to a previously formless traffic island. Originally one of 26 sculptures selected for the city-sponsored 1967 exhibition, "Sculpture in Environment," it was one of the first abstract sculptures to be permanently sited on city property.

The site, scale, and inherent movement of *Alamo* harmoniously interact, a result of planning and luck. When Donald Lippincott first approached Rosenthal in 1966, he offered to enlarge a sculpture on view in the Whitney Annual, but instead Rosenthal preferred to enlarge one of his cubes. It was decided to make the cube eight feet square because that was the largest size that could be transported. The work's perfect scale, which can compete architecturally yet does not overwhelm the viewer, was determined, Rosenthal recounts, "because of a truck."

Rosenthal designed the work around a central interior post so that its orientation could be adjusted after installation. He did not conceive the sculpture as a participatory piece that could be made to rotate on its axis, but is pleased that it evolved that way.

Minimalist in its bold primary form, yet tempered by the crafted details of geometric surface cut-outs, *Alamo* combines an impersonal machine aesthetic with an individualized sensibility. A miniaturized version of this popular sculpture is presented annually as the Doris C. Freedman Award, created by Mayor Koch to honor an individual or organization that has contributed significantly to the city's urban environment. *Alamo* was also the first sculpture to be conserved through the Adopt-A-Monument program, co-sponsored by the Municipal Art Society and the City of New York.

**Fabricated by:** *Lippincott, North Haven, Connecticut*. **Collection of:** *City of New York; anonymous gift*.

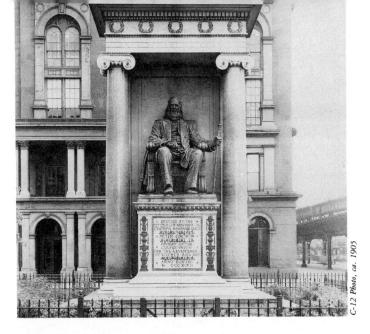

C-12 Photo, ca. 1905

## C-12 Peter Cooper, 1894

**Sculptor:** *Augustus Saint-Gaudens (1848–1907).* **Pedestal by:** *Stanford White.* **Media and size:** *Bronze statue, over life-size; marble and granite pedestal and canopy.* **Location:** *Cooper Square in front of Cooper Union, where the Bowery splits to become Third and Fourth Avenues.*

Saint-Gaudens presents Peter Cooper as an elderly man with a full beard and long hair, a man of towering importance in the city's life, presiding at one of the countless gatherings he organized to deal with civic problems. From the outset the sculptor conceived the portrait as a seated figure, but he made 27 models varying its position and arrangements of clothing and cane before settling on the final composition. Saint-Gaudens brought strong personal feeling to the commission because he had taken free art courses at the Cooper Union while still an apprentice cameo cutter. He was even personally enrolled by the great man himself, who had his shoes made by Saint-Gaudens' father, an immigrant French bootmaker.

Cooper (1791–1883), a manufacturer, inventor, and philanthropist, had little opportunity for education and took deep satisfaction in establishing, out of his own pocket, a school offering free courses in science, chemistry, electricity, engineering, and art to both women and men, and the first reading room open to the general public. The brownstone Cooper Union Building, in front of which the statue stands in a pocket park, was completed in 1859.

The large bronze statue sits in a regal fringed chair, placed on a pedestal beneath a temple-like structure composed of granite columns and marble entablature. Designed by the sculptor's architect-collaborator, Stanford White, it is ornamented with floral borders and fine lettering, all of which Saint-Gaudens later concluded to be somewhat too delicate for the heavy bearded figure.

**Dedicated:** *May 29, 1897.* **Signed and dated:** *Augustus Saint-Gaudens Fecit MD CCC XCIV.* **Foundry mark:** *Cast by Lorne & Aubry.* **Collection of:** *City of New York; gift of New Yorkers.*

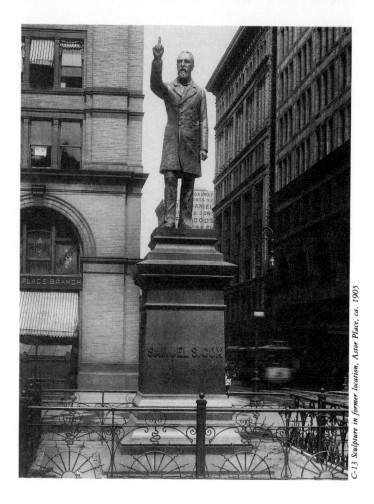

## C-13 Samuel Cox, 1891

**Sculptor:** *Louise Lawson (186?–1900).* **Media and size:** *Bronze statue, over life-size; granite pedestal.* **Location:** *Tompkins Square, 8th Street and Avenue A.*

Congressman Samuel Sullivan Cox (1824–1889), known as the "postman's friend," introduced legislation to raise the salary of letter carriers and to provide them with paid vacations. In gratitude for his efforts, mailmen from all over the country contributed money for this statue honoring their spokesman.

Standing rigidly in a frock coat with his left hand clenched in a fist at his side and his right hand pointing in the air, *Samuel Sullivan Cox* has never won critical praise. In 1924, without authorization, letter carriers relocated the statue from Lafayette Street and Fourth Avenue to Tompkins Square, where it has become defaced by graffiti.

**Dedicated:** *July 4, 1891.* **Signed:** *Louise Lawson–Sculptor.* **Foundry mark:** *Cast by the Henry Bonnard Bronze Co / N.Y. 1891.* **Collection of:** *City of New York; gift of United States Letter Carriers.*

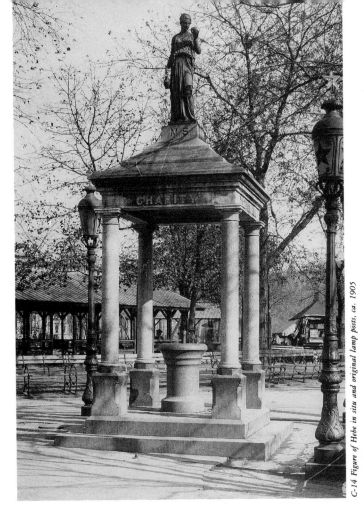

*C-14 Figure of Hebe in situ and original lamp posts, ca. 1905*

## C-14 Temperance Fountain, 1888

**Designer:** *Henry D. Cogswell.* **Media and size:** *Granite structure, 13 feet high; zinc under life-size figure.* **Location:** *Tompkins Square, near Avenue A south of the 9th Street transverse.*

Heavily used Tompkins Square is a two-block city park in the East Village. It has luxuriant trees, winding paths, and many benches always filled in the warm weather. Just east of Avenue A at the 9th Street entrance is a small granite temple that used to shelter an ice-water drinking fountain. A zinc statue of Hebe, the water carrier, stood for years atop the little temple. The purpose of this park ornament was to encourage the drinking of cool, pure water instead of alcoholic beverages. It was given to the city in 1888 by the Moderation Society, as a gift from a San Francisco dentist, Dr. Henry Cogswell, an ardent temperance supporter who provided similar fountains to several cities. The fountain in Washington, D.C.'s Old Market Space has a slender zinc water bird perched on its roof and is being restored.

Tompkins Square's little stone pavilion is now marred by graffiti, and the charming life-size figure of Hebe has been stored by the Parks Department since vandals removed her hands. The park and its *Temperance Fountain* are slated for rehabilitation in the future.

Hebe, an attractive example of mass-produced art, was ordered from the catalogue of J. L. Mott Company which had its zinc statues made by Morris J. Seelig in Brooklyn. Hebe is modeled on the figure of mythical Hebe, dating from 1816 by the Danish neoclassical sculptor Thorvaldsen. The words "Temperance," "Faith," "Hope," and "Charity" are inscribed on the sides of the canopy, along with the initials "M.S.," standing for Moderation Society.

As this turn-of-the-century photograph illustrates, Dr. Cogswell also provided four bronze ornamental posts, supporting cut-glass lamps. The fountain, complete with amenities, cost him about $8,000.

**Collection of:** *City of New York; gift of Dr. Henry Cogswell under the auspices of the Moderation Society.*

*C-15 Photo, ca. 1905*

# C-15 Slocum Memorial Fountain, 1906

**Sculptor:** *Bruno Louis Zimm (1876–1943).* **Media and size:** *Marble stele, 9 feet high.* **Location:** *Tompkins Square, north of 9th Street between the wading pool and the loggia.*

On June 15, 1904, the excursion steamboat *General Slocum* caught fire and sank in New York's East River. Over 1,000 passengers, mostly women and children, died. Many of the victims were German immigrants who lived in the area of Tompkins Square on New York's Lower East Side. The Slocum Survivors Association erected a large memorial in Lutheran Cemetery at Middle Village, Queens, to mark the burial site of unidentified persons killed in the disaster. In addition, the Sympathy Society of German Ladies sponsored this small memorial fountain for Tompkins Square.

The fountain is a rectangular stele, rounded at the top. Mounted on the front toward the bottom is a shell-like scalloped basin, formerly situated below a lion's head which spouted forth water. Decorating the front of the shaft is a delicate low relief depicting a small girl and boy looking out to sea toward a steamboat. Because the fountain has been severely vandalized, the subtleties of the relief carving are no longer evident.

Zimm did a similarly styled commemorative fountain, the *Woman's Health Protective Association Fountain* (1909–1910), for Riverside Drive and 116th Street. It consists of a graceful 12-foot-high marble stele, a fountain, and two benches, now unfortunately damaged. A delicate relief of two classically draped female figures holding a lamp adorns the stele, below which a fountain previously trickled into a basin.

Bruno Zimm was a member of the artist colony at Woodstock. He did numerous memorials and architectural reliefs, including the frieze on the pediment of the Fine Arts Building in San Francisco.

**Signed:** *B.L. Zimm.* **Collection of:** *City of New York; gift of the Sympathy Society of German Ladies.*

## C-16 The Fables of La Fontaine, 1954

**Sculptor:** *Mary Callery (1903–1977).* **Media and size:** *Steel, painted black with color accents, 11 feet high by 23 feet wide by 2 feet deep.* **Location:** *P.S. 34, 720 East 12th Street at Avenue D.*

A welded ensemble of bent and flattened pieces of steel, *The Fables of La Fontaine* is a whimsical invention, occupying a window-like opening near the entrance to P.S. 34. From a distance the sculptural grille appears flat and calligraphic, but close at hand its depth is evident in the forms that swing out from the top and bottom. Commissioned by architects Harrison and Abramovitz during the school building boom of the 1950s, Callery designed this engaging metal construction for children to climb on, an artistic alternative to playground equipment.

Depicting characters from three La Fontaine fables, Callery represents from left to right, "The Fox and the Crow," "The Frog and the Bull," and "The Three Thieves and the Donkey." Most of the metal pieces resemble industrial I-beams, ingeniously transformed into organic shapes. Callery also employs textured steel elements, visible for example in the body of the frog, which enrich the fabric of the sculpture. In addition the artist originally enlivened the black grille with bright color accents, today faded.

Working in Paris from 1930 to 1940, Callery fell under the influence of Picasso who prompted her to depend on her imagination and to depart from the model. World War II forced her to return to this country, where she embarked on a successful career, marked by numerous exhibitions and important commissions. Callery is best known for sculptures like this one, attenuated and frieze-like, often described as drawings in space.

**Collection of:** *City of New York; purchased by the New York City Board of Education.*

# (D)
# MIDTOWN SOUTH
## 14th Street to 34th Street

Sculptural centers in midtown south are the region's two major parks, Union Square, at 14th Street and Broadway, and Madison Square, farther north on Broadway at 23rd Street. These sites are especially rich in 19th-century sculpture and feature some of New York's best.

Union Square, originally called "Union Place," was where the old Bloomingdale Road (Broadway) and the rambling old Bowery Road (here the end of Fourth Avenue) converged. In 1832, around the time when other private residential squares were created in the city, the Common Council officially designated this area "Union Park." Surrounded by a tall iron fence, under lock and key, it served primarily the wealthy residents of this growing fashionable district. With the advance of the city northward, the square became part of "downtown," and served as a space for political meetings, first during the Civil War for Union supporters and then in the 20th century for suffrage and labor advocates. Newly renovated, Union Square retains the form it assumed in the early 20th century. Sculpture is positioned rather symmetrically within the park. In the center stands the *Murphy Memorial Flagpole,* marking the site of an old fountain. The earliest works honor Abraham Lincoln, the Marquis de Lafayette, and George Washington. Of special interest is the equestrian statue of our first president which was unveiled in 1856 and was the city's first outdoor bronze.

Madison Square's sculptures were erected during the last quarter of the 19th century when that park was at the center of New York's social scene. Surrounded by mansions and such famous hotels and restaurants as the Fifth Avenue Hotel at 23rd Street and Delmonico's Restaurant at 26th Street, the park attracted New York's elite. For a short time, when an effort was being made to raise money for the *Statue of Liberty*'s pedestal, the colossus' hand and arm were on view here for a fee. In 1881 the *Farragut Monument* was unveiled in its original location facing Fifth Avenue at 26th Street, across from Delmonico's. Bronzes of other 19th-century notables mark the park's corners. Across from Madison Square is the Appellate Court, a delicate classical building bedecked with sculpture.

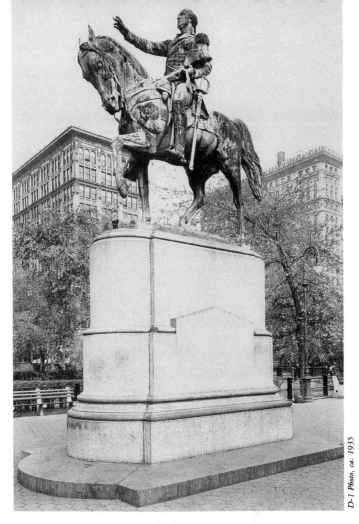

## D-1 George Washington, 1853–1855

**Sculptor:** *Henry Kirke Brown (1814–1886).* **Pedestal by:** *Richard Upjohn.* **Media and size:** *Bronze equestrian statue, 14 feet high; granite pedestal.* **Location:** *Union Square, in the center of the terrace facing 14th Street.*

New Yorkers wanted an equestrian statue of George Washington as early as 1802, but it was not until 1851 that a viable Washington monument committee was organized. It sought out Henry Greenough, prominent neoclassical sculptor, and Henry Kirke Brown to do the job, perhaps jointly, although just how that would work out was not clear. However, Greenough died almost at once and Brown, with the assistance of J. Q. A. Ward, created the Union Square *Washington,* the city's first major outdoor bronze statue. It was unveiled on July 4, 1856. A dignified and vigorous work, it exemplified Brown's passionate belief that American artists should celebrate their American heritage, using what art historian Wayne Craven calls a "simple and direct naturalism." They should, he felt, even use American foundries, although few such existed, rather than ship pieces abroad for casting. Brown's *Washington* was only the second equestrian to be cast in the United

States, the first being Clark Mills' *Andrew Jackson* opposite the White House in Washington.

Contributors to the New York project, primarily wealthy merchants who lived in the fashionable Union Square district, stipulated the work's equestrian format and location. Brown chose the moment when, on November 25, 1783, Washington officially reclaimed the city from the British. The commander of the Continental Army is said to have come with his troops from the Van Cortlandt house down Broadway, stopping where it crosses 14th Street. The sculpture was erected at this spot on a small fenced plot in the middle of the street. Decades later it had to be moved to the safety of Union Square when it became clear that it and vehicular traffic were mutually hazardous.

Brown presents Washington erect in his saddle, with his right arm outstretched and palm downward. This gesture, and the overall composition, evoke the famous classical equestrian statue of Marcus Aurelius, which Michelangelo sited on the Capitoline Hill in Rome. By referring to the statue of Marcus Aurelius, Brown suggests that Washington deserves comparison with the Roman emperor.

Brown used Houdon's definitive likeness of the general as a model for the portrait and studied Washington's Continental uniform, preserved in the Capitol, to guide him in designing the costume. The monument, an essay in quiet grandeur, harmonizes classical composition with realistic detail, establishing, as Lewis I. Sharp has pointed out, "the accepted formula for public statuary in America for the next twenty-five years."

**Dedicated:** *July 4, 1856.* **Signed:** *H.K. Brown / Sculptor / J.Q.A. Ward Assistant.* **Cast at:** *Ames Foundry, Chicopee, Massachusetts.* **Collection of:** *City of New York; gift by public subscription.*

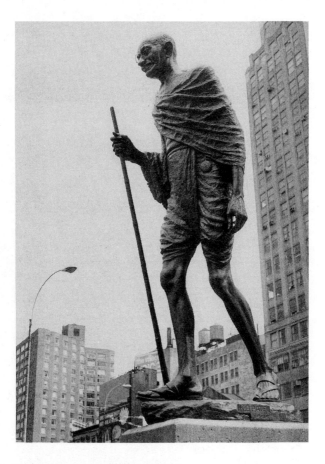

## D-2 Mohandas Gandhi, 1986

**Sculptor:** *Kantilal B. Patel (1925– )*. **Media and size:** *Bronze statue, over life-size; granite pedestal*. **Location:** *Union Square, on the southwest pedestrian triangle, 14th Street at Broadway*.

Advocate of nonviolent protest, Mohandas Gandhi (1869–1948), better known as Mahatma Gandhi (Great Soul), is depicted here holding his familiar walking stick and wearing the dhoti, a reference to Hindu asceticism. The simple home-spun cotton garment also reminds us of Gandhi's efforts to revive Indian home industries, particularly the spinning of yarn. Gandhi was one of this century's extraordinary political and religious leaders. An Indian nationalist, he dedicated his life to India's struggle for independence from the British. Saintly in his simplicity and religious devotion, Gandhi advocated passive noncooperation, initiating boycotts and personal fasts.

According to Parks Department Commissioner Henry J. Stern, the Parks Department chose this park for the statue's location because of the tradition of protest associated with Union Square. Gandhi's likeness joins those of American patriots, Lincoln, Washington, and Lafayette.

**Dedicated:** *October 2, 1986*. **Collection of:** *City of New York; gift of the Gandhi Memorial International Foundation*.

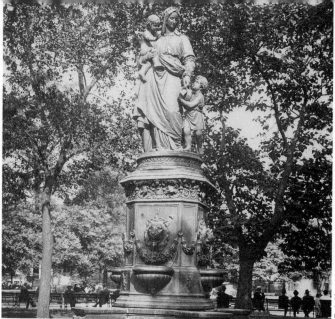

D-3 Photo, ca. 1905

## D-3 Union Square Drinking Fountain, 1881

**Sculptor:** *Karl Adolph Donndorf (1835–1916).* **Media and size:** *Bronze group, over life-size; pink granite pedestal.* **Location:** *Union Square, west side between 15th and 16th Streets.*

Today outdoor drinking fountains are rare in New York City, but in the 19th century they were common civic amenities. They served a need and promoted ideals of health, charity, and temperance. Daniel Willis James (1832–1907), a leading philanthropist, donated this fountain for Union Square, hoping, he said, "it shall be the means of kindling in any heart that spirit of love—Charity—it is intended to illustrate."

Inspired by fountains they viewed while touring Germany, Daniel Willis James and Theodore Roosevelt formulated a plan for a comparable fountain for New York City. They hired J. Leonard Corning to select an artist and oversee the details of the commission. Corning recommended the German academic sculptor Karl Adolf Donndorf, who signed a contract on May 10, 1877, stipulating that the work be completed in 2½ years.

Donndorf's elaborate and very Victorian work integrates a complex bronze figurative group with a richly ornamented pedestal that originally held the plumbing and drinking spouts for water. The central figure, a mother holding a baby, is the traditional allegorical symbol for charity. Standing calmly and enfolded in graceful classicizing drapery, she gazes lovingly down at a small son who reaches for a pitcher at her side. The artist used his wife and baby as models for the group.

The concept of benign nature underlies the decorative motifs of birds, fruit, flowers, and four lizards embellishing the octagonal pink granite pedestal. Previously, water issued from four lions' heads, a motif found in Greek and Roman fountains, into four basins below, and tin drinking cups hung from chains next to the water spouts.

**Dedicated:** *October 25, 1881.* **Signed:** *A. Donndorf. fec.* **Foundry mark:** *G. Howaldt—Braunschweig / 1881.* **Collection of:** *City of New York; gift of Daniel Willis James.*

## D-4 Charles F. Murphy Memorial Flagpole, 1926

**Sculptor:** *Anthony de Francisci (1887–1964)*. **Pedestal by:** *Perry Coke Smith*. **Media and size:** *Granite flagpole base, 36 feet in diameter; bronze bas-reliefs, 9½ feet high*. **Location:** *Center of Union Square*.

This elaborate flagpole is variously known as the Independence Flagstaff and the Murphy Memorial, a dual identity arising from its history. It marks the site of an earlier flagpole, erected by the Tammany Society under the direction of Tammany Hall boss Charles F. Murphy (1858–1924). When Murphy died, his supporters wanted to transform the flagpole into a monument to him, but Murphy was a controversial figure and numerous New Yorkers opposed the plan; they did not want a monument to Murphy to dominate Union Square and overshadow the statues of national heroes Lincoln, Washington, and Lafayette. Instead, donors raised the new flagpole in honor of the 150th anniversary of the signing of the Declaration of Independence. The resulting Independence Flagstaff recalls the liberty poles of pre-Revolutionary times which English colonists erected to protest English policies.

On the southern face of the extensive drum-like base of the flagpole is a large plaque displaying the Declaration of Independence. Two bronze reliefs encircle the base. To the right is an allegory representing the evolution of civilization under democratic rule, which sculptor de Francisci contrasts with the relief on the left, representing civilization under tyrannical rule. Above the bronze reliefs is a freedom plaque bearing the coats of arms of the 13 original colonies. In 1987 Parks Department officials restored the monument and reinstalled the towering flagpole, one of the tallest in the state.

**Dedicated:** *July 4, 1930*. **Signed and dated:** *Anthony de Francisci / Perry Coke Smith / 1926*. **Foundry mark:** *Roman Bronze Works, New York*. **Collection of:** *City of New York; gift of the Charles F. Murphy Committee*.

D-5 Photo, ca. 1920

## D-5 Abraham Lincoln, 1868

**Sculptor:** *Henry Kirke Brown (1814–1886).* **Media and size:** *Bronze statue, over life-size; granite pedestal.* **Location:** *Union Square, north end on the axis with 16th Street.*

Soon after the assassination of Abraham Lincoln in 1865, the Union League Club, a Republican organization founded two years earlier to promote good government, commissioned Henry Kirke Brown to create this commemorative statue. Of the many outdoor portrait statues of Lincoln erected in the United States, this appears to be the first in New York City. Sculptor Brown made a somewhat similar image of Lincoln for the then-City of Brooklyn. It was placed in Prospect Park.

The 16th president's tall rangy frame, gaunt features, and characteristic brooding expression are familiar to all Americans. Brown shows the statesman in a pensive mood, standing with one foot advanced. In his left hand is a scroll, possibly his second inaugural address. An excerpt from that speech, "with malice toward none; with charity toward all," was inscribed on a fence that originally surrounded the statue. A vestige of neoclassicism, a cloak envelops Lincoln's contemporary, baggy attire. Sculptors of the day often combined neoclassical elements with a more direct naturalism, tempering realism with idealism. Brown's portrait of Lincoln is a convincing likeness, but as is often true of this artist's work, it lacks psychological depth.

**Dedicated:** *September 16, 1870.* **Signed:** *H.K. Brown.* **Foundry mark:** *R. Wood & Co. / Bronze Founders / Phila.* **Collection of:** *City of New York; gift by public subscription under the auspices of the Union League Club.*

# D-6 Marquis de Lafayette, 1873

**Sculptor:** *Frédéric-Auguste Bartholdi (1834–1904).* **Pedestal by:** *H. W. DeStuckle.* **Media and size:** *Bronze statue, over life-size; granite pedestal.* **Location:** *Union Square, east side between 15th and 16th Streets.*

Bartholdi's emotionally charged portrait of the Marquis de Lafayette (1757–1834) suggests an actor in a historical melodrama. In a letter of February 17, 1872, the sculptor explained his intentions to the French director of fine arts: "I would like to propose to you that I describe as completely and simply as possible the act of arrival and the ardor and devotion of the hero." The artist shows Lafayette standing on a ship's prow in the act of pledging his heart and sword to the American revolutionaries.

When the youthful, idealistic, and wealthy Lafayette arrived in this country he enlisted for the cause of liberty and soon won a congressional commission as a major-general in the Continental Army. Lafayette spent much of his own fortune aiding the Revolution. His success in America also helped persuade France to send troops and supplies, most notably Rochambeau's expeditionary force which helped Washington win the decisive Battle of Yorktown.

Lafayette became a legend in his own time. Invited to revisit the United States in 1824 by President Monroe, he was acclaimed as he toured the country for a year, beginning with his historic visit to New York City. Samuel F. B. Morse's famous painting of the older Lafayette, now in City Hall, marks that occasion.

**Dedicated:** *September 6, 1876.* **Signed and dated:** *A. Bartholdi 1873 and H. W. DeStuckle, Arch.* **Foundry mark:** *F. Barbedienne Fondeur-Paris.* **Collection of:** *City of New York; gift of the French government in recognition of the aid provided by New Yorkers to Parisians during the Franco-Prussian War; French residents of New York paid for the pedestal.*

*D-7 Sculpture in former location, Bryant Park, ca. 1905*

# D-7 Washington Irving, 1885

**Sculptor:** *Friedrich Beer (1846–1912).* **Media and size:** *Bronze bust, colossal-size; high granite pedestal.* **Location:** *In front of Washington Irving High School, 40 Irving Place at East 17th Street.*

This bronze bust of Washington Irving (1783–1859), the first American writer to attain international recognition, was given to the city by a German physician and admirer of Irving. The bust was originally intended for Central Park. The park commissioners had to consult the Art Committee, which seems to have been divided on the matter. Architect Edward Kendall of the American Institute of Architects reported: "I consider it quite successful in model and workmanship and am assured by a near relative of Mr. Irving's that features and general characteristic, while faulty, are in the main well reproduced." On the other hand, painter Daniel Huntington, president of the National Academy of Design, disagreed, stating that the bust failed to convey Irving's "dignity or refinement of expression." The realistic portrait portrays an older Irving with sagging facial muscles and a thoughtful tilt of the head.

The outcome was that the Washington Irving memorial was erected in Bryant Park. When that park was totally redesigned 50 years later with WPA funds, the Irving bust on its tall granite pedestal was relocated here adjacent to the large Washington Irving High School. Coincidentally, the house on the opposite corner belonged to Irving's nephew.

The public remembers Irving for his short stories and histories, including his early burlesque *Knickerbocker's History of New York* of 1809 and his famous *Rip Van Winkle* and *Legend of Sleepy Hollow,* both written in 1820.

**Rededicated:** *October 29, 1935.* **Signed:** *Beer 1885.* **Collection of:** *City of New York; gift of Dr. Joseph Wiener.*

## D-8 Peter Stuyvesant, 1936

**Sculptor:** *Gertrude Vanderbilt Whitney (1875–1942).* **Pedestal by:** *Noel and Miller.* **Media and size:** *Bronze statue, life-size; granite pedestal.* **Location:** *Stuyvesant Square, between 15th and 17th Streets, west of Second Avenue.*

The statue of Peter Stuyvesant (1592–1672) stands on land that is now a public park but was once part of his big farm. The farm, or bouwerie as the Dutch called it, was granted to him in 1650 by the Dutch West India Company. It stretched from 5th Street to 17th Street and from Fourth Avenue to the East River—quite a gift to the man who served as director-general of New Netherland from 1646 until the English assumed control in 1664.

In 1836 his great-great-grandson, Peter Gerard Stuyvesant, sold four acres of the farm, the present Stuyvesant Square, to the city for five dollars. The park's two principal ornaments are the Gertrude Vanderbilt Whitney portrait statue of the autocratic old governor in the center of the square, and the 1846 7½-foot-tall cast-iron fence that—all 2,560 feet of it—bounds the park's perimeters.

The Netherland-American Foundation commissioned Whitney to create the statue of Stuyvesant. One of her last works, it was exhibited at the Netherlands Pavilion at the 1939 New York World's Fair before being permanently installed in Stuyvesant Square. The crusty old governor stands stiffly with his peg leg, often spoken of as his silver leg because of its silver bands, propped in front of him. Whitney suggests his personality by his swagger and haughty tilt of the head.

**Dedicated:** *June 7, 1941.* **Signed:** *G.V. Whitney Sc.* **Foundry mark:** *Roman Bronze Works, New York.* **Collection of:** *City of New York; gift of the Netherland-American Foundation.*

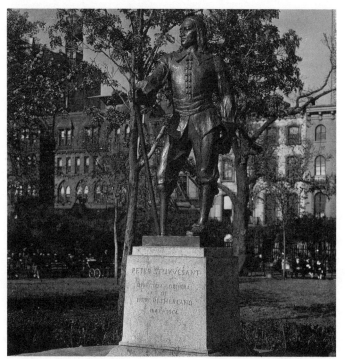

*D-8 Photo, 1941*

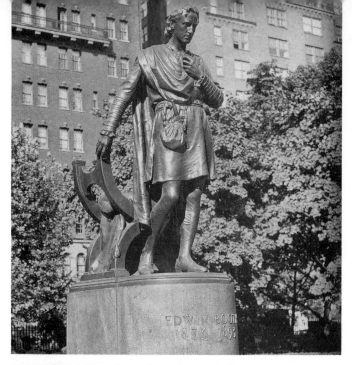

## D-9 Edwin Booth as Hamlet, 1917

**Sculptor:** *Edmond T. Quinn (1868–1929).* **Pedestal by:** *Edwin S. Dodge.*
**Media and size:** *Bronze statue, life-size; granite pedestal.* **Location:**
*Gramercy Park, between 20th and 21st Streets at Lexington Avenue.*

Walking north on Irving Place, you can see the pensive figure of actor Edwin
Booth through the wrought-iron fence encircling Gramercy Park. Only local
residents, who maintain this private park, have keys to enter. In 1831 the real
estate developer Samuel Ruggles laid out this charming green enclave
reminiscent of a London park.

The statue shows Booth (1833–1893) in his most famous role. He has
just risen from a chair as he bends his head forward and holds his hand on his
chest, readying himself for Hamlet's famous soliloquy. Described as a
"small, lithe, elegant" figure with a magnificent voice, Booth captivated
audiences with his stirring performances.

Appropriately, he stands facing his former residence at 16 Gramercy Park.
Today his handsome town house with its decorative ironwork provides
quarters for the Players Club. Booth founded the club in 1888 and devoted
part of his home to house it.

In the southeast corner of Gramercy Park stands *Fantasy Fountain* (1983)
by Gregg Wyatt. Designed to capture the imagination of children, Wyatt's
4½-foot-tall bronze is composed around a sphere graced on either side by the
benign faces of a smiling Moon God and Sun Goddess. Forming an arc above
the sphere, dancing giraffes intertwine their limbs. During warm weather, to
the delight of children, water issues from the mouths of the giraffes. Wyatt
has a much more ambitious work incorporating similar motifs at St. John the
Divine. (See J-1).

**Dedicated:** *November 13, 1918.* **Collection of:** *Trustees of Gramercy Park;
gift of members of the Players Club.*

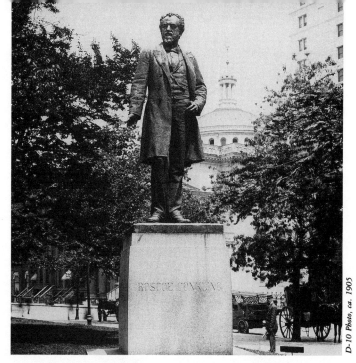

*D-10 Photo, ca. 1905*

## D-10 **Roscoe Conkling, 1893**

**Sculptor:** *John Quincy Adams Ward (1830–1910).* **Media and size:** *Bronze statue, over life-size; granite pedestal.* **Location:** *Madison Square, near the southeast entrance at 23rd Street.*

The forceful and charismatic Roscoe Conkling (1828–1888) was a controversial statesman who dominated the Republican party in New York state during the Reconstruction period. As congressman (1859–1863 and 1865–1867) and United States Senator (1867–1881), Conkling battled to retain control over federal administration in New York state, particularly the management of the New York customhouse. He returned to a successful law career in New York City after his resignation from the Senate in 1881.

After Conkling's death, caused by overexposure when he got lost in Union Square during the blizzard of 1888, a group of friends commissioned Ward to create a commemorative statue for that city park. The park commissioners, however, rejected the proposal on the grounds that Conkling wasn't important enough to occupy one of the four corners of Union Square reserved for "four great Americans," so the statue was placed in the newer Madison Square.

Ward's statue is characterized by an invigorated realism. Animated by the furrowed brow, tilt of the head, and gesturing hand, the chiseled features and trim figure record Conkling's fine physique. Conkling's bronze likeness lives up to his reputation as the "finest torso" in public life.

Some of Conkling's friends criticized the sculpture because it lacked aggressiveness, and told a reporter, "He was a man of force, both in his pose and in his speech . . . and that statue does not express that strongly enough."

**Signed:** *J. Q. A. Ward / Sculptor.* **Foundry mark:** *Cast by the Henry-Bonnard Bronze Company / New York 1893.* **Collection of:** *City of New York; gift of friends.*

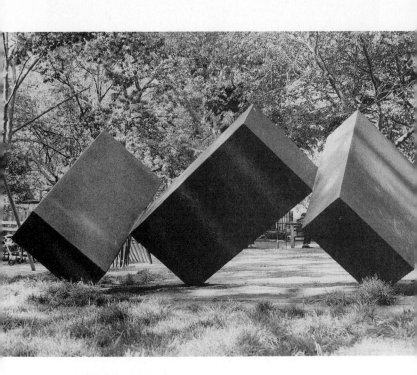

## D-11 Skagerrak, 1972

**Sculptor:** *Antoni H. Milkowski (1935– ).* **Media and size:** *Cor-Ten steel, 7 feet high by 7 feet wide by 16 feet long.* **Location:** *Madison Square, near 23rd Street.*

Beneath the historic tall trees of Madison Square, three cubic rectangles resting on their corners form *Skagerrak,* named after an arm of the North Sea separating Denmark and Norway. Two of the geometric steel modules lean at right angles on either side of a third cubic element, positioned between them. With only their edges touching, each module appears to be tenuously balanced, suspended before a fall.

Since the 1960s sculptor Antoni Milkowski has worked with the reductive, machined forms of Minimalism. He limits his vocabulary to simple geometric units which he arranges in unpredictable ways. *Skagerrak,* for example, looks like a different sculpture when seen from opposite sides. Generally limited to eight elements, so that the individual parts and the whole work can be seen simultaneously, Milkowski's sculptures also reveal his interest in the perceptual theories of Gestalt psychology, the psychology of form.

**Collection of:** *City of New York; gift of the Association for a Better New York.*

*D-12 Photo, ca. 1905*

## D-12 **William H. Seward, 1876**

**Sculptor:** *Randolph Rogers (1825–1892).* **Media and size:** *Bronze statue, over life-size; red Levante marble pedestal.* **Location:** *Madison Square, the southwest corner at 23rd Street and Fifth Avenue.*

William H. Seward was governor of New York (1838–1843), a prominent antislavery senator (1849–1861), and secretary of state (1861–1869). His influence prompted President Ulysses S. Grant and Generals Burnside and Butterfield to subscribe to this commemorative statue. The general public, however, probably remembers the statesman less for his power and more for his purchase of Alaska from Russia in 1867 for $7.2 million, derided as "Seward's Folly."

Seward was the first New Yorker to be honored with a public monument erected in the city. Randolph Rogers received the commission in 1874, shortly after completing a statue of Lincoln for Philadelphia. Because of similarities between the two works, some people have said that Rogers used the lanky figure of the president for Seward's body and merely substituted a new head. However, a comparison of the statues reveals that this popular anecdote is a myth.

Rogers belongs to the second generation of American expatriate sculptors who went to Rome and Florence to pursue their craft. Working in both a neoclassical and a realistic mode, his sculpture includes examples in marble derived from literary, mythological, and biblical themes, as well as realistic portrait statues in bronze.

**Dedicated:** *September 27, 1876.* **Signed and dated:** *Randolph Rogers inv. et mod / Romae MDCCCLXXV.* **Foundry mark:** *Gegossen durch Ferd. V. Miller O. Sohne / Muchenn 1876.* **Collection of:** *City of New York; gift by public subscription, 250 subscribers.*

# D-13 Worth Monument, 1854–1857

**Architect:** *James Goodwin Batterson (1823–1901).* **Media and size:** *Granite obelisk, 51 feet high; bronze relief.* **Location:** *On the triangle at Broadway, Fifth Avenue, and 24th Street.*

On November 14, 1857, the City of New York with a public ceremony transferred the remains of Maj.-Gen. Jenkins Worth (1794–1849) from Greenwood Cemetery to this site in Manhattan. A Renaissance-style obelisk marks his grave, almost the only burial on Parks Department property other than Grant's Tomb (see I-25).

Worth is best known as a Mexican War hero. He was a brilliant leader in battle and, according to historical accounts, a bellicose individual in private life. His first military experience occurred during the War of 1812 when he was only 18 and culminated with his appointment as brigadier-general by President Polk.

The unusually interesting granite obelisk, set on a rectangular pedestal, bears four bands carved in the granite, inscribed with the names of the major battles in which Worth fought. Other military references appear in the bronze trophy, a complex ornament composed of cannons, swords, and other weapons, and mounted on the south face of the obelisk. Below it is the central sculptural element, a spirited high relief of General Worth on horseback. Clothed in full regalia, he holds a sword aloft, perhaps a reference to the sword with bejeweled handle awarded to him by Congress after the Mexican War. The sculptor of the bronze decorations and relief is unknown.

The cast-iron fence is outstanding. It is a fine example of mid-19th-century decorative ironwork designed as a series of swords thrust into the ground. The sword handles are topped by little helmets and are clearly patterned on the honorary sword bestowed on General Worth by the State of New York, while the fence is linked together with wreathed oak leaves connoting honor. Its maker is not known. Corner ornamental gas lamp posts added in the 1880s have disappeared.

**Dedicated:** *November 25, 1857.* **Collection of:** *City of New York; purchase.*

# D-14 Farragut Monument, 1880

**Sculptor:** *Augustus Saint-Gaudens (1848–1907).* **Pedestal by:** *Stanford White.* **Media and size:** *Bronze statue, over life-size; Coopersberg black granite pedestal and exedra.* **Location:** *North end of Madison Square, near 26th Street.*

This memorial to Admiral Farragut changed the course of American monumental sculpture. A total design, each component—figure, pedestal, lettering, setting, and iconographical elements—contributes toward the work's thematic and stylistic unity. As Saint-Gaudens' first major public sculpture, the *Farragut Monument* established him as the nation's foremost sculptor and inaugurated a life-long collaboration with the architect Stanford White.

Saint-Gaudens was a master of human psychology, able to conceptualize the intellectual and emotional character of his subject. This statue is a convincing portrait of Farragut, but it is also an expression of the Civil War hero's integrity and courage. Realistically portrayed as though standing on a ship's prow, with feet spread apart and coat blowing in the wind, Farragut appears invincible. He was the Civil War's most celebrated naval commander, winning glory for his capture of New Orleans and for his subsequent success at the Battle of Mobile Bay. During the taking of this Confederate port, Farragut was lashed high on the ship's mast so that he could see farther into the distance, and when torpedoes blocked the advance of his fleet, Farragut gave the now-famous command, "Damn the torpedoes! Full speed ahead!"

The vertical thrust of the statue counterbalances the horizontal, curved pedestal, or exedra, an integral component of the whole. Stylized reliefs by

Saint-Gaudens depicting Loyalty (left) and Courage (right) enrich White's pedestal on either side of the central pier and strengthen the message conveyed by the statue. On the pedestal below the figure of Farragut, a pattern of linear waves flows over an unsheathed sword, symbolizing Farragut's devotion to a life on the sea. At the ends of the exedra are dolphins. Saint-Gaudens also introduces here an unprecedented use of lettering. The stylized inscription celebrating Farragut's achievements wraps around the allegorical figures and almost becomes an extension of the waves. Some historians view this sinuous sculptural relief as the first example of Art Nouveau in America.

Although White and Saint-Gaudens carefully selected the original site, Fifth Avenue at the edge of Madison Square at 26th Street, a number of observers criticized this location. In contrast to the monument's designers, who felt that more people would view the work if it were oriented toward Fifth Avenue, detractors disliked the way the memorial's back faced the park. In 1909 city officials approved shifting the memorial eastward a few feet so Fifth Avenue could be widened. In 1935 the whole monument was relocated to the northern edge of the park. By this time the bluestone exedra had eroded severely, and the Parks Department authorized sculptor Karl Gruppe to supervise a WPA team of artists in carving a replica in durable Coopersberg black granite. During the creation of the new exedra, workers discovered a lead box buried beneath the monument, containing several New York newspapers dated 1881, a volume of *Letters of Admiral Farragut,* several small coins, and a parchment containing the names of subscribers.

Early in 1986 neighborhood sentiment ran high when the Metropolitan Museum, which had borrowed the Farragut for a Saint-Gaudens exhibit, proposed that it retain the bronze statue indoors to protect it from acid rain and replace it with a replica. The Farragut statue was ceremoniously returned to its pedestal, with a promise of regular protective waxing. The four months of discussion that this controversial proposal prompted aroused wide interest and developed an entirely new public awareness of the monument and its sculptor.

**Dedicated:** *May 25, 1881.* **Signed and dated:** *Modelled by avg. Saint-Gaudens / Paris MDCCCLXXX.* **Signed:** *Augustus Saint-Gaudens Sculptor. Stanford White Architect.* **Foundry mark:** *Cast by Adolphe Gruet.* **Collection of:** *City of New York; gift by public subscription.*

D-15 Photo, 1934

## D-15 Chester Alan Arthur, 1898

**Sculptor:** *George Edwin Bissell (1839–1920).* **Pedestal by:** *James Brown Lord.* **Media and size:** *Bronze statue, over life-size; granite pedestal.* **Location:** *Madison Square, near the northeast entrance at 26th Street.*

The erection of the statue of Chester Alan Arthur (1830–1886) on the northeast corner of Madison Square completed the quartet of political and military figures marking the corners of the park. In a letter to the Art Commission in 1898, sculptor Bissell pointed out that bronze likenesses of personal and political associates of President Arthur—Conkling, Farragut, and Seward—were already situated on the periphery of Madison Square, making this a particularly appropriate site.

Arthur, a New York lawyer, was collector of New York's Customs from 1871 to 1878, but because of corrupt practices he was removed from office by President Hayes. He was reputedly a leader of the Republican political machine run by his friend Roscoe Conkling (see D-10). In 1880 Arthur was chosen as the running mate to James Garfield, and when Garfield was assassinated, he became the 21st president.

Fashionably dressed, Arthur stands in front of an elaborate armchair. It is draped with an Oriental rug and has the presidential seal on its back. He holds a book in his left hand, keeping place with a finger inserted into the open pages, while he addresses an unknown audience. The ornate pedestal, embellished with carved moldings, completes the image of an elegant Victorian. In 1896 Bissell had created the successful and carefully appointed portrait statue of Abraham De Peyster, now in Hanover Square (see A-12).

**Dedicated:** *June 13, 1899.* **Signed and dated:** *George E. Bissell / Sculptor 1898.* **Foundry mark:** *The Henry-Bonnard Bronze Co. / Founders. New York.* **Collection of:** *City of New York; gift of Arthur's personal friends.*

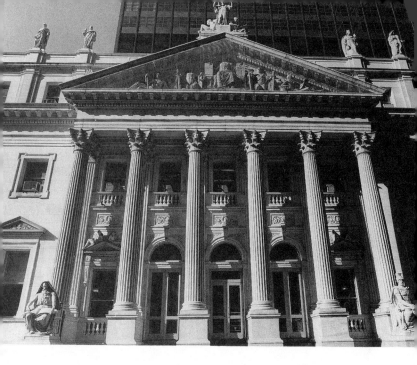

## D-16 Appellate Division of the Supreme Court Façade Sculpture, 1896–1900

Sculptors: *See text.* Architect: *James Brown Lord (1859–1902).*
Location: *Northeast corner of 25th Street and Madison Avenue.*

In 1896 James Lord proposed his design for the Appellate Court House, which he envisioned as a Neo-Palladian structure adorned with an elaborate series of murals and sculptures. Lord alloted one-third of the $700,000 building budget to artistic ornamentation. Conceived in the wake of the Columbian Exposition during the height of enthusiasm for Beaux Arts design, the Appellate Court House is one of New York's most lavish public buildings. The overtly didactic message of its murals and sculptures also reflects the prevailing attitude that art should edify the public.

As did many architects of the period, Lord assigned the themes and locations of artworks. With the assistance of consulting scholars, he devised a thematic program which celebrated luminaries of world legal history. Supplementing this primary theme are personifications of attributes associated with the practice of law. Sculptures flank the entrance on 25th Street, adorn and crown the pediments on both the 25th Street sides and Madison Avenue sides, and grace the roof balustrade. A number of different sculptors, most of whom were members of the National Sculpture Society, contributed works.

To the left and right of the portico on 25th Street are *Wisdom,* a male figure with flowing beard, reminiscent of Michelangelo's *Moses,* and *Force,* a male figure wearing Roman armor and holding a sword in his lap. They are by Frederick Wellington Ruckstull (1853–1942), a competent academic sculptor who was also later a vociferous opponent of modern art. He argued that abstract art was symptomatic of cultural degeneracy and believed that art, particularly sculpture, should serve a patriotic and moral purpose.

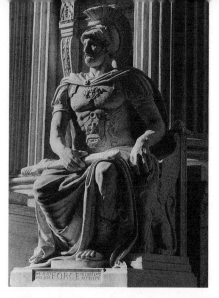

Above the windows within the portico are the semi-reclining male and female figures *Morning, Night, Noon,* and *Evening* by Maximillian M. Schwartzott (active 1898–1926). The symbolism suggests the timelessness of law and justice.

In the pediment above the portico on 25th Street is *Triumph of Law* by Charles Henry Niehaus (1855–1935). Arrayed around the central, iconic female figure, Law, are reclining male figures, representing Roman soldiers. Father Time and an unidentified youth occupy the corners of the pediment.

Along the roof balustrade on 25th Street, a series of single standing statues, representing historical figures associated with the world's great legal systems, are arranged in four pairs. In the center is an allegorical group depicting Justice. In 1955 the statue of Mohammed was removed during restoration of the building because of objections voiced by several Muslims, whose religious commitments forbid graven images. All the sculptures were moved west one bay, leaving an empty pedestal on the eastern end. From left to right the sculptures are: *Zoroaster* (Persian law), by Edward Clark Potter (1857–1923); *Alfred the Great* (Anglo-Saxon law), by Jonathan Scott Hartley (1845–1912); *Lycyrgus* (Spartan law), by George Edwin Bissell (1839–1920); *Solon* (Athenian law), by Herbert Adams (1858–1945); *Justice,* by Daniel Chester French (1850–1931), a standing female figure with uplifted arms holding two torches, flanked by semi-reclining male figures representing Power and Study; *Saint Louis* (French law), by John Talbott Donoghue (1853–1903); *Manu* (Indian law), by Augustus Lukeman (1871–1935); and *Justinian* (Roman law), by Henry Kirke Bush-Brown (1857–1935).

The façade sculpture on the Madison Avenue side continues the themes and arrangement of the sculpture on the 25th Street façade. Four caryatids representing the four seasons and implying law's universality stand above the cornice of the portico. From left to right they are *Winter, Autumn, Summer,* and *Spring,* by Thomas Shields Clarke (1860–1920). Above them on the roof balustrade, from left to right are: *Confucius* (Chinese law), by Philip Martiny (1858–1927); *Peace,* by Karl Bitter (1867–1915), a standing female figure holding a dove in her left hand, flanked by Strength and Abundance; and *Moses* (Hebraic law), by William Couper (1853–1942).

**Collection of:** *City of New York; purchase.*

# D-17 Sentinel, 1966–1968

**Sculptor:** *Theodore Roszak (1907–1981)*. **Media and size:** *Cast bronze plates on copper frame, 25 feet high.* **Location:** *Public Health Laboratories, 455 First Avenue at the southeast corner of 27th Street.*

*Sentinel* is an abstract monument, conceived by sculptor Theodore Roszak "in homage to those intrepid men and women who dedicated themselves to science and humanity." It is composed of sleek, straight-edged machine forms juxtaposed against textured, curving organic forms. The sculpture arouses associations between the man-made and natural worlds. A hard-edged construction resembling a giant probe or microscope points upward from the center of a sweeping crescent. This massive crescent is coated with hardened accretions of molten metal. Together the parts suggest man's dependence on both technology and nature.

    *Sentinel,* one of the celebrated sculptor's later monumental works, recapitulates motifs from both his early Constructivist period and his successive expressionist phase. These welded, hammered, and brazed metal constructions convey emotional energy; their textured surfaces, twisted parts, and angular silhouettes could be interpreted as a record of pain and suffering.

**Dated:** *1966.* **Collection of:** *City of New York; purchase.*

# D-18 Mitochondria, 1972–1975

**Sculptor:** *John Rhoden (1918– ).* **Media and size:** *Bronze abstract sculpture, 12 feet high; mounted on steel column.* **Location:** *Bellevue Hospital, on the hospital lawn, east of First Avenue between 26th and 27th Streets.*

Inspired by the recent discovery of the double helix, sculptor John Rhoden designed this sculpture to simulate the DNA molecule, an appropriate theme for a hospital. He explains: "The metamorphosis of energy is indicated by the active negative forms produced by the encirclement of the life-giving fluids, which in turn produce the expendable energy to power other activities of the cell." Suggesting the movement of a DNA molecule, the bronze appears to contract and expand, forming twisting metal ribbons which circumscribe three irregular voids. Because the sculpture is mounted on a high steel column, it is visible from the elevated FDR Drive as well as from the lawn.

*Mitochondria* was Rhoden's third commission for a hospital. His first was *Family* at Harlem Hospital (see J-21), followed by *Oriel* (1968–1972), a Cor-Ten steel relief decorating the façade of the Psychiatric Pavilion of Metropolitan Hospital. Approximately 10 feet high by 20 feet long, it consists of a calligraphic grille placed on curved, sweeping planes which suggest an eye, symbolizing a "window to the mind." As the steel sculpture weathers, it changes color, with the development of the metal's natural orange-brown patina.

**Signed and dated:** *Rhoden MCML XXIII.* **Foundry mark:** *Modern Art Foundry New York, New York.* **Collection of:** *City of New York.*

## D-19 The Child, 1979

**Sculptor:** *Edwina Sandys (1938– ).* **Media and size:** *Marble sculpture, 16 feet high.* **Location:** *In front of the United Nations International School at 24–50 East River Drive (FDR Drive), between 24th and 25th Streets.*

Abstracted from the human figure, *The Child* portrays a mother and father in profile, cradling a baby represented by the space in the work's center. The British sculptor Edwina Sandys, granddaughter of Sir Winston Churchill, carved the piece out of a single block of Carrara marble. The work was erected in celebration of the International Year of the Child, and appropriately stands in front of the United Nations International School. It is visible from the FDR Drive.

**Dedicated:** *October 13, 1979.* **Collection of:** *United Nations; gift of Edwina Sandys, Leone Chapira, and Robert Howard.*

# D-20 Descent from the Cross, 1972

**Sculptor:** *Reuben Nakian (1897–1986).* **Media and size:** *Bronze abstract sculpture, 10 feet high.* **Location:** *Saint Vartan Armenian Cathedral, northeast corner of Second Avenue and 34th Street.*

In the spirit of Rubens' painting *Raising of the Cross,* Nakian's sculpture is a forceful construction of lunging and leaning elements, an abstract translation of the old master's baroque drama. Large textured blocks, aligned vertically and diagonally, appear to be tumbling downward.

In an interview with *New York Times* critic Grace Glueck, Nakian explained the evolution of this monumental sculpture: "I knew Rubens' *Raising of the Cross* . . . composition in Antwerp, and I decided mine might have this theme. I began to struggle with it, to depict agony. At first I tried to bring abstract and naturalistic elements into it; they didn't click. After a year and a half, I didn't know what to do. But then I finally finished it, and I think it's a great work of art."

In early 1977 when Archbishop Torkom Mangoogian, Primate of the Diocese of the Armenian Church of North America, saw the sculpture he decided to raise funds to purchase and cast it for the plaza of Saint Vartan's Armenian Cathedral.

Trained in the classical tradition, Nakian, son of Armenian parents, often drew inspiration from Renaissance and baroque masters. In his work he explored heroic themes based on classical and religious subjects, which he animated with expressionist, raw energy.

**Dedicated:** *November 15, 1977.* **Collection of:** *Saint Vartan's Armenian Cathedral.*

## D-21 **Triad, 1969**

**Sculptor:** *Irving Marantz (1912–1972).* **Media and size:** *Bronze abstract sculpture, 15 feet high by 8 feet wide by 4 feet deep; polished granite pedestal.* **Location:** *475 Park Avenue South at the southeast corner of 32nd Street.*

Irving Marantz was a painter who turned to sculpture only during the last five years of his life. *Triad* was his second major outdoor piece. The cluster of three figures abstracted into planes and cubes stands with elegant dignity on a raised podium of steps where it communicates a sense of warmth and togetherness. The slate-gray color of its bronze patina is sympathetic to the brown brick background of the building, and its scale is most felicitous. In theme and cubistic arrangement of elements, *Triad* restates Picasso's *Three Musicians,* possibly alluding to the three Cohen brothers, the realtors who commissioned the work.

Despite the artist's limited experience with the three-dimensional medium, Emily Genauer, a former critic for the *New York Post,* commented that Marantz "brings surprising strength to his forms."

Marantz's final work can be observed two blocks to the north at 3 Park Avenue, at the southeast corner of 34th Street. Called *Obelisk to Peace* (1972), it is a 23-foot-high tapered biomorphic column, an abstract reinterpretation of an ancient monumental form. Unlike Egyptian obelisks, which often celebrate military victories, the organic shapes of *Obelisk to Peace* meld into a single entity, suggesting unity and concord. The towering sculpture, burnished to a golden sheen, stands out against the brown brick building.

Marantz died before he was able to enlarge his model and oversee its casting in bronze, so his son brought this sculpture to completion. It was cast at the Modern Art Foundry.

**Signed and dated:** *Marantz / 1969.* **Commissioned by:** *Cohen Brothers Realty Corporation.*

## D-22 Horace Greeley, 1892

**Sculptor:** *Alexander Doyle (1857–1922).* **Media and size:** *Bronze statue, over life-size; granite pedestal.* **Location:** *32nd Street between Broadway and Sixth Avenue.*

For 30 years Horace Greeley (1811–1872) edited the *New York Tribune*, a paper shaped by his humanist ideals and moral standards. When he started the influential weekly in 1841, Greeley promised in advertisements that it "will labor to advance the interests of the people and to promote their moral, social, and political well-being." The outspoken journalist crusaded for a variety of causes, irrespective of party positions, including worker's rights and the abolition of slavery and capital punishment. He was a newspaperman who had begun as a journeyman printer and worked his way up, becoming himself a symbol of American success. Greeley's funeral brought throngs of mourners to City Hall where his body lay in state before a large funeral procession down Broadway.

Doyle's bronze portrait figure is less famous than J. Q. A. Ward's sculpture of Greeley (see B-6), the only journalist to be honored by more than one commemorative statue in Manhattan. The Typographical Society commissioned this work because Greeley was the first president of Typographical Union No. 6. It lacks the veracity and psychological intensity of Ward's sculpture and exaggerates Greeley's fringe of whiskers. Correspondence between Doyle and the Parks Department reveals that the artist wanted the sculpture to be erected in City Hall Park, but ironically Ward's ended up there and Doyle's was placed in the burgeoning Herald Square area, where James Gordon Bennett, Jr.'s Herald Building (1892–1895) was under construction.

**Dedicated:** *May 30, 1894.* **Signed:** *Alex Doyle Sculptor.* **Foundry mark:** *Cast by the Henry-Bonnard Bronze Company / New York 1892.* **Collection of:** *City of New York; gift of Horace Greeley Post Number 577 G.A.R., New York Typographical Union Number 6, and Brooklyn Typographical Union Number 98.*

*D-22 Photo, ca. 1905*

# D-23 Samuel Rea, ca. 1910

**Sculptor:** *Adolph A. Weinman (1870–1952).* **Media and size:** *Bronze statue, 10 feet high.* **Location:** *Pennsylvania Station, at the entrance to 2 Penn Plaza, off Seventh Avenue at 32nd Street.*

Monumental columned old Pennsylvania Station is remembered for many things, not the least of which are the 22 big granite eagles that stood along its cornice line and the large clock against which leaned two classical stone figures. These were all created by sculptor Adolph Weinman, who also did portrait statues of two Pennsylvania Rail Road presidents. One of these, *Samuel Rea,* stands on a pedestal at the entrance to 2 Penn Plaza, the commercial structure that replaced the old McKim, Meade and White masterpiece station. Rea was Pennsylvania Rail Road president from 1913 to 1925, a heyday for railroading, before planes and buses took over. His 10-foot-tall bronze likeness originally occupied a niche in the old station's cavernous interior, as did that of earlier president Alexander Cassatt, now at the Rensselaer Polytechnic Institute in Troy, New York. Sculptor Weinman did both at about the same time that he began work on the gilded *Civic Fame* on the Municipal Building (see B-15).

Weinman's granite eagles have been dispersed, except for the two that remain at the Seventh Avenue entrance to 2 Penn Plaza. The mammoth stone frame of the clock with the two reclining figures ended up in the dump at Secaucus, New Jersey, and became the subject of classic horror photographs deploring the destruction of landmarks.

**Signed:** *A.A. Weinman, Sculptor.* **Foundry mark:** *Roman Bronze Works, New York.*

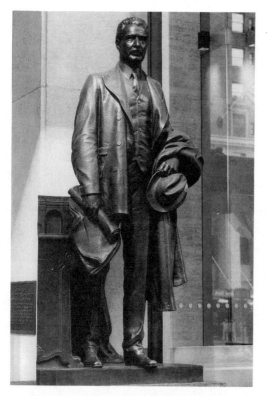

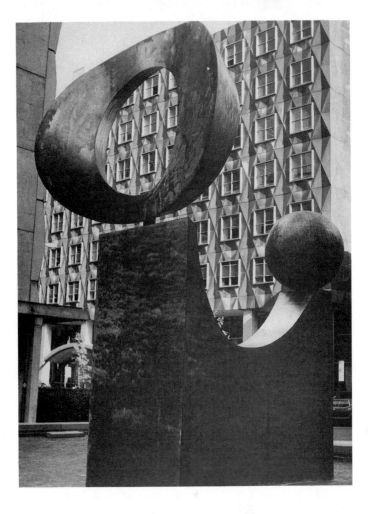

## D-24 Eye of Fashion, 1976

**Sculptor:** *Robert M. Cronbach (1908– ).* **Media and size:** *Hammered and welded brass, 18 feet high.* **Location:** *Fashion Institute of Technology, in the plaza at the southwest corner of Seventh Avenue and 27th Street.*

This playful abstract work constructed from hammered and welded brass has three elements: a sphere, a ring, and a wedge with concave sides and a scooped-out top. Interacting like pieces in a game, the sphere appears to have just rolled out of the ring above, down and up the incline to its perch on the opposite end of the wedge. Cronbach uses a vocabulary of curves and planes to give gravity, an invisible force, a visible form.

In the school's stark brick-and-concrete plaza, the sculpture's bold geometric rhythms compete forcefully with the surrounding architecture. Cronbach, whose numerous commissions for outdoor works go back to the 1930s, has said, "I consider this one of my more successful public sculptures."

**Signed and dated:** *Cronbach 1976.* **Collection of:** *City of New York; purchase.*

## D-25 Chelsea Park Memorial, ca. 1920

**Sculptor:** *Philip Martiny (1858–1927).* **Pedestal by:** *Charles Rollinson Lamb.* **Media and size:** *Bronze statue, over life-size; granite pedestal.* **Location:** *Chelsea Park, 28th Street and Ninth Avenue.*

Numerous New York City communities erected memorials in honor of neighborhood youths who died in World War I. In contrast to the majority of Civil War monuments, these memorials celebrate the enlisted man, not the officer, and they had a personal significance for each community. The memorials suggest that the heroes of World War I were the men in the trenches.

Shortly after completing the *Chelsea Park Memorial,* Philip Martiny designed a similar work for nearby Abingdon Square (see C-1). As was Martiny's practice, he used a basic figure, which he modified slightly for various commissions. In both memorials, a solitary soldier stands with feet braced apart and head turned to the left. Here the soldier holds a rifle across his thighs, while a windblown overcoat flaps around him. In both these works we see Martiny's characteristic flare for decorative elements and animated form.

**Dedicated:** *April 7, 1921.* **Signed:** *Ph – Martiny – Sc.* **Foundry mark:** *Roman Bronze Works N.Y.* **Collection of:** *City of New York; gift of the Chelsea Memorial Committee.*

# (E)
# MIDTOWN EAST
## *34th to 59th Streets, east of Fifth Avenue*

———————

Some of New York's newest sculptures can be found in this neighborhood of elegant shops and high-rise buildings. Standing next to corporate headquarters and luxury apartments, they present a lively assortment of materials and styles. William King's engaging *Companions,* a steel-plate figurative sculpture, welcomes us to an apartment house not far from Michael Heizer's cryptic, granite-and-steel *Levitated Mass* at IBM's headquarters. Park Avenue, a broad boulevard that used to be an open cut revealing the New York Central Railroad tracks below, has a number of sculptures along its ample sidewalks. It passes through the Helmsley Building and loops around Grand Central Terminal, whose southern façade bears the heroic sculptural clock *Transportation* by Jules-Félix Coutan, below which stands a statue of the "commodore," Cornelius Vanderbilt.

The region's largest concentration of outdoor pieces graces the grounds of the United Nations, a kind of international sculpture garden located east of First Avenue between 42nd and 47th Streets. Since the United Nations complex was completed in 1953 the governments of member countries, organizations, and individuals have presented various gifts, many of them works of art. Of the approximately 75 donations, nine are outdoor sculptures. Most of these are located in the breezy, spacious north garden, which visitors can enter at 46th Street. Prominent among the United Nations' outdoor sculptures are *Peace* and *Single Form,* clearly visible from First Avenue. Although of varying styles and by artists from around the world, most of these sculptures share a common theme: they express a desire for peace and friendship among nations.

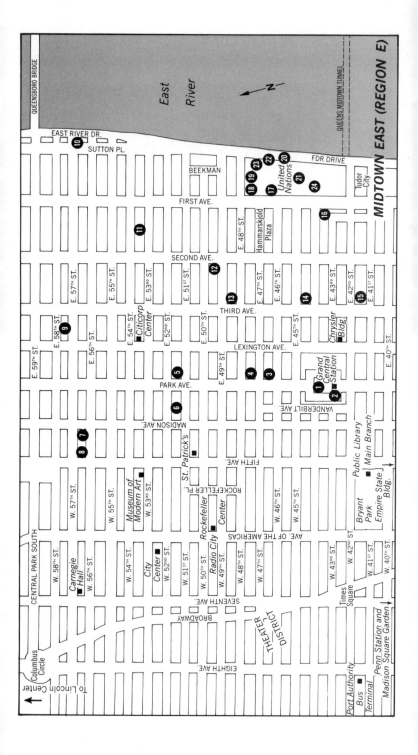

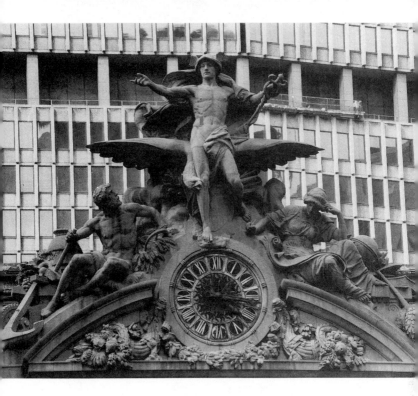

# E-1 Transportation, 1912–1914

**Sculptor:** *Jules-Félix Coutan (1848–1939).* **Architect:** *Warren and Wetmore.* **Media and size:** *Limestone group and clock, 48 feet high.* **Location:** *Grand Central Terminal roof, south façade at 42nd Street and Park Avenue.*

Grand Central Terminal's stupendous sculptural clock surmounts the entrance to New York's most elegant gateway. Mercury is at the center of this assemblage of mythological figures. As messenger of the gods and the deity of commerce and the market, he strides forward carrying his magic wand, the caduceus.

The creator of the figure, the French academic sculptor Coutan, described Mercury as "the god of speed, of traffic, and of the transmission of intelligence." On his left is Minerva, goddess of wisdom and invention, who studies a scroll as she reclines among books. She symbolizes intellectual energy. On his right is Hercules, who holds an anvil and sits with a cogwheel, anchor, and beehive beside him. He symbolizes physical energy. The group suggests that mind and body are the basis of economic success and in effect support commerce, a fitting tribute to railroad magnate Commodore Cornelius Vanderbilt (see E-2), the financier who assembled an entire railroad system and built the first Grand Central Terminal.

One of the largest architectural sculptures ever constructed, *Transportation* weighs over 1,000 tons and is built from separate stones that are layered and cemented together. John Donnelly carved the colossal figures from quarter-size plaster models shipped from Paris to the William Bradley & Son stone yards in Long Island City.

**Installed:** *June 1914.*

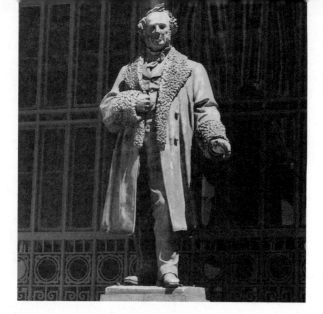

## E-2 Cornelius Vanderbilt, 1869

Sculptor: *Ernst Plassmann (1823–1877)*. **Media and size:** *Bronze statue, over life-size; granite pedestal.* **Location:** *Upper roadway, on front of the south façade of Grand Central Terminal.*

The statue of railroad and steamship magnate Cornelius Vanderbilt (1794 –1877) is appropriately located at the façade of Grand Central Terminal where he brought his railroad empire into being. The bronze image is, however, almost impossible to view except from an automobile while driving up the ramp from lower Park Avenue, or on foot by stepping out onto a small second-level side ramp entrance of the Grand Hyatt Hotel.

The swaggering figure of the Commodore, imposing in a fur-trimmed great-coat, is the work of the German-born American sculptor Ernst Plassmann. Albert DeGroot (1813–1884), a well-known captain of two of Vanderbilt's most luxurious boats on the Albany–New York line and an intimate of the Commodore, arranged the commission for the *Vanderbilt*. The sculpture was done in 1869, presumably from life, and was moved to this hard-to-see location in 1913 when the present Grand Central Terminal was completed on the site of Vanderbilt's earlier and smaller Grand Central Depot.

Over the years writers had come to attribute the *Vanderbilt* sculpture to DeGroot, who was indeed interested in art and handled the ornamentation of Vanderbilt's luxury steamboats. The attribution of the *Vanderbilt* statue to sculptor Ernst Plassmann was clarified by historian David M. Kahn in an article in *The Connoisseur,* June 1980.

From 1869 until 1913 the statue stood in a niche of a 150-foot-long and 31-foot-high bronze panoramic panel decorating the front of Vanderbilt's Hudson River Railroad Freight Depot constructed just south of Canal Street. That structure and its web of tracks are long gone. The impressive background relief panel replete with images of railroads, steamships, and agricultural implements seems to have been scrapped after the Vanderbilt statue was relocated.

**Fabricated at:** *The foundry of George and Valentine Fischer.*

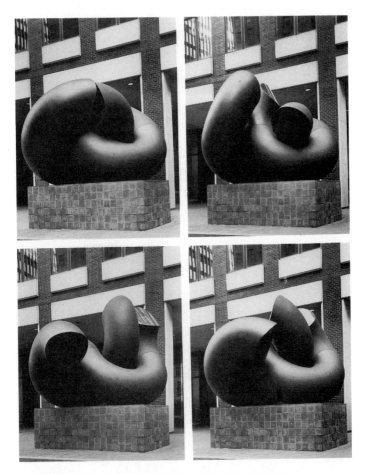

## E-3 Performance Machine, Big O's, 1986

**Sculptor:** *Lowell Jones (1935– ).* **Media and size:** *Fiberglass, painted black, 12 feet high.* **Location:** *Olympia & York Plaza, 245 Park Avenue at East 47th Street.*

This kinetic sculpture is driven by a solar-powered motor connected to a solar panel on the roof of 245 Park Avenue and a system of chains. It is the only sculpture of its kind in New York. Composed of two doughnut-shaped parts, the upper quadrants of the sculpture rotate during a four-hour cycle, a movement that is not immediately perceptible. California sculptor Lowell Jones explains that "the slow movement of the sculpture's parts allows it to be perceived as static sculpture-in-the-round at any given time and movement becomes evident due to the changing relationships of the form's segments." Thus the sculpture makes solar energy visible.

Since the early 1970s Jones has been investigating solar-kinetic concepts. Collaborating with his friend, the Canadian artist Charles Pachter, he has begun to realize many of his ideas.

**Unveiled:** *March 2, 1986.* **Commissioned by:** *Olympia and York.*

# E-4 Taxi!, 1983

**Sculptor:** *J. Seward Johnson, Jr. (1930– ).* **Media and size:** *Bronze statue, life-size.* **Location:** *Chemical Bank, at the southeast corner of Park Avenue and East 48th Street.*

Stepping out of the entrance of Chemical Bank's world headquarters, a businessman attempts to hail a cab. As if shouting "taxi!" he raises his right hand and clutches his raincoat and briefcase beneath his left arm. The executive is actually a life-size bronze statue, one of several sculptures by J. Seward Johnson, Jr., located in New York City's streets and plazas.

Following one of the oldest sculptural traditions in Western art, Johnson approaches the bronze figure, not so much as sculpture but as narrative. He emphasizes details of clothes and accessories over the work's formal qualities, and is disinterested, for example, in the skillful arrangement of lights and darks or in the volumetric treatment of hair. Still, Johnson's works amuse the public, providing people with identifiable and accessible imagery.

**Cast at:** *The Johnson Atelier, New Jersey.* **Commissioned by:** *Chemical Bank.*

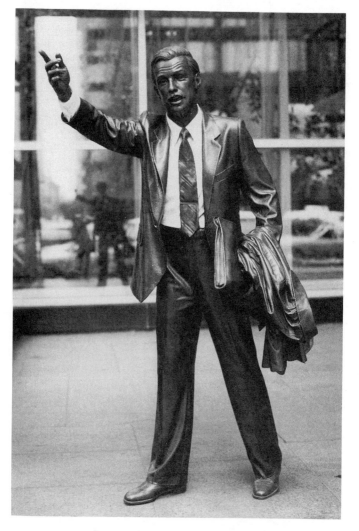

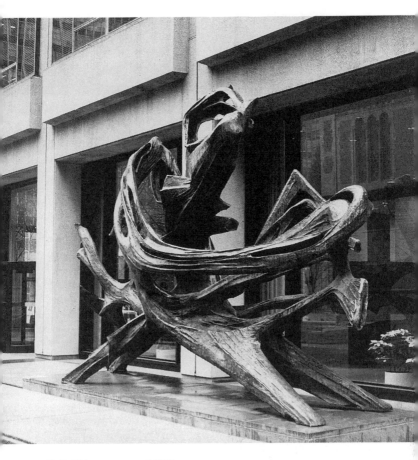

## E-5 Dinoceras, 1971

**Sculptor:** *Robert Cook (1921– ).* **Media and size:** *Bronze, 12 feet high by 20 feet long.* **Location:** *345 Park Avenue, on the 51st Street side.*

Occupying a raised plaza area at the base of a Park Avenue skyscraper, this textured skeletal structure with deep striations suggests the violent motions of an animal. The swirling bronze surface is taut, in places forming a thin membrane stretched over the branching elements. Using the lost-wax casting technique, sculptor Robert Cook modeled *Dinoceras* in beeswax on a bamboo armature, creating one of the largest wax sculptures ever made. It is a unique cast.

The title refers to the horned mammal, dinoceras, that inhabited the North American continent during the Eocene period, and oddly enough is also a compound of two Latin roots which together mean "dynamic wax."

Cook, who lives in Rome, made his reputation in the 1950s with his spirited, figurative works. Examples can be seen in the nearby lobby of Cumberland House, an apartment building, at 62nd Street and Madison Avenue and downtown at 80 Pine Street in the financial district.

**Dedicated:** *October 27, 1971.* **Signed:** *Robert Cook.* **Commissioned by:** *Jack and Lewis Rudin.*

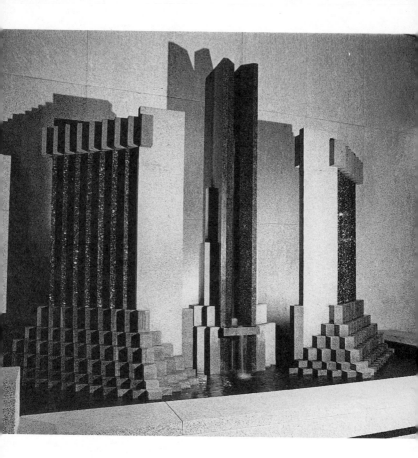

## E-6 Water Trilogy, 1986

Sculptor: *Ron Mehlman (1937–  ).* **Media and size:** *Granite and glass, 20 feet high by 15 feet wide.* **Location:** *Security Pacific Plaza, 40 East 51st Street, between Madison and Park Avenues.*

This architectonic fountain/sculpture stands on one side of an open public plaza at the base of a tall office building. Constructed of granite and glass, animated by water and light, *Water Trilogy* is both solid and ephemeral. It consists of three primary elements, a narrow vertical strip of glass mounted in granite, flanked by two stepped granite-and-glass walls which angle outward in a V shape. Seen from a distance, the symmetrical work forms a triangular composition, evocative of an altar. Water shimmers over the strips of colored glass, imbedded between the slabs of granite and illuminated from behind, transforming the sculpture's center into a cascade of liquid light.

Since 1980 sculptor Ron Mehlman has been working with marble, granite, and glass, juxtaposing colors, and wedging and overlapping slabs and blocks. He creates complex geometric compositions, seeking the perfect balance between contrasting hues and negative and positive spaces. Mehlman designed *Water Trilogy* for this plaza, matching the color of the granite to the pavement and the building façade. It is best seen at night when it takes on a mystical aura.

**Unveiled:** *December 10, 1986.* **Commissioned by:** *Jack and Lewis Rudin.*

# E-7 Levitated Mass, 1982

**Sculptor:** *Michael Heizer (1944– ).* **Media and size:** *Granite, stainless steel, water, 2½ feet high by 16½ feet wide by 25½ feet deep.* **Location:** *IBM regional headquarters on the northwest corner of Madison Avenue and 56th Street.*

Competing with the gigantism of American architecture and landscape, Michael Heizer is best known for his monumental earthworks in the Nevada desert. This work, commissioned by IBM, is his first permanent sculpture in New York City; although it is much smaller than his celebrated *Double Negative* (1969) and *Complex One* (1972) in Nevada, its form and conception derive from his earlier earth sculptures, massive manipulations of soil and rock.

*Levitated Mass* consists of an 11-ton boulder which rests on four unseen supports inside a pentagonal steel tank, shaped to frame the boulder. To heighten a sense of weightlessness, to increase the illusion of a rising rock, Heizer included a sheet of rushing water over the bottom of the tank. The idea for the piece evolved out of Heizer's preoccupation with mass, the simple essence of sculpture, which he explored in a series of earthworks in 1969.

Heizer refrains from carving natural boulders, but having altered this one to fit the tank, he explained, "I had to put life back into it," so he incised it with straight cuts which are a "lineal code," devised to represent the work's location. Assigning a numerical number to letters in the alphabet, the cuts represent the letters *M, A, D* and the number 56 and correspond to etched lines on the stainless-steel tank. These markings suggest Egyptian rock gravure and American Indian petroglyphs, which have long interested this artist.

A low, horizontal work amid skyscrapers, *Levitated Mass* provides pedestrian seating along its edges and encourages the viewer to linger. It's a quiet, cryptic sculpture by a leading artistic innovator.

**Dedicated:** *December 16, 1982.* **Commissioned by:** *International Business Machines.*

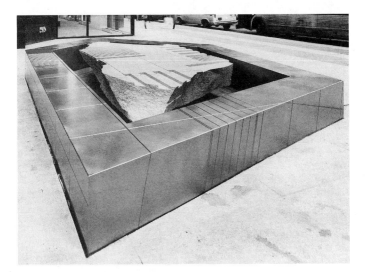

# E-8 Atlas Clock, ca. 1853

**Sculptor:** *Henry Frederick Metzler (active 1850s).* **Media and size:** *Painted wood figure, 9 feet high.* **Location:** *Tiffany & Company, Fifth Avenue and 57th Street on the southeast corner.*

Atlas shouldering his clock has marked Tiffany & Company since 1853 when the famous jewelry store moved into a four-story building at 550 Broadway, between Prince and Spring Streets. Charles Tiffany commissioned his friend Frederick Metzler, a carver of ship figureheads, to create Atlas, a wooden sculpture painted to resemble bronze. The clock came along each time Tiffany moved to a new location. Today it adorns its sixth home, where it is positioned above the handsome stainless-steel doors of the Fifth Avenue entrance at this pivotal intersection with 57th Street.

The *Atlas Clock,* noted for its accurate time, long served clerks and messengers who could not afford pocket watches. According to legend, Tiffany's celebrated mascot stopped at the exact minute that President Lincoln died, 7:22 A.M. on April 15, 1865.

**Collection of:** *Tiffany and Company.*

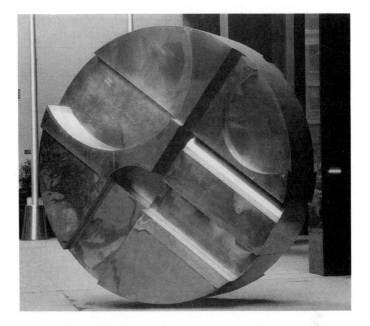

# E-9 Rondo, 1968

Sculptor: *Bernard (Tony) Rosenthal (1914– ).* **Media and size:** *Bronze disk, 11 feet in diameter.* **Location:** *111 East 58th Street, between Lexington and Park Avenues.*

This bronze disk gracing the north side of 58th Street is a bold geometric form which has been carved, scooped, and leveled. Deep shadows and reflected planes activate its sensuous, golden surface, luminous under a protective lacquer coat. Commissioned by the architect William Lescaze shortly after Rosenthal's *Alamo* (see C-11) was installed, *Rondo* is stylistically similar to that cube on Astor Place. It also pivots and its scale is large enough to be assertive in an architectural setting, yet small enough to attract people.

The sculpture originally stood in the plaza in front of 110 East 59th Street, but a store owner complained that it blocked visibility of his shop, so building owners relocated *Rondo* to the southern entrance to the building. There, Tony Rosenthal explains, "it just happens"—an unexpected object on a busy midtown street.

As a young man Tony Rosenthal studied at the Cranbrook Academy with Carl Milles, who taught him about the nature of materials and outdoor sculpture. Over time, Rosenthal developed an abstract, geometric style which bears little resemblance to his mentor's fanciful figures.

**Signed and dated:** *Rosenthal 69.* **Fabricator's mark:** *Lippincott / North Haven, Connecticut.*

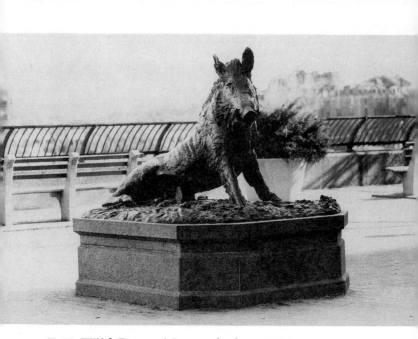

# E-10 **Wild Boar, this cast before 1970**

**Media and size:** *Bronze statue, life-size; low granite pedestal.* **Location:** *Vest-pocket park where 57th Street dead-ends at Sutton Place.*

This sculpture on New York's Upper East Side is a replica of the bronze *Wild Boar,* completed in 1634 by Renaissance sculptor Pietro Tacca (1557–1640). In Florence, where it adorns a fountain in the Mercato Nuovo, it is a favorite sculpture. Tacca modeled his bronze sculpture on an antique marble work on view in the Uffizi Gallery. It was customary during the Renaissance to make bronze replicas of antique sculptures, and Grand Duke Cosimo II commissioned Tacca to execute the 1634 bronze copy.

The Etruscan marble boar, fondly known as "Porcellino," has long been admired for its striking realism. According to Tacca's biographer, Baldinucci, the sculptor did not want to lose any of the details of the antique work, and studied a recently killed boar to aid him, evidenced in the textured fur and realistic snout and mouth. In addition, Tacca designed a new bronze base, covered with plants and animals, including frogs, field mice, crabs, lizards, and even a snake engulfing a mouse in its jaws.

New York City's *Wild Boar* is well sited in a small vest-pocket public park near the East River. Mounted on a low pedestal, the detail of the work is visible to passersby.

Just three blocks south at Sutton Place South and 54th Street is another gift of Hugh Trumbull Adams, an armillary sphere (1971) fabricated by Kenneth Lynch & Sons. Invented by the Greeks, armillary spheres became elaborate works of art during the Renaissance. This contemporary sphere, less ornate and complex than many Renaissance examples, is a decorative rendition of the traditional astronomical instrument. Zodiac figures in gold leaf encircle the inner ring, pierced in the center by an arrow. The whole apparatus remains stationary and functions primarily as a sun dial.

**Collection of:** *City of New York; gift of Hugh Trumbull Adams through Salute to the Seasons Fund for a Better New York.*

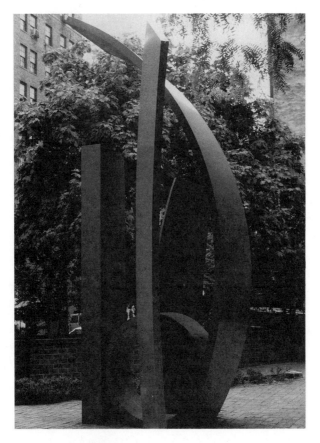

# E-11 **Accord, 1979**

**Sculptor:** *Alexander Liberman (1912– ).* **Media and size:** *Welded steel painted coral red, 18½ feet high by 11½ feet wide by 9½ feet deep.* **Location:** *At the park entrance next to Connaught Tower, 300 East 54th Street, east of Second Avenue.*

The circle and cylinder, and their variations, are recurrent motifs in Liberman's work. Here in a landscaped brick-paved public plaza a steel ring rests between a rectangle and a crescent-shaped plane, which extends above both the slab and the ring in a protective gesture. Two more curving planes symmetrically branch out from the inner ring, completing the enclosure. Although one can view the work as an essay in Constructivism, its solids and voids allude to male/female sexuality. Liberman recounted in a 1970 interview with Walter Hopps that ". . . my nature resists mass—because I find mass something obtuse. And I think there has to be an opening. . . . I think one has to penetrate. And I think we have to be drawn in to the mystery."

In addition to being a sculptor, noted for his monumental constructions wrought from boiler tanks, Liberman is also a painter, photographer, and graphic designer.

**Unveiled:** *May 11, 1979.* **Collection of:** *54th Street East, Benenson Realty, New York.*

## E-12 Companions, 1985

**Sculptor:** *William King (1925–  ).* **Media and size:** *Aluminum plate, painted black, 16 feet high.* **Location:** *Sterling Plaza, at the northwest corner of 49th Street and Second Avenue.*

Standing among the trees, forming a gateway, *Companions* portrays two friends locked in greeting. Long limbed, they bend at the waist and reach out toward one another, their clasped arms united in an oval. The lanky silhouettes cut from pieces of aluminum plate are reminiscent of children's stick-figure drawings. Their body parts, such as their circular heads and rectangular torsos, are simple geometric shapes, riveted and welded together. Humorous as well as inventive, this construction is full of subtle, playful details. Both figures appear off-balance. One stands on one leg with the right leg swinging up behind, and the other stands like an awkward child, with one leg bowed out and the plate feet pointing in opposite directions.

Sculptor William King is a humanist, attuned to people's behavior and to social mores. Since the 1940s he has been depicting the figure, sometimes with bitter satire and sometimes, as in this case, with gentle wit. He has worked with various materials including wood, burlap, vinyl, and most recently, aluminum plate. Typically, these large constructions, many of which are placed out-of-doors, show human beings in a positive light, nurturing and helping one another.

*Companions* is a friendly sculpture which enlivens this urban plaza. Fred Wilpon, chairman of Sterling Equities, Inc., the building's developer, remarked at the sculpture's dedication: "As soon as I became familiar with Mr. King's work, I knew that it would be the perfect complement to our philosophy and quality of life at Sterling Plaza." Children from nearby Public School 59 helped name the sculpture and participated in its unveiling.

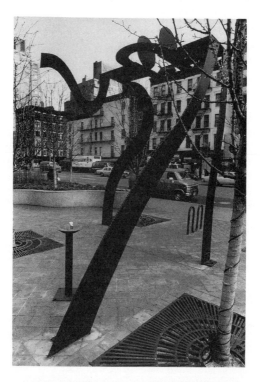

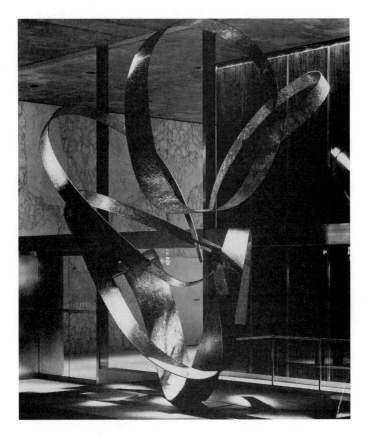

# E-13 Contrappunto, 1963

**Sculptor:** *Beverly Pepper (1924– ).* **Media and size:** *Stainless steel, 15 feet high; black granite pedestal.* **Location:** *777 Third Avenue, between 48th and 49th Streets.*

Suggesting the motion of an underwater sea creature, *Contrappunto* is composed of bands of burnished stainless steel which curl, loop, and gently sway. The convoluted steel ribbons appear to be continuous, but the sculpture actually consists of two parts. The top half, rotated by a motor, hangs from the ceiling of the building's entrance, enacting the movement suggested by the stationary lower half. Lacking mass, the sculpture has a lightness alien to steel and a linear rhythm akin to the gestural brush strokes of Abstract Expressionist painting.

*Contrappunto* is sculptor Beverly Pepper's first public commission in this country and is an example of this American artist's early work in steel, a material she prefers. She received the commission as a result of her participation in "Sculpture nella Città," an exhibition which took place in 1962 in Spoleto, Italy. She and nine other participants, including Americans David Smith and Alexander Calder, were invited to work in local factories prior to the festival. The architect of 777 Third Avenue, William Lescaze, saw the Spoleto show and asked Smith to do a large-scale sculpture for this site. He declined and recommended Pepper instead.

**Collection of:** *William Kaufman Organization.*

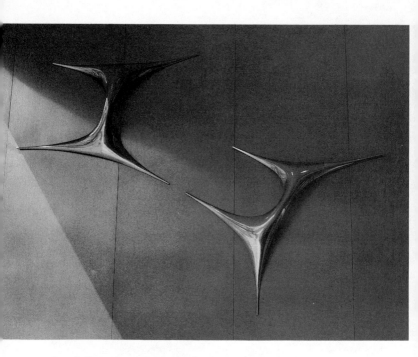

# E-14 **Continuum, 1956**

**Sculptor:** *José de Rivera (1905–1985).* **Media and size:** *Abstract stainless-steel sculpture, 7 feet high by 10 feet wide.* **Location:** *711 Third Avenue, between 44th and 45th Streets.*

José de Rivera believed in uniting modern architecture, painting, and sculpture, views he shared with architect William Lescaze who commissioned this stainless-steel relief. Lescaze wanted de Rivera to create an element that would be an integral part of the stainless-steel vestibule wall, not a tacked on decoration. Composed of two forms positioned along a curve, *Continuum* suggests two leaping figures, each element terminating in points that dissolve under reflected light.

De Rivera is best known for his linear, tubular constructions, rotating curvilinear forms that glide through and circumscribe space. Inspired by modern scientific and mathematical theories, de Rivera wanted to translate his understanding of matter, light, and space into sculptural form.

The William Kaufman Organization, which owns the building, believes the workplace should be a pleasant environment and has sponsored many inventive artworks and plazas to enhance its office structures. This was the Kaufman's first property in which art and architecture were integrated. (See A-11 and A-14.) In addition to de Rivera's sculpture, in the stainless-steel lobby there is a vivid mosaic by Hans Hofmann.

**Collection of:** *William Kaufman Organization.*

## E-15 Windward, 1961

**Sculptor:** *Jan Peter Stern (1926– ).* **Media and size:** *Flat bronze weathered plates, 10 feet high.* **Location:** *200 East 42nd Street, at the entrance on Third Avenue near East 41st Street.*

*Windward* has been described "as the first free-standing abstract sculpture to be placed on a New York sidewalk." Composed of broad ribbons of flat metal, the sculpture's sweeping curves are meant to suggest the motion of wind rustling through branches and leaves. As it is inconspicuously sited, very close to the building's ribbed wall and beneath an overhang, *Windward* is often missed by passersby.

The German-born Stern came to this country in 1938. Known for his sculptures in architectural settings, he has other public works at the Prudential Center in Boston and the Maritime Plaza in San Francisco.

**Erected:** *April 24, 1962.* **Commissioned by:** *The Durst Organization.*

## E-16 Peace Form One, 1972–1980

Sculptor: *Daniel Larue Johnson (1938– )*. **Pedestal by:** *Haines Lundberg Waehler*. **Media and size:** *Stainless-steel shaft, 50 feet high; pentagonal bronze base, 20 feet wide.* **Location:** *Ralph Bunche Park, on the west side of First Avenue at 43rd Street, opposite the United Nations.*

A stainless-steel shaft, conceived by the artist as "a shining symbol of man's renunciation of war and corruption," shimmers in the center of Ralph Bunche Park, recently dedicated as New York's first peace park. Suggesting an obelisk or a needle, *Peace Form One* is an elongated wedge rising out of a pentagonal base. Elegant and streamlined, it acts as a vertical counterpart to the towering glass United Nations Secretariat building across the street and to the ivy-hung wall and the Tudor City buildings behind. The shaft's burnished steel surface captures and reflects light in myriad ways, creating a pattern of swirls and patches over the angled planes. Johnson designed the sculpture to rotate, but it is currently secured in one position.

*Peace Form One* commemorates Ralph Bunche (1904–1971), known as "the great peacemaker" of the United Nations. The statesman orchestrated the armistices between Israel and the Arab states in 1949, for which he won the Nobel Peace Prize in 1950. Bunche is perhaps the only black American of his generation to achieve worldwide fame as a brilliant negotiator.

Johnson, a personal friend of Bunche, proposed this memorial to the United Nations Art Committee shortly after the statesman died. Because of a moratorium on artworks for the United Nations grounds, Johnson had to find an alternative site, which the city provided. The Phelps-Stokes Fund raised funds for the memorial to Bunche, a longtime trustee of the organization.

**Dedicated:** *September 15, 1980.* **Signed:** *Daniel.* **Fabricated by:** *Lippincott, North Haven, Connecticut.* **Collection of:** *City of New York; gift of the Phelps-Stokes Fund, Ralph J. Bunche Memorial Committee.*

# E-17 **Peace, 1954**

**Sculptor:** *Antun Augustinčić (1900–  ).* **Media and size:** *Bronze equestrian statue, 16 feet high; pedestal faced with marble quarried in Yugoslavia.* **Location:** *United Nations North Garden, on the east side of First Avenue (entrance at 46th Street).*

Boldly silhouetted against the sky, a heroic equestrienne holds aloft an olive branch in her left hand and carries a globe in her right, symbolizing the quest for worldwide peace. Resolute, she presses her lips firmly together and looks straight ahead. Her powerful, neighing steed carries her forward as her cape billows behind. Sculpted by Yugoslavian artist Antun Augustinčić, the work on its high pedestal has an architectonic quality and its angular, geometric forms reflect the influence of his teacher, Ivan Mestrovic. Augustinčić is known internationally for his monumental sculptures, examples of which are located in Yugoslavia, Argentina, and Albania.

**Presented:** *December 15, 1954.* **Collection of:** *United Nations; gift of the Government of Yugoslavia.*

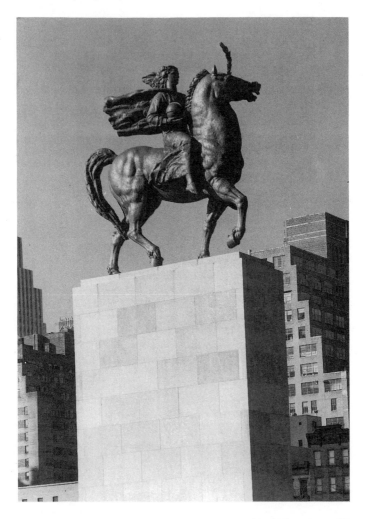

## E-18 Padre Francisco de Vitoria, 1976

**Sculptor:** *Francisco Toledo (1940– ).* **Media and size:** *Bronze bust, over life-size; granite pedestal.* **Location:** *United Nations, North Garden, on the east side of First Avenue (entrance at 46th Street).*

This quiet study of a monk portrays a solemn but thoughtful Francisco de Vitoria (1486–1546), a Spanish theologian and political theorist who helped formulate modern international law. Presented by King Juan Carlos of Spain during his official visit to the United Nations, the bust is a fitting gift to this international body. It is the work of Mexican-born artist Francisco Toledo, who is better known for his graphics and paintings.

**Presented:** *June 4, 1976.* **Signed and dated:** *F⁰ Toledo / 1976.* **Foundry mark:** *E. Capa / Fundio / Madrid.* **Collection of:** *United Nations; gift of Spain.*

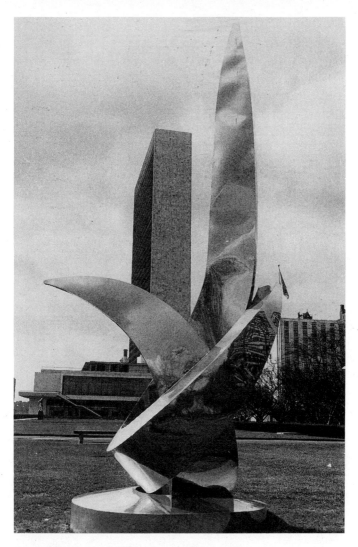

## E-19 Roots and Ties for Peace, 1983

**Sculptor:** *Yolanda d'Augsburg Ulm.* **Media and size:** *Stainless steel, 18 feet high.* **Location:** *United Nations, in the Rose Garden at the northeast end.*

*Roots and Ties for Peace* is an abstract sculpture with a symbolic message of unity. The stainless-steel work consists of two curvilinear and intertwining forms, with a highly reflective surface that mirrors its environment and complements its tapered elements. A gift to the United Nations from the Brazilian government, the sculpture is said to portray "the artist's concept of her cultural roots in Europe and emotional ties to Brazil and the Americas joining forces . . . for peace."

The Brazilian-born sculptress created *Roots and Ties for Peace* in her studio in Madrid, where she is currently living. An art historian as well as an artist, she has exhibited in Paris, London, Lisbon, and Rome.

**Collection of:** *United Nations; gift of the Brazilian government.*

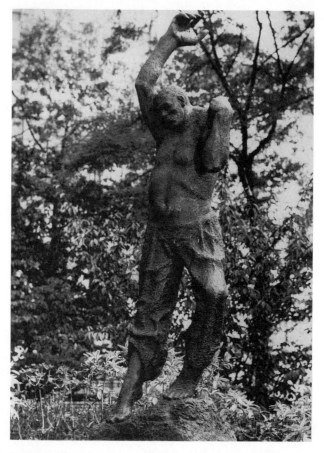

## E-20 The Rising Man ("Die Aufsteigende"), 1975

**Sculptor:** *Fritz Cremer (1906– ).* **Media and size:** *Bronze statue, over life-size; granite pedestal.* **Location:** *United Nations, North Garden, on the east side of First Avenue (entrance at 46th Street).*

An image of struggle and emerging consciousness, *The Rising Man* by German sculptor Fritz Cremer depicts a man pushing upward from the earth. He stands on a mound with his left leg bent and right leg extended, groping upward with his raised right arm as if unfolding and breaking through an invisible encasement. Naked except for loose trousers, the man's angular body is slightly distorted, thin in places, flabby in others, with a small head and huge hands. The sculpture's surface is extremely coarse which, coupled with the figure's gesture, suggests a form taking shape.

United Nations press materials state that Cremer "dedicated the work to the peoples liberating themselves from oppression." Having lived through the Nazi era, Cremer has used his art to decry fascism, creating monuments to concentration camp victims at Auschwitz, Buchenwald, and Mathausen. *The Rising Man* is part of a more recent series of politically symbolic figures which include *Those Who Accuse, Those Who Fall,* and *Those Who Never Submit.*

**Presented:** *September 17, 1975.* **Dated:** *1975.* **Collection of:** *United Nations; gift of the German Democratic Republic.*

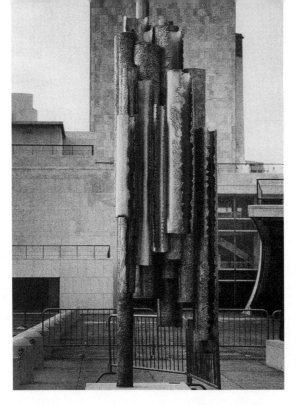

## E-21 Study for Monument to Sibelius, 1964

Sculptor: *Eila Hiltunen (Pietinen) (1922– )*. **Media and size:**
*Stainless-steel sculpture, 15 feet high.* **Location:** *United Nations, in the
plaza in front of the General Assembly Building.*

This cluster of steely-gray metal pipes of various lengths, some thick, some
thin, marks the end of a public promenade from the visitors entrance to the
General Assembly Building at the United Nations. Behind it stands a row of
trees and beyond that is the East River. Welded from stainless-steel pipes, the
sculpture suggests a pipe organ and becomes even more interesting on close
examination as one notes the jagged openings and surfaces laced with drips
and rivulets of molten metal.

Given by the Finnish government to the United Nations, it was created in
homage to the music of the great Finnish composer Jean Sibelius (1865
–1957). This steel sculpture in the United Nations plaza is in fact a study of
a portion of the tremendous steel monument erected in Sibelius Park in
Helsinki. After winning the competition for the Sibelius monument, it took
Finnish sculptor Eila Hiltunen, with the help of one assistant, four years to
construct that towering 26-foot-high work consisting of 580 pipes.

Best known for his seven symphonies and his patriotic tone-poems of the
1890s, Sibelius often composed mournful string passages that have been
likened to the Finnish wind. Sculptor Hiltuen has said of her work: "My
brain changed the feeling I got from his music into sculptured vision." Some
avow that during stormy weather the Sibelius monument in Helsinki, which
like this study resembles a pipe organ, emits sorrowful sounds, almost like
sighing.

**Presented:** *September 29, 1983.* **Signed and dated:** *Hiltunen / 1964.*
**Collection of:** *United Nations; gift of Finland.*

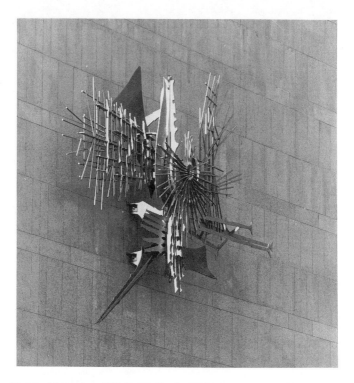

# E-22 Abstract Wall Relief, 1961

**Sculptor:** *Ezio Martinelli (1913– )*. **Media and size:** *Aluminum sculpture, 17 feet high by 30 feet long.* **Location:** *On the exterior of the east wall of the United Nations, General Assembly Building, facing the East River.*

A jewel-like ornament, Martinelli's very large golden aluminum construction adds color and texture to an austere façade. One hundred one strips of anodized aluminum radiate from the center, forming a skeletal composition that suggests the plumes of a peacock. Martinelli described it as "an aspirational piece of sculpture" but asserted that it has no intended symbolism.

The National Council for U.S. Art, an association of private citizens formed in 1953, commissioned the work, its third gift to the United Nations. The National Council was created to ensure that contemporary American artists are represented in the United Nations collection, although usually the governments of member nations, not private citizens, make gifts to this international body. Dag Hammarskjold, then secretary-general of the United Nations, chose Martinelli's design and, with chief architect Wallace K. Harrison, selected this location.

**Presented:** *October 27, 1961.* **Collection of:** *United Nations.*

# E-23 Let Us Beat Our Swords into Plowshares, 1958

**Sculptor:** *Evgeniy Vuchetich (1908– ).* **Media and size:** *Bronze statue, over life-size; granite pedestal.* **Location:** *United Nations, at the north end of the Rose Garden, on East River Terrace.*

This dramatic sculpture by Soviet artist Evgeniy Vuchetich illustrates the famous passage from Isaiah, "They shall beat their swords into plowshares and their spears into pruning hooks. Nation shall not lift up sword against nation. Neither shall they learn war any more." Vuchetich portrays a heroic nude lunging forward as he raises a mallet to strike a sword, transforming an implement of war into an implement of peace. The figure's youthful, muscular body and even features recall the idealized male nudes of Greek classical sculpture. Powerful in its conception and execution, Vuchetich's sculpture won the Grand Prix at the Brussels International Exposition in 1958.

Vuchetich is one of the Soviet Union's most eminent sculptors, earning the title of People's Artist of the USSR. Like other Soviet Realist artworks, his figurative sculptures celebrate the worker, labor, and the state. He has designed numerous monuments for his native country, among them *The Motherland,* a colossus erected in Volgagrad that commemorates the Soviet victory over the Germans in World War II.

**Presented:** *December 4, 1959.* **Collection of:** *United Nations; gift of the Union of Soviet Socialist Republics.*

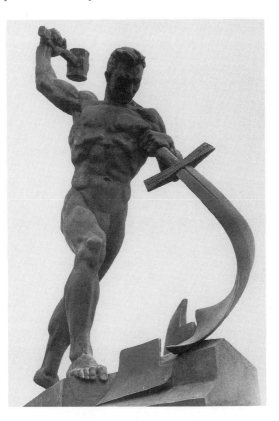

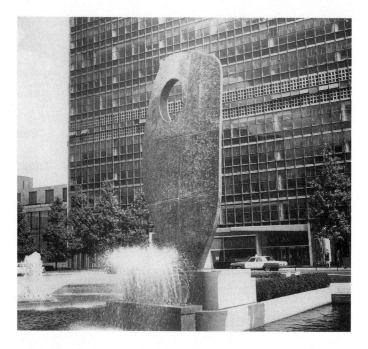

# E-24 Single Form, 1964

**Sculptor:** *Barbara Hepworth (1903–1975).* **Media and size:** *Bronze abstract sculpture, 21 feet high.* **Location:** *United Nations, in the pool in front of the Secretariat Building.*

This biomorphic slab pierced by a hole rises somberly from the pool in front of the United Nation's Secretariat Building, almost the first image to attract the eyes of visitors. Sculptor Barbara Hepworth created the work in memory of Secretary-General Dag Hammarskjold, explaining that it embodied her feelings "about his life, his nobility, his intense unity as a person." Hammarskjold was an admirer of Hepworth's work, and before his death in a plane crash in 1961 he had discussed with her the possibility of erecting one of her sculptures on the United Nations grounds. He died before the project got underway, but the United Nations, aware of his intentions, invited Hepworth to create this memorial.

A central figure in the English abstract movement, Hepworth explored the expressive possibilities of biomorphic form. In 1934 she created her first "single form," a recurring motif in her work. Many of her sculptures, like this one, have a characteristic eye, a tunnel that opens up the sculpture's interior, introducing a new spatial relationship between solid and void. Hepworth's experiments in this area have become a standard component of the language of abstract sculpture.

Surfaces also play an important role in Hepworth's sculpture. *Single Form,* for example, is cast from six pieces of bronze, evident in the lines on one side, but its textured surface looks more like stone, suggesting a primitive monolith. Situated in a circular pool surfaced with waves of colored stone, the looming bronze stands out against the Secretariat Building behind.

**Dedicated:** *June 11, 1964.* **Collection of:** *United Nations; gift of the Jacob Blaustein Foundation.*

# (F)
# MIDTOWN WEST
## *34th to 59th Streets, west of Fifth Avenue*

---

This part of Manhattan vibrates with excitement. The theater district, transportation centers, pedestrian oases, Equitable Center and Rockefeller Center (see special section), the commanding New York Public Library and its backyard, Bryant Park, are all part of it. In its many forms and styles, public sculpture here echoes the rhythms and nuances of this rich urban backdrop.

Some unexpected delights are Stephen Antonakos' neon arcs on 42nd Street and the sculptures *Waiting* and *42nd Street Ballroom* inside the Port Authority Bus Terminal, open around the clock. The Equitable Center also provides several gathering places for passersby, enhanced with public sculptures by Scott Burton, and in the lobby, murals by Thomas Hart Benton.

In dramatic contrast to these innovative recent projects, classically inspired architectural sculptures augment the grandeur of the New York Public Library, and Bryant Park is the site for other traditional monuments. This formal park located between Fifth Avenue and Avenue of the Americas (Sixth Avenue and 40th and 42nd Streets) was known as Reservoir Square when the massive Croton Distributing Reservoir, built in 1845, stood at its Fifth Avenue end. Earlier it had been a paupers' cemetery, then in 1853 the site of the first American World's Fair in the Crystal Palace that burned in 1858, and then a campground for Union soldiers during the Civil War. In 1871 it was laid out as a proper Victorian city square and was renamed in 1884 in honor of the American poet William Cullen Bryant. Abused because of peripheral subway construction during the 20th century, Bryant Park was redesigned in the 1930s and began undergoing renovations again in 1987.

As for sculpture in Bryant Park, over the years it has come and gone. The first sculptures to be erected here were the statue of Dr. Marion Sims and the bust of Washington Irving, placed in storage during the 1920s because of construction and eventually relocated. Next came the *William Cullen Bryant Memorial,* planned as an integral element of the library's western terrace, then the *Lowell Memorial Fountain,* the bust of Goethe, and the statue of William Earl Dodge, moved here in 1941 from Herald Square. Most recently, the Andrada monument was added and integrated with the entrance and wall at the park's northwest corner. The park is used also for temporary exhibitions of sculpture sponsored by the Public Art Fund.

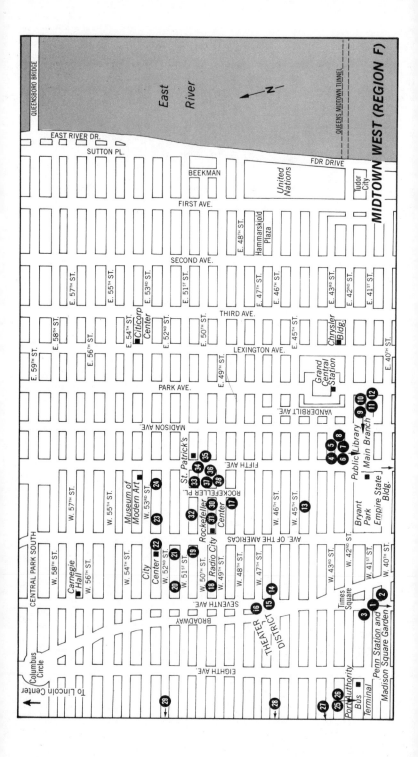

## F-1 The James Gordon Bennett Memorial *or* Bell Ringers Monument, 1939–40

**Sculptor:** *Antonin Jean Paul Carles (1851–1919).* **Architect:** *Aymar Embury II.* **Media and size:** *Bronze group, over life-size; granite niche.* **Location:** *Herald Square, intersection of Avenue of the Americas (Sixth Avenue) and Broadway between 34th and 35th Streets.*

In 1894 newspaper magnate James Gordon Bennett, Jr., moved the *New York Herald,* established by his father on Park Row, uptown to a lavish new building designed by Stanford White and modeled on the early Renaissance town hall in Verona (see photo for F-7). Although the building was demolished in 1921, the newspaper's memory lingers on in the name of Herald Square and the memorial in the small triangular park just south of where its building stood. Large bronze figures of the goddess Minerva and two brawny bell ringers, together with a clock and assorted owls, were saved from the roofline of the old building.

The younger Bennett lived much of the time in Paris, and it was there in 1894 that he commissioned the bronze figures which were created by Carles, an École des Beaux-Arts–trained sculptor, who had them cast in a French foundry and shipped to New York.

Minerva, goddess of wisdom and invention, stands above the bell ringers and holds out her right hand as if in command, while her left grasps a spear and shield. Her bird, the wise old owl, whose green eyes used to blink when he was atop the Herald Building, perches on the bell. Somewhat below Minerva in front of the granite niche are the bell ringers, affectionately referred to as "Stuff and Guff." Rotating at the waist, each appears to hit the bell with his heavy hammer, but unknown to most observers, their hammers stop three inches from the bell while a mallet hidden inside a box behind the bell strikes the hour.

**Installed:** *Herald Building, March 1, 1895.* **Monument dedicated:** *November 19, 1940.* **Foundry mark:** *SIOI–Decauille, Fondeur Paris.* **Collection of:** *New York University (on permanent loan); gift of the Sixth Avenue Association.*

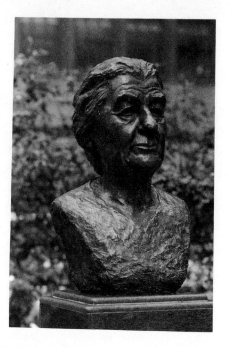

## F-2 Golda Meir, 1980

**Sculptor:** *Beatrice Goldfine (1923– )*. **Media and size:** *Bronze over life-size portrait bust; pink granite pedestal.* **Location:** *Golda Meir Square, near the entrance to 1411 Broadway, at 39th Street.*

Shown in this portrait sculpture with her head tilted slightly upward and her eyebrows raised, an older Golda Meir appears proud and determined. Sculptor Beatrice Goldfine, who knew Meir personally, explained how she wanted "to capture Mrs. Meir's inner personality, strength, warmth, and concern for all people."

Described as "one of the great women in Jewish and world history," Golda Meir helped found the State of Israel and was the country's fourth prime minister. She immigrated to Palestine as a young woman and began to work for the labor movement, eventually rising to influential positions in the government of Israel's first premier, David Ben-Gurion.

**Dedicated:** *October 3, 1984.* **Signed:** *B. Goldfine / 1980.* **Commissioned by:** *The Jewish Community Relations Council of New York.*

# F-3 The Garment Worker, 1984

**Sculptor:** *Judith Weller (1937– ).* **Media and size:** *Bronze statue, over life-size; granite pedestal.* **Location:** *Plaza in front of 555 Seventh Avenue, between 39th and 40th Streets.*

Sculptor Judith Weller hoped to make the invisible worker visible by creating this heroic-size figure. Inspired by her father, for many years a member of the International Ladies Garment Workers Union, the sculpture recalls the contributions of earlier generations of Jewish men who, with Italian immigrants at the turn of the century, sometimes earned less than one dollar for a 14-hour day. The statue of a machine operator wearing a skullcap symbolizes this first wave of immigrants, the industry's initial labor force. Today the majority of garment workers are Asian women.

Asked why she works in a figurative style, Weller explains that she is motivated by the conviction that "today the artist's responsibility is to show the human figure, the human being, and to treat it with reverence." A composite figure, *The Garment Worker,* she says, is "more than one person" and is "larger than the model." It was one of the few statues commemorating an industrial worker to be erected in New York City. Contributions for the fabrication of the sculpture came from members of the International Ladies Garment Workers Union as well as from designers and manufacturers.

Weller exhibited a 24-inch-high model of *The Garment Worker* in a National Sculpture Society exhibition at the Lever House in 1978 where members of the International Ladies Garment Workers Union saw the work. A photograph of it was published in the union periodical *Justice,* and the enormous warm response prompted Weller to seek funding to create a large statue for the garment district.

**Dedicated:** *October 10, 1984.* **Collection of:** *City of New York; gift of Judith Weller and 30 companies in the garment district.*

## F-4 Josephine Shaw Lowell Memorial Fountain, 1912

**Architect:** *Charles Adams Platt (1861–1933).* **Media and size:** *Granite lower basin, 32 feet in diameter; granite upper basin, 13 feet in diameter.* **Location:** *Bryant Park, at the west end near Avenue of the Americas.*

Josephine Shaw Lowell (1843–1905) devoted her life to public service. A pioneer social worker and active reformer, she was the first woman member of the State Board of Charities and was the founder of the Charity Organization Society. She is also the first woman to be honored by a conspicuous monument in New York City.

Under the chairmanship of former Mayor Seth Low, the Josephine Shaw Lowell Memorial Committee commissioned Charles A. Platt to design a memorial fountain. Although the committee intended to erect it in Corlear's Hook Park on the Lower East Side where Josephine Lowell worked most of her life, it was placed on the east side of Bryant Park. Later it was moved to its present site, where it terminates the central vista and dominates the western end of the park.

Platt, an architect, landscape architect, painter, and etcher, greatly admired Italian gardens and published a well-known book on the subject. His overall design for the pink granite *Josephine Shaw Lowell Memorial Fountain,* which includes a shallow contoured basin resting on a classically ornamented central pedestal, set in a large pool, reflects the influence of Italian Renaissance fountains. The work's graceful lines and the quiet play of water make it a handsome public amenity and a dignified memorial.

**Dedicated:** *May 21, 1912.* **Collection of:** *City of New York; gift of the Josephine Shaw Lowell Memorial Committee.*

# F-5 William Cullen Bryant Memorial, 1911

**Sculptor:** *Herbert Adams (1858–1945).* **Architect:** *Thomas Hastings.*
**Media and size:** *Bronze statue, over life-size; marble canopy and pedestal.*
**Location:** *Behind the New York Public Library, Bryant Park.*

One of the most elaborate sculptural settings in the city houses the large
seated bronze figure of William Cullen Bryant (1794–1878), for 50 years a
major political and cultural force in New York. It stands on the raised terrace
at the back of the New York Public Library.

As longtime editor of the *New York Evening Post* Bryant crusaded for
abolition of slavery, workers' rights, free trade, and free speech. He helped
bring a then little-known presidential candidate, Abraham Lincoln, to the
attention of New Yorkers. His was a strong voice demanding that Central
Park be established, and he supported such cultural institutions as the
Metropolitan Museum of Art, serving for years as president of the New York
Gallery of Fine Arts. As editor, writer, and poet, as well as crusader, he was
well known throughout the United States.

Bryant had many friends in the city and more than one enemy. When a
monument was proposed on the occasion of his 70th birthday, and actually
created by sculptor Launt Thompson (1833–1894) in the form of a bust
intended for Central Park, the opposition of machine politicians prevented its
erection. It can be found in the collection of the Metropolitan Museum,
where it was politely accepted on temporary loan in 1874. However, in 1884,
some years after Bryant's death, his friends achieved recognition for him
when Reservoir Square at 42nd Street and Avenue of the Americas was
renamed Bryant Park.

Then in 1907, when the New York Public Library was under construction,
the issue of a memorial to Bryant was again brought up. Thomas Hastings,

co-architect with John Carrère for the library, envisioned a formal approach through Bryant Park to the west side of the vast Beaux Arts structure. It would terminate with a major centerpiece in the center of the otherwise austere rear wall of the library with its vertical strip windows illuminating bookstacks inside. The park was already named for Bryant, and this location beside a library was perfect for a man of letters.

Hastings invited the prominent New York sculptor Herbert Adams to execute a portrait statue. Then the architect designed a marble Renaissance canopy within which it would sit, between paired Roman Doric columns with large classical urns at either side, the whole finished off with a marble balustrade.

Adams created a heroic-size figure working from photographs and other likenesses. For its modeling and casting he was paid $14,000. He showed Bryant seated in dignified repose leaning slightly forward, his lower body draped by a rug. The bearded visage with wrinkled brow contemplates a manuscript on his lap, while his right hand grasps the curved arm of a Renaissance style chair. Adams here achieves a sculptural simplicity akin to that of Saint-Gaudens' seated *Peter Cooper* (see C-12).

In 1987 the Art Commission approved a plan to build two restaurant pavilions on either side of the Bryant Memorial. Although the initial plan presented to the Art Commission contemplated the removal of the marble balustrades flanking the memorial, the Art Commission successfully urged that the balustrades remain part of the new scheme. Plans for the monument's restoration are underway, and its integrity will be preserved.

**Signed and dated:** *Herbert Adams Sculptor – MCMI.* **Foundry mark:** *Gorham Company Founders.* **Collection of:** *City of New York; gift of the William Cullen Bryant Memorial Committee of the Century Association (of which Bryant was a founder).*

# F-6 Johann Volfgang von Goethe, ca. 1832

**Sculptor:** *Karl Fischer (1802–1865).* **Pedestal by:** *Victor Frisch.* **Media and size:** *Bronze bust, over life-size; high granite pedestal.* **Location:** *Bryant Park, near 41st Street.*

Goethe (1749–1832), one of Germany's greatest writers, became a national hero. His crowning literary achievement was the drama *Faust,* over which the poet labored for 60 years. A towering intellect, Goethe had a broad range of interests, and he also made major scientific and philosophical contributions.

In 1876 founding members of the Goethe Club in New York secured a large cast of a bust of Goethe executed by the well-known German sculptor Karl Fischer. It was placed in the Metropolitan Museum. By 1932 the club, now called the Goethe Society, wanted to mark the centennial of Goethe's death by placing the sculpture on more public display. The plan was to set it out in Bryant Park, at that time about to be restored and relandscaped. After erecting the bust the society learned that it was an iron casting plated with copper, so at the request of the Parks Department it had the 19th-century portrait bust replaced by a replica in bronze cast in 1934. Goethe's bust, in which Fischer very realistically portrays him as an older man with sagging jowls and deep folds beneath his eyes, also has neoclassical elements, such as the bald eye, carved without a pupil, and the severe herm-shaped torso. It stands in the shadow of the Public Library at the south end of the raised terrace, in a sense balancing J. Q. A. Ward's bronze statue of William Earl Dodge (see F-7).

**Dedicated:** *February 15, 1932.* **Signed:** *K. Fischer.* **Collection of:** *City of New York; gift of the Goethe Society of America.*

## F-7 William Earl Dodge, 1885

**Sculptor:** *John Quincy Adams Ward (1830–1910).* **Media and size:** *Bronze statue, over life-size; granite pedestal.* **Location:** *Bryant Park, northeast corner.*

William Earl Dodge (1805–1883) was known as the "Christian Merchant," a man successful in business but ever mindful of his moral responsibilities. He began as a dry-goods merchandiser, later forming with his father-in-law the firm of Phelps, Dodge & Company, a leader in the copper and metals trade. An active civic leader and critic of slavery, Dodge was one of the organizers of the Young Men's Christian Association in America, and from 1865 to 1883 the president of the National Temperance Society.

Not long after Dodge died at the age of 78, his close friends formed a committee to erect a commemorative statue. The movement to erect a memorial to Dodge was symptomatic of a growing desire to honor admired citizens in public statuary, a departure from the artistic geniuses, generals, and statesmen typically commemorated.

Ward's bronze statue of Dodge records his fine physical appearance and cordial manner, attributes noted by his contemporaries. He is shown leaning on a podium, pausing while making a speech. The original stone pedestal by Richard Morris Hunt, pictured here, included a drinking fountain, a reference to Dodge's devotion to temperance. In 1941 the city moved the statue from its original location in Herald Square to the northeast corner of Bryant Park to make room for the *James Gordon Bennett Memorial* (see F-1). As for Hunt's pedestal, its whereabouts are unknown.

**Dedicated:** *October 22, 1885.* **Signed:** *J.Q.A. Ward / sculptor / 1885.* **Foundry mark:** *The Henry-Bonnard Bronze Company / New York, 1885.* **Collection of:** *City of New York; gift by public subscription under the auspices of the Chamber of Commerce of the State of New York.*

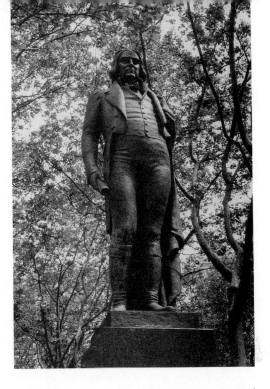

# F-8 José Bonidacio de Andrada e Silva, 1954

**Sculptor:** *José Otavia Correia Lima (1934– ).* **Media and size:** *Bronze statue, over life-size; granite pedestal.* **Location:** *Bryant Park, at the southwest corner of 42nd Street and Avenue of the Americas.*

In recognition of Brazilian-American friendship, the City of New York accepted this statue of José Bonidacio de Andrada e Silva (1763–1838) as a gift from the Brazilian government. Andrada, a geologist, statesman, and scholar, is the figurative patriarch of Brazilian independence, proclaimed in 1822 during the regime of Dom Pedro I. A leading contributor to the Constitution of 1824, Andrada helped formulate Brazilian democratic principles.

The consul-general of Brazil conceived the idea for this memorial. After consultation with the New York City Parks Department, which established guidelines for the monument, the Brazilian government sponsored an open competition in Brazil. The winning design is a straightforward portrait statue, characterized by flattened surface detail and a frontal orientation. Andrada, shown as a sophisticated man of letters, holds a scroll in his right hand and steadies a cape draped over his shoulder with his left. The broad, horizontal pedestal of the monument forms part of a wall to Bryant Park. The statue appropriately faces the Avenue of the Americas, so named in 1945 to express hemispheric solidarity, and in this respect the Andrada monument is related to the South American figures Bolívar and San Martín, and that of the Cuban Martí, also erected in the 1950s at the north end of the avenue at Central Park (see G-42, G-43, and G-44).

**Dedicated:** *April 22, 1955.* **Signed and dated:** *Lima / sculptor / Rio de Janeiro / 1954.* **Collection of:** *City of New York; gift of the Government of Brazil.*

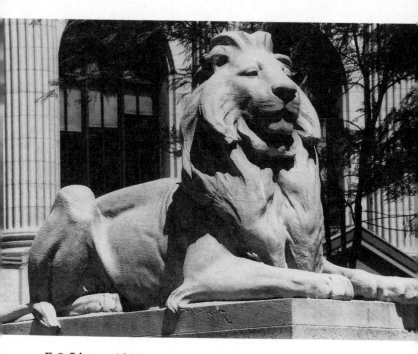

## F-9 Lions, 1911

**Sculptor:** *Edward Clark Potter (1857–1923).* **Media and size:** *Pink Tennessee marble, life-size.* **Location:** *New York Public Library, Fifth Avenue at 41st Street.*

This handsome marble palace, a dignified Beaux Arts design inspired by French Renaissance architecture, is one of New York's most splendid public structures. In keeping with the overall scheme, architects Carrère and Hastings devised a restrained sculptural program that was finally complete in 1920, nine years after the library was finished. They limited works to four locations: the attic, end pediments, fountain niches on either side of the portico, and the foot of the regal stairway. The sculptures enhance the approach to the library and enrich the architecture.

World renowned, and perhaps more familiar to New Yorkers than any other sculpture in the city except the *Statue of Liberty,* the two marble lions on either side of the front steps of the New York Public Library are great favorites. At Christmastime they wear around their necks large green wreaths with red bows.

It's hard to believe today, but the lions drew derisive comments when first unveiled. Sculptor Potter intended them to be icons of nobility, but the press complained that the lions lacked regal splendor, and over time their mild demeanor won them such nicknames as "Patience and Fortitude."

Potter made a similar pair of lions for the east entrance of the Morgan Library on 36th Street and Madison Avenue. He specialized in animal subjects, particularly horses, and collaborated with Daniel Chester French on several equestrian monuments, among them the equestrian statues of General Grant in Philadelphia's Fairmont Park and General Hooker in Boston.

**Collection of:** *City of New York; purchase.*

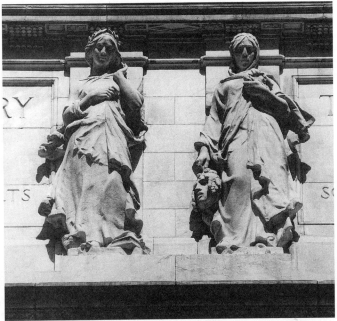

*F-10 Poetry and Drama*

# F-10 Sculpture on Attic Story of the New York Public Library, 1914

**Sculptor:** *Paul Wayland Bartlett (1865–1925).* **Media and size:** *Georgia marble, 10½ feet high.* **Location:** *New York Public Library, Fifth Avenue at 41st Street.*

These figures (from left to right: *History, Romance, Religion, Poetry, Drama,* and *Philosophy*) are among the most noteworthy examples of Beaux Arts architectural sculpture in this country. Forced to work within a narrow space, Paul Bartlett still created convincing three-dimensional forms, characterized by broad planes and fluid lights and darks. In addition, he endowed these dynamic figures with psychological depth and individuality, unusual qualities in architectural figures.

The group symbolizes various fields of knowledge, an allusion to the building's function. *History* and *Philosophy,* bearded male figures draped in the style of classical statues of ancient sages, are at either end of the series, flanking two pairs of female figures. *Romance,* holding a bouquet of flowers, and *Religion,* with hands clasped in obedience, are on the left. On the right are *Poetry,* a gentle, self-absorbed figure holding a book, and *Drama,* a figure holding two masks. Placed above the columns of the library's regal entrance, the works accentuate the building's architectural lines.

Renovations, both interior and exterior, carried out during the 1980s have returned the library to its original splendor. Unfortunately, pollution had already permanently damaged some of the exterior marble sculpture, particularly these fragile attic figures.

**Collection of:** *City of New York; purchase.*

# F-11 **Truth** *and* **Beauty, 1914–1920**

**Sculptor:** *Frederick MacMonnies (1863–1937).* **Media and size:** *Marble statues, over life-size.* **Location:** *New York Public Library, Fifth Avenue between 42nd and 43rd Streets.*

In richly embellished fountain niches, the two white marble allegorical figures, *Truth* and *Beauty,* frame the entrance to the New York Public Library. Stereotypical conceptions, *Truth* is a partially draped male figure seated on a sphinx, symbol of mystery, and *Beauty* is a nude female figure seated on a Pegasus. In Greek mythology, Pegasus was the winged horse whose hoof touched the earth and created the sacred wellspring, Hippocrene, source of poetic inspiration. MacMonnies' juxtaposition of Pegasus with the allegorical figure of Beauty suggests that beauty is a source of inspiration.

**Truth signed and dated:** *MacMonnies 1920.* **Collection of:** *City of New York; purchase.*

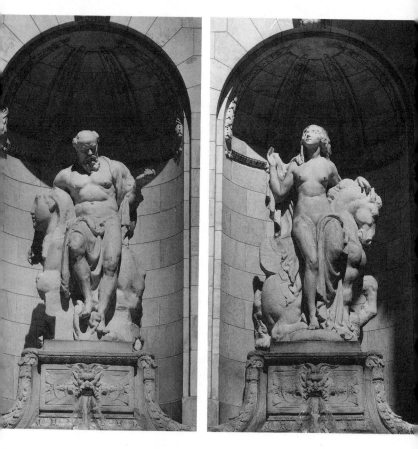

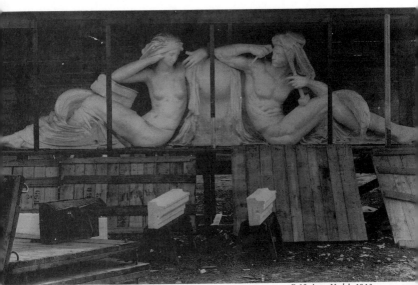

*F-12 Arts, Model, 1913*

## F-12 **Arts** *and* **History, ca. 1913**

**Sculptor:** *George Gray Barnard (1863–1938).* **Media and size:** *Marble statues, over life-size.* **Location:** *New York Public Library, north and south pediments, facing Fifth Avenue between 41st and 42nd Streets.*

Barnard, known for his Michelangelesque figures, designed the groups for the two pediments at the ends of the façade of the New York Public Library. The group in the south pediment is entitled *Arts* and is composed of two semi-reclining figures flanking a globe. The female figure, symbolic of literature, balances a book in her lap while her male counterpart, symbolic of sculpture, welds a hammer and chisel. *History,* in the north pediment, is composed of a sleeping male figure dressed in armor with a dove at his feet, and a partially draped female figure that turns to write "Life" on the central tablet. The allegory suggests that those who fought for peace, here symbolized by the dove, are dead but their deeds live on; past events underlie life's present course.

When the reliefs were installed, a controversy ensued between the sculptor and Donnelly and Ricci, the firm that carved the figures. Barnard claimed that the sculptures were not properly tilted forward and that Donnelly and Ricci had not adhered to his models. Despite Barnard's dissatisfaction, the pedimental sculptures were not replaced.

**Collection of:** *City of New York; purchase.*

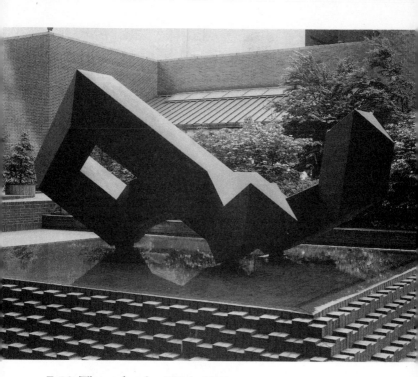

## F-13 Throwback, 1976–1979

**Sculptor:** *Tony Smith (1912–1980).* **Media and size:** *Aluminum, painted black, 6 feet high by 10 feet wide.* **Location:** *Courtyard of International Paper Building, 77 West 45th Street.*

Called *Throwback* by sculptor Tony Smith because "it recalls an earlier period," this aluminum construction sprawls, dips, and rises. Composed of tetrahedrons (a triangular pyramid) and octahedrons (eight-faced figures), it is multifaceted, providing new configurations when seen from different angles. At times they eye merges sections and the work seems to have window-like openings. Because it rests on only three points, the piece has a light, airy quality. Unlike Smith's other powerful sculpture in Manhattan, *Tau* (see H-2), *Throwback* has a flirtatious grace.

Varying light can transform this and almost all of Smith's works, making planes dissolve and forms disappear. The effect is magical, but it is one Smith did not seek. He asserted, "I'm not aware of how light and shadow falls on my pieces. I'm just aware of basic form."

*Note:* This plaza does not have 24-hour access and is open from 7 **A.M.** to 7 **P.M.** from September 16 to May 14, and until 8:30 **P.M.** the rest of the year.

**Collection of:** *International Paper Company.*

# F-14 I. Miller Building Sculptures, ca. 1927–1929

**Sculptor:** *Alexander Stirling Calder (1870–1945).* **Media and size:** *Four marble statues, life-size.* **Location:** *1552 Broadway, at 46th Street.*

In 1927 I. Miller, a shoe store long patronized by theatrical people, took a vote to identify the most popular actresses in various realms of the theater with the aim of erecting a statue of each on the new I. Miller store. The public chose Ethel Barrymore to represent drama, Marilyn Miller to represent musical comedy, Mary Pickford to represent film, and Rosa Ponselle to represent opera.

Sculptor Alexander Stirling Calder depicts these four great ladies of the American stage in their famous roles. Set along the building's cornice line, from left to right they are Ethel Barrymore as Ophelia, Marilyn Miller as Sunny, Mary Pickford as Little Lord Fauntleroy, and Rosa Ponselle as Norma.

**Dedicated:** *October 20, 1929.*

*F-14 Rosa Ponselle as Norma*

## F-15 Father Francis P. Duffy, ca. 1936

**Sculptor:** *Charles Keck (1875–1951).* **Media and size:** *Bronze statue, over life-size; granite pedestal, cross, steps, and paving.* **Location:** *Broadway and Seventh Avenue between 46th and 47th Streets.*

At first glance it seems odd to find a statue of Fr. Francis Duffy in Times Square with its neon lights and flashing signs; but then it seems most appropriate when it becomes clear that this area was part of the predominantly Irish neighborhood known as "Hell's Kitchen" where he was for years pastor of Holy Trinity Roman Catholic Church, close by on 42nd Street west of Broadway.

From here he departed with many of his parishioners for Europe to participate in World War I. As chaplain of the "Fighting Irish" 165th Regiment, Father Duffy displayed heroism on the front lines and was severely wounded. After the war, he received the Distinguished Service Cross. Duffy was widely regarded as "the apostle of toleration," and at the statue's dedication in May 1937, representatives of the Catholic, Protestant, and Jewish clergy spoke.

In his interpretation of the soldier-priest, Keck couples references to war with allusions to his subject's calling. Dressed in a World War I uniform, Father Duffy assumes a forthright stance clutching a Bible in his hands. Nearby is a doughboy's helmet and behind the statue looms a Celtic cross, lending the monument funereal, religious, and ethnic significance.

**Unveiled:** *May 2, 1937.* **Collection of:** *City of New York; gift of Father Duffy Memorial Committee (statue) and W.P.A. (setting).*

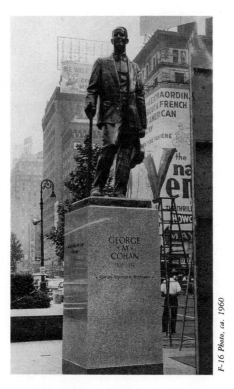

# F-16 George M. Cohan, 1958

**Sculptor:** *Georg John Lober (1892–1961).* **Pedestal by:** *Otto F. Langmann.* **Media and size:** *Bronze statue, over life-size; granite pedestal.* **Location:** *Duffy Square, Broadway and Seventh Avenue at 47th Street.*

The life of George M. Cohan (1878–1942), playwright, actor, producer, director, and songwriter, is intertwined with the history of the American musical theater. His 1904 production of *Little Johnny Jones* established the American musical as a distinct theatrical form and also introduced such lasting favorites as "Yankee Doodle Boy" and "Give My Regards to Broadway." Cohan went on to write some of the nation's most popular songs, including "You're a Grand Old Flag" and the patriotic World War I song "Over There." For it, one war later, in 1941, he was awarded a congressional medal.

Irving Berlin organized the campaign for a memorial to Cohan, then Oscar Hammerstein 2nd took the lead as the second chairman of the George M. Cohan Memorial Committee. Hammerstein clashed with the Actor's Equity Union, which opposed the project because in 1919, during the infancy of Actor's Equity, Cohan had sided with the producers and had helped to organize a company union. Actor's Equity never forgave him.

The memorial portrays the song-and-dance man with hat and cane. *Cohan* stands toward the northern part of the theater district facing south on Broadway, an allusion to the songwriter's devotion to the "Great White Way."

**Signed:** *Georg Lober Sculptor / Otto F. Langmann Architect.* **Collection of:** *City of New York; gift of the George M. Cohan Memorial Fund.*

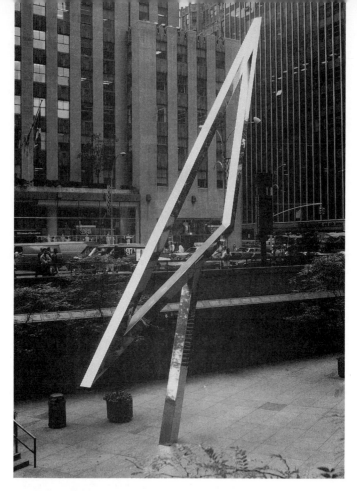

# F-17 Sun Triangle, 1973

**Designed by:** *Athelstan Spilhaus (1911– ).* **Executed by:** *Harrison, Abramovitz and Harris.* **Media and size:** *Stainless steel, 50 feet high.* **Location:** *In the sunken plaza in front of the McGraw-Hill Building, between 48th and 49th Streets on Avenue of the Americas.*

This ingenious sculpture, clearly visible also from the sidewalk, was designed by meteorologist and oceanographer Athelstan Spilhaus. It illustrates the relationship between the sun and the earth at the solstices. Each side of the large metal triangle points to the four seasonal positions of the sun at solar noon in New York. The shortest bottom side points to the sun's lowest position on the winter solstice at noon about December 21; the longest side points to the sun on the spring and fall equinoxes at noon about March 21 and September 23, and the steepest side points to the sun's highest position on the summer solstice at noon about June 21.

In keeping with the scientific theme of the stainless-steel sculpture, maps imbedded in the pavement of the plaza illustrate the earth's land and water masses. The plaza also has a reflecting pool, symbolizing the sun, with nine stainless-steel spheres, representing the nine planets.

**Collection of:** *McGraw-Hill.*

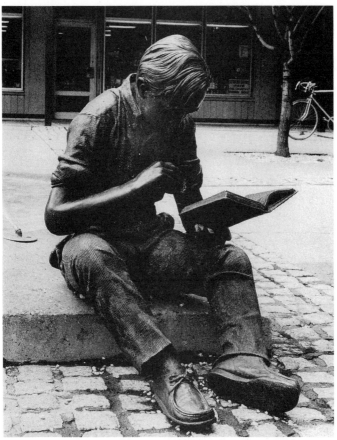

## F-18 Out to Lunch, ca. 1980

**Sculptor:** *J. Seward Johnson, Jr. (1930–  ).* **Media and size:** *Bronze statue, life-size.* **Location:** *Behind the Exxon Building, west of Avenue of the Americas and between 49th and 50th Streets.*

J. Seward Johnson, Jr., sees his works as humanizing elements among "monolithic towers and cold glass." Johnson explains: "One of my fellas sitting on a bench says, 'Come on in, celebrate the recess, the lunch break; take a moment and use this spot.' " *Out to Lunch,* positioned opposite a wall of cascading water in a sitting area, suits its location.

*Out to Lunch* is one work in an edition of seven, a typical number for Johnson's editions of cast bronzes. The sculptor adapts each bronze in a series to specific situations by changing details. In other editions of this sculpture, depicting a boy propped on a staircase, eating a hamburger and reading a book about fishing, Johnson has substituted different books. For example, in the version commissioned by Tyndale House of Wheaton, Illinois, a publisher of religious books, the boy reads the Bible, whereas the same figure near a Kansas City McDonald's reads *There's No Such Thing as a Free Lunch.*

**Cast at:** *The Johnson Atelier, New Jersey.* **Collection of:** *The artist, on indefinite loan.*

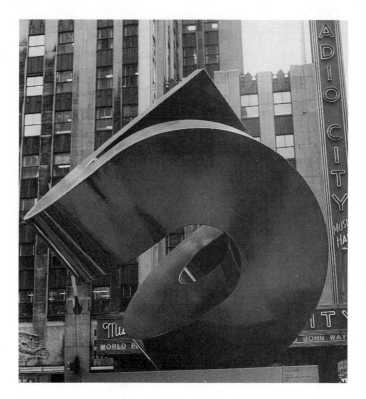

## F-19 Cubed Curve, 1972

**Sculptor:** *William Crovello (1929– ).* **Media and size:** *Steel painted blue, 12 feet high by 8 feet wide.* **Location:** *Americas Plaza, in front of the Time & Life Building, 1271 Avenue of the Americas at 50th Street.*

Large enough to hold its own with the Time & Life skyscraper behind it, this blue-painted metal sculpture stands like a giant insignia on a raised terrace. Its elegant sweeping curves were inspired by classical Japanese calligraphy, an art form that this American-trained sculptor studied in Japan from 1957 to 1961, following a stint in the United States Air Force.

Crovello's *Cubed Curve* was the first of six large-scale contemporary sculptures sponsored by the Association for a Better New York to "bring the peace of the museum to the commercial New York street scene." The association, a group of 100 businessmen, formed in 1971, planned to purchase the six works and rotate them on loan around the city. When Rockefeller Center purchased *Cubed Curve* for its extensive art collection, the hollow steel construction was given a permanent home. Another of the association's purchases, *Skaggerak* (see D-11), is now on a permanent site in Madison Square.

**Installed:** *January 20, 1972.* **Collection of:** *Rockefeller Center; purchased from the Association for a Better New York.*

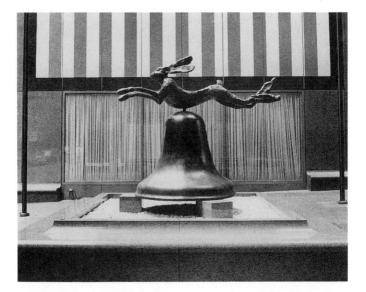

# F-20 Hare on Bell (1983) *and* Young Elephant (1984)

**Sculptor:** *Barry Flanagan (1941– ).* **Media and size:** *Bronze sculptures, 7 feet high and 8 feet high respectively.* **Location:** *Equitable Center Galleria, between 51st and 52nd Streets and Avenue of the Americas and Seventh Avenue.*

Like Aesop and other story tellers, the British sculptor Barry Flanagan uses the hare as a symbol of man: in motion, vulnerable, curious, and subjected to forces beyond his control. In this open-ended central galleria space are two humorous bronze fountain sculptures. Roughly formed and bearing an enigmatic message, they contrast with the grand space of the granite-faced atrium and the high-art elegance of Sol LeWitt's reductivist murals.

At the northerly end of the galleria a hare dances wildly on top of an elephant balanced precariously on a bell, and at the other end a larger hare leaps over a bell. The cast-bronze animals retain the spontaneity of the modeled and rolled clay, evident in the lumpy forms of the leaping hare and in the coiled limbs of its dancing counterpart. Flanagan is known for his unorthodox approach to traditional materials.

Equitable Center, in the tradition of nearby Rockefeller Center, combines business, art, and pleasure. The headquarters for some of the nation's leading corporations, it also contains restaurants, stores, a branch of the Whitney Museum of Art, and the Paine Webber Gallery, as well as a permanent collection of sculptures and murals placed in the complex's interior and exterior spaces. The Equitable Life Assurance Society regards its art program as an integral feature of the Equitable complex and allocated $7 million for it. Hundreds of works of art were commissioned or acquired, including sculptures by Scott Burton (see F-21), Barry Flanagan, and Paul Manship, and murals by Roy Lichtenstein, Thomas Hart Benton, Sol LeWitt, and Sandro Chia.

**Signed and dated:** *Young Elephant f 84.* **Commissioned by:** *Equitable Life Assurance Society.*

## F-21 Urban Plaza South 1985–1986

**Sculptor:** *Scott Burton (1939– ).* **Media and size:** *Series of verde mergozzo granite tables and stools.* **Location:** *51st Street, next to the Paine Webber Building at 1285 Avenue of the Americas.*

"Sculpture or furniture?" we might ask after seeing Scott Burton's series of geometric tables and stools, clustered here in identical groups and arranged in a grid. Burton's monolithic stone benches, tables, and chairs, whose forms recall Minimalist sculpture, straddle the line between high and low art. Viewed in a gallery, Burton's pieces are "art," but in a public space where one is free to touch, lean, and sit, not to mention eat a sandwich, they become public amenities.

Burton conceived this as a permanent street café. He also designed a drinking fountain and litter receptacles, which blend with the sidewalk paving, and two triangular planters edged with benches stained silver and filled with Sargent weeping hemlock trees. Burton's first corporate commission, *Urban Plaza South,* opened in June 1986, occupies 4,000 square feet and helped the developer meet city requirements for zoning advantages.

Burton did a similar design for *Urban Plaza North,* recently completed, and a semicircular marble seating arrangement with a planter for Equitable's Seventh Avenue lobby.

**Commissioned by:** *Equitable Life Assurance Society.*

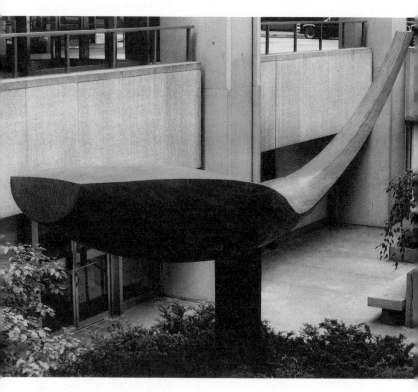

## F-22 Transition, 1965

**Sculptor:** *Raymond Granville Barger (1907– ).* **Media and size:** *Everdur bronze, 21 feet high.* **Location:** *In a sunken plaza in front of 1301 Avenue of the Americas at 52nd Street.*

*Transition* was one of the first modern sculptures to be erected on the Avenue of the Americas, installed at the time J.C. Penney opened its towering new headquarters early in 1965. To cut fabrication costs, artist Raymond Barger welded together copper strips instead of having the piece cast, patterning the design and construction of the sculpture on a boat. Some liken the sculpture, which seemingly floats in the sunken plaza, to a giant whale. Barger says that he chose the title *Transition* for his sculpture "because the under part has rounded forms like those of the people below and the upper part has straight lines like the architecture above it." Other public commissions by Barger, a graduate of the Yale School of Fine Arts, include a colossal "Goddess of Perfection" for the 1939 World's Fair.

**Installed:** *January 23, 1965.* **Commissioned by:** *The Uris Brothers.*

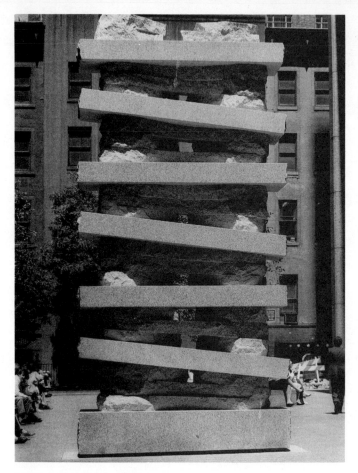

## F-23 Lapstrake, 1987

**Sculptor:** *Jesús Bautista Moroles (1950– ).* **Media and size:** *Granite, 22 feet high.* **Location:** *E. F. Hutton Plaza, next to 31 West 52nd Street.*

Inspired by Aztec and Egyptian architecture, Moroles endows his architectonic sculptures with a primitive presence. This vertical mass of alternating layers of rough-hewn and polished granite blocks suggests an ancient ruin. In its gray color and blocky form, *Lapstrake* complements the massive red granite piers forming the façade of the adjacent E. F. Hutton headquarters building.

The construction consists of polished granite slabs alternating with rough-hewn circular blocks stacked tier on tier with a jaunty tilting irregularity. The circular blocks manage to suggest two crude columns rising through the slabs, some horizontal, some angled, adding to the sculpture's internal rhythms. The walkway through this plaza between the Hutton building and the CBS Building to its west has planters with large trees and ample seating provision, always a favorite combination in commercial New York. *Lapstrake* adds much visual interest to an already interesting public space.

This sculpture is the first major outdoor work in New York by Moroles, well known in his home state of Texas. He prefers to work in granite, which he cuts into interlocking elements of contrasting textures and shapes.

**Installed:** *April 25, 1987.* **Commissioned by:** *E. F. Hutton Corporation.*

## F-24 Ceiling and Waterfall for 666 Fifth Avenue, 1955–1957

**Sculptor:** *Isamu Noguchi (1904– ).* **Architect:** *Carson and Lundin.*
**Media and size:** *Aluminum and stainless steel, 40 feet long.* **Location:**
*666 Fifth Avenue, in the passageway between 52nd and 53rd Streets, west of
Fifth Avenue.*

Incorporating sound and light, Noguchi's waterfall unites recurrent themes
in his work and enlivens the shadowy passageway between two busy
midtown streets. The planar water sculpture consists of a series of undulating
vertical louvers, placed at right angles to a stainless-steel wall. Seen from a
three-quarter view, the eye fills in the space between each louver, merging the
elements into molded contours or waves. The ridged, stainless-steel wall
evokes sand pounded by the ocean or the raked earth of Japanese gardens.
Light flickers along the ridges, transforming drops of falling water into
falling light, and the sound of the bubbling water dulls the noise of nearby
traffic. The white louvered ceiling of the lobby inside, also designed by
Noguchi, gently dips and rises. The sculptor likens it to a "landscape of
clouds." The contoured louvers of both these works recall Noguchi's
biomorphic, marble slab sculptures of the 1940s.

**Signed:** *Isamu Noguchi.*

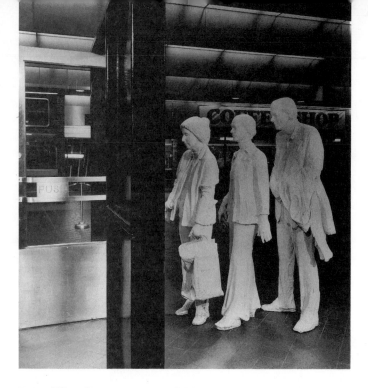

# F-25 The Commuters, 1980

Sculptor: *George Segal (1924– ).* **Media and size:** *Bronze group with white patina, life-size.* **Location:** *South wing waiting room of the Port Authority Bus Terminal. Main entrance is at 42nd Street and Eighth Avenue.*

Three white figures arranged in a slight diagonal and in ascending size order stand slumped, bored, resigned, as they wait at their departure gate. A frozen clock records the frozen moment. Wearing casual clothes, holding jackets, handbags and shopping bags, these life-size bronze people were made from plaster casts of Segal's wife and two of their friends. Using Johnson and Johnson's "extra-fast-setting plaster bandages," Segal swathes his models in sections and pieces the molds together. Left rough and unfinished, the bronze patinated a dead white, these ghost-like casts capture expressive gestures and attitudes.

Like *The Commuters,* most of Segal's sculptures re-create scenes from daily life, showing ordinary people in simulated, ordinary environments. He began doing them in the early 1960s when Pop Art was the craze, and his works inspired by popular culture have often been linked to that trend.

After a year-long competition, during which a Port Authority committee reviewed 250 proposals, it selected Segal's tableau. The New Jersey artist had a special interest in the bus terminal, since he has been a longtime commuter. In addition to *The Commuters,* Segal has created about 12 other sculptures on similar themes.

**Dedicated:** *April 1982.* **Collection of:** *The Port Authority of New York and New Jersey.*

## F-26 42nd Street Ballroom, 1983

**Sculptor:** *George Rhoads (1926– )*. **Media and size:** *Kinetic sculpture, 96 inches square*. **Location:** *Port Authority Bus Terminal, north wing. Main entrance is at 42nd Street and Eighth Avenue.*

Like a giant pinball machine, *42nd Street Ballroom* amuses bus commuters with bells, chimes, whistles, gongs, and cascading billiard balls. The viewer pushes a button to activate this self-contained, audio-kinetic sculpture that ejects balls into various pathways, enacting any number of random maneuvers. The mechanical action of the sculpture's parts is plainly visible. Rhoads explains, "Machines are interesting to everybody but people usually don't understand them, because, as in a gasoline engine, the fun part goes on inside the cylinder."

In his work Rhoads popularizes kinetic art, expanding on ideas first explored in the 1920s by Constructivist Naum Gabo and Bauhaus teacher Laszlo Moholy-Nagy, and more recently by Alexander Calder and Jean Tinguely. He began attracting attention in the late 1960s with sculptures commissioned for shopping malls. He now has pieces at the Boston Museum of Science and at Boston's Logan Airport, and in the main terminal of La Guardia Airport. As Richard Kostelanetz observed in a *New York Times* article, "what Rhoads has realized is popular public art, sculptures that are capable of keeping the attention of nearly everyone without sacrificing their esthetic integrity." As *42nd Street Ballroom* demonstrates, his engaging constructions are well suited to waiting rooms, where they offer a welcome diversion.

**Installed:** *November 29, 1983*. **Collection of:** *The Port Authority of New York and New Jersey.*

## F-27 Neon for 42nd Street, 1979–1981

**Sculptor:** *Stephen Antonakos (1926– ).* **Media and size:** *Blue and red neon tubes on blue wall, 43 feet high by 105 feet long.* **Location:** *440 West 42nd Street, between Ninth and Tenth Avenues.*

Four incomplete circles of red and blue neon tubes arc lyrically in gestural lines of vibrating color. Perfectly scaled to its site, *Neon for 42nd Street* gently expands the façade's surface without overwhelming it. The various curves of the four lines seem to move at different speeds, yet remain in harmony with each other. The red neon tubes face the street, the blue face the wall, causing a reflected blue light that forms a diffuse glow. Neon, typically associated with Las Vegas and nearby Times Square, is here a sculptural medium of intense light, color, and form. Antonakos likens neon to ". . . a kind of controlled paradise."

He began doing free-standing neon works in the 1960s, then undertook larger architectural commissions in the following decade. Recurrent motifs are incomplete geometric shapes, usually in blue, red, and green. Linear and reductive, Antonakos' works have a formal elegance bordering on calligraphy.

The neon sculpture was commissioned as part of the new Theater Row, a rehabilitation of buildings on the south side of the block between Ninth and Tenth Avenues. Antonakos chose this wall because of its visibility from nearby buildings and to motorists leaving the Lincoln Tunnel.

**Commissioned by:** *Theatre Row Phase I, II.*

# F-28 Senes, 1973

**Sculptor:** *William Crovello (1929– ).* **Media and size:** *Stainless-steel plate, 8 feet 8 inches high; granite pedestal.* **Location:** *Pier 86, at the foot of West 46th Street near the U.S.S.* Intrepid.

Composed of four interconnecting U-shaped elements which branch out in four different directions, *Senes* is effective from numerous angles. Its reflective surfaces and sleek lines share the industrial edge characteristic of much 20th-century sculpture. Originally erected in a vest-pocket plaza off 57th Street, the sculpture was relocated to its present site in 1979.

Sculptor William Crovello was born in New York City, but he made his reputation outside the United States, exhibiting works in Tokyo, London, and Madrid. He sculpts with stone and metal, creating spare, geometric forms based on a single module. His *Cubed Curve* can be seen in front of the Time & Life Building (see F-19).

**Signed and dated:** *Crovello '73.* **Collection of:** *City of New York; gift of Peter Sharp and Jerome L. Green.*

## F-29 Flanders Field Memorial, 1929

**Sculptor:** *Burt W. Johnson (1890–1927).* **Pedestal by:** *Harvey Wiley Corbett.* **Media and size:** *Bronze statue, over life-size; granite pedestal.* **Location:** *De Witt Clinton Park, at Eleventh Avenue and 53rd Street.*

Just before he was killed in action during World War I, John McCrae wrote the poem "Flanders Field," which concludes: "If ye break faith / with those who died / We shall not sleep / though poppies grow / On Flanders Field."

The verse, which is inscribed on the granite pedestal, inspired sculptor Burt Johnson to depict a doughboy standing with his gun strapped over his left shoulder, gazing at a handful of poppies. Apparently, Johnson died shortly after he completed the monument, for which he was never paid.

**Dedicated:** *1930.* **Collection of:** *City of New York; gift of the Clinton District Monument Association.*

## Rockefeller Center

**Architects:** *Reinhard & Hofmeister; Corbett, Harrison & MacMurray; Raymond Hood, Godley & Fouilhoux.* **Location:** *48th to 51st Streets between Fifth Avenue and Avenue of the Americas.*

The "city-within-a-city," Rockefeller Center attracts over 50 million people a year. The complex contains 21 office buildings, some 30 restaurants, and America's first man-made outdoor skating rink. With landscaped promenades, elegant shops, and its own private street, it is a model of urban planning.

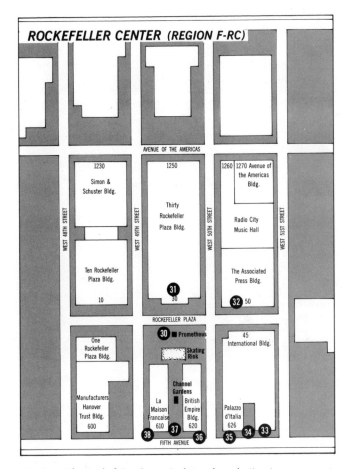

## ROCKEFELLER CENTER (REGION F-RC)

AVENUE OF THE AMERICAS

| 1230 Simon & Schuster Bldg. | 1250 Thirty Rockefeller Plaza Bldg. | 1260 | 1270 Avenue of the Americas Bldg. |

WEST 48TH STREET | WEST 49TH STREET | WEST 50TH STREET | WEST 51ST STREET

Radio City Music Hall

Ten Rockefeller Plaza Bldg.

10

The Associated Press Bldg.

**31** 30

**32** 50

ROCKEFELLER PLAZA

One Rockefeller Plaza Bldg.

**30** ■ Prometheus

Skating Rink

45 International Bldg.

Manufacturers Hanover Trust Bldg.

600

Channel Gardens ■

La Maison Française 610

British Empire Bldg. 620

Palazzo d'Italia 626

**38**

**37**

**36**

**35**

**34**

**33**

FIFTH AVENUE

Nothing like Rockefeller Center had ever been built when construction began soon after the 1929 stock market crash. It was carried forward to completion in that bleak time as an act of faith by the Rockefeller family.

Designed by a group of architects, among them Raymond Hood, Harvey Wiley Corbett, and Wallace K. Harrison, the center unites Beaux Arts planning with modern functionalism. It was organized as a symmetrical unit around a central dramatic vista, the Channel Gardens that lead west from Fifth Avenue to the handsome RCA tower. Buildings increase in height from Fifth to Sixth Avenue, enhancing the dramatic impact and providing tenants with ample light and air.

To complement its majestically massed buildings and embellish their interiors, Rockefeller Center planners commissioned about 100 works of art to carry out the overall theme "New Frontiers and the March of Civilization."

Aside from the two major free-standing sculptures, *Prometheus* (see F-30) and *Atlas* (see F-34), most of the center's exterior sculptural elements are reliefs on façades or above building entrances. Although they are figurative, many share the streamlined aesthetic of the Art Deco style and a number explore such new materials as glass blocks, stainless steel, and aluminum. The reliefs make specific reference to the buildings they adorn, lending each structure a pictorial identity. The remainder of this section, F-30 to F-38, is about Rockefeller Center artworks.

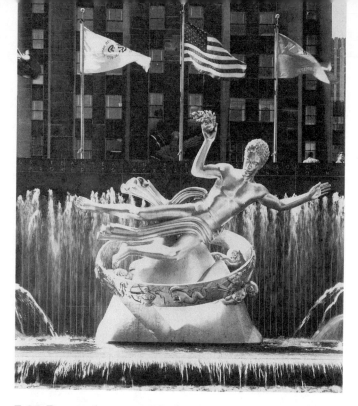

## F-30 Prometheus, 1934

**Sculptor:** *Paul Manship (1885–1966).* **Media and size:** *Gilded bronze statue, over life-size; granite pedestal.* **Location:** *Rockefeller Center, at the west end of the lower plaza.*

A golden silhouette glistening at the end of the vista formed by the Channel Gardens, *Prometheus* is Rockefeller Center's most prominent and best-known sculpture. Manship shows the Titan Prometheus, who according to Greek mythology was the founder of civilization and creator of the human race, bringing fire from heaven to earth. The ring with its signs of the zodiac represents heaven, while the mountain-like base represents earth. Prometheus holds aloft the flame as he flies. At either side smaller figures of a man and a woman represent humankind. Above the fountain's waters behind the sculpture is a quotation from the Greek playwright Aeschylus: "Prometheus, teacher in every art, brought the fire that hath proved to mortals a means to mighty ends." The sculpture typifies Manship's interest in classical subjects and also his schematic simplification of the human figure.

Positioned as it is at the end of the Channel Gardens and at the base of the precipitous RCA Building, it visually links these horizontal and vertical planes. But for most of us the sculpture with its sharp contours in shining gold, set in its splashing fountain surrounded by fluttering flags, quite simply electrifies the sunken plaza.

Over half a century ago when *Prometheus* was installed it drew more criticism than praise, even receiving the epithet "Leaping Louie." While it may lack the elegance and grace of Manship's best works, in the context of Rockefeller Center its scale is faultless, its presence gleaming.

**Dedicated:** *January 9, 1934.* **Collection of:** *Rockefeller Center.*

## F-31 Wisdom, *with* Light *and* Sound, 1933

**Sculptor:** *Lee Lawrie (1877–1963).* **Media and size:** *Limestone panels above, glass screen below, 15 feet high by 55 feet wide.* **Location:** *Entrance to RCA Building at 30 Rockefeller Plaza.*

Above the RCA Building's entrance is *Wisdom,* a vast panel, notable for its pioneer use of molded glass. The polychromed figure of Wisdom thrusts his arm downward. With a huge compass he traces on the glass screen below the cycles of Sound and Light, which disseminate wisdom. Over the entrances on either side stone figurative reliefs depict Sound and Light, underscoring the work's cosmic content and alluding to the television and radio studios in the RCA building.

The panel commands attention. At 15 feet high and 55 feet wide, it is a synthesis of stone, color, and glass positioned at the end of the central axis on the center's most celebrated building.

Wisdom's torso, carved in relief from limestone, is stylized into angular forms that project from a background of muted blue with maroon and gold accents. Beneath the stone panel light floods through the glass screen into the lobby while adding to the complexity of the design. The screen consists of 240 glass blocks, produced at the Corning Glass Works, each hand-poured and containing intended imperfections that give an appearance of light passing through liquid.

Lawrie, noted for his fine architectural sculpture, had previously worked for John D. Rockefeller on his Riverside Church. The center's preferred sculptor, he received two of the most important commissions (see F-34) and created a total of ten limestone panels for La Maison Française, British Empire Building, One Rockefeller Plaza, and the International Building.

**Collection of:** *Rockefeller Center.*

## F-32 **News, 1940**

**Sculptor:** *Isamu Noguchi (1904– ).* **Media and size:** *Stainless-steel plaque, 22 feet high by 17 feet wide.* **Location:** *The Associated Press Building, 50 Rockefeller Plaza, between 50th and 51st Streets.*

A masterwork too often missed by visitors, this powerful relief is one of the last figurative works by Noguchi, who is better known for his abstract pieces. Noguchi won this commission in the only open competition held by Rockefeller Center builders.

Showing newsmen at their trade, the bas-relief conforms to the overall theme at the center, "New Frontiers and the March of Civilization," and expresses the function of the Associated Press Building. Five men are clustered into a unified group equipped with a telephone, a teletype, a camera, a wirephoto, and a reporter's pad and pencil. Radiating lines behind them allude to Associated Press wire services and its global network. The foreshortened figures, sweeping curves and planes, and dramatic variation in the depth of the relief intensify the work's impact, making it one of the center's most impressive sculptures.

This piece of architectural art was executed in stainless steel, an experimental medium which Noguchi proposed instead of bronze. It has proved a happy choice because stainless steel holds up better than bronze in today's polluted air. It is one of the first and largest bas-reliefs ever cast in stainless steel and weighs ten tons.

**Installed:** *April 29, 1940.* **Signed and dated:** *ISAMU NOGUCHI / 1940.* **Collection of:** *Rockefeller Center.*

## F-33 Youth Leading Industry, ca. 1936

**Sculptor:** *Attilio Piccirilli (1866–1945).* **Media and size:** *Glass bas-relief, 16 feet high by 10 feet wide.* **Location:** *Over the main entrance of International Building North, 636 Fifth Avenue, between 50th and 51st Streets.*

Inspired by the classical heroic nude, Piccirilli shows a young male, symbolizing youthful leadership, guiding a charioteer, symbolizing industry and commerce. The strong contours of the profiled figures, dramatic gestures, and diagonal lines formed by the rearing horses convey a sense of motion and drama.

The glass block used to create this work was at the time a new material, first employed for commercial use in this country only three years earlier in a service station in Columbus, Ohio. Its first large-scale artistic use seems to have been in Rockefeller Center in 1933 when hand-poured sections were custom-made at the Corning Glass Works to form the glass overdoor screen at the entrance to the RCA Building at 30 Rockefeller Plaza (see F-31).

The glass blocks for the Piccirilli monochromatic glass mural were cast with a special type of Pyrex intended to simulate fluid, and the relief is especially effective at night when illuminated from behind. By 1986 the mural was very dirty and sagging imperceptibly, so it was disassembled, cleaned, and reerected with fresh bonding material. Restored, it looks as crisp as the day it was first placed along with a mate over the door of 626 Fifth Avenue. The center replaced that Piccirilli work with the bronze panels by Manzù.

**Installed:** *May 1936.* **Collection of:** *Rockefeller Center.*

# F-34 Atlas, 1937

**Sculptor:** *Lee Lawrie (1877–1963).* **Media and size:** *Bronze statue, 15 feet high; granite pedestal.* **Location:** *In front of the International Building, 630 Fifth Avenue, between 50th and 51st Streets.*

Of all the sculpture associated with modern architecture, this bold statue of Atlas is most happily related to the structure behind it. Other fine examples are the red Noguchi cube on lower Broadway (see A-20), the Dubuffet *Trees* beside Chase Manhattan Bank (see A-17), and the three-part stainless-steel group at the Family Court (see B-10), all downtown.

Reflecting the identity of the International Building, a huge armillary sphere represents the world on the muscular shoulders of Atlas. He was the mythical Titan condemned by Zeus to carry the world. Atlas is a powerful figure, 15 feet tall, stepping onto a 9-foot pedestal while balancing on his back a dynamic see-through sphere that is 21 feet in diameter. The sphere bears the 12 zodiac signs and has an axis pointing to the North Star. The whole ensemble is equivalent in height to a four-story building. The massive figure and sphere amply fill the cubic entrance court, a rare instance of sculpture and modern architecture scaled in perfect harmony.

Lawrie recalls that he was told to "make something that would effectively mark this entrance," but "at the same time, the sculpture should not obstruct the views of the windows in the entrance court, nor cause great shadows."

This bronze sculpture is impeccably maintained with washing and waxing three times a year.

**Erected:** *January 1937.* **Foundry:** *Roman Bronze Works.* **Collection of:** *Rockefeller Center.*

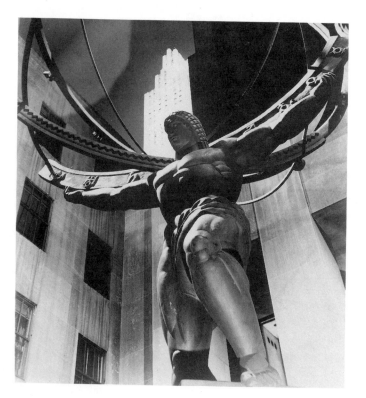

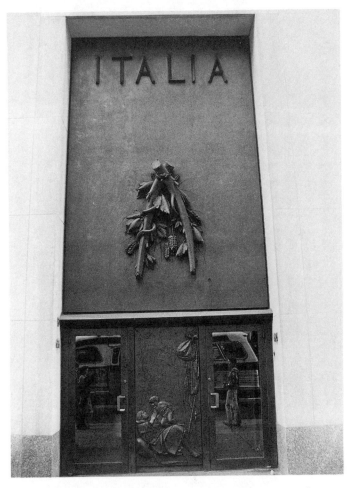

## F-35 The Italian Immigrant *and* Italia, ca. 1965

**Sculptor:** *Giacomo Manzù (1908– ).* **Media and size:** *Bronze reliefs:* Immigrant, *6 feet 7 inches high by 3 feet 2 inches wide;* Italia, *15 feet 7 inches high by 10 feet 5 inches wide.* **Location:** *Palazzo d'Italia, 626 Fifth Avenue.*

At the entrance to Palazzo d'Italia Italian sculptor Giacomo Manzù honors the Italian immigrant in this low-relief panel, at eye level between two doors, which shows a barefoot mother and child resting next to their traveling pack. Above the doors a bold high relief depicts a bough of grapevines and wheatstalks, symbolic of the earth's fruitfulness. In both panels the bronze surface retains the freshness of wet clay in the delicately incised lines and slab-like forms.

Admired for his series of standing cardinals and his doors for St. Peter's in Rome, unveiled in 1964, Manzù is one of the leading figurative sculptors of the 20th century. He is steeped in the tradition of the Renaissance and eloquently expresses humanist themes. The panels, stylistically different from the center's 1930s architectural sculpture, replaced the original relief which was removed in 1940.

**Installed:** *May 1965.* **Collection of:** *Rockefeller Center; gift of Fiat of Italy.*

## F-36 Industries of the British Commonwealth

**Sculptor:** *Carl Paul Jennewein (1890–1978).* **Media and size:** *Gilded bronze relief, 18 feet high by 11 feet wide.* **Location:** *British Empire Building, 620 Fifth Avenue, over the main entrance.*

To the north of the Channel Gardens is the British Empire Building at 620 Fifth Avenue, a counterpart to La Maison Française. Both buildings have impressive gilded overdoor panels of the same size, 18 feet high by 11 feet wide, so the fine entrances, together with the Channel Gardens, make a striking Fifth Avenue frontage between 49th and 50th Streets.

Above the entrance to the British Empire Building is a panel of strong design, restrained and informative, entitled *Industries of the British Commonwealth.* Onto its dark-colored bronze surface sculptor Jennewein applied nine individual gold-leafed figures of men and women modeled in high relief, all shown in workaday clothing. This formally arranged relief contrasts sharply with the intricate and flowing design over the entrance to the La Maison Française.

The nine rather stylized figures of workers are arranged in three vertical rows. A fisherman, seaman, and coal miner symbolize the industries of the British Isles; a woman carrying a bag of salt, a woman next to a tobacco plant, and a man holding stalks of sugarcane symbolize the industries of India; a shepherd symbolizes the wool industry of Australia; a reaper symbolizes the wheat industry of Canada; and a woman among cotton plants symbolizes the cotton industry of Africa.

**Installed:** *January 1933.* **Signed and dated:** *C.P. Jennewein / © / 1933.* **Collection of:** *Rockefeller Center.*

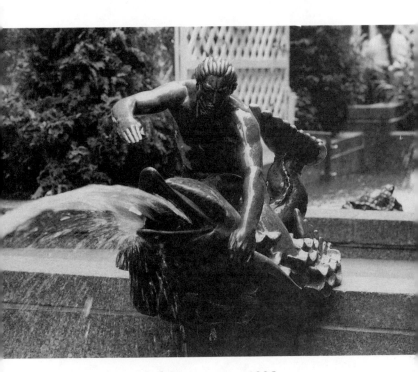

## F-37 Fountainhead Figures, ca. 1935

**Sculptor:** *René Paul Chambellan (1893–1955).* **Media and size:** *Six bronze statues, 3 feet high.* **Location:** *Rockefeller Center in the Channel Gardens, between La Maison Française and the British Empire Building, 48th and 49th Streets.*

Amid the changing foliage of the Channel Gardens are six Tritons and Nereids jubilantly riding dolphins. In season water gushes from the mouths of the dolphins into a series of mirrored pools, creating a rhythmic cascade leading from Fifth Avenue to the lower plaza at the base of 30 Rockefeller Plaza, focal element of the center. The stylized figures symbolize qualities that have spurred humankind ahead. In sequence from Fifth Avenue toward the lower plaza, they are Leadership, Will, Thought, Imagination, Energy, and Alertness.

Sculptor René Chambellan, best known for his decorative architectural sculpture, completed a number of other works for Rockefeller Center. They include Radio City Music Hall's stainless-steel auditorium doors and four limestone panels on the façades of the British Empire Building and La Maison Française.

**Installed:** *1935.* **Collection of:** *Rockefeller Center.*

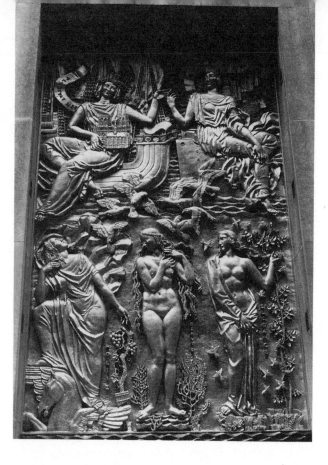

## F-38 The Friendship of France and the United States, ca. 1934

**Sculptor:** *Alfred Janniot (1889–1969).* **Media and size:** *Gilded bronze panel, 18 feet high by 11 feet wide.* **Location:** *Over the entrance to La Maison Française, 610 Fifth Avenue.*

La Maison Française is marked by a gold-leafed bronze relief that is as complex as any mural. It was created by Alfred Janniot, one of France's leading 20th-century sculptors. He was a Chevalier of the Legion of Honor and had shortly before gained international recognition for his 1931 relief for the façade of the Colonial Museum in Paris.

On looking up one sees three luscious golden ladies who represent Poetry, Beauty, and Elegance, a novel and Gallic allegorical theme that brings to mind the famed three graces. Higher on the panel are the design's central subjects. New York is at the right and Paris at the left, holding a model of Notre Dame. Each charming female figure is seated on the prow of a ship. Inscribed on a scroll behind Paris is that city's motto: "Fluctuate nec mergitur," meaning "It floats but never sinks." Such details as the cityscape of skyscrapers behind New York give the relief a rich pictorial quality. The huge panel was cast in the Gorham Foundry in this country.

**Installed:** *January 1934.* **Signed:** *Alfred / Janniot / Sculpteur.* **Foundry mark:** *Gorham Company Founders.* **Collection of:** *Rockefeller Center.*

# (G)

# CENTRAL PARK

## *59th to 110th Streets and Fifth Avenue to Central Park West (Eighth Avenue)*

———

Landscape architects Frederick Law Olmsted (1822–1903) and Calvert Vaux (1824–1895) created Central Park from a wasteland of swamps, stone quarries, and squatter's shanties. It was conceived in the tradition of the English garden as a total work of art: unified, rhythmic, and inspiring.

Although English gardens often contained sculpture and architecture, Olmsted and Vaux wanted to limit the intrusion of artifice in their landscape. They argued that "the idea of the park itself should always be uppermost in the mind of the beholder." Despite their intentions, more than 50 sculptures are located in and around New York's prized 840 acres. Public sculpture often expresses civic pride and ethnic identity, and as Central Park was America's first grand public park, groups of immigrant New Yorkers were eager to display images of their national heroes here.

In order to regulate the placement of sculpture, in 1873 the Central Park Board of Commissioners issued official guidelines with two primary aims: to improve the quality of the works and to protect the picturesque landscape. They distinguished between portrait statues and "ideal" works, sculptures based on imaginary subjects. Commemorative works were considered suitable for the formal parts of the park, such as the Mall or the named entrance gates. "Ideal" works could be integrated among natural elements, such as *The Falconer* high on a rocky outcropping.

The park's oldest monument is the Egyptian Obelisk (16th century B.C.), but the first work erected was the bust of Schiller, placed in the Ramble in 1859. Most of the sculptures are in the southern half of the park or on its edges, with a concentration on the Mall, a kind of promenade. Nineteenth-century sculpture, including masterpieces by some of America's finest artists, predominates and illustrates styles ranging from neoclassicism to naturalism, to Beaux Arts grandeur. Works honor writers, musicians, and artists of various nationalities, as well as great statesmen and war heroes. There are also some delightful animal sculptures and 20th-century pieces that invite viewer participation, especially by children.

# CENTRAL PARK

1. Arsenal
2. Wollman Rink
3. Dairy
4. Chess and Checkers
5. Carousel
6. Delacorte Clock
7. Children's Zoo
8. Zoo (under construction)
9. Tavern on the Green
10. The Mall
11. Naumburg Bandshell
12. Frick Museum
13. Bethesda Fountain
14. Cherry Hill Fountain
15. Loeb Boathouse
16. New-York Historical Society
17. American Museum of Natural History
18. Hayden Planetarium
19. Shakespeare Gardens
20. Delacorte Theater
21. Swedish Cottage
22. Metropolitan Museum of Art

*(REGION G)*

WEST   CENTER   EAST

Frederick
Douglass Circle

ADAM CLAYTON POWELL JR. BLVD

LENOX AVE.

Frawley
Circle

CENTRAL PARK NORTH (110TH ST.)

The Meer

35

36

33

32

34

31

W. 106TH ST.

Great
Hill

41   30

29

40   28

39   E. 102ND ST.

W. 100TH ST.

North Meadow

East
Meadow

W. 97TH ST.

W. 96TH ST.

97TH ST. TRANSVERSE

38   E. 96TH ST.

27

CENTRAL PARK WEST

FIFTH AVENUE

W. 90TH ST.

The Reservoir

26

37   25

36

24

WEST DR.

E. DRIVE

86TH ST.

35

W. 85TH ST.

23

35   E. 85TH ST.

23. Ross Pinetum
24. Guggenheim Museum
25. Cooper-Hewitt Museum
26. Jewish Museum
27. Tennis Courts
28. Museum of the City of New York
29. Conservatory Garden
30. Museo del Barrio
31. Fort Fish Site
32. Fort Clinton Site
33. Nutter's Battery Site
34. Lasker's Rink and Pool
35. Blockhouse
36. 110th Street Boathouse

N

## G-1 The Sherman Monument, 1892–1903

**Sculptor:** *Augustus Saint-Gaudens (1848–1907).* **Pedestal by:** *Charles Follen McKim.* **Media and size:** *Bronze equestrian group, over life-size; pink granite pedestal.* **Location:** *Grand Army Plaza, Fifth Avenue at 59th Street.*

*The Sherman Monument* ranks among the most distinguished equestrian groups of Western art. To have it outdoors where all can see it by day or night and in every season is one of the blessings of public art. It was given to the city by the generation that had taken part in the Civil War, and it was created by a sculptor who venerated Gen. William Tecumseh Sherman as his ideal of the American military hero.

In 1888 Saint-Gaudens had modeled a bust of Sherman from life in 18 two-hour sittings, each a memorable experience for the artist. It is this rigorously truthful portrait with its creased and stubbled face and squared shoulders that we see in the equestrian statue, completed early in 1903. It

was Saint-Gaudens' last major work and fulfilled his desire to honor the heroes of the Civil War and "to help in any way to commemorate them in a noble and dignified fashion worthy of their great service."

*The Sherman Monument* is a rare combination of the real and the ideal. The general, in a plain field uniform with a windblown military cape, erect on his spirited mount, is contrasted with an allegorical figure of Victory on foot. She leads, striding forward with her right arm raised and a palm branch of peace clasped in her left hand. Although she is a separate figure, Saint-Gaudens unites her with Sherman and his horse by making their movements parallel. The brisk trot of the horse (modeled on the famous jumper, Ontario) and the extended stride of Victory are one motion. Saint-Gaudens also uses such corresponding compositional elements as Victory's outstretched wings and Sherman's billowing cape to harmonize the group.

Saint-Gaudens worked on this monumental group first in New York, then in his studio in Paris, and finally at his summer studio in Cornish, Vermont. After it had been cast in bronze in Paris and then sent to this country, he had it set up in a field near his summer studio in order to study it from all sides and various distances, an activity that amazed his rural neighbors. Before *The Sherman Monument* was unveiled it had become widely known because versions of it in large-scale plaster models had been shown in international exhibitions. Its unveiling took place on Memorial Day, May 30, 1903, with a military parade in which some of Sherman's own men marched, and during which the bands played "Marching Through Georgia." It was written that "all recognized the fallen pine branch beside the left rear hoof of the horse as a symbol of Sherman's march to the sea through the State of Georgia." Saint-Gaudens was present and, although tired and sick, was buoyed up by the tremendous reception of the crowd.

The statue was a gleaming golden group. The artist, having complained of "seeing statues look like stove pipes" (a reference to the traditional statuary brown or black color), had it covered with two layers of gold leaf and envisioned a light-colored base. Now the granite pedestal is darkened by city grime, and the gold leaf has been removed after years of peeling.

Although Saint-Gaudens and Charles Follen McKim, architect of the base, had wanted the Sherman to be placed near *Grant's Tomb,* both the Grant and Sherman families objected, so the 59th Street location was chosen. Saint-Gaudens then had to persuade the Parks Department to enlarge the surrounding plaza so that the work could be viewed from all angles at the proper distance.

**Dedicated:** *May 30, 1903.* **Signed and dated:** *Augustus Saint-Gaudens M.C.M. III.* **Collection of:** *City of New York; gift of the citizens of New York under the auspices of the Chamber of Commerce of the State of New York.*

## G-2 Pulitzer Fountain (Pomona), 1913–1916

**Sculptor:** *Karl Bitter (1867–1915).* **Architect:** *Thomas Hastings.* **Media and size:** *Bronze statue, over life-size; marble fountain, 68 feet in diameter.* **Location:** *Grand Army Plaza at 59th Street and Fifth Avenue.*

Manhattan's Grand Army Plaza is one of the most successful and prominent public spaces in America, largely as a result of Karl Bitter's vision. As early as 1898 the sculptor had proposed a unified treatment for the unstructured plazas on both sides of 59th Street. Bitter admired the Place de la Concorde in Paris and envisioned two complementary fountains positioned on islands on a parallel line at either end of the plaza, divided by 59th Street. In 1903, despite Bitter's recommendations, Saint-Gaudens' equestrian statue of Sherman, a possible obstacle to a future, symmetrical design, was erected on the north end of the plaza. However, in 1912 city planners reconsidered a scheme for the whole space when publisher Joseph Pulitzer bequeathed $50,000 "for the erection of a fountain at some suitable place in Central Park, preferably at or near the Plaza entrance at 59th Street, to be as far as possible like those in the Place de la Concorde, Paris, France."

A series of competitions and meetings took place before development of the plaza began. Acting as an advisory committee to the executors of the will, members of the National Sculpture Society recommended that Bitter design the fountain. Bitter was also the newly appointed sculptor member of the Art Commission, and before he would undertake the project, he argued that the scheme required more comprehensive architectural planning. In 1913 a closed competition was held in which five architectural firms participated.

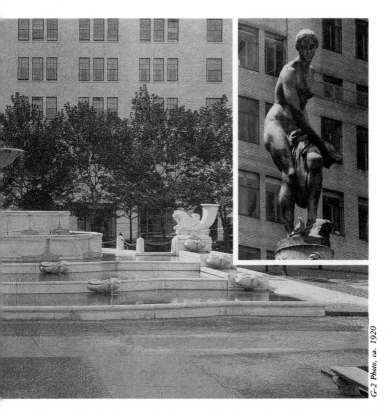

G-2 Photo, ca. 1920

Thomas Hastings' proposal, fully sympathetic to Bitter's original scheme, won. Limited by the amount of the bequest and in lieu of a second fountain, Hastings recommended relocating the Sherman statue 16 feet west and into the center of the 59th Street side of the plaza, its present site.

In the tradition of Italian Renaissance fountains, the *Pulitzer Fountain* is composed of six stone basins rising upward in a pyramidal form, crowned by the graceful bronze figure of Pomona, goddess of abundance. Giant ramshead horns of plenty designed by Orazio Piccirilli, flank the fountain on both sides. Hastings' original design included a figure, which Bitter developed and refined. In a pose typical of numerous allegorical nudes, Pomona bends forward, curving toward her right, and steps up with her left leg. In opposition to the sinuous line of her torso and legs, she gently swings her arms to the left, where they clasp a basket of fruit at her side. Bitter's tragic death in an automobile accident prevented him from carrying the model to completion. His studio assistant, Karl Gruppe, aided by Isadore Konti, executed the full-scale work and completed the details of hair and fruit.

Today the fountain retains its original appearance, but the plaza has lost Hastings' balustrade and the paired rostral columns, which established a more sharply defined rectangle enclosing the circular fountain. One of the city's proudest memorials to the City Beautiful movement, the marble *Pulitzer Fountain* has not weathered well and requires extensive restoration, which may be undertaken soon with private funds.

**Dedicated:** *May 1916.* **Collection of:** *City of New York; bequest of Joseph Pulitzer.*

## G-3 Thomas Moore, 1879

**Sculptor:** *Dennis B. Sheahan (active late 19th-century).* **Media and size:** *Bronze bust, over life-size; granite pedestal.* **Location:** *Central Park, near the 59th Street pond.*

Irish residents of New York, following the pattern of other ethnic residents, honored their national poet Thomas Moore on the centennial of his birth. Commemorative statues of Shakespeare, Burns, Scott, and Schiller already stood in Central Park when the bust of Thomas Moore was unveiled. Mayor Edward Cooper remarked at the dedication ceremonies that, "as America stands for the broadest humanity," she warmly "embraces the great representative celebrities of every nation in her sympathies." Moore is best remembered for his Irish Melodies (1808–1834), including the popular "The Last Rose of Summer," and for his biography of Lord Byron (1830).

Sheahan's lively portrait presents a youthful Moore in an attitude of poetic reverie, with his head turned slightly toward the right, glancing toward the pond in the southeast corner of the park. He wears a high-collared shirt with a cravat, and the details of dress and face are sensitively rendered. Well received, *Thomas Moore* was the first piece of sculpture for which approval by committees of the National Academy of Design and the Chapter of Architects was required before it could be erected in Central Park.

**Dedicated:** *May 28, 1880.* **Signed and dated:** *D.B. Sheahan Sculpt. / New York 1879.* **Foundry mark:** *Geo. Fischer / Bronze Founders, N.Y.* **Collection of:** *City of New York; gift of the Friendly Sons of St. Patrick Society.*

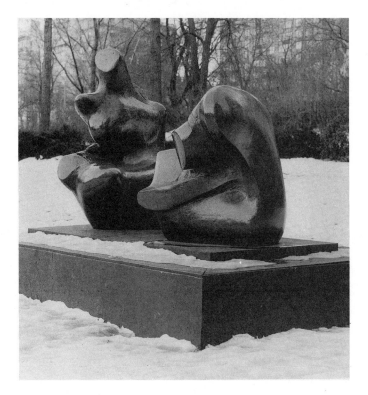

## G-4 Two Piece Reclining Figure: Points, 1969–1970

**Sculptor:** *Henry Moore (1898–1986).* **Media and size:** *Abstract bronze sculpture, 12 feet long.* **Location:** *Temporarily sited in Central Park, near the pond at 59th Street.*

Inspired by the human form and natural elements, England's internationally acclaimed sculptor Henry Moore devoted much of his life to wedding figuration with abstraction. Like other sculptors of this century, Moore used the human body, usually female, to explore formal concerns, such as the relationship of solids to voids and the effect of shifting perspectives. Although he sculpted standing figures and groups, Moore favored the reclining figure, first seen in his works of the 1920s. This bronze, an example of his later, segmented reclining figures, suggests rock formations; its sloping contours and textural contrasts appear to be shaped by the forces of wind and rain.

*Two Piece Reclining Figure: Points* was part of the City of New York's 1985 boroughwide outdoor exhibition of Henry Moore sculptures. All 25 works in that exhibition came from the collection of George and Virginia Ablah, who donated one of those sculptures to New York City. This lumbering, earthy piece originally sat on a floating base in the pond, but it became a favorite object of birds and seagulls and had to be relocated to land. Its permanent site is still under review.

**Collection of:** *City of New York; gift of George and Virginia Ablah.*

*G-5 Photo, 1936*

# G-5 Antelopes, Birds, Monkeys, Lions, and Wolves, ca. 1934

**Sculptor:** *Frederick George Richard Roth (1872–1944).* **Media and size:** *Three limestone panels, varying sizes.* **Location:** *Central Park Zoo, 64th Street off Fifth Avenue, behind the Arsenal (panels are on the Tropical and Polar Zone buildings and on the Gift Shop and Zoo School).*

In 1934, soon after Robert Moses became the first commissioner of parks for all five boroughs, he set in motion a complete renovation of Central Park. This included the regrouping and rebuilding of the menagerie buildings of the Central Park Zoo. Although the new zoo was a vast improvement over the antiquated and rat-infested Victorian menagerie, by 1980 it, too, had become outdated. A modern facility, designed by Roche-Dinkeloo and Associates in consultation with the New York Zoological Society, was begun in 1985.

Characteristic of Moses' concern with detail and humanizing architectural features, low limestone reliefs depicting various animals graced the exterior of the 1934 animal houses. They were among the numerous commissions awarded to F. G. R. Roth, from 1934 to 1936 chief sculptor of the Parks Department during the period of New Deal work-relief programs.

European-trained, Roth was a versatile sculptor who portrayed a wide variety of animals in different media and styles. His Central Park reliefs reflect his earlier experimental work in colorful, ceramic tile, and his gentle sense of humor. Using simple, flat planes and sharp outlines, Roth emphasizes the humorous personality rather than the anatomy of his monkeys, the grace of the swans and peacocks, and the explosive energy of the antelopes. Similar reliefs by Roth enhance the animal houses at Prospect Park Zoo.

**Collection of:** *City of New York; purchased with federal funds under the Temporary Emergency Relief Administration Program; at least one panel is signed by Roth.*

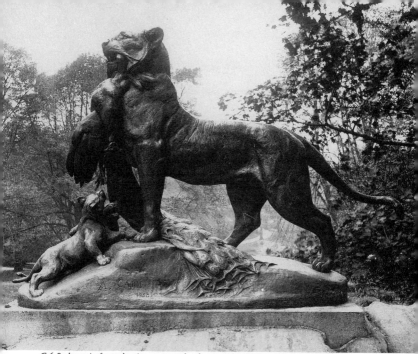

*G-6 Sculpture in former location, on natural rock outcropping in Central Park, ca. 1905*

## G-6 Tigress and Cubs, 1866

**Sculptor:** *Auguste Cain (1821–1894).* **Media and size:** *Bronze group, over life-size.* **Location:** *Central Park Zoo, Intelligence Garden, Fifth Avenue at 64th Street.*

On October 28, 1867, in the early days of the park, 12 Americans, including Samuel F. B. Morse, presented *Tigress and Cubs* to the Central Park Commission. They wrote: "The undersigned citizens of the United States . . . have great pleasure in presenting . . . the bronze statue of the 'Tigress,' heroic size, the masterpiece of Cain. . . . Its vigorous execution and acknowledged artistic merit, we trust, will entitle it to be considered by the Commissioners of Central Park as worthy of occupying a prominent position in the pleasure grounds to which every American points with pride."

By 1867 Cain had achieved widespread critical and public acclaim. He had won numerous medals and important commissions, including a contract to create pieces for the Palais de Tuileries in Paris. The donors of *Tigress and Cubs* had viewed the sculpture in Cain's studio before the work appeared in the Universal Exposition of 1867. The sculpture depicts a sleek and graceful feline standing triumphantly with a dead peacock in her mouth, while her cubs scamper hungrily at her feet. A similar piece is in the Jardin des Tuileries.

The Central Park commissioners initially placed *Tigress and Cubs* in a secluded, wooded part of the park. Clarence Cook, a prominent 19th-century art critic, advocated the sculpture's relocation to a more suitable environment, and by 1934 *Tigress and Cubs* had been moved to the Central Park Zoo.

**Presented:** *October 28, 1867.* **Signed and dated:** *A. Cain / 1866.* **Foundry mark:** *F. Barbedienne.* **Collection of:** *City of New York; gift of Samuel F. B. Morse and others.*

## G-7 Delacorte Clock, 1964–1965

**Sculptor:** *Andrea Spadini (1912– ).* **Entryway by:** *Edward Coe Embury.*
**Designer:** *Fernando Texidor.* **Media and size:** *Six bronze animals, 4 feet*
*high; two bronze monkeys.* **Location:** *Central Park Children's Zoo, near*
*Fifth Avenue at 64th Street.*

At most daytime hours, the musical clock above the southern entrance to the
Central Park Children's Zoo draws a crowd; two bronze monkeys with
hammers appear to strike a bell, while a fanciful parade of musical animals
circle below. The figures include a bear shaking a tambourine, a kangaroo
and its offspring blowing a horn, an elephant squeezing an accordion, a goat
playing the pipes of Pan, a hippopotamus stroking a violin, and a penguin
drumming. This cacophonous bunch rotates to the tune of nursery rhymes,
32 in all. A shorter performance occurs on the half hour.

Delighted by animated clocks in Europe, philanthropist and publisher
George T. Delacorte commissioned this one, partially patterned on earlier
examples. The oldest mechanical clocks, dating to the 14th century, typically
incorporated religious or royal images and were placed on cathedrals and city
halls. Later clocks, such as the "Zytglogge" of Berne, include more whimsical
figures, and its carousel of bear cubs parading with axes and spears may have
been the model for Central Park's clock.

Delacorte has bestowed other gifts on New York, including Central Park's
bronze statue of *Alice in Wonderland* (see G-29), the Delacorte Theater in the
park, and the fountain in City Hall Park.

**Dedicated:** *June 24, 1965.* **Collection of:** *City of New York; gift of George
T. Delacorte.*

# G-8 Honey Bear *and* Dancing Goat, ca. 1935

**Sculptor:** *Frederick George Richard Roth (1872–1944).* **Media and size:** *Bronze statues, 6 feet high.* **Location:** *Central Park Zoo, at the Penguin Building and at the Visitors Service Building, 64th Street and Fifth Avenue*

This pair of whimsical fountain statues contrasts sharply with the realistic portrait of Balto (see G-11), which Roth had executed earlier. Like storybook characters, the goat and bear assume human attributes as they balance on their hind legs with their heads thrown back, bodies rotating. Water sprays from the mouths of five frogs positioned around the foliage in the base. In these niche fountains, Roth humorously reflects on antique and Renaissance sculpture, in which chubby, nude putti typically dance in the center of water jets; here Roth replaces the putti with cavorting animals.

**Collection of:** *City of New York; purchase, Temporary Emergency Relief Administration funds.*

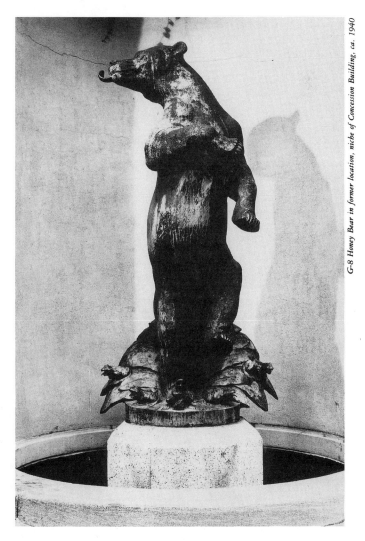

*G-8 Honey Bear in former location, niche of Concession Building, ca. 1940*

# G-9 Lehman Zoo Gates, 1960–1961

**Sculptor:** *Paul Manship (1885–1966).* **Media and size:** *Bronze, on a granite pedestal, 18 feet high by 26½ feet wide by 6 feet deep.* **Location:** *Central Park, at the park entrance to the Children's Zoo, west margin of Fifth Avenue at 66th Street.*

A gate, in contrast to a wall, divides without impeding vision. Paul Manship's decorative, linear style lends itself to this purpose as illustrated by the Lehman Gate, marking the entrance to the Children's Zoo.

A horizontal band of stylized vegetation forms two arches between three stone pillars. Figures of boys playing the pipes of Pan surmount the outside piers and a larger-scaled boy dancing with two goats crowns the center. Birds, with fanciful crests and tail feathers, chirp at their random posts on the tendril-like branches. Patterned on the theme of music, the gate's celebratory tone was a fitting memorial to the 50th wedding anniversary of Governor Lehman and his wife, for which the work was commissioned.

**Collection of:** *City of New York; gift of Gov. and Mrs. Herbert H. Lehman.*

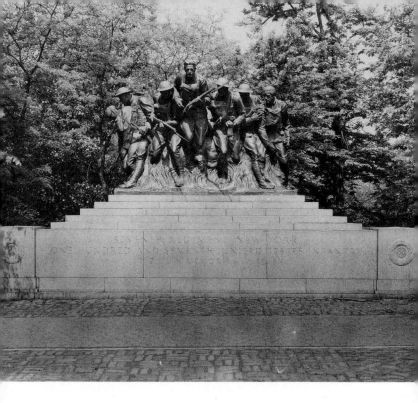

# G-10 107th Infantry Memorial, 1926–1927

**Sculptor:** *Karl Illava (1896–1954).* **Pedestal by:** *Rogers and Haneman.*
**Media and size:** *Bronze group, over life-size; 32-foot-long granite pedestal.*
**Location:** *Central Park, at Fifth Avenue and 67th Street.*

The terror and courage of soldiers charging the front lines in World War I is
so fully conveyed in the *107th Infantry Memorial* because it came out of the
sculptor's personal experiences as a sergeant with the 107th Infantry. He not
only imagined it, he had lived it.

Forming a pyramid, the figures in the group express a range of emotions
and attitudes. Wounded soldiers slump on the periphery as the three central
figures, with grimacing mouths and clenched fists, attack with bayonets. The
heightened drama of the lunging group invites comparison with the
Washington, D.C., *Iwo Jima Memorial* based on the famous photograph of
soldiers raising the flag. Like Gertrude Vanderbilt Whitney's World War I
memorial (see J-26), this monument tells of the common soldier and the
comradeship of enlisted men. In a less serious moment Illava described the
group as "the doughboys chasing each other out of Central Park."

Because of its size (it is 32 feet long) and its placement above eye level very
close to the Fifth Avenue sidewalk, it is clearly seen by pedestrians, and also
by riders in the continuous flow of traffic. There are maintenance problems
with the bayonets on this bronze sculpture. Vandalism has led the Parks
Department to recast several replacements at once to have them in reserve.

**Dedicated:** *September 29, 1927.* **Signed:** *KARL ILLAVA Sculptor.* **Dated:**
*1926–1927.* **Collection of:** *City of New York; gift of the 7th–107th
Memorial Committee.*

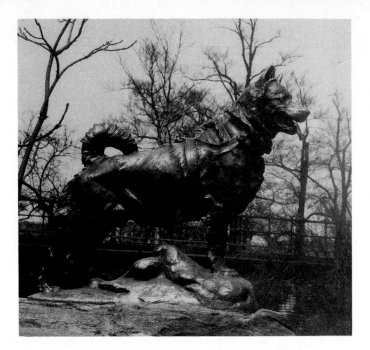

# G-11 **Balto, 1925**

**Sculptor:** *Frederick George Richard Roth (1872–1944).* **Media and size:**
*Bronze statue, over life-size, and slate tablet; mounted on natural rock.*
**Location:** *Central Park, East Drive at 66th Street.*

This is New York's only statue commemorating a dog. The Siberian husky
Balto was an undisputed hero. He led a dogsled team on the long final lap
through a blizzard and over Arctic terrain to carry antitoxin desperately
needed to arrest a diphtheria epidemic in Nome in January 1925. The driver
of the dog team told reporters: "I couldn't see the trail. Many times I
couldn't even see my dogs, so blinding was the gale. I gave Balto, my lead
dog, his head and trusted to him. He never once faltered. It was Balto who
led the way. The credit is his."

Balto died as a result of the expedition. The Balto Memorial Committee
commissioned the celebrated Brooklyn-born animal sculptor Frederick G. R.
Roth to create this statue. Roth portrays Balto panting heavily with his legs
spread, the trace hanging from his back, as he stands on a rough trail
surveying the distance. Fluent modeling enlivens the form, convincingly
life-like under the tufts of fur. A low-relief plaque on the rock below shows a
dog team in action. The National Academy of Design awarded Roth the
1925 Speyer prize for his statue of the husky.

Beloved by children, *Balto* shows the effects of their stroking and
climbing. They have rubbed his back, sides, and snout golden, while his
underside and tufted hind legs exhibit the dull-green color of copper-sulfate
residues.

**Signed:** *F.G.R. Roth ©.* **Dated:** *1925.* **Foundry mark:** *Roman Bronze
Works NY.* **Collection of:** *City of New York; gift of the Balto Monument
Committee.*

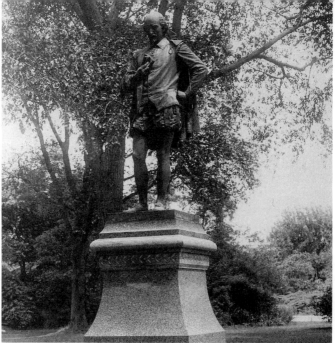

*G-12 Photo, ca. 1905*

## G-12 William Shakespeare, 1870

**Sculptor:** *John Quincy Adams Ward (1830–1910).* **Pedestal by:** *Jacob Wrey Mould.* **Media and size:** *Bronze statue, over life-size; granite pedestal.* **Location:** *Central Park, south end of the Mall.*

In 1864 Edwin Booth, a leading American Shakespearean actor (see D-9) and three others laid a cornerstone for this statue in honor of the 300th anniversary of William Shakespeare's birth in 1564. At the approach of this anniversary, groups in England and Germany planned monuments, spurring cultural leaders in New York to do so as well. In a time when America was proving her cultural sophistication, a tribute to Shakespeare, would also be a tribute to American arts and letters. As Col. Henry G. Stebbins said in his dedication address, this statue "will remind coming generations that we were able to appreciate the genius and know how to fitly honor the memory of Shakespeare."

The Civil War delayed plans for the memorial, but in 1866 its sponsors held a competition and went on to select the design of sculptor J. Q. A. Ward. Ward was faced with the problem of creating a likeness although no definitive one exists, and in the end he relied on the bust of the poet in the cemetery in Stratford-upon-Avon. As Ward scholar Lewis I. Sharp has indicated, Ward, finding it difficult to formulate a pose, turned to his friend, the actor James Morrison Steele MacKay. He posed for Ward, helping him arrive at an expressive and thoughtful posture. For the costume, Ward sought the advice of Edwin Booth. Finally unveiled in 1872, the statue combines a classical *contrapposto,* a graceful weight shift, with such realistic details of costume as the short slashed trunks, full cloak and doublet of the Elizabethan period.

**Dedicated:** *May 23, 1872.* **Signed and dated:** *J.Q.A. Ward. / 1870.* **Foundry mark:** *R. Wood & Co. / Bronze Founders / Phila.* **Collection of:** *City of New York; gift of the citizens of New York.*

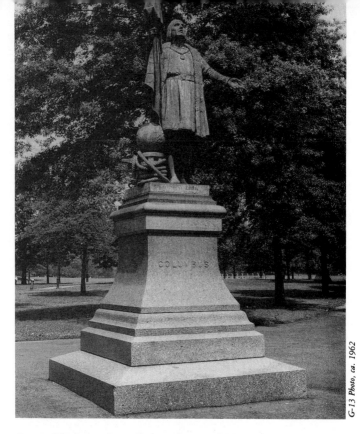

## G-13 Christopher Columbus, 1892

**Sculptor:** *Jeronimo Suñol (1839–1902).* **Pedestal by:** *Napoleon Le Brun.*
**Media and size:** *Bronze statue, over life-size; granite pedestal.* **Location:**
*Central Park, south end of the Mall.*

The 400th anniversary of Columbus' discovery of the Americas was marked
by a wave of interest that led to the vast Columbian Exposition in Chicago
and the erection of two large monuments in New York City. This bronze
statue in Central Park was one and the stone Columbus Circle column topped
by its marble figure was the other (see I-1).

The prestigious New York Genealogical Society provided funds and
ordered the bronze work by Jeronimo Suñol, one of Spain's leading
19th-century sculptors, to be cast in Barcelona. According to a speech by
Gen. James Grant at its unveiling, it is a modified copy of Suñol's 1885
statue located in the Plaza de Colón in Madrid.

Suñol portrays Columbus with his left hand outstretched and his face
uplifted in gratitude to God, a reference to the explorer's religious devotion.
In his right hand he holds a flag over a globe, probably an allusion to the
Spanish conquest of the New World. Behind Columbus is a capstan, a
mechanical device used on ships to wind rope.

**Dedicated:** *May 12, 1894.* **Signed and dated:** *J. Sunol 1892.* **Foundry
mark:** *Federico Masriera / Fundidor Barcelona 1892.* **Collection of:** *City of
New York; gift of New Yorkers under the auspices of the New York Genealogical
Society.*

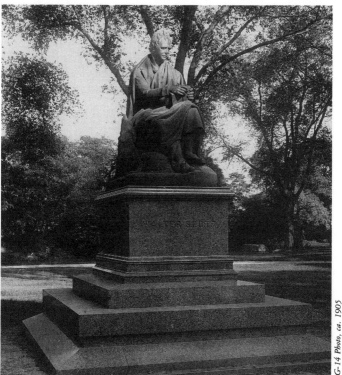

## G-14 Walter Scott, 1871

**Sculptor:** *Sir John Steell (1804–1891).* **Media and size:** *Bronze statue, over life-size; Peterhead granite pedestal.* **Location:** *Central Park Mall.*

Novelist and poet Sir Walter Scott (1771–1832) was a hero in 19th-century Scotland and the subject of that country's first major national monument. The elaborate architectural Gothic stone canopy beneath which sits a marble effigy of Scott was unveiled in 1845 on Prince's Street in Edinburgh. Some 25 years later as the centennial of Scott's birth approached, Scottish Americans asked the Edinburgh sculptor Sir John Steell, who had created the marble figure of Scott, to make a replica of it in bronze.

Steell shows Scott writing, seated on a rock with his hound at his side. In 1872 a reporter for the *New York Times* described the sculpture, commenting, "There has been a manifest endeavor to portray him [Scott] as he was known when among men, even to his loose stockings and his low, easy shoes, tied carelessly with leather cords. In the face the same idea is still paramount, and while the great intellect of the man is not forgotten, the leading thought has been to make it a characteristic portrait."

Today Scott is celebrated above all for his invention of the historical novel. His Waverley series, begun in 1814, introduced the romantic tale, including such popular books as *Ivanhoe.* His poems "The Lay of the Last Minstrel" and "The Lady of the Lake" revived the spirit of the old Scottish ballads and secured a firm place for Scott among poets.

**Dedicated:** *November 2, 1872.* **Signed and dated:** *Jn. Steell R.S.A. Sculpt. Enin R. 1871.* **Collection of:** *City of New York; gift from Scottish Americans.*

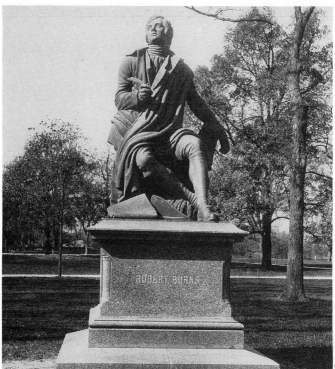

## G-15 Robert Burns, ca. 1880

**Sculptor:** *Sir John Steell (1804–1891).* **Media and size:** *Bronze statue, over life-size; granite pedestal.* **Location:** *Central Park Mall.*

Robert Burns (1759–1796), Scotland's national poet, faces Scotland's foremost novelist, Sir Walter Scott, at the southern entrance to Central Park's Mall. Subscribers to the monument, mostly resident Scots, awarded the commission to Sir John Steell in 1873, paying the Scottish sculptor 2,000 guineas. They specified the material and colossal dimensions of the monument, but allowed the sculptor to interpret his subject freely. Burns sits on a tree stump, absorbed in contemplation of his love Mary, to whom he has written the poem inscribed on the scroll at his feet. A plough alludes to his peasant origins. Characteristic of Steell's sculpture, the heavy generalized forms lack an interior anatomical structure as well as convincing surface details.

Burns, the son of a farmer, perceptively wrote about human experience and rural themes. Drawing on Scottish folk traditions, Burns published "Poems, Chiefly in the Scottish Dialect" in the 1780s, and traveled to Edinburgh where he amused fashionable society as the "ploughman-poet." Dropping out of favor, the ardent Burns devoted the latter part of his life to writing songs to traditional Scottish airs, reviving and elevating Scottish folk song to a high art. His best known song, "Auld Lang Syne," is still sung, though to another tune.

**Dedicated:** *October 2, 1880.* **Collection of:** *City of New York; gift of Scottish-Americans.*

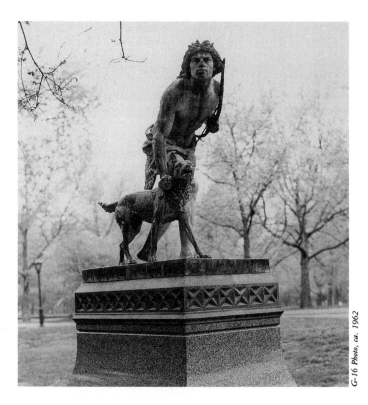

## G-16 The Indian Hunter, 1866

**Sculptor:** *John Quincy Adams Ward (1830–1910).* **Media and size:** *Bronze statue, over life-size; granite pedestal.* **Location:** *Central Park, southwest of the Mall.*

This first sculpture by an American to be placed in Central Park won immediate critical and public approval. At the time it was done, in the second half of the 19th-century, American sculptors were just starting to focus on American subjects. John Quincy Adams Ward, his work characterized by a bold realism and a predominance of American themes, was a central figure in this development of a native school of sculpture. He was a New York artist, and there are more works by Ward in this city than by any other sculptor of his generation.

Ward's *Indian Hunter* established him as a leading post–Civil War sculptor. He had been working on the theme of an Indian hunting since about 1860, and in 1862 he exhibited a statuette of *The Indian Hunter* at the National Academy of Design. Encouraged by its reception, Ward enlarged it in plaster. What a tribute to Ward that 23 of America's leading artists and art patrons underwrote this bronze cast.

Walking stealthily, the Indian bends forward, as he clutches a bow and arrow in his left hand and restrains the dog at his side with his right. The figure's intent gaze, tensed muscles, and lunging position suggest imminent action. Ward enlivens the surface of the bronze by sharply contrasting the rough folds of the Indian's loincloth and the dog's fur with the smooth, sinuous ripples of the figure's chest, arms, and legs.

In *The Indian Hunter* Ward unites direct observation of nature with a

classical composition. The convincing aboriginal character of the facial features, a quality not evident in earlier models, results from studies Ward made of Dakota Indians. As Lewis I. Sharp has pointed out, the position of the lower body, particularly the strong diagonal of the back leg, is similar to the well-known antique sculpture, the *Borghese Gladiator,* in the Louvre in Paris. Ward, like numerous 19th-century sculptors, looked to the antique for guidance, here using an ancient Greek sculpture to assist him in working out compositional problems.

The *Indian Hunter* typifies an intense interest in the native American Indian during this period and a tendency to romanticize him. While Ward portrayed the noble savage, many another American artist showed him as a barbarian.

**Dedicated:** *February 4, 1869.* **Signed and dated:** *J.Q.A. Ward / Sculptor. / N.Y. 1866.* **Foundry mark:** *BRONZE BY / L.A. AMOUROUX. N.Y.* **Collection of:** *City of New York; gift.*

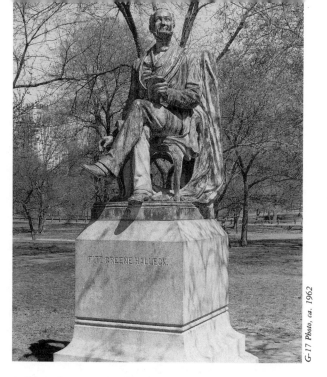

# G-17 Fitz-Greene Halleck, 1876

**Sculptor:** *James Wilson Alexander MacDonald (1824–1908).* **Media and size:** *Bronze statue, over life-size; granite pedestal.* **Location:** *Central Park Mall.*

The 19th-century biographer of Fitz-Greene Halleck (1790–1872), Gen. James Grant Wilson, organized a subscription for this first monument honoring an American poet to be erected in New York City. Very likely it was General Wilson who persuaded President Rutherford B. Hayes, attended by his cabinet, personally to present this statue to the city, although Halleck was of less than national stature. Contemporary reports account that 10,000 people turned out on May 15, 1877, for the dedication, and the resultant trampling and damage to Central Park prompted officials to prohibit similar activities in the future.

Halleck, a writer of satirical and romantic verse, was a leading member of the Knickerbocker group. His "Croaker Papers," written in collaboration with Joseph Rodman Drake, appeared in the *New York Evening Post* in 1819, and brought him popular recognition. Halleck is now viewed as a lesser poet, greatly influenced by Scott and Burns, whose effigies are appropriately nearby.

Sitting with his legs crossed, Halleck has an urbane air. He is poised in the act of writing with his right hand extended and face lifted upward, a conventional pose for literary figures. The ornate Victorian chair and the poet's elegant dress underscore the sculptor's love of realistic detail. MacDonald, a member of the post–Civil War generation of American sculptors, executed this work during the period of his greatest popularity.

**Dedicated:** *May 15, 1877.* **Signed and dated:** *Wilson McDonald / Sculptor / 1876.* **Collection of:** *City of New York; gift by public subscription headed by Gen. James Grant Wilson.*

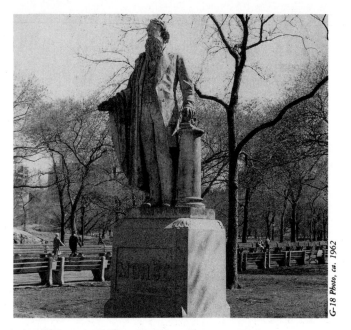

## G-18 Samuel Finley Breese Morse, 1870

**Sculptor:** *Byron M. Pickett (active 1870s).* **Media and size:** *Bronze statue, over life-size; granite pedestal.* **Location:** *Central Park, north end of the Mall.*

Artist and inventor Samuel F. B. Morse (1791–1872) was the last person to be honored during his lifetime by a statue in Central Park. In 1873, a year after Morse died, the Central Park commissioners issued a rule that all subjects must be deceased for at least five years before a commemorative sculpture could be placed in the park.

Inventor of the Morse Code, Morse pioneered electromagnetic telegraphy, sending his famous message, "What hath God wrought," from Washington to Baltimore on May 24, 1844. Previous to his career as an inventor, which began around 1832, Morse was a gifted portraitist and history painter. His full-length painting of Lafayette in City Hall ranks as one of the era's most impressive Romantic portraits. Morse was also a leader in art organizations and was the first president of the National Academy of Design (1826 –1842).

Pickett's uninspired statue depicts Morse standing with his left arm resting on a telegraphic instrument and holding a telegraphic despatch in his right hand. William Cullen Bryant aptly remarked at the sculpture's unveiling: ". . . the civilized world is already full of memorials which speak the merit of our friend, and the grandeur and utility of his invention. . . . Thus the Latin inscription in the Church of St. Paul in London, referring to Sir Christopher Wren, its architect—'If you would behold his monument, look around you'—may be applied in a far more comprehensive sense to our friend, since the great globe itself has become his monument."

**Dedicated:** *June 10, 1871.* **Signed and dated:** *B. M. Pickett. / Sculpt. 1870.* **Foundry mark:** *M. J. Power. / Bronze Founder. N.Y.* **Collection of:** *City of New York; gift of telegraph operators.*

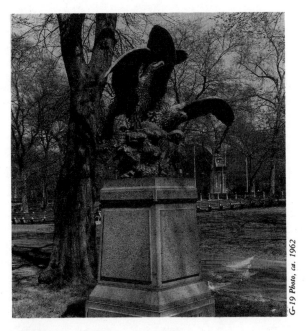

## G-19 Eagles and Prey, ca. 1850

**Sculptor:** *Christophe Fratin (1800–1864).* **Media and size:** *Bronze group, life-size; granite pedestal.* **Location:** *Central Park, northwest of the Mall.*

By the mid–19th century a group of French sculptors, called *animaliers,* had established a new genre of sculpture featuring wild, exotic animals. These artists, among whom was Christophe Fratin, shared a romantic fascination with terror and with life-and-death struggles.

In 1831 Fratin made his debut in the prestigious annual Salon after studying under the great French Romantic painter Gericault. Later he showed at London's Great Exposition of 1851 in the Crystal Palace. Critics admired the quality of his bronze casts as well as his virtuoso modeling.

*Eagles and Prey* illustrates the adage "survival of the fittest." Two birds of prey, with their talons outstretched and wings flapping, attack a goat trapped between two rocks. Using abundant surface details and precise anatomy, Fratin conveys the fury of the encounter and dramatizes the eagles' victory. Striving for verisimilitude, the sculptor articulates every feather of the powerful wings and carves intricate crevices into the rock.

*Eagles and Prey* was the first *animalier* sculpture in Central Park. Although the park commissioners viewed it as an appropriate park embellishment, Clarence Cook, the noted 19th-century critic, disagreed. He wrote in his 1869 book on Central Park that *animalier* sculpture "does not belong to the tranquil rural beauty of the park scenery. . . . they are apart from the purpose of noble art, whose aim is to lift the spirit of man to a higher region and feed him with grander thoughts."

**Signed and dated:** *Fratin / 1850.* **Foundry mark:** *Fondu Par Calla à Paris.* **Collection of:** *City of New York; gift of Gordon Webster Burnham in 1863.*

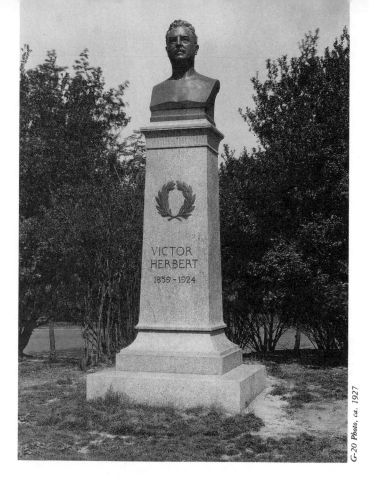

*G-20 Photo, ca. 1927*

## G-20 **Victor Herbert, 1927**

**Sculptor:** *Edmond T. Quinn (1868–1929).* **Media and size:** *Bronze bust, over life-size; granite pedestal.* **Location:** *Central Park Mall, across from the bandstand.*

In a 1924 obituary of Victor Herbert (1859–1924), a reporter for the *New York World* wrote that the composer had "raised light opera music to a degree of harmonic sophistication that it had never before reached." Beginning his musical career as a cellist in Strauss' orchestra in Vienna, Herbert came to the United States in 1886 and gradually moved away from classical music to more popular forms. His celebrated comic operas include *The Fortune Teller, Babes in Toyland, Mlle. Modiste,* and *The Red Mill.* Herbert also composed the dramatic score for the film classic *The Birth of a Nation,* and the movies *Little Old New York, The Great White Way,* and *Yolanda.* Widely broadcast over the radio, Herbert's music reached a broad popular audience.

In this naturalistic portrait bust, Quinn presents an earnest Herbert, gazing out into the distance. Herbert faces the Central Park bandstand, where he had often performed to large enthusiastic audiences as bandmaster of the 22nd Regiment, New York National Guard.

**Signed and dated:** *QVINN-SC. / 1927.* **Collection of:** *City of New York; gift of the American Society of Composers, Authors, and Publishers.*

# G-21 Ludwig von Beethoven, 1884

**Sculptor:** *Henry Bearer (1837–1908).* **Media and size:** *Bronze bust, over life-size; granite pedestal with bronze allegorical figure.* **Location:** *Central Park Mall, north end opposite the bandshell.*

Beethoven's stature as a composer rivals only that of Bach and Mozart. Making the transition from classicism to romanticism, Beethoven invented new musical forms, culminating in his Symphony No. 9 in D minor (1822).

In celebration of its 25th anniversary, the German-American Beethoven Mannerchor, a choral society, presented on July 22, 1884, a heroic bust of the composer to the City of New York. The German-born sculptor Henry Bearer depicts Beethoven with an intense gaze, a furrowed brow, and a generous crown of unkempt hair. The bust rests on a 12-foot-high granite pedestal adorned with a personification of the Genius of Music, an allegorical bronze female figure with a lyre. The sculptor succeeds in capturing the arrogance, eccentricity, and uncompromising determination typically ascribed to the composer. An almost identical portrait of Beethoven by Bearer is in Brooklyn's Prospect Park.

**Signed:** *H. Bearer Sc.* **Collection of:** *City of New York; gift of the Beethoven Mannerchor.*

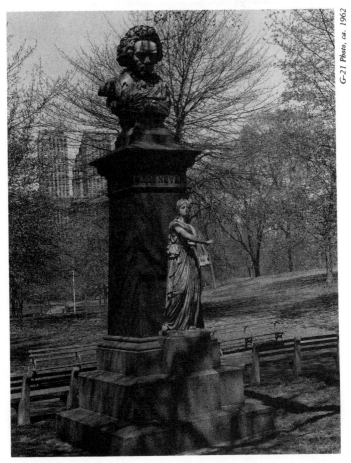

*G-21 Photo, ca. 1962*

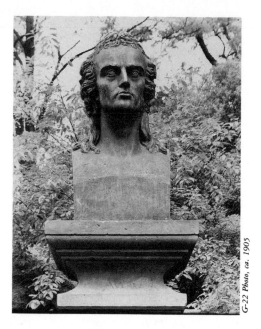

## G-22 Johann Christoph Friedrich von Schiller, ca. 1859

**Sculptor:** *C. L. Richter.* **Media and size:** *Bronze bust, over life-size; granite pedestal.* **Location:** *Central Park, across from the bandshell (but will be relocated to the Ramble).*

Of all the sculptures in Central Park this was the very first to be set out among the sapling trees and newly shaped and landscaped hillsides—quite a distinction, and at the least a note of considerable historical interest.

The 1859 centennial of Schiller's birth was an international event, marked by celebrations in Germany and in American cities where German immigrants resided. This neoclassical idealization of Schiller was unveiled on November 9, 1859, the first day of New York's three-day commemorative Schiller festival.

Dramatist, historian, and philosopher, Schiller (1759–1805) was above all a "Poet of the People." His plays *Wilhelm Tell, Mary Stuart, Don Carlos,* and *Wallenstein* aroused passion in his fellow Germans, and Schiller became the object of their devout admiration and love. He was a defender of liberty and his writings were a clarion call for freedom. To salute the poet's devotion to basic human rights, France made him a citizen of its new republic in 1792.

**Dedicated:** *November 9, 1859.* **Collection of:** *City of New York; gift of German-Americans.*

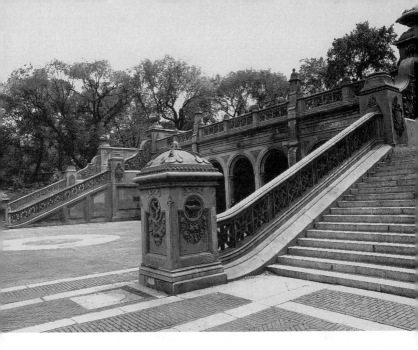

# G-23 Bethesda Fountain Terrace, begun ca. 1862

**Sculptor:** *Jacob Wrey Mould (1825–1884).* **Architect:** *Calvert Vaux (1824–1895).*

The *Bethesda Fountain Terrace* terminates the Mall with a grand gesture. It is the most formal element in Central Park. An architectural stone structure on two levels joined by a sweep of steps, it has slender columns and graceful arches. Its stone balustrade is all but covered with small-scale carvings based on natural forms and Moorish ornaments. Little wonder that it brings to mind the Alhambra. As a youth in England J. W. Mould, its sculptor, is said to have been apprenticed to Owen Jones, known for his published work on the Alhambra. In his 1869 description of Central Park, Clarence Cook complimented Mould: "He combines a strong feeling for color with an equal enjoyment of form, and he has such delight in his art that it is far easier for him to make every fresh design an entirely new one, than to copy something he has made before."

Reopened in 1987 after an extensive restoration, including a recarving of many of the eroded elements, *Bethesda Fountain Terrace* has been returned to its former grace. The two posts flanking the stairway have carved images representing Night and Day. The three vignettes representing Day, on the east, consist of a rising sun, the cock crowing, and a farm scene. The three panels representing Night, on the west, consist of the lamp burning next to a book, a bat and an owl, and the whimsical Halloween witch flying over a jack-o'-lantern. Balustrades and posts of the stairs leading to the fountain have intricate panels carved with fauna and flora of the four seasons.

This is the one place in the park where Olmsted and Vaux planned to have an elaborate display of sculpture. They envisioned a gallery of 26 statues and busts honoring distinguished Americans. A lack of funds made this impossible; thus ornamental finials cap the posts.

**Collection of:** *City of New York; purchase.*

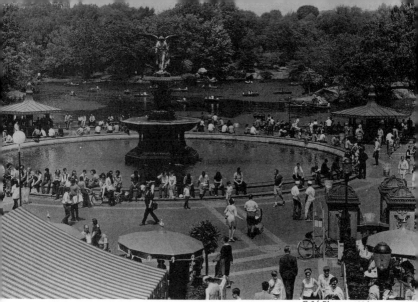

*G-24 Photo, ca. 1965*

## G-24 Bethesda Fountain, Angel of the Waters, 1868

**Sculptor:** *Emma Stebbins (1815–1882).* **Fountain substructure by:** *Jacob Wrey Mould and Calvert Vaux.* **Media and size:** *Bronze angel, over life-size; four bronze putti, life-size; blue stone lower basin, 15 feet in diameter.* **Location:** *Central Park, Bethesda Terrace.*

*Bethesda Fountain,* the only sculpture commissioned as part of the design of Central Park, and its centerpiece, cost over $60,000, an unprecedented sum in 1863. Its sculptor, Emma Stebbins, was the first woman to receive a commission for a major work in New York City.

Stebbins derived her subject from the Gospel of St. John. She compared the pool of Bethesda, whose waters, stirred by an angel, miraculously healed the sick, to the water which flowed as a purifying force into the homes of New Yorkers, a reference to the Croton Aqueduct, completed in 1842.

The neoclassical winged figure has an idealized face and heavy voluminous forms. With wings widespread, the angel strides forward as she symbolically stirs the waters of Bethesda with her right hand and carries a lily, emblem of purity, in her left. Putti figures, personifications of Temperance, Purity, Health, and Peace, surround the shaft below the upper basin. Varied and inventive capitals grace the paired columns that support the lower basin.

Critics universally acclaimed the fountain's substructure, while most insulted the angel, as the sculptor was the sister of Col. Henry G. Stebbins, President of the Central Park Board of Commissioners. The writer for the magazine *The Aldine* remarked, ". . . we see a nondescript being with a very masculine body, an inexpressive female face, huge outstretched wings, stiff arms, drapery that fills with wind like yacht sails in a storm, and elaborate details of celestial dressmaking quite wonderful to contemplate." Despite the fact that the public did not universally celebrate *Bethesda Fountain* in its time, it is today a beloved landmark in Central Park.

**Dedicated:** *May 31, 1873.* **Signed and dated:** *Emma Stebbins inv. mod. Rom 1868.* **Foundry mark:** *Ferd. V. Miller fudt* [?] *Munchen 187* [?]. **Collection of:** *City of New York; purchase.*

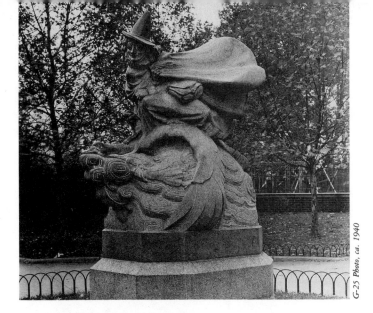

## G-25 Mother Goose, 1938

**Sculptor:** *Frederick George Richard Roth (1872–1944).* **Media and size:** *Granite statue, life-size; granite pedestal.* **Location:** *Central Park, near East Drive at 72nd Street.*

Mother Goose, cloak flying, rides a goose into the wind at the entrance to the Mary Harriman Rumsey Playground. The low reliefs on the sides of the angular, architectonic form depict, among others, the familiar nursery-rhyme characters Little Jack Horner eating his Christmas pie, Humpty Dumpty falling through the air, and Little Bo Peep seeking her lost sheep. Although conceptually the sculpture is imaginative, its overall design lacks fluidity and the charm of other Roth pieces in Central Park.

**Signed:** *F.G.R. Roth.* **Collection of:** *City of New York; purchase, Works Project Administration funds.*

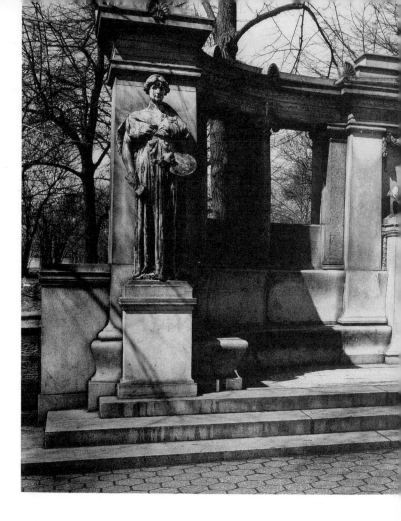

## G-26 Richard Morris Hunt Memorial, 1896–1901

**Sculptor:** *Daniel Chester French (1850–1931)*. **Exedra by:** *Bruce Price.*
**Media and size:** *Bronze figures and bust, over life-size; granite exedra.*
**Location:** *Fifth Avenue, between 70th and 71st Streets.*

Richard Morris Hunt (1828–1895) was the first American architect to train
at the famed École des Beaux-Arts in Paris. There he studied a range of
historic styles and principles of planning and construction that would be
reflected in his many notable buildings. Most of his work in New York is
gone: the Tribune Tower, the Lenox Library, the many mansions for the
wealthy, especially the châteaux for the Vanderbilts and Astors, but there are
still the Metropolitan Museum, his iron-front commercial building in Soho,
and the huge granite pedestal of the *Statue of Liberty*.

Hunt led in professionalizing the practice of architecture. He urged
collaboration among the arts and took leadership roles in pressing for higher
standards for public art. So it is little wonder that at his death artists,
architects, and critics banded together to honor him. Hunt had been the
founding president of the Municipal Art Society in 1892, and it organized
the fundraising and work on the memorial. Daniel Chester French won the

prestigious commission and asked Bruce Price, who had been a student of Hunt's, to design the architectural setting.

The *Richard Morris Hunt Memorial* successfully unites the craft of sculptor and architect, nicely balancing architectural elements with sculpture. In the center of the neo-Renaissance exedra, against a shallow alcove suggesting a temple, stands French's lively portrait bust of Hunt. Allegorical figures represent Painting and Sculpture (left) and Architecture (right) at the ends of the colonnade, their reserved classicism contrasting with the heightened naturalism of the portrait bust. *Painting and Sculpture* holds a palette in her left hand, and in her right hand grasps a sculptor's mallet. *Architecture* gently cradles a model of the Administration Building, designed by Hunt for the 1893 Columbian Exposition. The memorial to Hunt was carefully sited opposite one of his best-known buildings, the Lenox Library, which in true New York tradition was demolished a mere 15 years later to make way for the Frick mansion of 1913.

**Dedicated:** *October 31, 1898.* **Signed and dated:** *Daniel C. French Sc. 1900 (on each allegorical figure).* **Dated:** *1898 (on bust of Hunt).* **Foundry mark:** *The Henry Bonnard Bronze Co. NY 1900.* **Collection of:** *City of New York; gift by public subscription organized by the Municipal Art Society.*

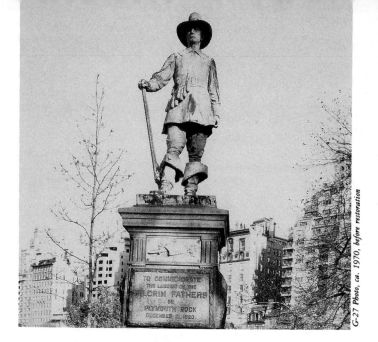

*G-27 Photo, ca. 1970, before restoration*

## G-27 **The Pilgrim, 1884**

**Sculptor:** *John Quincy Adams Ward (1830–1910).* **Pedestal by:** *Richard Morris Hunt.* **Media and size:** *Bronze statue, over life-size; four bronze bas-reliefs; granite pedestal.* **Location:** *Central Park, north side of the East 72nd Street transverse road.*

The Pilgrims of Plymouth Rock occupy a special place in the American imagination. In November of 1620 a group of 30 arrived in the *Mayflower,* landing on Cape Cod instead of their destination, Virginia, and established the first permanent settlement in New England. Their early hardships, friendship with the Indians, and first harvest feast are symbolically re-created each year on Thanksgiving.

On the occasion of the New England Society's 75th year, the association sought to honor the early colonists and commissioned sculptor J. Q. A. Ward to create an appropriate statue, one of the Pilgrim Fathers of Plymouth Rock, "some typical historical personage of the earliest period. . . ." Ward fulfilled this request by creating a figure historically accurate in its details yet one that fails to express a state of mind. *The Pilgrim* is more of a costume piece than an embodiment of character. The figure maintains a rigid stance, its right hand grasping the muzzle of a flintlock musket, the butt of which rests on the ground, while the doublet and broad collar, wide-rimmed hat, heavy boots, and wide belt and buckle are true to the period. But, as Russell Sturgis the critic commented in 1902, the work suffers for its "excessive costume" while not "getting to the man. . . ."

In addition to the bronze figure on its tall granite pedestal, there are four bas-reliefs depicting "Cross-bow and Arrows," the ship "Mayflower," "Commerce," and "Bible and Sword." The work was given a full-scale restoration in 1979 under the auspices of the Central Park Conservancy.

**Dedicated:** *June 6, 1885.* **Signed and dated:** *J.Q.A. Ward / Sculptor 1884.* **Foundry mark:** *The Henry-Bonnard Bronze Co. New York 1884.* **Collection of:** *City of New York; gift of the New England Society.*

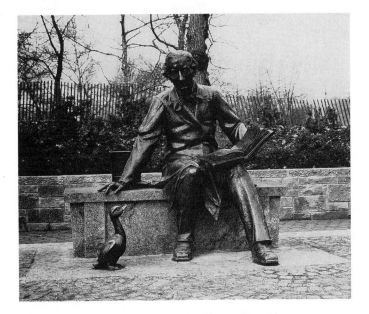

## G-28 Hans Christian Andersen, 1956

**Sculptor:** *Georg John Lober (1892–1961).* **Pedestal by:** *Otto F. Langmann.* **Media and size:** *Bronze statue, over life-size; granite pedestal.* **Location:** *Central Park, on the west side of Conservatory Lake, opposite East 74th Street.*

Hans Christian Andersen sits close to the ground, inviting children to climb into his lap, which they do with delight. The Lincolnesque figure reads from a book inscribed with the tale of *The Ugly Duckling* to an imaginary audience, the 2-foot-high bronze bird sitting near his feet. This shy, lanky Danish author created 168 fairy tales and was the first writer to produce a successful body of children's literature.

Sponsored by the Danish-American Women's Association in honor of the 150th anniversary of Andersen's birth, Lober's realistic portrait is strikingly similar in pose and theme to John Gelert's statue of the writer, erected in Chicago's Lincoln Park in 1896. Chicago-born Lober was possibly inspired by this precedent, but his primary source material came from a visit to Andersen's hometown in Denmark, where a portrait bust of the author by Lober is also on view at the Odense Museum.

When it was erected, during the heyday of Abstract Expressionism, Lober's statue provoked criticism from New York art experts; however, children, and the general public, quickly adopted the work. They sounded an alarm when the "Ugly Duckling" was stolen in August 1973. People offered money to cover the cost of replacing the duck, but the Parks Department uncovered the 60-pound bronze bird in a paper bag in a Queens lot, and the original Ugly Duckling is now well secured.

**Dedicated:** *September 18, 1956.* **Signed and dated:** *1956 by Georg S. Lober.* **Foundry mark:** *Modern Art Fdry. N.Y.* **Collection of:** *City of New York; gift of the Danish-American Women's Association.*

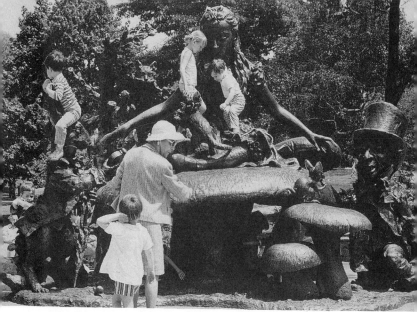

## G-29 Alice in Wonderland, 1959

Sculptor: *José de Creeft (1900–1982).* **Project designer:** *Fernando Texidor.* **Media and size:** *Bronze group, 11 feet high.* **Location:** *Central Park, Conservatory Pond, on axis with 75th Street and Fifth Avenue.*

Without question, the most beloved of the sculptures in Central Park, *Alice in Wonderland* appeals to old and young, especially the very young. They climb all over it. This is exactly what George Delacorte intended when he commissioned the sculpture in honor of his wife, Margarita, who, he said, "read *Alice* to all our children." Her favorite quotes from Lewis Carroll's fantastic tales of *Alice,* written in 1862, encircle the base of the whimsical group.

Alice is shown holding court on a mushroom throne surrounded by the March Hare, the Mad Hatter, the Dormouse, and the Cheshire Cat. Sculptor José de Creeft re-creates the book's fantasy world by constructing an environment populated by *Alice in Wonderland* characters, designed so that children can explore the underside of mushrooms, pet the Dormouse, and look the March Hare straight in the eye. De Creeft's felicitous sense of scale evokes this make-believe world. Alice is small enough to sit on a mushroom but large enough to hold a child in her lap. The features and costumes of de Creeft's figures strongly resemble John Tenniel's illustrations in the 1865 edition of the book. Alice in de Creeft's sculpture is also said to resemble the artist's daughter Donna.

As it turns out, the Spanish-born, French-trained de Creeft is better known to New Yorkers for this bronze tableau than for the direct carvings in wood and stone which he had pioneered earlier in the 20th century. These had sleek, sensuous smooth forms, while the *Alice* sculpture is full of crevices, textures, and irregular surfaces for children to experience.

**Dedicated:** *May 7, 1959.* **Signed:** *Jose de Creeft / sculptor; F. Texidor / project designer; Karsay Sandor / 1959.* **Foundry mark:** *Modern Art Foundry / N.Y.* **Collection of:** *City of New York; gift of the George and Margarita Delacorte Foundation.*

# G-30 Still Hunt, 1881–1883

**Sculptor:** *Edward Kemeys (1843–1907).* **Media and size:** *Bronze statue, over life-size; mounted on a natural boulder.* **Location:** *Central Park, East Drive at 76th Street.*

Crouched on a rock, ready to spring, a bronze panther stalks its prey. It was a stroke of genius to position the panther directly on this rocky outcropping without a pedestal, endowing it with a startling immediacy.

Kemeys, the first American sculptor to specialize in animals, was undoubtedly influenced by the French *animaliers,* a group of sculptors led by Antoine-Louis Barye (1796–1875). Self-taught, Kemeys made the decision to become a sculptor while working as an axman in Central Park's corp of engineers during the 1860s. He was particularly interested in the animal life indigenous to the United States and made numerous trips into the unsettled West to observe animals in their natural habitat.

In *Still Hunt* he captures the tension of the coiled cat thrusting its head forward, its gaze riveted on its next victim. The deeply carved eyes, stylized facial features, and rough hatchmarks scratching the surface of the bronze provide an impression of the animal rather than a literal likeness.

*Still Hunt* was erected in Central Park almost 20 years after *Tigress and Cubs* (1866) by Auguste Cain (see G-6) and *Eagles and Prey* (1863) by Christophe Fratin (see G-19). Unlike the French *animaliers,* Kemeys did not excell in the virtuoso rendering of textures and anatomical structure, and *Still Hunt* differs from these French precedents in its simple composition and stylized forms. The bronze panther is one of Kemeys' most significant works and a public favorite. His *Hudson Bay Wolves,* done in 1872, is in Philadelphia's zoo, and since 1894 his paired lions have guarded the front steps of the Chicago Art Institute.

**Dedicated:** *1883.* **Signed:** *E. KEMEYS.* **Foundry mark:** *M. J. Power / Bronze Founder NY.* **Collection of:** *City of New York; gift.*

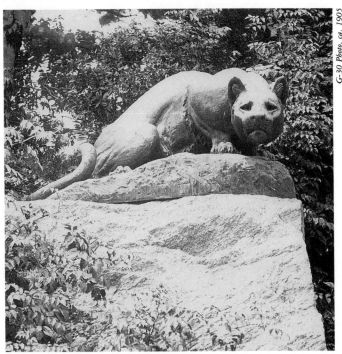

*G-30 Photo, ca. 1905*

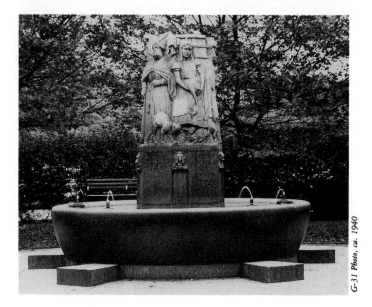

## G-31 Sophie Irene Loeb Fountain, 1936

**Sculptor:** *Frederick George Richard Roth (1872–1944).* **Architect:** *Badgeley & Wood.* **Media and size:** *Reinforced concrete fountain, 4 feet high.* **Location:** *Central Park, James Michael Levin Playground, 76th Street off Fifth Avenue.*

In 1926 the philanthropist August Heckscher provided funds for a playground in Central Park. When the Parks Department rebuilt the playground in 1935, they commissioned Roth to design this children's drinking fountain as a memorial to Sophie Irene Loeb, a writer and social worker who took a particular interest in children.

Roth devised the fountain around the theme of *Alice in Wonderland,* conceiving the primary element as a pylon-like castle, faced with characters from Lewis Carroll's fantasy. On the front the figures include Alice, the Duchess, and the Cheshire Cat; on the right are the Mad Hatter, White Rabbit, and Griffon; on the rear are the Kneeling Page and Queen; and on the left is the King. Roth employs a range of relief styles, varying the depth of the carved figures.

José de Creeft explored the same Alice in Wonderland theme 25 years later in another Central Park sculpture (see G-29). In contrast to Roth's architectonic design, de Creeft's sculpture invites young viewers to climb as well as to look.

**Dedicated:** *1936.* **Signed:** *F.G.R. Roth sc / Badgeley & Wood / Archts.* **Collection of:** *City of New York; purchase.*

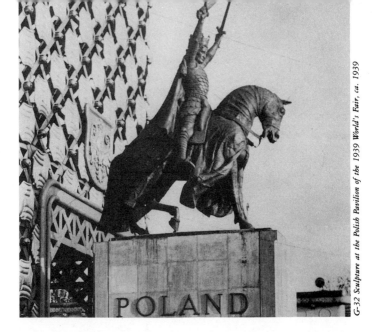

## G-32 King Jagiello, 1939

**Sculptor:** *Stanislaw Kazimierz Ostrowski (1879–1947).* **Pedestal by:**
*Aymar Embury II.* **Media and size:** *Bronze equestrian statue, over life-size;
granite pedestal.* **Location:** *Central Park, north of the 79th Street transverse
road, just east of Belvedere Lake.*

The Polish sculptor Stanislaw Ostrowski modeled an equestrian statue of
Poland's legendary warrior in 1908–1909 as an entry in a competition
sponsored by the pianist Paderewski for a monument for the city of Cracow.
Although he did not win that commission, 30 years later the Polish Chamber
of Industry and Commerce chose his Jagiello design for the entrance to the
Polish Pavilion at the 1939–1940 World's Fair in New York City, seen in
this photograph. In the wake of the Nazi invasion of Poland, *King Jagiello*
not only recalled Polish heroism but embodied a contemporary spirit of
defiance. In 1945 the exiled Polish government presented the monument to
the City of New York.

The first Christian Grand Duke of Lithuania, King Jagiello united
Lithuanian and Polish lands by marrying the Queen of Poland. This
monument refers to a specific episode preceding the Battle of Grunwald (July
15, 1410), when King Jagiello purportedly crossed above his head the two
swords that his adversaries had tauntingly handed him. It was an augur of
success, as the mythologized king conquered the Teutonic Knights of the
Cross.

Standing in his stirrups, with swords dramatically crossed above, the bold
torso of the king is immovably frontal, in contrast to the arched neck of the
straining horse. Heraldic emblems of Poland and Lithuania are woven into
the richly decorated capes draping horse and rider. In 1986 this highly
detailed bronze, which had been hastily cast, was cleaned and repatinated.

**Dedicated:** *July 15, 1945.* **Foundry mark:** *Fon. fm (cast in Italy).* **Signed
and dated:** *Stanislaw K. Ostrowski 1939.* **Collection of:** *City of New York;
gift of the King Jagiello Monument Committee.*

*G-33 Photo, ca. 1905*

## G-33 Egyptian Obelisk "Cleopatra's Needle," ca. 16th century B.C.

**Media and size:** *Syone granite, 71 feet high.* **Location:** *Central Park, west of the Metropolitan Museum of Art at about 82nd Street.*

New York's Egyptian obelisk, one of a pair, has a mate in London. The Khedive of Egypt gave the obelisk to the United States after the opening of the Suez Canal in 1869, but arrangements to bring it here from Egypt were not completed for another decade. William H. Vanderbilt contributed over $100,000 to cover the cost, and Lt.-Cmr. Henry H. Gorringer engineered the actual removal, which involved constructing a special railroad track to haul it up from the Hudson River.

The obelisks were put up at the Temple of Tum at Heliopolis around the year 1461 B.C. by Thothmes III to mark 40 years of his reign. During the era of Augustus in 12 B.C., the Romans moved them to the water entrance of Caesareum at Alexandria. Although Cleopatra died seven years before New York's obelisk arrived in Alexandria, it has always been called "Cleopatra's Needle."

Originally dedicated to the sun god, Egyptian obelisks have since served many purposes. In Rome, Christian popes of the 17th-century appropriated the pagan symbol to proclaim papal authority. In New York, the obelisk proclaimed America's international importance.

The four sides of New York's obelisk are inscribed with Egyptian hieroglyphics honoring Thothmes III (18th Dynasty). Four bronze crabs, one at each corner of the obelisk, first placed there by the Romans, are 19th-century replicas of the originals, two of which are in the Metropolitan Museum of Art.

**Dedicated:** *January 22, 1881.* **Collection of:** *City of New York; gift of Ismail, Khedive of Egypt.*

## G-34 Alexander Hamilton, 1880

Sculptor: *Carl Conrads (1839–?)*. **Media and size:** *Granite statue, over life-size.* **Location:** *Central Park, 83rd Street and East Drive.*

Hamilton's son and biographer commissioned this statue of a young Hamilton as an orator. He wears the usual costume of the period, including a wig, ruffled collar, and buckle shoes. Thirteen stars for the 13 colonies are carved in the granite pedestal above a high relief depicting a sword, scabbard, and military chapeau. This is one of the few free-standing granite sculptures in New York City and the igneous stone is holding up well in today's polluted air and acid rain.

Alexander Hamilton (1755?–1804), a masterful writer and orator, was one of the nation's most powerful statesmen. Although he held elitist views, advocating an aristocratic ruling class, he battled for a strong centralized government and for the ratification of the Federal Constitution. He was the principal author of the *Federalist Papers* (1787–1788), a series of 85 essays published in New York journals to garner support for the Federal Constitution. Hamilton's eloquent writings helped sway the vote in favor of ratification, and remain classic texts of political theory. Hamilton achieved further distinction as the first secretary of the treasury, establishing the Bank of the United States in 1790. He died in 1804 of wounds received during the famous duel with Aaron Burr, a longtime political opponent.

**Dedicated:** *November 22, 1880.* **Signed:** *C. Conrads.* **Inscribed:** *N.E. Granite Works / Hartford, CT.* **Collection of:** *City of New York; gift of John C. Hamilton.*

G-35 Fred Osborn, Robert Moses, and Paul Manship at sculpture's dedication, 1953

## G-35 William Church Osborn Memorial Playground Gateway, 1952

**Sculptor:** *Paul Manship (1885–1966).* **Gateposts designed by:** *Aymar Embury II.* **Media and size:** *Bronze gate with granite posts, 5 feet 5 inches high by 8 feet wide.* **Location:** *Central Park, inside the playground at 84th Street and Fifth Avenue.*

The name Paul Manship brings to mind the sleek *Prometheus* at the Rockefeller Center ice rink. This bronze gate in a play area alongside Fifth Avenue is Manship in a different idiom; delicate, small scale, reaching out to children by interweaving animals and foliage into a gate leading to their playground. He illustrates five scenes from Aesop's fables. Pairs of animals positioned as if in conversation in an open composition of branches, curling tendrils, and swaying grasses illustrate the moral of each fable, which is also told on a nearby plaque.

Noted for his "keen sense of design," Manship excelled in creating ornamental sculpture, inventing complex decorative patterns in stone and bronze without sacrificing form. Here the various animals merge gracefully into the intricate foliage, yet they retain a sense of fullness and three-dimensionality. The crispness of the individual elements, characteristic of Manship's sculpture, resulted from his method of carving directly into the plaster model.

The gates honor William Church Osborn (1862–1951), a one-time president of the Children's Aid Society and also of the adjacent Metropolitan Museum of Art. They were placed in storage after suffering vandalism, but plans are underway to replace stolen elements and to refurbish the work's patina. They are expected to be reinstalled soon between the tall stone gateposts with the appealing fauns and bears back atop the posts.

**Dedicated:** *June 15, 1953.* **Signed and dated:** *Paul Manship Sculptor 1952.* **Collection of:** *City of New York; gift of the William Church Osborn Memorial Committee.*

# G-36 John Purroy Mitchel Memorial, ca. 1926

**Sculptor:** *Adolph Alexander Weinman (1870–1952).* **Architectural setting by:** *Thomas Hastings and Don Barber.* **Media and size:** *Gilded bronze bust, over life-size; granite stele.* **Location:** *Central Park, Fifth Avenue and 90th Street.*

The youngest mayor of New York, John Purroy Mitchel (1879–1918) took office in 1914 at the age of 34. After a public career of fighting corruption in city government, Mitchel successfully ran for mayor as the Fusion party candidate on the issue of civic reform. Although Mitchel introduced significant improvements, public support for him declined as he became increasingly associated with industrialists and with the wealthy. Shortly after losing his bid for reelection in 1917, he died in a plane accident while training in the aviation corps for duty in World War I.

The memorial to Mitchel consists of an elaborate stone architectural setting, with stylized pediment, pilasters, and entablature that suggest a temple. Funerary urns are carved in high relief on the pilasters. A stone canopy hangs over the gilded bronze bust, and a polished black stone slab behind it provides a dramatic backdrop for the gilded inscription.

In 1986 the Central Park administrator had this work cleaned and gold-leafed, and the granite balustrade was rebuilt.

**Dedicated:** *1928.* **Collection of:** *City of New York; gift of the John Purroy Mitchel Memorial Committee.*

# G-37 William T. Stead Memorial, 1913

**Sculptor:** *George James Frampton (1860–1928).* **Architect:** *Carrère and Hastings.* **Media and size:** *Bronze and Indiana limestone; 4 feet high by 5 feet wide.* **Location:** *Central Park, at Fifth Avenue and 91st Street.*

Although few of us recognize his name today, William Thomas Stead (1849–1912) was an influential British journalist at the turn of the century. He died on the *Titanic,* going down with the ship after helping others to safety. So greatly was he admired in London that a bronze wall plaque was installed on the Embankment, the promenade along the Thames. In 1920 American admirers had a copy made of it and set into Central Park's wall. Stead had lived for a while in New York.

The *Stead Memorial* has a central bronze profile portrait done in relief, enframed with stylized festoons of exotic foliage and also two small free-standing allegorical figures. One is an armored knight representing Fortitude, the other an angelic figure representing Sympathy.

Frampton, a British artist, was a central figure in the late–19th-century English art movement known as the New Sculpture. Many artists associated with this group used decorative materials such as semiprecious stones, experimented with color, and invented new forms of architectural carving.

Ten blocks uptown from the *Stead Memorial* another wall relief honors journalist Arthur Brisbane (1864–1936), who achieved fame writing editorials for the New York *Evening Journal.* As part of the park wall, it consists of a granite shaft with a seat at one side. A sunken medallion, carved with a profile portrait of Brisbane by sculptor Richmond Barthé, is set into the wall above the bench.

**Dedicated:** *July 5, 1920.* **Signed and dated:** *George Frampton RA / 1913.* **Collection of:** *City of New York; gift of the Committee of the American Stead Memorial.*

*G-38 Sculpture in former location, 96th Street and Fifth Avenue, ca. 1909*

## G-38 Albert Bertel Thorvaldsen Self-Portrait, 1892

**Sculptor:** *Albert Bertel Thorvaldsen (1770–1844).* **Media and size:** *Bronze group; central figure, life-size; allegorical figure, under life-size; granite pedestal.* **Location:** *Central Park, off Fifth Avenue at 96th Street.*

New York City's only statue of a sculptor is a bronze copy of a marble self-portrait that Thorvaldsen made in 1839, which is in the Thorvaldsen Museum in Copenhagen. Like most life-size works scaled for indoors, it looks a little small outdoors as it is here on a pretty wooded rise where the 96th Street transverse meets Fifth Avenue.

Although the famed Danish sculptor was nearing 70 years of age, he depicted himself as an idealized younger man holding a chisel and mallet. He wears a workman's blouse, open to reveal the chest, soft slippers, and leg coverings that accentuate his supple calf muscles. The whole figure suggests strength and control. His elbow rests on a small figure of a young woman, actually a statue of *Hope,* that he had modeled in 1817 to serve as a support for the original marble. On the granite pedestal are copies of Thorvaldsen's most famous relief medallions, *Night* and *Day.*

Thorvaldsen succeeded Italy's Antonio Canova as the leading neo-classical sculptor of the 19th century. He was the first to emulate the more severe Greek style of the mid–5th century B.C., the heroic age of Athenian sculpture, rather than the later classical works that inspired Canova. Most observers admired the pristine contours and formal purity of his sculpture. His influence on younger artists was enormous, and by the time of his death, his name was renowned in both Europe and America.

**Dedicated:** *November 18, 1894.* **Dated:** *Nyso / den 5. Octob. 1839.* **Foundry mark:** *Lauritz Rasmussen's / Bronze [illegible] Kjobenhavn. 1892.* **Collection of:** *City of New York; gift of Danish-Americans.*

*G-39 Sculpture on original pedestal in former location, Bryant Park, ca. 1905*

## G-39 Dr. James Marion Sims, 1892

**Sculptor:** *Ferdinand von Miller II (1842–1929).* **Pedestal by:** *Aymar Embury II.* **Media and size:** *Bronze statue, over life-size; granite pedestal.* **Location:** *Central Park, at Fifth Avenue and 103rd Street.*

This oversize portrait of a surgeon is from the hands of a German sculptor whose father was a celebrated bronze founder in Munich much sought out by 19th-century sculptors to cast their works.

Shortly after Dr. Sims' death in 1883, a journal of surgery, the *Medical Record,* launched a subscription for a commemorative statue. Within a year 12,000 members of the medical profession and former patients had pledged $10,000. In the fall of 1894 the statue was erected on a Victorian-style stone pedestal in Reservoir Square, after 1884 called Bryant Park. Around 1928 when the park fell into disrepair the statue was put in storage until 1934, when it came to light again still protected by tarpaulins under the Williamsburg Bridge. It was then placed on a new stone pedestal on the Fifth Avenue edge of Central Park at 103rd Street, appropriately facing the Academy of Medicine.

Dr. Sims, often called the father of modern gynecology, developed new surgical methods and instruments; especially noteworthy was a silver wire for sutures in 1849. He founded the Woman's Hospital of New York. Known internationally, he received awards from France, Belgium, Italy, and Spain, and was called on to care for leading European women, including the Empress Eugénie.

**Dedicated:** *October 20, 1894.* **Signed and dated:** *Von Miller fec / Muchen 1892.* **Collection of:** *City of New York; gift by public subscription organized by the* Medical Record.

*G-40 Clay sketch, ca. 1926*

## G-40 **Burnett Memorial Fountain, 1926–1936**

**Sculptor:** *Bessie Potter Vonnoh (1872–1955).* **Consulting Architect:** *Aymar Embury II.* **Media and size:** *Bronze figures, life-size; granite pedestal resting in a pool.* **Location:** *Central Park, in the Conservatory Garden, Fifth Avenue and 105th Street.*

The friends of Frances Hodgson Burnett wanted to honor the author of *Little Lord Fauntleroy,* published in 1886, and *The Secret Garden,* in 1909, with a memorial in keeping with her personality and life's work. Instead of a portrait statue, they proposed a children's corner for a park or playground, with a marble bench or two, a small fountain or perhaps a birdbath—a type of work generally found in private gardens. Bessie Potter Vonnoh, known for her impressionistic small bronzes, devised a plan that was amplified by consulting architect Aymar Embury II. A site was chosen by the Parks Department in the newly created Conservatory Garden established in 1936 on the site of the old Central Park greenhouses.

Vonnoh shows a reclining lad lazily playing a flute while a graceful young girl stands and listens. She holds a large seashell brimming with water, and at her feet a birdbath continuously spills over into a pool, creating a gentle fountain. As these bronze figures were vandalized (the boy's arm and flute, the girl's hand, and a bird were stolen), the Central Park Administrator's Office had sculptor John Terken restore the fountain figures in 1980. He remodeled the lost parts, which were recast at the Roman Bronze Works.

**Dedicated:** *1936.* **Signed:** *Bessie Potter Vonnoh Sc.* **Collection of:** *City of New York; gift of the Frances Hodgson Burnett Memorial Committee.*

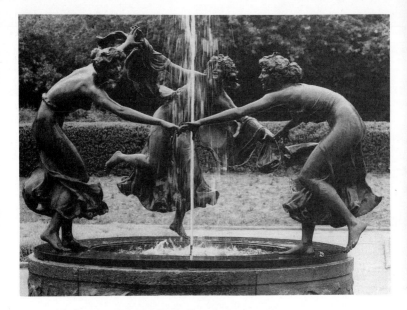

## G-41 The Untermeyer Fountain (Fountain of the Three Dancing Maidens), before 1910

Sculptor: *Walter Schott (1861–1938)*. **Media and size:** *Bronze, life-size figures; limestone base, 8 feet 2 inches in diameter.* **Location:** *Central Park, at the Conservatory Garden, Fifth Avenue and 104th Street.*

Set off to perfection in the Conservatory Garden, this charming fountain came to Central Park in 1947 from Samuel Untermeyer's Yonkers estate named Greystone, now Seton College for Girls. It appears to be a unique cast and is possibly the only example in this country of Walter Schott's work.

Three dancing maidens cavort precariously around the rim of a raised carved stone base which holds bubbling water that pours from the masks carved in relief on its sides. With drapery swirling, smiles flashing, and hair flying the group expresses joie de vivre and youthful abandon. It is equally effective from all angles. Varied gestures, garments, hairstyles, and facial features particularize each girl, yet together the three create a harmonious composition.

Schott was a prominent German sculptor, a favorite portraitist among German aristocrats. His most famous works are the terrace and statues he designed for Kaiser Wilhelm II's addition to San Souci in Potsdam, formerly the palace of Frederick the Great.

The *Three Dancing Maidens* was shown at the Brussels World's Fair in 1910 where it won the Great Gold Medal. Schott mentions in his autobiography that his Berlin friend Herr Rudolphe Moss owned the sculpture in 1930, but just when or from whom it was acquired by the Untermeyers is unclear.

**Dedicated:** *1947.* **Signed:** *Walter Schott.* **Foundry mark:** *Aktien –Gesellleschaft / Gladenbeck / Berlin–Friedrichshagen.* **Collection of:** *City of New York; gift of the sons and daughters of Samuel and Minnie Untermeyer.*

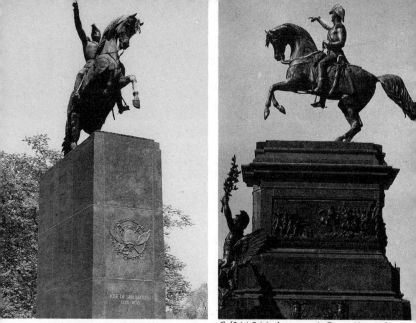

*G-42 (a) Original monument in Buenos Aires, 1948*

## G-42 José de San Martín, ca. 1950

**Sculptor:** *Louis Joseph Daumas (1801–1887).* **Landscape architects:** *Clarke, Rapuano and Holleran.* **Media and size:** *Equestrian statue, over life-size; granite pedestal.* **Location:** *Central Park South and Avenue of the Americas.*

The Argentinean general José de San Martín (1778–1850) liberated Argentina, Chile, and much of Peru from Spanish colonial rule. Son of a high Spanish official, he was sent to Spain to attend military schools, then returned to lead the revolt in his native land. This dignified equestrian sculpture, which shows him guiding his forces in battle, is a reduced copy of a grand monument erected in 1862 in Buenos Aires. Its French sculptor, Louis Joseph Daumas, who studied at the École des Beaux-Arts, achieved a remarkable feat in balancing the rearing horse. Horse and rider are supported on only the animal's rear legs. In 1950 the citizens of the Argentine capital gave this 20th-century cast of the 1862 original to New York to mark the centennial of San Martín's death and also to complete an exchange begun when Americans earlier gave a statue of George Washington to Buenos Aires.

The United States first voiced official recognition of newly liberated South American countries in the Monroe Doctrine of 1823. Over a century later, in 1940, the Senate ratified the Act of Havana, a joint action taken by the Pan-American Union to prevent Germany and other European countries from taking over European colonies in the New World. New York City officials renamed Sixth Avenue the Avenue of the Americas in 1945 and created this Central Park plaza at its northern end.

San Martín was place on its high polished-granite pedestal at the west side of the plaza in May of 1951, a month after Bolívar was set on his matching pedestal at the east side.

**Dedicated:** *May 25, 1951.* **Cast by:** *Humberto Radaelli, Buenos Aires.* **Bronze escutcheon (1954):** *Anthony de Francisci (1887–1964).* **Collection of:** *City of New York; gift of the City of Buenos Aires.*

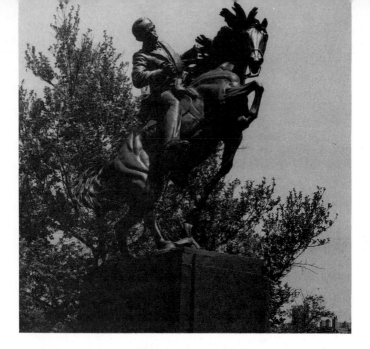

# G-43 José Martí, 1959

Sculptor: *Anna Vaughn Hyatt Huntington (1876–1973)*. **Engineers and
landscape architects:** *Clarke & Rapuano*. **Media and size:** *Bronze
equestrian statue, over life-size; granite pedestal*. **Location:** *Central Park
South and Avenue of the Americas*.

In the wake of the South American wars for independence, José Martí
(1853–1895), Cuban patriot, journalist, and poet, campaigned for the
liberation of Cuba from Spanish domination. Exiled in New York, he
continued to agitate for Cuban freedom, and in 1892 organized the Cuban
Revolutionary party. Martí returned to Cuba in 1895 where he died in action
at the battle of Dos Ríos, marking the beginning of Cuba's war for
independence.

In 1950 Dr. José Garcia-Mazas, a Cuban-born professor living in New
York, originated the idea of a monument to José Martí. The renowned
sculptor Anna Hyatt Huntington agreed to execute the work and offered it as
a gift to the Cuban government. Although Huntington completed the work
in 1959, it was not unveiled until 1965, because the city feared a
confrontation between pro- and anti-Castro factions at the site of the
memorial. Both groups regarded Martí as a symbol of their cause and wanted
to identify themselves publicly with this potent image, so the city delayed the
unveiling ceremony until the political climate had quieted down.

The equestrian statue shows Martí at the moment he was mortally
wounded. In civilian clothes, he clutches his side as he tries to regain his
balance. Huntington heightens the drama of the moment by depicting the
rearing horse with a flying mane and twisting neck. The Martí memorial is
Huntington's last major work, unveiled when she was 89, and it exhibits the
greater stylization typical of her later works.

**Dedicated:** *May 1965*. **Collection of:** *City of New York; gift of Anna
Vaughn Hyatt Huntington to the Cuban government*.

# G-44 Simón Bolívar, 1919

Sculptor: *Sally Jane Farnham (1876–1943).* **Media and size:** *Bronze equestrian statue, over life-size; granite pedestal.* **Location:** *Central Park South and Avenue of the Americas.*

Called "The Liberator" by South Americans, Simón Bolívar fought for independence between 1810 and 1825, freeing from Spanish domination what are today Venezuela, Colombia, Ecuador, Peru, Bolivia, and Panama. After his death in exile he became a legend, and his name marks the central square of almost every city and town in Venezuela. In New York's Central Park, he stands in Bolívar Plaza, designed by the city to terminate the Avenue of the Americas.

The Bolívar statue is an excellent portrait by the American sculptor Sally Jane Farnham, who won an international competition held by Venezuela. She loved horses and did several equestrian statues, but this 1919 work is her most famous. It was first placed on Central Park West near 83rd Street in 1921, after a graceless equestrian of Bolívar had been ordered removed by the city's art authorities, who had also rejected a proposed replacement.

The artist captures her subject's intellectual and heroic qualities. The furrowed brow and resolute mouth give the bronze figure a sense of dignity and nobility. Bronze coats-of-arms on the very, very tall polished granite pedestal represent Colombia, Ecuador, Peru, and Bolivia. Nearby on matching pedestals are equestrian statues of San Martín of Argentina and Martí of Cuba.

**Dedicated:** *April 19, 1921; rededicated April 19, 1951.* **Collection of:** *City of New York; gift of the Venezuelan government.*

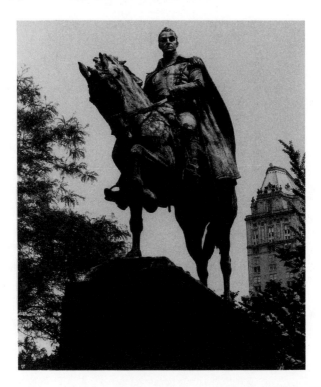

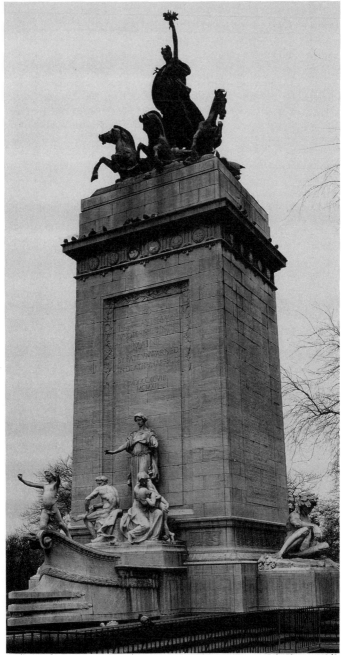

# G-45 The Maine Monument, 1901–1913

Sculptor: *Attilio Piccirilli (1866–1945).* **Architect:** *H. van Buren Magonigle.* **Media and size:** *Primary elements include marble pylon, 44 feet high; colossal bronze group; 9 marble figures, over life-size.* **Location:** *Entrance to Central Park at 59th Street and Columbus Circle.*

*The Maine Monument* is the most grandiose Beaux Arts war memorial in Manhattan. It has a triangular shape because the original plan was to place it in Long Acre Square, now Times Square, on a triangular piece of land, but city officials delayed approval of the commission and had to designate an alternative site, which was this entrance to Central Park. The design won over 40 others submitted in a competition held in 1901 for a victory memorial to the 260 sailors who perished when the battleship *Maine* exploded in Havana Harbor, touching off the Spanish-American War. It also honors all others who fought in that war. The commission vice-chairman was William Randolph Hearst, whose *New York Journal* had long supported the cause of the Cuban rebels. The design chosen was that of a little-known young American artist, Attilio Piccirilli, from a family of sculptors in Italy, and a well-established New York architect, H. Van Buren Magonigle.

This monument is striking in its complexity and size. The colossal, gilded bronze group, Columbia Triumphant, a female figure in a seashell pulled by three seahorses, surmounts a massive stone pylon. At the base of the pylon, facing Columbus Circle, is Victory, kneeling on a ship's prow, jutting into the pool. He holds aloft two olive wreaths. Behind him, Peace, a robed female figure, seemingly in a trance, stretches out her arms, and forms the apex of the triangular group arranged below her. The Michelangelesque male seated to her right is Courage, the counterpart to Fortitude, on her left. On the rear of the monument, Justice stands with eyes closed and arms raised, flanked by the Warrior, who executes her will, and History, who records her deeds. Semi-reclining figures of an old man, the Pacific Ocean, and a youth, the Atlantic Ocean, at either side of the memorial, suggest the scope of national victory.

The allegorical program of the *Maine Monument* reflects America's turn-of-the-century self-perception as a triumphant democracy. In 1980 the Parks Department restored the monument, the first such major restoration in the park.

A study in plaster for the head of Courage, given to the city by Piccirilli in 1945, is located in the Art Commission rotunda in City Hall.

A commemorative plaque cast from metal recovered from the *Maine* was created by Charles Keck (1875–1951) in 1913, and in 1936 the city purchased it with WPA funds. The bronze tablet, placed at the rear of the *Maine Monument,* on the east side, is 12 inches by 22½ inches and reads simply "In Memoriam, 1913."

**Dedicated:** *May 30, 1913.* **Signed:** *Atillio Piccirilli Sculptor; Harold van Buren Magonigle FAIA Architect.* **Collection of:** *City of New York; gift of the National Maine Monument Fund Committee.*

## G-46 Giuseppe Mazzini, 1876

**Sculptor:** *Giovanni Turini (1841–1899).* **Pedestal by:** *F. Matriati.*
**Media and size:** *Bronze bust, over life-size; granite pedestal.* **Location:**
*Central Park, West Drive, near West 66th Street.*

Looking down on passersby from a high pedestal, this large bronze bust
portrays Giuseppe Mazzini (1805–1872), writer and passionate advocate of
a united Italy, who devoted his life to unification under a republican form of
government and to religious freedom. Mazzini's ideals conformed to
American 19th-century democratic principles, and New York citizens
welcomed a commemorative bust of the Italian patriot. A writer for the *New
York Times* stated, "Our acceptance of it gives voice to the hearty sympathy
we have always felt for all nations struggling to be freer and greater, and is a
recognition of the living force of Mazzini's ideas in the politics of the world."

One of the more arresting busts in the park, the bearded face conveys the
intensity and cerebral character of the man. Contemporary commentators
said that sculptor Turini had captured a good likeness of Mazzini's chiseled
cheekbones and protruding brow. The light tilt of the head to the left and a
decisive glance animate the portrait.

In 1831 Mazzini had organized the "Young Italy" movement, which
Garibaldi joined and then went on to command Italy's revolutionary forces.
It is interesting to note that Turini, who did this fine bust in 1876, also did
the full-length statue of Garibaldi in Washington Square in 1888, but with
less success (see C-6).

**Dedicated:** *May 29, 1878.* **Signed and dated:** *G. Turini / Sculptor / New
York 1876.* **Foundry mark:** *G. Fischer & Bro. / Bronze Works, N.Y.*
**Collection of:** *City of New York; gift of Italian-Americans.*

## G-47 Seventh Regiment Memorial, 1869

**Sculptor:** *John Quincy Adams Ward (1830–1910).* **Pedestal by:** *Richard Morris Hunt.* **Media and size:** *Bronze statue, over life-size; granite pedestal.* **Location:** *Central Park, West Drive at 67th Street.*

This statue of a handsome young Civil War soldier and a similar work by Martin Milmore were the prototypes for many of the metal Civil War figures standing in small-town squares or on courthouse lawns across the country. They were produced in such numbers that it was possible to order them from catalogs.

The soldier is posed as though standing guard, both hands on his rifle, clothed in a heavy army overcoat and wearing a visored cap. The monument does not salute a specific hero but honors the 58 fallen members of the Seventh Regiment, New York's favorite, and the state's first group to respond to President Lincoln's call for volunteers days after Fort Sumter surrendered in April 1861.

Soon after the end of the Civil War, the Monument Association of the Seventh Regiment requested a site in the park for a memorial. Permission was granted by the Board of Central Park Commissioners, "provided that such structure nor any of its appendages be of a sepulchral character." They did not want the park to take on the look of a cemetery.

Ward completed the statue in 1869, with the help of an actor named Steele MacKaye who modeled wearing his regimental uniform. The bronze figure was cast at the Robert Wood foundry in Philadelphia at a time when many artists still had their works cast abroad. It stands on an austere tall granite pedestal sparely ornamented with incised stars and stripes, the words "Pro Patria" and also the dates "1861–1865," recording the regiment's long, hard years of service.

**Dedicated:** *June 22, 1874.* **Signed and dated:** *J.Q.A. WARD 1869.* **Foundry mark:** *R. Wood & Co. / Bronze Founders / Phila.* **Collection of:** *City of New York; gift of the Seventh Regiment National Guard.*

# G-48 Daniel Webster, 1876

Sculptor: *Thomas Ball (1819–1911).* **Pedestal by:** *Messrs. Batterson, Canfield, & Co.* **Media and size:** *Bronze statue, colossal; high granite pedestal.* **Location:** *Central Park, West Drive near West 72nd Street entrance.*

Daniel Webster's charisma and physiognomy captivated Boston sculptor Thomas Ball. The sculptor's direct naturalism lent itself to portraiture, and from pictures and memory he modeled a life-size bust which he completed after catching a glimpse of the great orator and senator from Massachusetts, who died shortly thereafter. The finished bust was such an immediate success that in 1853 Ball went on to make a 2-foot-high statuette that became such a favorite that it was patented and replicated innumerable times, making it one of the first mass-produced sculptures in this country.

In the 1870s Gordon Burnham wrote Ball requesting him to enlarge his statuette into the 14-foot-tall figure that now stands near 72nd Street. Unfortunately the colossal size copy missed the mark. Now as then, the tall bronze figure on its overly tall granite base overpowers the roadway on the west side of the park. Olmsted and Vaux foresaw that this would have been its effect on the Mall where Burnham had originally wanted it. They said it would dwarf the other sculptures and block the view.

Recently restored, it now has a light-colored patina that gives it a brassy look.

**Dedicated:** *November 25, 1876.* **Signed:** *Thomas Ball.* **Dated:** *1876.* **Cast at:** *Von Miller's Foundry, Munich.* **Collection of:** *City of New York; gift of Gordon W. Burnham.*

LIBERTY AND UNION,
NOW AND FOREVER,
ONE AND INSEPARABLE.

DANIEL WEBSTER

G-48 Photo, ca. 1905

## G-49 The Falconer, 1871

**Sculptor:** *George Blackall Simonds (1844–1929).* **Media and size:** *Bronze statue, over life-size; granite pedestal.* **Location:** *Central Park, West 72nd Street transverse road.*

Dramatically silhouetted against the sky, this fanciful conception portrays a youthful falconer, dressed in an Elizabethan doublet, stretching toward the falcon, poised for flight on his left wrist. The sculpture's smooth surfaces, athletic pose, and idealized anatomy recall classical Greek sculpture while its costume recalls England's past. Skillfully positioned on a natural outcropping of Manhattan schist, *The Falconer*'s scale, location, and hunting theme blend into the park's landscape.

George Simonds, Master of the English Art Worker's Guild (1884–1885), was himself a falconer and president of the British Falconer's Club. Unlike those sculptors who made only models which they gave to artisans to turn into stone or bronze, Simonds advocated artists' involvement in the technical aspects of sculpture. In 1886 Simonds presented a paper to the guild and stated: "these [original] works can only be produced by the [lost] wax process, and by the artist himself, or at least under his immediate supervision." *The Falconer,* one of Simonds' best sculptures, was cast using the lost-wax method. A second copy exists at the Society of Fine Art at Trieste.

After almost 100 years in the park, this sculpture was vandalized, losing its gauntleted arm and the falcon. Joseph Bresnan, then the Parks Department monuments officer, and sculptor Domenico Facci, relying on photographs, re-created the lost parts and the Parks Department had them cast in bronze. Although it took some years, the statue was reinstalled in 1982.

**Dedicated:** *May 31, 1875.* **Signed and dated:** *George Simonds Romae / MDCCCLXXI.* **Foundry mark:** *C PAPI F[?].* **Collection of:** *City of New York; gift of George Kemp.*

*G-50 Photo, ca. 1905*

# G-50 Alexander von Humboldt, 1869

**Sculptor:** *Gustaf Blaeser (1813–1874).* **Media and size:** *Bronze bust, over life-size; granite pedestal.* **Location:** *Central Park, at Central Park West and 77th Street.*

Standing under the spreading canopy of leaves of the handsome old American elm at West 77th Street, one can gaze up into the expressive face of Alexander von Humboldt (1769–1859), the pioneering naturalist and scholar. How seemly that this bust on its tall stone pedestal is now located beside the Explorer's Gate looking across Central Park West to the Museum of Natural History.

In 1799 von Humboldt left for a five-year exploration of South America, writing to a friend, "my true purpose is to investigate the interaction of all the forces of nature." His life work culminated in his five-volume opus *Cosmos,* an examination of the physical universe.

Von Humboldt was a man appreciated in his own time, and the anniversary of his birth set off worldwide celebrations. In New York a von Humboldt monument association commissioned a bronze bust for Central Park by the German sculptor Gustaf Blaeser. The 19th-century chronicler Walter S. Wilson quotes from a letter written to the association's president: "Blaeser knew Humboldt well, and works from memory, from Rauch's bust, from Schrader's best picture, and . . . from the cast taken of the head after death. You will get a work of art, and excellent likeness, of enduring value."

Honoring a man dedicated to the study and preservation of nature, it is one of the earliest sculptures placed in Central Park, and unquestionably one of the most appropriate.

**Dedicated:** *September 14, 1869.* **Signed and dated:** *GUST. BLAESER. FEC. BERLIN 1869.* **Foundry mark:** *Georg Howaldt & Sohn geg. / Braunschweig 1869.* **Collection of:** *City of New York; gift of the von Humboldt Monument Association.*

*G-51 Romeo and Juliet*

## G-51 The Tempest (1966) *and* Romeo and Juliet (1977)

**Sculptor:** *Milton Hebald (1917– ).* **Media and size:** *Bronze groups, over life-size; granite pedestal.* **Location:** *Central Park, near the entrance to the Delacorte Theatre, Central Park West and 81st Street.*

Two bronze statues illustrating Shakespearean characters mark the entrance to the Delacorte Theatre, home of Shakespeare in the Park, one of New York's liveliest traditions. Like the theater, they are the gift of George Delacorte.

*Romeo and Juliet,* pictured above, conveys lyrical calm. Hebald conceived them as stylized, cylindrical forms with smooth surfaces and little detail. The lovers are poised before a kiss as Juliet throws back her head in anticipation and Romeo bends over her.

*The Tempest* depicts the magician Prospero as he shelters his daughter, Miranda, under his left arm and casts a spell with the attenuated fingers of his right hand. The group is animated by its exaggerated gesture, windblown drapery, and irregular surfaces.

*The Tempest:* **Collection of:** *City of New York; gift of George Delacorte in honor of Joseph Papp.* ***Romeo and Juliet:* Dated:** *1977.* **Cast at:** *Spartaco Dionesi Foundry in Rome, 1978 (one of six casts).* **Inscribed:** *For Valerie George Delacorte / Hebald 1977.* **Collection of:** *City of New York; gift of George T. Delacorte.*

# (H)
# UPPER EAST SIDE
## *59th to 110th Streets, east of Fifth Avenue*

---

In this part of the city, where museums and residential buildings are plentiful, public sculptures are scarce. A major reason is the lack of small urban squares and green landscaped enclaves. The uncompromising grid laid on the city in 1811 reduced the number of residual spaces that lend themselves to plantings and sites for sculpture.

One exception to the grid here is the modest strip of park along the high edge of the East River, Carl Schurz Park, lying south of Gracie Mansion beginning at 87th Street. There, in a grotto-like setting, Peter Pan plays his flute to an audience of forest animals. Ten blocks south in John Jay Park, two welded-steel sculptures by Douglas Abdell project striking silhouettes, and on the median of Park Avenue, at virtually its highest point at 92nd Street, rises Louise Nevelson's painted steel construction *Night Presence IV*. Aside from these examples, most outdoor works, such as the interlocking geometric sculpture at 425 East 61st Street by Herbert Feuerlicht, stand in the small plazas in front of modern high-rise apartments.

Another group of sculptures in the Upper East Side are associated with institutional buildings and include Tony Smith's looming presence *Tau*, at Hunter College, Noguchi's carved boulder adjacent to the Metropolitan Museum of Art, and various works on temporary exhibition in front of the Guggenheim and Whitney Museums. These are recent works, reminders of the extensive development that has transformed the Upper East Side in the last few decades.

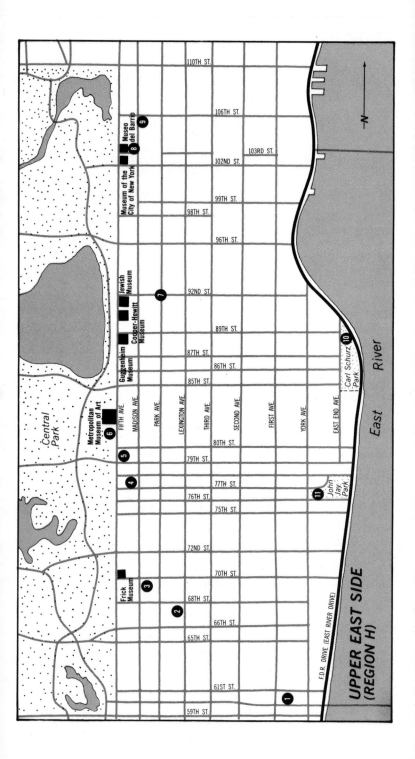

# H-1 Embrace, 1973

**Sculptor:** *Herbert A. Feuerlicht (1929– ).* **Media and size:** *Cor-Ten steel, painted red, 22 feet high.* **Location:** *425 East 61st Street, between York and First Avenues.*

Two interlocking geometric elements comprise *Embrace,* an abstraction with human content set in a small landscaped plaza beside a tall modern building. Fabricated in metal, the sculpture's straight edges, repetitiveness, and formal simplicity reflect the influence of Minimalism, yet the work's title, the relationship of the elements, and the sculpture's vertical orientation suggest the human figure. Originally, *Embrace* was the color of weathering steel until the owners painted it a warm, bright red in the late 1970s.

Sculptor Herbert Feuerlicht favors industrial materials and is a proficient welder. In addition to his own art, he has assisted other artists and furniture designers in the fabrication of their works. Another of his pieces that the public can readily see is the wall relief in the Chemical Bank located in the Exxon Building at Avenue of the Americas.

**Installed:** *November 14, 1973.* **Fabricated by:** *Milgo.* **Commissioned by:** *Kalikow Realty & Construction Corp.*

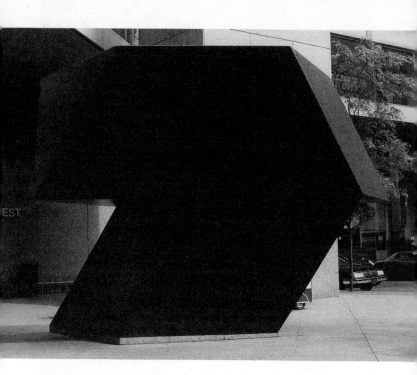

## H-2 Tau, 1965–1980

**Sculptor:** *Tony Smith (1912–1980).* **Media and size:** *Welded-steel sculpture, painted black; 14 feet high.* **Location:** *Hunter College, at the entrance on the southwest corner of East 68th Street and Lexington Avenue.*

*Tau,* so named because it resembles the letter "T," is compact, menacing, and elusive. As one climbs the steps from the subway below, it looms up ahead, an explosive force entrapped in the plaza. Two strong axes, one at a slight diagonal and the other horizontal, push against each other. The multiplanar horizontal element unpredictably shifts directions midway, yet the parts merge seamlessly. Painted a matte black, the sculpture reflects little light, and although it is hollow, it looks like a solid mass.

Tony Smith's sculptures are investigations which probe the relationship between geometric solids and space. Modular constructions, they are typically composed of tetrahedrons (a triangular pyramid) and octahedrons (a solid figure having eight faces). His reductive, geometric, machine-made forms have often been seen in the context of contemporaneous works called Primary Structures or Minimal Art. But Smith's works, often going beyond their analytical origins, take on a mysterious presence, at times arousing an emotional response in the viewer.

Smith was a practicing architect when he turned to sculpture in the early 1960s. He taught sculpture at Hunter College, and it was there that he evolved his sculptural system. The college administration purchased this work shortly after his death in 1980 as a monument in his honor. One wonders, though, how Smith himself would have felt about this site, for he preferred to place his works out of doors in a natural environment.

**Edition:** *One out of an edition of three.* **Collection of:** *City of New York; purchase.*

# H-3 Untitled, 1969

**Sculptor:** *Gonzalo Fonseca (1922–  ).* **Media and size:** *Carrara marble column, 6 feet high.* **Location:** *In front of the Twentieth Century Fund Building, 41 East 70th Street.*

Described by the artist as a "column with objects," Fonseca's untitled work is spare in form but rich in associations. The sculptor has pierced holes, carved indentations, and scratched cryptic, pictorial graffiti into the six-foot-high column of Carrara marble that bulges slightly toward the middle. Most noticeable is the projecting ledge that supports a tapering cylinder and a disk on a block, suggesting votive figures. Consistent with much of Fonseca's work, references to architectural form, devotional objects, and pretechnological cultures emerge in this sculpture.

The Uruguayan-born Fonseca has produced private and intimate works as well as monumental public pieces. He is best known for the environmental, outdoor sculptures (1964–1965) he created for the planned community of Reston, Virginia. He was one of two Latin Americans represented in the 1968 International Sculpture Symposium in Mexico.

**Signed:** *Fonseca / 1969.* **Collection of:** *Twentieth Century Fund.*

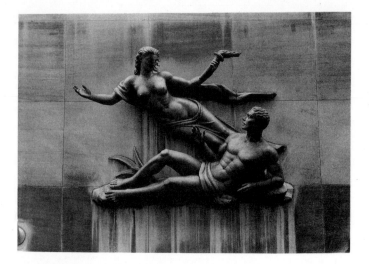

# H-4 Venus and Manhattan, ca. 1945

**Sculptor:** *Wheeler Williams (1897–1972).* **Media and size:** *Bronze group, over life-size.* **Location:** *980 Madison Avenue, between East 76th and 77th Streets.*

Well above street level on the façade of 980 Madison Avenue, formerly the location of Parke-Bernet Galleries, is this gilded high relief entitled *Venus and Manhattan.* A combination of classical mythology and modern allegory, it shows Venus with her arms outstretched as if in welcome, floating above a recumbent male figure, reminiscent of antique river gods. Beatrice Proske, a scholar of American sculpture, describes it as "an allegory of the enlightenment brought to the city through the arts of other lands." After the sculpture was set in place it became apparent that part of Venus extended 18 inches beyond the legal building line. Some members of the Board of Estimate wanted to charge Parke-Bernet a fee, but the work was finally approved.

Wheeler Williams, a successful figurative sculptor, created numerous works for public buildings throughout the United States. Trained as an architect, his architectural sculptures reflect his first profession in their clarity, compositional organization, and sharply chiseled contours.

## H-5 The Castle, 1970

**Sculptor:** *Priscilla Kapel.* **Media and size:** *Welded steel, 15 feet high.*
**Location:** *985 Fifth Avenue, at the northeast corner of East 79th Street and Fifth Avenue.*

No bird may have so much as perched on it, but still this fanciful metal construction seems like a sophisticated birdhouse resting on a post amid shrubbery.

Its sculptor, Priscilla Kapel, called it *The Castle* and gave it towers and turrets, tiled roofs, arched doorways, and curving staircases. Surely it does evoke a medieval structure, while her use of varied textures and colors helps make the imaginary castle believable.

At any rate, Sunday strollers study it with interest and Fifth Avenue bus riders watch for it. It is a "place marker" that says you are now at 79th Street.

**Signed and dated:** *P. Kapel / 70.*

# H-6 Unidentified Object, 1979

**Sculptor:** *Isamu Noguchi (1904– ).* **Media and size:** *Basalt, 11½ feet high.* **Location:** *Fifth Avenue at 80th Street, adjacent to the Metropolitan Museum of Art.*

This is one of Noguchi's carved boulders which he describes as "a reconciliation with nature," an answer to "pretentious monuments." The color, texture, and contours of the found rocks are as vital to the finished piece as the tooled, pockmarked passages. Vertically oriented, they evoke the monoliths of Stonehenge. His preoccupation with the earth, nature, permanency, and time is manifest in these monumental stone sculptures.

Noguchi's fondness for stone and direct carving developed during his apprenticeship with the sculptor Brancusi in 1927. Over time, the carving of the rock came to have a spiritual significance, described by Noguchi as ". . . the Zen of sculpture, where the stone and the artist is one."

Noguchi executed *Unidentified Object* for the space allotted to the Public Art Fund for rotating displays of sculpture at the entrance to Central Park at Fifth Avenue and 60th Street. After its temporary exhibition there in 1979, he presented it to the Metropolitan Museum of Art.

**Collection of:** *Metropolitan Museum of Art.*

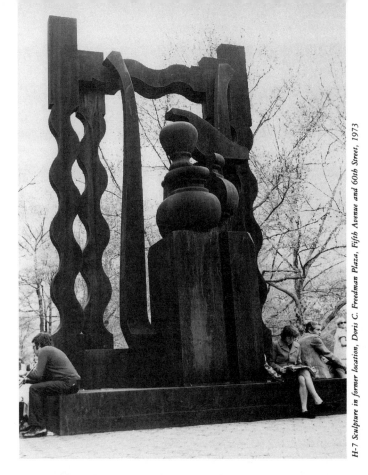

*H-7 Sculpture in former location, Doris C. Freedman Plaza, Fifth Avenue and 60th Street, 1973*

# H-7 **Night Presence IV, 1972** (original model 1955)

**Sculptor:** *Louise Nevelson (1900–1988).* **Media and size:** *Cor-Ten steel, 22 feet high by 13 feet wide by 9 feet deep.* **Location:** *Center mall of Park Avenue at 92nd Street.*

In celebration of half a century of living and working as an artist in New York, Louise Nevelson presented *Night Presence IV* to the city. The work was briefly exhibited at the entrance to Central Park at 60th Street and Fifth Avenue before its relocation to this site, selected by the artist and the Department of Cultural Affairs.

*Night Presence* is one of Nevelson's earliest outdoor metal works, and derives from a small wood sculpture of 1955. Silhouetted against the sky, each element of the sculpture is a discrete unit, lending the work an architectonic quality. It is an open construction in which, when viewed frontally, the work's shaped negative spaces assume an active role in the composition. In the center and framed by undulating ribbons of steel are forms based on turned, wooden doorknobs, surmounted by a cut-out of a bird in profile. Enlarged, these forms based on found objects acquire a totemic quality.

**Dedicated:** *December 14, 1972.* **Dated:** *1972.* **Fabricated at:** *Lippincott, North Haven, Connecticut.* **Collection of:** *City of New York; gift of Louise Nevelson.*

*H-8 DeWitt Clinton*

# H-8 Alexander Hamilton *and* DeWitt Clinton, ca. 1940

**Sculptor:** *Adolph A. Weinman (1870–1952).* **Media and size:** *Nickel silver bronze statues, over life-size.* **Location:** *Museum of the City of New York, at Fifth Avenue and 103rd Street.*

These statues, conceived as a pair, stand in niches on either side of the entrance to the Museum of the City of New York. Hamilton (1757–1804) was a leading statesman and orator. Clinton (1769–1828) was mayor of New York for most of the period between 1803 and 1815 and later, as governor of New York state, presided over the grand opening of the Erie Canal.

Although Adolph Weinman created these figures in 1940 in a new alloy called nickel silver, he created them in the style of the mid–19th century, evidenced by their smooth surfaces and simple and direct naturalism. In fact Weinman based the figure of Hamilton on one that Robert Ball Hughes designed in 1833 for the New York City Merchants Exchange, a sculpture that leading art historian Wayne Craven considers "the first marble portrait statue executed in America." Hughes' marble was destroyed when the Exchange burned in December 1835, but several models exist, including one owned by the Museum of the City of New York.

The figures by Weinman weigh approximately one ton each and were at that time the largest ever cast in nickel silver, chosen because its pale silvery color was regarded as well matched to the white marble niches. The nickel content of the alloy which is in the bronze family endows it with corrosion-resistant properties as it does stainless steel. Now, after nearly 50 years on heavily trafficked Fifth Avenue, the color of both the pristine marble and the silvery metal have darkened.

**Dedicated:** *January 14, 1941.* **Signed** *(on statue of Clinton): A.A. Weinman. Sculptor.* **Cast at:** *The Roman Bronze Works, Long Island City, New York.* **Collection of:** *City of New York; gift of a trustee of the Museum of the City of New York.*

## H-9 Sculptured Panels, ca. 1956

**Sculptor:** *Costantino Nivola (1911– ).* **Media and size:** *Four cast concrete panels, each 5 feet high by 8 feet wide.* **Location:** *On the west wall of the gymnasium wing of Junior High School 13, 1513 Madison Avenue at East 106th Street.*

In 1950 Costantino Nivola developed a new method of sand casting bas-relief sculpture in concrete and began creating reliefs and murals for a variety of architectural locations. Muted and planar, Nivola's works from the first appealed to architects. His panels for Junior High School 13 were commissioned in the 1950s during a Board of Education construction boom, and are early examples of his sand-casting technique.

In a letter to the Art Commission of October 8, 1956, the architect of the school, Frederick G. Frost, Jr., describes Nivola's working method and the projected panels for Junior High School 13: "In developing his designs, Mr. Nivola starts his modelling with representations of an idea. As he develops the forms they become less and less representational and more and more abstract until in their final state they may be regarded as pure abstractions which may or may not have meaning for each person viewing them. The panels do not attempt to tell a story: they are intended as decorative elements to provide design interest for this principal façade of the building."

The finished reliefs, massed into geometric shapes, create a pattern of projections and shadows. Some of the forms are vaguely anthropomorphic and suggest standing figures. Clusters of detail, which appear to be dripped concrete, add complexity to the designs.

**Collection of:** *City of New York; purchase.*

## H-10 Peter Pan, 1928

**Sculptor:** *Charles Andrew Hafner (1889–1960).* **Media and size:** *Bronze statue, 59 inches high.* **Location:** *Carl Schurz Park, near East 87th Street.*

Once part of a fountain in the lobby of the old Paramount Theater in Times Square, Peter Pan now presides over his forest friends in a grotto-like alcove in Carl Schurz Park. The slender youth seated on a tree stump props himself up with his bent right leg as he twists and looks downward toward the fawn, rabbit, and toad below. With his horn, and wearing a belted tunic and a pointed cap with a feather, he would be hard to mistake for anyone else.

Written by Sir James Matthew Barrie, the play *Peter Pan or the Boy Who Wouldn't Grow Up* appeared in 1905 at the Empire Theater in New York featuring Maude Adams and her company. This famous actress was also the subject of one of Hafner's best-known portrait busts, and probably she was the inspiration for Peter Pan.

**Installed:** *September 8, 1975.* **Signed and dated:** *C. A. Hafner Sculptor / New York 1928.* **Collection of:** *City of New York; gift of Hugh Trumbull Adams through Salute to the Seasons Fund for a Better New York, 1975.*

## H-11 Kryeti-Aekyad #2 *and* Eaphae-Aekyad #2, 1979

**Sculptor:** *Douglas Abdell (1947– ).* **Media and size:** *Welded steel, painted black.* Kryeti-Aekyad #2, *91 inches high;* Eaphae-Aekyad #2, *117 inches high.* **Location:** *John Jay Park, East 76th Street and York Avenue.*

Abdell's strongly two-dimensional sculptures are cut-outs in steel. They frame space, defining irregular, jagged voids which fit into the steel structure like pieces in a puzzle. The names for *Kryeti-Aekyad* #2 and *Eaphae-Aekyad* #2, derive from the artist's invented language. Part of what Abdell calls the "Aekyad series," the sculptures are variations on a theme, sharing the same formal vocabulary. The artist likens his work to writing and calligraphy, referring to the "Aekyads" as "letter sculptures." He views them as building blocks of potentially more complex structures, just as the alphabet is the basis of written language.

Abdell patterns his sculptures on drawings that he traces onto plate steel, cutting out the shapes and carefully welding them together. For Abdell, the artist is responsible for the crafting of the design, so he fabricates his own

sculptures. Abdell began on a more intimate scale, with complex forms, but the "Aekyad" series evolved toward structural simplicity and a larger scale.

The sculptures in John Jay Park were first exhibited on Park Avenue in conjunction with Abdell's 1979 show at Crispo Gallery. Most Park Avenue residents liked the works, and when the Rosentiel Foundation offered to buy them, residents signed petitions requesting that they stay. City authorities, however, ruled out Park Avenue as a site for sculpture, and offered John Jay Park. Once the Rosentiel Foundation learned that the sculptures would not remain in its neighborhood, it decided to purchase only *Kryeti-Aekyad* #2.

***Kryeti-Aekyad #2:*** **Collection of:** *City of New York; gift of the Rosentiel Foundation.* ***Eaphae-Aekyad #2:*** *On temporary loan from the artist.*

# (I)

# UPPER WEST SIDE

*59th to 110th Streets, west of Central Park*

---

The largest concentrations of public sculpture in this densely populated three square miles of Manhattan can be seen at Lincoln Center, Fordham University, and along elegant Riverside Drive, but outdoor works also embellish apartment complexes, schools, and a number of small islands where Broadway crosses other avenues.

The southern part of the region bears the fruits of the urban-renewal project that made way for Lincoln Center and nearby Fordham University in the 1960s. In the plazas flanked by the travertine façades of the center's performing arts buildings, sculptures by 20th-century giants Alexander Calder and Henry Moore deserve special note. Inside Lincoln Center buildings numerous other artworks are on public display. Southward, across West 60th Street, Fordham University has amassed a collection of outdoor sculptures, most facing Columbus Avenue.

Farther north, Riverside Drive and Park rise and dip along the western edge of Manhattan from 72nd Street to 152nd Street. Ornate apartment buildings border the drive to the east, while to the west the Palisades can be seen across the Hudson River. Designed in 1875 by Frederick Law Olmsted (1822–1903), and expanded in 1937 by Gilmore D. Clarke, chief landscape architect under Parks Commissioner Robert Moses, Riverside Drive and Park provide a scenic drive, promenade, and recreation area. City authorities have made changes over the years, particularly in 1937 with the construction of the Henry Hudson Parkway, but the park remains an elegant ribbon of green mediating between the urban landscape and the river.

The many monuments dotting Riverside Drive face west, forming a row and enhancing the effect of a stately promenade. *Grant's Tomb* was the first to be erected; during the first three decades of the 20th century other sculptures were placed in quick succession. On foot or from a car one can view the parade of eight monuments, which include the *Joan of Arc* by Anna Vaughn Hyatt Huntington, restored through the City's "Adopt-A-Monument" program in 1987, and the classical *Soldiers' and Sailors' Memorial*.

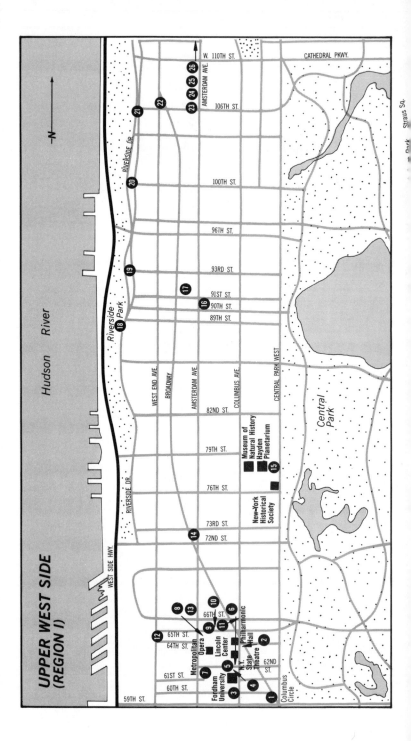

UPPER WEST SIDE
(REGION I)

Hudson River

Riverside Park

WEST SIDE HWY.

RIVERSIDE DR.

WEST END AVE.

BROADWAY

AMSTERDAM AVE.

COLUMBUS AVE.

CENTRAL PARK WEST

Central Park

W. 110TH ST.
CATHEDRAL PKWY.
106TH ST.
100TH ST.
96TH ST.
93RD ST.
91ST ST.
90TH ST.
89TH ST.
82ND ST.
79TH ST.
76TH ST.
73RD ST.
72ND ST.
66TH ST.
65TH ST.
64TH ST.
62ND ST.
61ST ST.
60TH ST.
59TH ST.

AMSTERDAM AVE.

Museum of
Natural History
Hayden
Planetarium

New-York
Historical
Society

Metropolitan
Opera

Lincoln
Center

N.Y. State
Theatre

Philharmonic
Hall

Fordham
University

Columbus
Circle

Straus Sq.

—N→

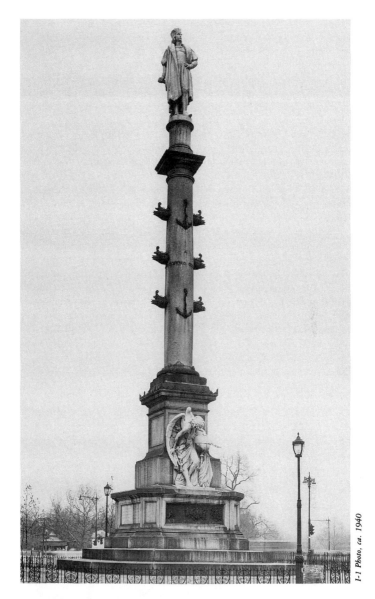

## I-1 Columbus Monument, 1892

**Sculptor:** *Gaetano Russo (active 1880s–1890s).* **Media and size:** *Granite column, 26 feet high; Carrara marble statue of Columbus, 13 feet high; Carrara marble allegorical figure of the Genius of Discovery; two bronze bas-reliefs, 2 feet high by 6 feet long.* **Location:** *Columbus Circle, Eighth Avenue and 59th Street.*

The celebratory *Columbus Monument* was unveiled October 12, 1892, on the 400th anniversary of Columbus' discovery of America. For almost a century now it has held its own at one of the city's great crossroads in spite of drastic changes in its surroundings. Here at the southwest corner of Central Park where Broadway intersects Central Park West, Eighth Avenue, and 59th

Street, a work of assertive presence is called for. The 13-foot-tall statue of Columbus on its 26-foot granite column poised on a high base surrounded by splashing fountains, a latter-day Roman victory column, fills the bill.

Besides its size and complex silhouette, the monument has elements of decoration based on the themes of discovery and conquest. To study these the pedestrian must pick his way with care through the vehicular traffic moving rapidly around Columbus Circle. On the south side of the base a nude winged marble figure of a youth bending to study a terrestrial globe represents the Genius of Discovery. On the base beneath him a rectangular bronze bas-relief panel shows Columbus putting ashore and giving thanks to God while natives peer from behind foliage. On the north side of the base on a bronze bas-relief panel, his three ships, the *Nina, Pinta,* and *Santa Maria* set sail from Spain. The column itself is ornamented with three pairs of bronze rostra, beak-like prows of ancient ships designed to ram enemy vessels.

The *Columbus Monument* embodies the pride of Italian-Americans in this intrepid navigator, venerated as a national hero. They donated funds for its construction and erection under the unflagging leadership of Carlo Barsotti, who used his newspaper, *Il Progresso,* to spur the nationwide campaign. Editor Barsotti also organized a veritable pageant for the monument's unveiling, which was attended by some 10,000 people, including officials of Italy, Spain, and the United States. There were military exercises, dance performances, and orations.

In 1960 Douglas Leigh, creator of Times Square spectacular signs, designed water displays with leaping jets of water patterned on fountains in Rome. These were presented to the city by the Delacorte Foundation, which now maintains them.

**Dedicated:** *October 12, 1892.* **Signed and dated on bronze tablets:** *G. Russo, ROMA 1892.* **Foundry mark:** *FOND / NELLI / ROMA.* **Collection of:** *City of New York; gift of Italian-Americans through a public subscription organized by Carlo Barsotti, editor of* Il Progresso.

*I-2 Photo, ca. 1930*

## I-2 **Dante Alighieri, 1912–1921**

**Sculptor:** *Ettore Ximenes (1855–1926).* **Pedestal by:** *Warren and Wetmore.* **Media and size:** *Bronze statue, over life-size; granite pedestal.* **Location:** *Dante Square, Broadway and 65th Street.*

The New York branch of the Dante Alighieri Society planned a Dante monument to salute the 50th anniversary of Italian unification in 1912, but the monument was not completed until 1921, so it marked the 600th anniversary of Dante's death. Carlo Barsotti, editor of the Italian newspaper *Il Progresso,* launched the campaign, the fifth public subscription he had organized for New York statues honoring Italians. The campaign caused a debate in the Italian-American community. Some people, believing that Barsotti was promoting the monument for his own self-interest, opposed the plan.

The Dante monument also aroused debate in official art circles. The Art Commission recommended a simpler conception, objecting to Ximenes' original design, which included an obelisk, four high reliefs, a wreath, and an eagle in addition to the Dante statue. There was also disagreement about the proposed location of the work in Times Square.

As completed, the monument consists simply of a very expressive robed figure of the poet, crowned by the customary laurel wreath and holding a copy of the *Divine Comedy.* The graceful stance, stylized folds of drapery, and piercing gaze endow the statue with an icon-like presence.

Italy's greatest poet, Dante Alighieri (1265–1321) wrote the first vernacular lyric masterpiece, the *Divine Comedy.* In this dramatic poem Dante narrates his voyage from Hell to redemption, creating a vision of the "other world" that has endured for over 600 years.

In 1921 Barsotti donated a replica of *Dante* for Meridian Hill Park in Washington, D.C.

**Dedicated:** *1921.* **Foundry mark:** *Denigris Brothers.* **Collection of:** *City of New York; gift of Italian-Americans.*

# I-3 Mother Playing, 1961

**Sculptor:** *Chaim Gross (1904– )*. **Media and size:** *Bronze statue, 48 inches high by 80 inches long.* **Location:** *Fordham University / Lincoln Center, on Columbus Avenue near 60th Street.*

The theme of mother and child is one of sculptor Chaim Gross's favorite subjects. Recalling his earlier sculptures of acrobats and dancers, Gross shows the figures in action, balanced precariously. Suggesting a seesaw, the mother's semi-reclining body forms an arc, supported in the middle by a narrow cylinder. She faces her small daughter, straddled across the end of her leg, and the two figures clasp one another with outstretched arms.

The Austrian-born Gross attracted attention in the 1930s with his direct carvings in wood, and he helped to create interest in that technique and medium. Later in his career he began making bronzes, freeing himself from the confines of a cylindrical piece of wood. He carved the model for *Mother Playing* in plaster, and the bronze retains the sharp planes and angles of the plaster model. Another cast of it stands in front of Hadassah–Hebrew University Medical Center in Jerusalem.

**Collection of:** *Fordham University; gift of Mr. and Mrs. Chaim Gross.*

## I-4 Peace, ca. 1985

**Sculptor:** *Leonardo Nierman (1932– ).* **Media and size:** *Bronze, 12 feet high.* **Location:** *Fordham University / Lincoln Center, on Columbus Avenue at 61st Street.*

*Peace* is a twisting, biomorphic form evocative of an eternal flame. It is one of the few outdoor bronzes by Nierman, who is better known for his brilliantly hued paintings, also reminiscent of flames. It was presented in 1985 and is Fordham University's most recent sculptural acquisition, positioned on the grassy slope of lawn along the Columbus Avenue margin of the campus.

**Collection of:** *Fordham University; gift of Mr. and Mrs. Stanley A. Young.*

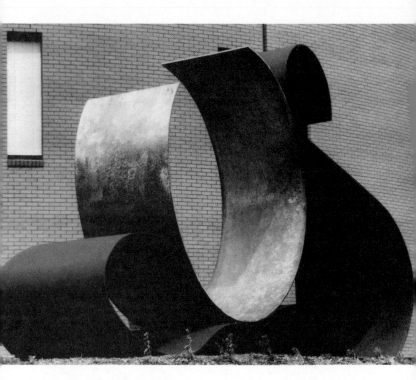

# I-5 City Spirit, 1978

**Sculptor:** *Lila Katzen (1932– ).* **Media and size:** *Cor-Ten and stainless steel, 12 feet high.* **Location:** *Fordham University / Lincoln Center, on Columbus Avenue at 61st Street.*

Perched on a hill in front of Fordham University's cylindrical law school is Lila Katzen's *City Spirit,* made from curls and loops of Cor-Ten and stainless steel. The sculptor explains, "I entitled the sculpture *City Spirit* because it was a combination form of a meandering shape (the dark Cor-Ten steel) enclosing a brilliant circular form (textured stainless steel) that signified the interlocking of all the elements of the city." Fordham University acquired the sculpture after it was exhibited there as part of Katzen's 1978 show.

Katzen is known for her open, calligraphic steel sculptures, made from folding and rolling steel rather than cutting and welding it. She says that steel is a "living, growing entity" with its own "identity," and also asserts that her work, although made from an industrial material, is responsive to human needs, conceived to work in harmony with people and a particular site.

**Collection of:** *Fordham University; gift of Mr. and Mrs. Sidney Feldman.*

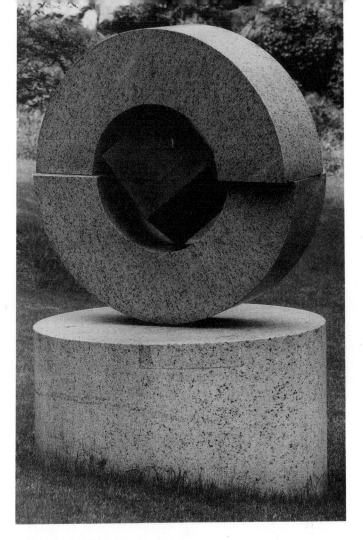

# I-6 Circle World #2, 1969

**Sculptor:** *Masami Kodama (1933– ).* **Media and size:** *Milford pink and black granite, 54 inches in diameter; granite pedestal, 54 inches in diameter.* **Location:** *Fordham University / Lincoln Center, on Columbus Avenue near 62nd Street.*

This compact geometric sculpture consists of two pink doughnut-like halves encircling a black cube. The halves do not form a perfect union and the cube, balanced on a point in the center, looks as though it might topple over, lending the sculpture an edgy, unpredictable quality. The work's title, *Circle World #2,* suggests that the sculpture has an underlying cosmic meaning, perhaps an allusion to the instability of the universe.

Sculptor Masami Kodama is a Japanese artist who has been living in this country for some 20 years. He works in various types of stone, favoring hard geometric forms which he combines in unexpected ways.

**Collection of:** *Fordham University; gift of Doris and Edward Rosenthal.*

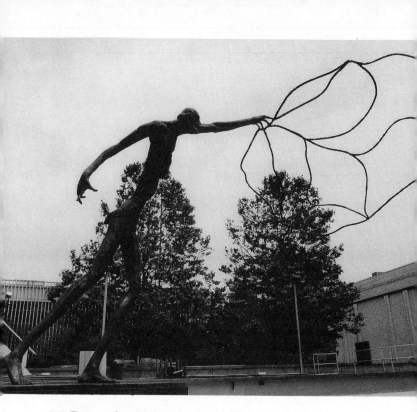

## I-7 Peter the Fisherman, 1965

**Sculptor:** *Frederick Shrady (1907– ).* **Media and size:** *Bronze statue, 28 feet high.* **Location:** *Fordham University / Lincoln Center, West 62nd Street.*

A secular interpretation of a religious theme, *Peter the Fisherman* (variously titled *St. Peter Casting a Net* or *Peter, Fisher of Men*) represents, in the words of its sculptor, "the enhanced role of the university casting its lines of influence, knowledge, and concern out over the metropolis." The piece is based on the biblical passage (Matthew 4:18–20) where Christ encounters Peter and his brother Andrew "casting a net into the sea", and beseeches them, "Follow me, and I will make you fishers of men."

Shrady depicts Peter as an attenuated figure dramatically casting a 14-foot net over the fountain pool. The expressionistic, emaciated image is characteristic of Shrady's style and of his interest in religious themes.

**Installed:** *1970.* **Commissioned by:** *Board of Trustees of Fordham University; gift of Mr. and Mrs. William T. Brady.*

# I-8 Le Guichet, 1963

**Sculptor:** *Alexander Calder (1898–1976).* **Media and size:** *Steel, painted black; 14 feet high.* **Location:** *Lincoln Center, in front of the New York Public Library and the Museum of the Performing Arts.*

This steel construction balances on four arched elements and a folded, triangular plate. Rising toward a point, the tentacle-like projections branch out in several directions, creating a series of archways through which the viewer can pass. Like a fantastic spider, *Le Guichet* straddles the plaza. The title suits the location, for it is the French word for ticket window, evoked by the hole piercing the triangular plate. Calder did not design the sculpture for the Lincoln Center site and consequently was unable to scale it to the surrounding architecture and plaza. After its installation, he punned: "It's too small for that spot. But the pigeons like Henry Moore than me," an allusion to the sculpture in the nearby reflecting pool.

The son and grandson of sculptors, Calder studied engineering before becoming a sculptor himself. His work combines the engineering dynamics of stripped form with whimsy and humor. He is most famous for his mobiles, floating constructions made from brightly colored biomorphic plates suspended from rods and wires. In 1932 Marcel Duchamp coined the term "mobile" to describe these kinetic works, and soon afterward Jean Arp quipped, "Well, what were those things you did last year—stabiles?" Since then, Calder's stationary works, among them *Le Guichet,* have been known as stabiles. They began as small, delicate pieces, paralleling the early mobiles, and by the 1960s evolved toward monumental forms, usually painted black or bright red. Calder's streamlined, majestic stabiles complement the glass-and-steel façades of International-style buildings and have become familiar landmarks in many American cities.

**Dedicated:** *November 15, 1965.* **Signed and dated:** *"Calder monogram" / 1963.* **Collection of:** *Lincoln Center for the Performing Arts; gift of Howard and Jean Lipman; on indefinite loan to the City of New York.*

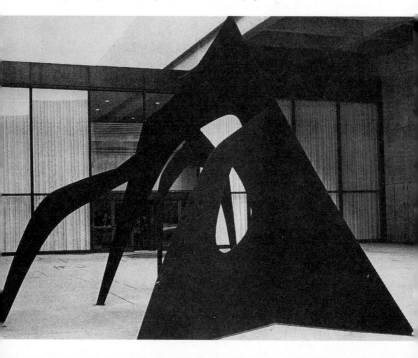

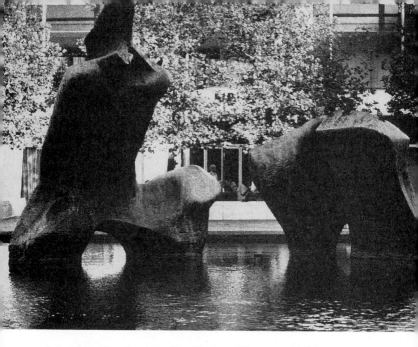

## I-9 Lincoln Center Reclining Figure, 1965

**Sculptor:** *Henry Moore (1898–1986).* **Media and size:** *Bronze abstract sculpture, 30 feet long.* **Location:** *Lincoln Center Plaza North, in the reflecting pool.*

Upon Henry Moore's death in 1986, art critic John Russell reflected that the English sculptor had become "in many parts of the world the No. 1 choice whenever a public sculpture was needed." Ironically this piece, one of Moore's largest and best known, provoked debate in 1965 when representatives of Lincoln Center presented it to city officials. At that time there were no other abstract sculptures on city property, and Moore was not yet a household name.

Moore's well-known sculptures of reclining figures, inspired by the Chacmool, a pre-Columbian Mexican male figure, combine a humanist content with the force of primitive art. Placed as it is in a reflecting pool, this work is also a meditative focal point. As is characteristic of many of Moore's sculptures, the negative spaces play an active role in a work's configuration, seen here in the cavities carved into the bottom of these two segments. Adding to the bronze's earthy quality is its textured surface, creased and rough like an elephant's skin.

Moore had already created a maquette of *Reclining Figure* when he received the Lincoln Center commission, and he was delighted with the opportunity of enlarging it to monumental proportions. Although the English sculptor preferred to isolate his works in a landscape where the sky is their only background, he liked the Lincoln Center site, commenting, "As people walk around it [the sculpture], I hope they will find continual interest from different angles and that it will give a contrast to the architecture which, like all architecture, is rather geometric and static."

**Installed:** *October 1965.* **Foundry mark:** *Guss H. Naack Berlin.* **Collection of:** *Lincoln Center; gift of the Albert A. List Foundation; on indefinite loan to the City of New York.*

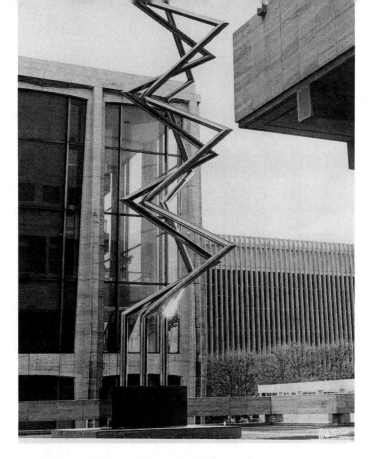

## I-10 Three Times Three Interplay, 1971

**Sculptor:** *Yaacov Agam (1928– ).* **Media and size:** *Stainless steel, 32 feet high.* **Location:** *Outside the Juilliard School, at Broadway and 65th Street.*

Its creator, Israeli artist Yaacov Agam, calls this a "transformable sculpture," for *Three Times Three Interplay* can assume an infinite number of forms. Composed of three movable shining stainless-steel tubes, shaped like zigzags, its elements interlock in a flat plane or project in multiple directions. As Agam describes it, the work is "not a statement, but a constant becoming, not a sculpture but many possibilities for one."

A pioneer in the field of kinetic art, a type of art that moves, Agam came to public notice in the 1950s with his abstract "transformable paintings." His interest in this art form stems from his spiritual commitment to Judaism, for as Agam has explained, the "driving force" of his work is his aim "to give plastic and artistic expression to the ancient Hebrew concept of reality." Agam's movable sculptures are analogous to this reality, which is always in flux and therefore cannot be represented by a fixed image. On a less philosophical note, Juilliard's sculpture is also an enjoyable object that incorporates chance and time and invites our participation.

**Dedicated:** *May 4, 1971.* **Collection of:** *Juilliard School; gift of Mr. and Mrs. George Jaffin on behalf of the America-Israel Cultural Foundation.*

## I-11 Richard Tucker, 1979

**Sculptor:** *Milton Hebald (1917– ).* **Media and size:** *Bronze bust, over life-size; stone pedestal.* **Location:** *Richard Tucker Park, at 66th Street, Broadway, and Columbus Avenue.*

Richard Tucker (1914–1975) was a leading tenor with the Metropolitan Opera from the time of his debut in 1945 until his death. His wife, Sarah, commissioned this bust in his honor, appropriately erected across the street from Lincoln Center. The well-known singer dominated the Metropolitan's repertoire of Italian opera, attaining special distinction for his interpretation of Radames in *Aïda*. He also sang in French opera, notably *Faust* and *Carmen*.

The loosely modeled bust, characterized by a textured surface, surmounts a high, streamlined pedestal. A similar bust of Tucker was unveiled in Tel Aviv in July 1979.

**Signed and dated:** *Hebald 1979.* **Collection of:** *City of New York; gift of Mrs. Richard Tucker.*

## I-12 James Felt Memorial, 1979

**Sculptor:** *William Tarr (1925– )*. **Media and size:** *Mayori-R steel, 10 feet high.* **Location:** *Amsterdam Houses Addition, on 64th Street between West End and Amsterdam Avenues.*

Throughout his long career in public service, James Felt campaigned for improved public housing, urging in a 1970 editorial that "zoning be radically modified or changed, for the growing shortage of decent housing is one of the city's most critical problems." In recognition of Felt's civic contributions as real estate developer, member of the City Housing Authority, chairman of the Public Development Corporation, and finally chairman of the City Planning Commission, the New York City Housing Authority commissioned this commemorative pylon at an Upper West side housing project.

Completed shortly after Tarr's memorial to Martin Luther King, Jr. (see I-13), this work was also conceived as an asymmetrical arrangement of cubic elements, embellished with welded letters and phrases pertaining to the subject's life. Positioned in a large plaza off the sidewalk, the slender tower, in contrast to the King memorial, blends into its surroundings.

**Collection of:** *New York City Housing Authority.*

# I-13 Martin Luther King, Jr., Memorial, 1973

Sculptor: *William Tarr (1925– ).* **Media and size:** *Mayori-R steel, 28 feet high by 28 feet wide by 28 feet deep.* **Location:** *Martin Luther King, Jr., High School, 122 Amsterdam Avenue at 66th Street.*

A bold departure from traditional commemorative sculpture, the *Martin Luther King, Jr., Memorial* conveys King's heroic spirit and civil rights achievements rather than portraying any physical likeness. The massive cube of weathering steel, bearing quotations, initial letters, and dates that mark the milestones of King's personal and public life, resembles a printer's block. Complementing the cubic silhouette of the school, the sculpture dominates the street corner, where it is plainly visible to passersby.

Sculptor William Tarr successfully translated the concept of a memorial sculpture into a contemporary idiom by combining a monolithic volume with specific letters and numbers, anticipating the later Vietnam Memorials in Washington, D.C., and New York City (see A-10). "The prime requisite," Tarr said, "was to make a valid work of art. For eons, people have been building obelisks with somebody's name on a plaque, but this is very personal."

The architect of the large high school, A. Corwin Frost, had originally commissioned Tarr to design a fountain for the plaza. After the assassination of Dr. Martin Luther King, Jr., on April 4, 1968, the school was renamed in his honor and Tarr proposed a plan for a memorial.

The cube's east side facing Amsterdam Avenue displays the initials of King's family members and his life dates, 1929–1968. The north face of the sculpture marks King's role as a civil rights leader by referring to other activists, represented by the initials in the upper left corner, and by citing dates of major civil rights events, visible on the lower right corner. Easily identifiable are "RDA" for Ralph D. Abernathy, "JJ" for Jesse Jackson, and "BR" for Bayard Rustin. Tarr further develops the civil rights theme on the southern façade. Welded on the top left is "12–10–64," the date when King accepted the Nobel Peace Prize. The initials SCLC (Southern Christian Leadership Conference) and MIA (Montgomery Improvement Association), for the organizations in which King played a key role, appear below.

In view of his violent death, the quotation representing King's commitment to nonviolent protest is especially poignant. "Just want to be there in love and in justice and in truth and in commitment to others so that we can make of this old world a new world."

Chosen as the city's "best monument" by *New York* magazine in 1985, the *Martin Luther King, Jr., Memorial* has unfortunately developed severe maintenance problems because of the nature of the weathering steel, compounded by the numerous welded surface elements. The City is currently exploring ways to remedy this situation.

**Signed and dated:** *W. Tarr © 1973.* **Collection of:** *City of New York; purchase.*

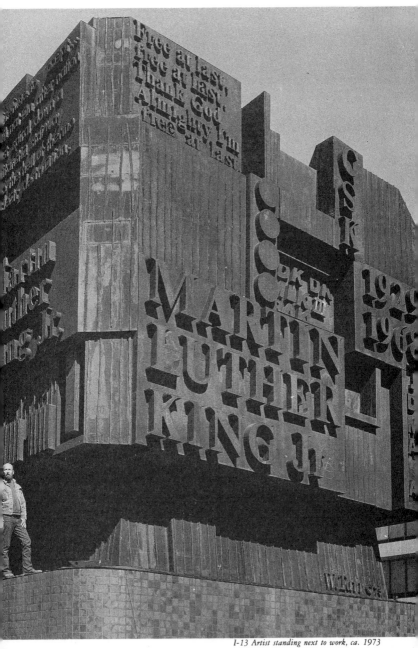

I-13 *Artist standing next to work, ca. 1973*

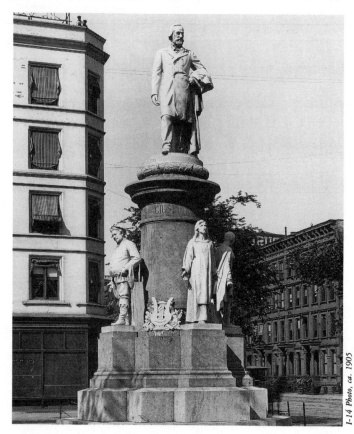

*I-14 Photo, ca. 1905*

## I-14 Giuseppe Verdi, 1906

**Sculptor:** *Pasquale Civiletti (1859–?).* **Media and size:** *White Carrara marble statue; granite pedestal; total height, 25 feet 6 inches.* **Location:** *West 73rd Street and Broadway.*

Verdi (1813–1901), the leading 19th-century Italian composer, created some of opera's most enduring works, including *Rigoletto, Il Trovatore,* and *La Traviata.* He was also an ardent patriot, and his death prompted Carlo Barsotti, editor of the Italian daily, *Il Progresso Italo Americano,* to use his newspaper to launch a nationwide public subscription for a memorial. The monument's unveiling, a suitably operatic performance, attracted 10,000 people. After a parade, speeches, and choral pieces, the granddaughter of Mr. Barsotti released a balloon anchored near the statue. As it rose, it set free 12 doves, lifted the red, white, and green veil from the statue, and showered the spectators with flowers.

Civiletti's complex design, comprising a cylinder, stepped platform, and five statues, typifies Italian 19th-century monumental art. Here, Verdi surmounts a high granite pedestal adorned with life-size marble figures representing four of the composer's most popular operatic heroes and heroines—Aïda, Otello, Falstaff, and Leonora (from *La Forza del Destino*). Marble lyres occupy spaces between the figures.

**Dedicated:** *October 11, 1906.* **Collection of:** *City of New York; gift of Italian-Americans.*

# I-15 Theodore Roosevelt Equestrian Statue, ca. 1940

Sculptor: *James Earle Fraser (1876–1953)*. Architect: *John Russell Pope*.
Media and size: *Bronze equestrian group, 16 feet high; granite pedestal*.
Location: *In front of the Museum of Natural History, at Central Park West and 79th Street*.

Theodore Roosevelt (1858–1919), known as the "conservationist president," sponsored legislation to preserve 18 natural wonders, including the Grand Canyon, and he tripled the national forest reserves. The state legislature allocated $3.5 million for a monument intended "to interpret the character of Roosevelt as naturalist and citizen" and chose this site in 1924. New York state's official memorial to Roosevelt is extensive and includes portions of the building's interior, its façade, steps, and plaza, as well as the imposing equestrian statue.

The sculptor of the bronze equestrian group, James Earle Fraser, was a longtime friend of Roosevelt's. The two had met in 1906 when Fraser did a portrait bust of the recently elected president. Here he shows Roosevelt as an explorer-hunter, assertively astride his horse flanked by figures of two guides afoot, one African, the other American Indian. Although Fraser intended the figures to symbolize the continents of Africa and America and "Roosevelt's friendliness to all races," today the figures appear to us as less than flattering stereotypes. Fraser, known for his sculptures of animals and of western themes, designed the 1913 nickel with an Indian head on one side and a buffalo on the other.

John Russell Pope, the architect of the pedestal for the grandiose bronze group, was designer of the large entrance at which it stands, and indeed of the entire Roosevelt Wing of the museum that was added in 1935.

Dedicated: *October 27, 1940*. Collection of: *City of New York; acquired by provision of the New York state legislature*.

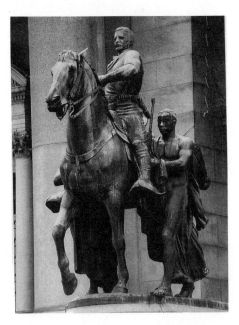

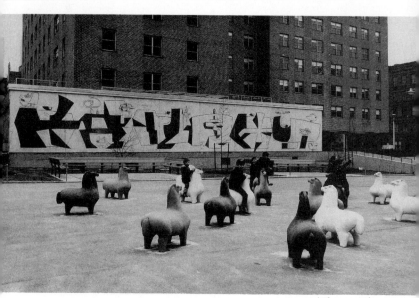

*I-16 Photo, ca. 1965*

# I-16 Stephen Wise Towers Playground Sculpture, 1964

**Sculptor:** *Costantino Nivola (1911– ).* **Landscape architects:** *Richard G. Stein & Associates.* **Media and size:** *Cast cement entrance wall, 20 feet high; cement stucco relief, 80 feet long; 18 cast concrete horses; two pyramidal fountains; concrete free-standing sculpture.* **Location:** *Stephen Wise Towers Playground, between 90th and 91st Streets, Amsterdam and Columbus Avenues.*

Looking at these chubby little play animals tells us why sculptor Nivola is a favorite for designing active playground sculpture. The horses, gently colored in gray-blue, salmon, or cream, gather in a loose circle so that each with its small rider faces all the others. Everyone has a good time, including onlookers.

The group stands with other Nivola works in the playground of Stephen Wise Towers, the first unit completed by the New York City Housing Authority in the large post–World War II West Side urban-renewal area. Public monies not being available, funding for this playground came from the J. M. Kaplan Fund, which set a wonderful standard. Later the city passed an executive order that up to 1% of the cost of new city structures should go for their embellishment by art.

The Italian-born Nivola, who has taught sculpture at Columbia University and done much work combining sculpture with architecture, wrote in a 1963 article of his conviction "that in order for sculpture to be effective and count in the scale of contemporary architecture, the artist must work with a medium and technique that is consistent with modern methods of building today." His cast concrete sculptures echo the materials and construction methods of the molded concrete structures of the Stephen Wise housing complex.

**Signed and dated:** *Nivola / 1964.* **Collection of:** *New York City Housing Authority; gift of the J.M. Kaplan Fund.*

## I-17 **Profile Canto West, ca. 1975**

**Sculptor:** *Ernest Trova (1927– ).* **Media and size:** *Stainless steel, 22 feet high.* **Location:** *Heywood Towers, West 91st Street east of Amsterdam Avenue.*

Ernest Trova is best known for his chrome-plated figures, symbols of modern man's alienation. Beginning in 1972 he translated this theme into an abstract form, launching his series of *Profile Cantos,* one of which is seen here in the plaza behind Heywood Towers. Trova patterned the *Profile Cantos* on his earlier sculptures of falling figures, and he has tried to suggest that motion by angling forms into space as if freezing their downward action. *Profile Canto West* consists of three primary elements—a partial disk, a box-like form, and a narrow band of steel jutting into space. In other sculptures in this series it is possible to liken the disk to a head, the box-like form to a torso, and the narrow bands of steel to arms and legs, but *Profile Canto West* bears little resemblance to the human body. The title, however, indicating the work's origin and its place in Trova's oeuvre, suggests that Trova conceived these sculptures as a series.

Kreisler Borg Florman Construction Company of Scarsdale, New York, the builder of this housing development and a patron of public art, purchased *Profile Canto West* in 1975 (see also Bethune Tower, J-20).

**Installed:** *April 1, 1975.*

*I-18 Photo, ca. 1935*

## I-18 Soldiers' and Sailors' Memorial, 1902

**Designed by:** *Charles W. Stoughton (1860–1944) and Arthur A. Stoughton (1867–1955).* **Architectural sculpture by:** *Paul E. M. DuBoy.* **Media and size:** *Marble and granite, 96 feet high.* **Location:** *Riverside Drive at West 89th Street.*

Patterned on, but larger than, the Choragic Monument of Lysicrates in Athens, the *Soldiers' and Sailors' Memorial* is a marble cylinder, capped by a pyramidal roof and ringed by a colonnade of 12 Corinthian columns. Like *Grant's Tomb* to the north (see I-25), it commands a dramatic view of the Hudson River while a regal approach and two mounted cannon enhance its setting.

Although the state legislature passed an act in 1893 establishing a Board of Commissioners for the *Soldiers' and Sailors' Memorial,* no action was taken until 1897, when the board held a competition. The Stoughton brothers won with their design, known as the "Temple of Fame." Sponsors wanted to locate the Civil War memorial at 59th Street and Fifth Avenue, today the site of the *Pulitzer Fountain* (see G-2), but considerations raised by city officials led the committee to select the Riverside Drive location.

**Dedicated:** *May 30, 1902.* **Collection of:** *City of New York; gift by Act of the New York state legislature.*

# I-19 Joan of Arc, 1915

**Sculptor:** *Anna Vaughn Hyatt Huntington (1876–1973).* **Pedestal by:** *John V. Van Pelt.* **Media and size:** *Bronze statue, over life-size; granite pedestal.* **Location:** *Riverside Drive and West 93rd Street.*

When the *Joan of Arc* equestrian statue was unveiled on December 6, 1915, it marked the 500th anniversary of the birth of the Maid of Orleans (1412–1431), but at that time, when World War I had already begun, it also saluted the unconquerable spirit of France. The French ambassador was present and awarded Anna Hyatt a decoration of the French government. The vibrant statue of Joan standing in her saddle, holding aloft her magical sword and firmly in control of her powerful steed, became the symbol of French-American goodwill.

When Anna Hyatt, a reserved young Boston sculptor of animals who would become one of America's foremost woman sculptors, went to France in 1907 for further study, she became engrossed with the lore and literature of Joan of Arc.

At the Paris Salon of 1910 Hyatt exhibited a full-size plaster equestrian statue showing Joan of Arc in armor on a spirited war horse, right before her first battle. The sculptor explained, "The work looks at Joan of Arc from a spiritual rather than warlike point of view, and is in keeping with her character as Lamartine presents her. The incident which I wish to portray is

after her finding of the consecrated sword. She is holding it up to her God and praying for guidance." The Salon reluctantly awarded Hyatt an Honorable Mention—as many doubted that a woman was capable of making a monumental equestrian statue without male assistance, much less completing it in four months.

Coincidentally, an American committee was planning a statue to mark the 500th anniversary of Joan's birth, and the design caught the eye of Americans at the exhibit. By 1914 Hyatt had been awarded the commission and had returned to this country to work on a revised model in a studio at her family's home in Gloucester, Massachusetts. Hyatt enlisted her niece to pose for Joan, and borrowed an active work horse from the local fire department to model the steed. Details of the horse's saddle and trappings as well as the young warrior's armor were researched with the help of a medievalist at the Metropolitan Museum in New York.

John Van Pelt, the collaborating architect, designed the pedestal in a Gothic style and incorporated in its blind arches actual stones removed from the dungeon in which Joan of Arc had been imprisoned. When the whole dynamic composition had been set in place on this hillside, it aroused tremendous interest in its sculptor. The reticent Anna Hyatt, who became the wife of the wealthy scholar Archer Huntington in 1923, was suddenly famous, and many commissions followed.

At least two replicas of Joan were made. One is in Canada, another is in Gloucester, where it was erected to honor both local soldiers lost in World War I and also its sculptor, who had carried the work to completion there. Several reduced copies exist, notably that in Brookgreen Gardens in South Carolina, the outdoor sculpture center which years later the sculptor and her husband established for her works and for the figurative works of other American artists.

**Dedicated:** *December 6, 1915.* **Collection of:** *City of New York; gift of the Joan of Arc Statue Committee.*

## I-20 Firemen's Memorial, ca. 1912

**Sculptor:** *Attilio Piccirilli (1868–1945).* **Architect:** *H. van Buren Magonigle (1867–1935).* **Media and size:** *Bronze bas-relief, 19 feet long by 8 feet high; two over-life-size groups, Knoxville marble.* **Location:** *Riverside Drive and West 100th Street.*

In the spring of 1908 at the funeral of Fire Chief Kruger, Bishop Potter suggested that a monument be erected in honor of the city's many fallen firemen. A committee formed and commissioned architect H. van Buren Magonigle and sculptor Attilio Piccirilli, then engaged on the *Maine Monument* at Columbus Circle (see G-45), to design the monument.

Originally intended for the north end of Union Square, the design includes an approach of steps, a platform with balustrade, a fountain basin, and the monument. The central architectural element is a marble sarcophagus on which is mounted a large bronze votive tablet depicting three galloping horses pulling a fire engine. Allegorical marble figures flank the sarcophagus, Sacrifice on the north and Duty on the south. Evoking the Pietà, Sacrifice is a partially draped woman supporting the limp body of her dead husband, a fireman killed in the line of duty. Duty is a mother seated next to a fire hydrant, holding a fire helmet and raincoat across her lap as she shelters the young son standing next to her. Classically conceived, the figures contrast with the realism of the narrative bas-relief.

There is an earlier fireman's memorial dating to 1834 in James Walker Park in Greenwich Village. It consists of a sarcophagus, embellished with two old-style firemen's helmets and a lamp. The memorial originally marked the graves of two young volunteer firemen who died side by side when a wall collapsed on them. Manhattan's third, and most recent, memorial to firemen stands in a chapel of the Cathedral of St. John the Divine. Shaped like a cross, it is made from charred beams which loom over a fireman's helmet buried in a pile of rubble. Firemen themselves created this powerful memorial.

**Dedicated:** *September 1913.* **Collection of:** *City of New York; gift of the Firemen's Memorial Fund Committee.*

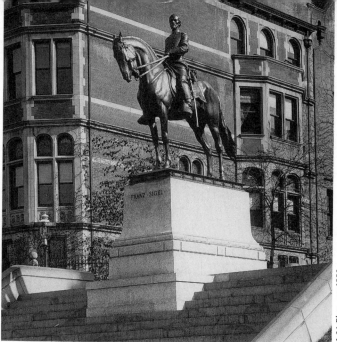

I-21 Photo, ca. 1905

## I-21 **Franz Sigel, 1904–1907**

**Sculptor:** *Karl Bitter (1867–1915).* **Pedestal by:** *Willis Bosworth.*
**Media and size:** *Bronze equestrian statue, over life-size; granite pedestal.*
**Location:** *Riverside Drive and West 106th Street.*

Franz Sigel (1824–1902) was a popular German-American who rallied many large German communities in the U.S. behind the Union; here sculptor Bitter shows him as he might have appeared commanding Northern troops during the Civil War. Sigel contributed to the Union victory in Missouri, notably at the Battle of Pea Ridge, and held various army commands until the close of the war. After his move to New York City in 1867, he devoted himself to journalism and politics, and became a venerated leader of New York's German-Americans.

*Franz Sigel* is the sole equestrian monument by Bitter, a Viennese-trained sculptor noted for his architectural and monumental sculpture. When Bitter won the commission, he was directing the sculptural scheme for the 1904 St. Louis World's Fair. Bitter often selected the sites of his outdoor monuments, and it was he who envisioned this unusual location at the top of a flight of stairs. The sculptor designed the statue so that it would be equally effective when seen from the stairs or by viewers in passing vehicles or even from boats on the Hudson River.

**Dedicated:** *October 1907.* **Signed and dated:** *KB / 1907.* **Foundry mark:** *JNO Williams / Founder.* **Collection of:** *City of New York; gift of the Sigel Monument Association.*

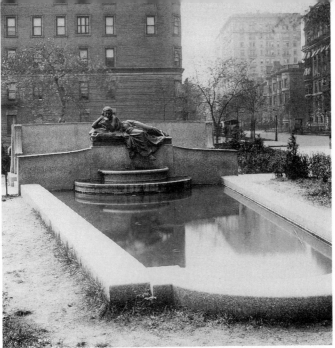

## I-22 Straus Memorial, 1913–1914

**Sculptor:** *Augustus Lukeman (1871–1935).* **Fountain and exedra by:** *Evarts Tracy.* **Media and size:** *Bronze figure, over life-size; granite fountain and exedra.* **Location:** *West 106th Street between Broadway and West End Avenue.*

New York philanthropists Ida and Isador Straus (1845–1912) lost their lives on the *Titanic* when it hit an iceberg and sank on April 14, 1912. This memorial to them consists of a granite fountain and exedra, together with a classically draped bronze female figure representing Memory. She reclines languidly on the edge of a pool, absorbed in contemplation. The memorial's small scale and imagery induce a feeling of serenity.

The *Straus Memorial* is in a small park near the site of the family residence, formerly at West 105th Street and Broadway. Lukeman and Tracy's model for this commemorative fountain was selected from a group of 59 designs in a competition. The rules had stipulated that the "design should reflect the unostentatious but purposeful character of the Strauses, avoid all loud or spectacular features," and that the "fountain should primarily present an object of beauty without necessarily containing an allegorical conception of a particular theme or subject." The memorial harmonizes with the small triangular park, surrounded by tall apartment buildings, and meets the criteria set by the donors.

Isador Straus is remembered for his role in developing R. H. Macy and Company into the world's largest department store. In 1896 he and two brothers assumed ownership of this famous business, creating a store that has become a city landmark. The Strauses were also major donors to Jewish charities.

**Signed and dated:** *Augustus Lukeman Sculptor 191[?].* **Foundry mark:** *JNO Williams Inc. / Founders N.Y.* **Collection of:** *City of New York; gift of the Straus Memorial Committee.*

# I-23 Samuel J. Tilden, 1917–1926

**Sculptor:** *William Ordway Partridge (1861–1930).* **Pedestal by:** *Wilder & White.* **Media and size:** *Bronze statue, over life-size; granite pedestal.* **Location:** *Riverside Drive and West 112th Street.*

Samuel J. Tilden (1814–1886) was governor of New York state, a presidential nominee, corporation lawyer, and the driving force behind the creation of the New York Public Library, formed in large part from the $6 million he bequeathed ($3 million was actually used because heirs contested his will). He also set aside $50,000 to pay for commemorative statues of himself for New Lebanon, his boyhood home, and New York. Disagreement over the site for the statue in New York City and a lawsuit brought by the sculptor against the executors of the will impeded progress on the monument, which was unveiled 40 years after Tilden's death.

The statue, one of Partridge's last works, shows Tilden standing beside a table upon which lies a copy of the U. S. Constitution. The statue exhibits the same loose modeling and understated costume characteristic of Partridge's portraits of Thomas Jefferson and Alexander Hamilton, located at Columbia University (see J-4 and J-5).

When Tilden died in 1886 he had one of the largest personal fortunes in America, the result of a brilliant law practice and sound investments. He was a man with a towering intellect who became nationally prominent during his lifetime because of his fight against corruption, particularly his prosecution of the infamous Tweed Ring and the Upstate Canal Ring.

**Dedicated:** *October 5, 1926.* **Collection of:** *City of New York; gift of the Executors of the Samuel J. Tilden Estate.*

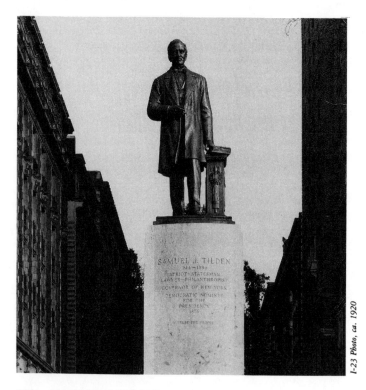

*I-23 Photo, ca. 1920*

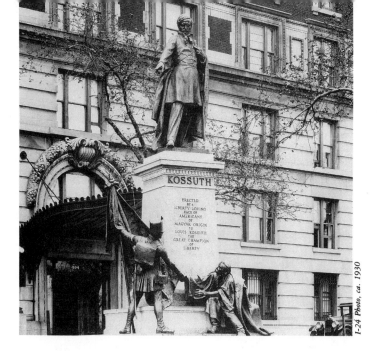

## I-24 **Lojas Kossuth, 1927**

Sculptor: *John Horvall [Janos Horvay] (1873–?)*. **Media and size:** *Bronze group, over life-size; Milford pink granite pedestal and platform.* **Location:** *Riverside Drive and West 113th Street.*

The Kossuth monument is a bronze tableau dramatizing the story of the Hungarian revolt against the Hapsburg monarchy. Lojas Kossuth (1802–1893), the Father of Hungarian Independence and a fiery writer and orator, gestures to the figures at the base, as if encouraging their actions. A soldier of the 1848 revolution carries the flag of independence as he bids farewell to the seated figure of an old peasant man, perhaps a symbol of the oppressed Hungarian people.

When Kossuth came to New York in 1851, the *New York Times* described the welcome as one of "the most magnificent and enthusiastic ever extended to any man in any part of the world." His arrival generated an outpouring of affection, unparalleled since Lafayette's visit in 1824. He, like Lafayette, fought for freedom, and in 1848 orchestrated the liberation of the Hungarian people. Briefly, he served as the first "governor" of Hungary, but was forced to flee before invading Russian armies. The remainder of his life was spent in exile.

The noble-born lawyer and journalist was an assertive charismatic leader, and the dedication of this statue was attended by controversy. The event attracted 25,000 spectators, among them a delegation of 520 Hungarian political officials who had traveled to the United States for the unveiling. Opponents of the conservative Horthy government, then in power in Hungary, staged a protest at the ceremony, decrying what they regarded as the hypocrisy of the Horthy administration for appearing to honor the memory of Kossuth and the principles he had fought for.

**Dedicated:** *March 15, 1928. Recast 1930.* **Collection of:** *City of New York; gift of American citizens of Magyar origin.*

# I-25 Grant's Tomb, 1897

**Architect:** *John Duncan (1855–1929).* **Sculptor:** *John Massey Rhind (1860–1936).* **Media and size:** *White granite monument, 150 feet high.* **Location:** *Riverside Drive at West 122nd Street.*

When Ulysses S. Grant (1822–1885) died he was one of the most popular men in America. His contemporaries compared his Civil War military achievements to the victories of Alexander the Great, Julius Caesar, and Napoleon Bonaparte. Some 90,000 people subscribed to a monument befitting his glory, and a million spectators witnessed its unveiling by President McKinley.

Controversy over the site and design of *Grant's Tomb* arose immediately after his death. The memorial committee, dissatisfied with the results of an open competition for a memorial design in 1888, organized a second, closed competition in 1890, at which time John Duncan's entry won. The architect's conception aimed to "produce an edifice which shall be unmistakably a Monumental Tomb, no matter from what point of view it may be seen." *Grant's Tomb,* the largest mausoleum in America, is highly visible from all directions as it commands a spectacular hill above the Hudson River opposite the Palisades. It is essentially a tripartite structure, composed of a square Ionic temple, surmounted by a circular colonnade, and capped by a conical roof.

Duncan envisioned an elaborate sculptural program for the tomb; however, only two figures by J. Massey Rhind adorn it. Over the entrance recumbent personifications of Victory and Peace present a plaque inscribed with Grant's famous words "Let Us Have Peace."

Over the years, various groups have made additions to the interior and exterior of *Grant's Tomb.* The most visible and publicized embellishment is the mosaic bench which snakes around the tomb's plaza. In 1973 community residents constructed the colorful sitting area under the direction of Pedro Silva of Cityarts Workshop.

**Dedicated:** *April 27, 1897.* **Collection of:** *National Park Service; gift by public subscription.*

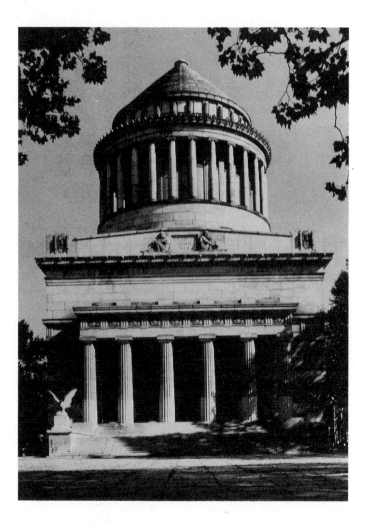

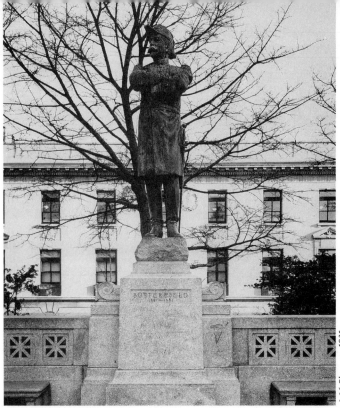

# I-26 Daniel Butterfield, 1917

**Sculptor:** *John Gutzon de la Mothe Borglum (1867–1941).* **Pedestal by:** *Ludlow & Peabody.* **Media and size:** *Bronze statue, over life-size; granite pedestal.* **Location:** *Sakura Park, Claremont Avenue and West 122nd Street.*

Daniel Butterfield (1831–1901) achieved distinction for his military service and business acumen, but his universally known accomplishment was "Taps," the familiar, melancholy bugle call. A Union soldier, he rose to the rank of major-general and chief of staff of the Army of the Potomac, and after the Civil War successfully engaged in numerous business enterprises, among them railroad and real estate ventures.

Julia L. Butterfield, Butterfield's second wife, left money in her will for a statue of her husband to be erected in New York City. She stipulated that the likeness be based on a bas-relief of her husband located at the Utica Historical Society, that the statue be over life-size, and that it portray Butterfield standing on a rock, simulating the terrain of Little Round Top, "made famous by General Butterfield." Borglum, of Mount Rushmore fame, was hired for the job.

The executors of the will claimed that Borglum's statue was not a good likeness of Butterfield and that the sculptor did not adhere to the contract, and therefore they refused to complete payment. Gorham Company, the foundry which cast the sculpture, was not paid but successfully sued the executors.

**Erected:** *February 23, 1918.* **Signed:** *Gutzon Borglum / Sculptor 1917.* **Foundry mark:** *Gorham Co. Founders.* **Collection of:** *City of New York; gift of Julia L. Butterfield estate.*

# (J)
# UPPER MANHATTAN

*North of 110th Street*

---

In the early 18th century this part of Manhattan was far beyond the city limits, a rural retreat dotted with country estates. Today it is a mosaic of ethnically diverse neighborhoods and rocky outcroppings affording dramatic vistas. Major institutions, including Columbia University and City College, are also located here.

On Columbia University's main campus, a regal civic space, between 114th and 120th Streets and Broadway and Amsterdam Avenue, is an impressive collection of 19th- and 20th-century sculptures by American and European artists. The university's icon, *Alma Mater* by Daniel Chester French, welcomes visitors as they mount the steps to Low Library. At the northern edge of the campus near the engineering building stands Belgian sculptor Constantin Meunier's *Le Marteleur,* a heroic image of a worker.

Just east of Columbia University is Morningside Park, a green enclave hugging a cliff, designed by Frederick Law Olmsted in the 1880s. Of the two sculptures there, Karl Bitter's *Carl Schurz Monument* off Morningside Drive overlooking Morningside Park should not be missed. A dramatic ensemble of stairs, plaza, statue, and exedra, it is a Beaux Arts tour de force, a splendid example of how sculpture, architecture, and landscape can be united.

On the other side of Morningside Park in East Harlem Artpark, the exuberant *Growth* was the first sculpture to be installed under the city's Percent for Art law. In contrast to *Growth,* sculptures of a very different sensibility decorate Audubon Terrace, a complex that includes the Hispanic Society of America, the Museum of the American Indian, the American Numismatic Society, and the American Academy of Arts and Letters, as well as an elaborate sculptural ensemble celebrating Hispanic subjects by Anna Vaughn Hyatt Huntington.

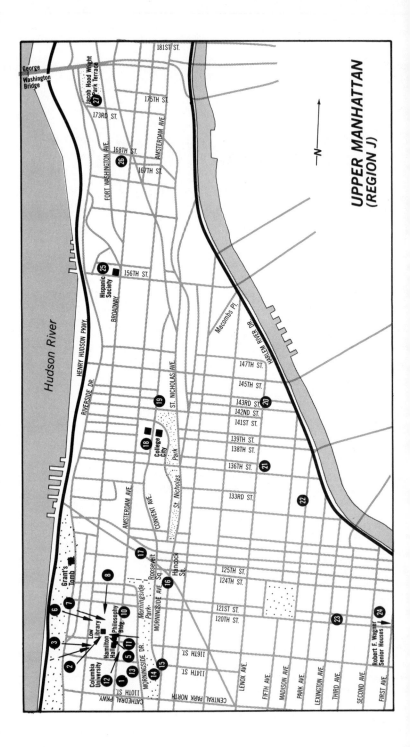

UPPER MANHATTAN
(REGION J)

Hudson River

George
Washington
Bridge

181ST ST.

Jacob Hood Wright
27 Park Terrace

175TH ST.

173RD ST.

168TH ST.

26

167TH ST.

FORT WASHINGTON AVE.

AMSTERDAM AVE.

Hispanic
Society 25

156TH ST.

BROADWAY

HENRY HUDSON PKWY.

RIVERSIDE DR.

Macombs Pl.

HARLEM RIVER DR.

147TH ST.

145TH ST.

143RD ST.

142ND ST.

141ST ST.

139TH ST.

138TH ST.

136TH ST.

133RD ST.

19

ST. NICHOLAS AVE.

18

College
City

20

21

22

St. Nicholas Park

CONVENT AVE.

AMSTERDAM AVE.

Grant's
Tomb

8

6

7

3

Low
Library

Philosophy
Bldg.

10

2

Columbia
University

Hamilton
Hall

12

5 11

1

13

14 15

17

Roosevelt
Sq.

16

Hancock
St.

Morningside Park

MORNINGSIDE DR.

MORNINGSIDE AVE.

125TH ST.

124TH ST.

121ST ST.

120TH ST.

116TH ST.

114TH ST.

110TH ST.

CATHEDRAL PKWY.

CENTRAL PARK NORTH

LENOX AVE.

FIFTH AVE.

MADISON AVE.

PARK AVE.

LEXINGTON AVE.

THIRD AVE.

SECOND AVE.

FIRST AVE.

23

24

Robert F. Wagner
Senior Houses

—N→

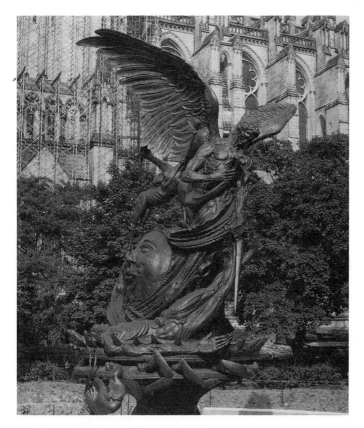

# J-1 Peace Fountain, 1984–1985

**Sculptor:** *Greg Wyatt (1949– ).* **Pedestal and setting by:** *Michael Antonson.* **Media and size:** *Bronze group, 40 feet high.* **Location:** *Cathedral of St. John the Divine, Amsterdam Avenue and West 111th Street.*

The Episcopal Diocese of New York at the Cathedral of St. John the Divine sponsored this very large bronze *Peace Fountain,* located in the cathedral close, in honor of the 200th anniversary of the diocese. It is dedicated to the children of the earth.

Celebrating the triumph of good over evil, the *Peace Fountain* is a complex arrangement of biblical and scientific symbols, juxtaposed in a surrealistic manner. Using a literal, figurative vocabulary, based on religious and secular concepts, the sculptor conveys a moral message. The winged figure of the archangel Michael dominates the work. He has struggled with and destroyed Satan, a twisted, decapitated body. With the triumph of good, peace will reign, symbolized by a giraffe, viewed by the artist as a peaceable animal, and a lion lying down with a lamb. A smiling sun and somnolent moon, back to back, suggest the natural rhythm of life. Rising up from the basin is a double-helix pedestal which represents DNA, the basis of life. Four "flames of freedom" surround the pedestal, surmounted by a giant crab, signifying life's origin in the sea.

**Foundry:** *Bedi Makky Art Foundry.* **Collection of:** *Cathedral of St. John the Divine; purchase.*

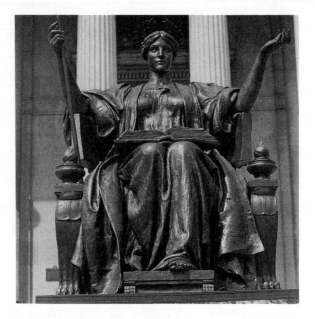

## J-2 Alma Mater, 1900–1903

**Sculptor:** *Daniel Chester French (1850–1931).* **Media and size:** *Bronze statue, over life-size; granite pedestal.* **Location:** *Columbia University, on the steps of Low Library.*

Sculptor Daniel Chester French conceived the stately, allegorical figure *Alma Mater* as an emblem of the university and as a sign of welcome. As French put it, he aimed "to make a figure that should be gracious in the impression that it should make, with an attitude of welcome to the youths who should choose Columbia as their College." During the late 1960s *Alma Mater* became a rallying point for student demonstrations, and it was damaged by a bomb. It has since been repaired.

French's idealization of Columbia's seal combines symmetry and eloquence in the figure's facial expression and gesture. Draped in an academic gown, *Alma Mater* wears a crown of laurels and sits on a throne. The scroll-like arms of the throne end in lamps, representing *Doctrina* and *Sapientia*. A book, signifying knowledge, balances on her lap, and an owl, the attribute of wisdom, is seen in the folds of her gown. Her right hand holds a scepter composed of four sprays of wheat, terminating with a crown of King's College. This refers to Columbia's origin as a Royalist institution in 1754 in lower Manhattan. *Alma Mater*'s raised arms are said to have been suggested by the actress Mary Lawton, who posed for portions of this sculpture.

The classical style of the figure complements the imposing domed and colonnaded Low Library behind it. Architect Charles Follen McKim of the firm McKim, Mead and White invited French to execute the sculpture, which was to harmonize with his larger composition of court and library.

**Signed and dated:** *D. C. French Sc-1903.* **Foundry mark:** *JNO. Williams / Bronze Foundry. New York.* **Collection of:** *Columbia University; gift of Mrs. Robert Goelet and Robert Goelet, Jr., in memory of Robert Goelet, class of 1860.*

## J-3 Letters, ca. 1915, *and* Science, 1925

**Sculptor:** *Charles Keck (1875–1951).* **Pedestal by:** *McKim, Mead and White.* **Media and size:** *Knoxville granite statues, over life-size; granite pedestal.* **Location:** *Columbia University, south and north pylons at the entrance on 116th Street and Broadway.*

In 1913 Columbia University drew up plans for two sets of pylons decorated with allegorical figures of the Arts, Science, Law, and Letters, grand gateways to the campus entrances on Broadway and Amsterdam Avenue. Only the Broadway figures were executed.

The class of 1890, in honor of its 25th anniversary, presented *Letters* to the university. This classically draped female figure holds an open book across her chest and stands on a low pedestal in front of a granite shaft that is surmounted by a large vase. A similar pylon and vase was erected ten years later at the north side of the entrance. There *Science,* a partially draped idealized male figure, holds a globe and compass.

**Signed and dated on** Science: *Charles Keck / Sculptor MCMXXV.* **Collection of:** *Columbia University;* Science, *gift of the Class of 1900.*

# J-4 Thomas Jefferson, 1914

**Sculptor:** *William Ordway Partridge (1861–1930).* **Media and size:**
*Bronze statue, over life-size; granite pedestal.* **Location:** *Columbia
University, in front of the Graduate School of Journalism.*

This introspective portrait of Thomas Jefferson embodies the sculptor's
concept of an intellectual hero, a type he sought to elevate over the military
victor. The slight downward tilt of the head, the wrinkled brow, firm set of
the lips, and easy *contrapposto,* a graceful weight shift, add a cerebral presence
to the sculpture's physical mass. In a statement of 1904 Partridge had
explained, "As the man on horseback becomes less essential . . . let us hope
to see the man of thought—the poet or writer who is the molder of
idealism. . . ."

Joseph Pulitzer, world-renowned journalist and founder in 1903 of the
Columbia School of Journalism, left $25,000 for a statue of Thomas
Jefferson to "adorn some public place in New York." The Pulitzer family
first requested that the statue of Jefferson be erected in City Hall Park as a
pendant to the admired bronze figure of *Nathan Hale* (see B-2). Accordingly,
they commissioned Partridge "to design a bronze statue, which is to
correspond in size and general character with the statue of Nathan Hale and
is to be erected on a pedestal similar to that of the Hale statue and to be
placed in a corresponding situation opposite the West wing of the City Hall."
The city Art Commission found this request inappropriate because
MacMonnies, sculptor of *Nathan Hale,* did not want it to be one of a pair,
and also because the redesign of City Hall Park was then under considera-
tion. As a result, the Pulitzer family gave the statue to Columbia University
with the understanding that the work be erected at the Columbia School of
Journalism.

**Dedicated:** *June 2, 1914.* **Signed:** *William Ordway Partridge Sculptor.*
**Collection of:** *Columbia University; gift of the estate of Joseph Pulitzer and
public subscription.*

## J-5 Alexander Hamilton, 1908

**Sculptor:** *William Ordway Partridge (1861–1930).* **Media and size:** *Bronze statue, over life-size; granite pedestal.* **Location:** *Columbia University, in front of Hamilton Hall.*

A former Columbia student, this second-generation American Beaux Arts sculptor executed a number of statues and busts for his alma mater. His works are characterized by loose, impressionistic modeling, broad forms, and minimal detail.

As in his 1892 statue of Hamilton, now at Hamilton Grange (see J-19), Partridge here portrays the patriot engaged in an impassioned speech. He subtly reworks this theme by restraining the figure's movement and by omitting details of the costume. The sketchy quality heightens the contrasts between darks and lights and is a more personal style for monumental sculpture than the studied naturalism typical of works by an earlier generation of American sculptors.

*Hamilton* is an appropriate companion piece to Partridge's *Thomas Jefferson,* done in 1914, which stands across the south campus in front of the School of Journalism (see J-4).

Within view of the Hamilton is another work by Partridge, the bust of *John Howard Van Amringe* (1922), located in the center of a colonnaded canopy in the Van Amringe Memorial Quadrangle. It exhibits the loose modeling and vibrant naturalism characteristic of Partridge's earlier portrait statues of Hamilton and Jefferson.

**Signed and dated:** *Ordway Partridge / Sc-1908.* **Collection of:** *Columbia University; presented by the Association of the Alumni of Columbia College.*

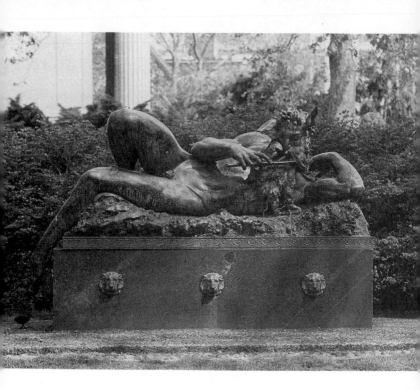

## J-6 The Great God Pan, 1894–1899

**Sculptor:** *George Grey Barnard (1863–1938).* **Media and size:** *Colossal bronze statue; granite pedestal.* **Location:** *Columbia University, west of Low Library.*

Pan, the pagan nature god who is half-goat and half-man, reclines lazily on a rock as he plays his pipe. He lies propped on his left arm with one leg hanging loose and the other bent behind him. Slanted eyes, a grinning mouth, and ears pointed in different directions animate his sly face, from which his moustache and beard flow in a cascade of curls. The powerful figure with its rippling muscles recalls Michelangelo's marble giants.

Pan attracted considerable attention when it was exhibited at the turn of the century and won the gold medal at the Paris Exposition of 1900. It was also a technological feat, for at the time it was made it was the largest bronze sculpture ever cast in one piece in the United States.

The sculptor, noted American artist George Grey Barnard, did not design Pan for Columbia's campus. In 1895 Barnard's longtime patron, Alfred Corning Clark, had commissioned him to create a Pan for a fountain in the courtyard of the Dakota apartment building on Central Park West at 72nd Street. After Clark's death, his family offered the sculpture to the city for Central Park, but a proposed site in the park was never agreed on. Eventually Clark's heirs gave it to Columbia University, where for a time it functioned as part of a fountain.

**Signed and dated:** *George Grey Barnard / Sculptor 1899.* **Signed in back:** *George Grey Barnard—Sculptor.* **Foundry mark:** *Cast in one piece by / Henry Bonnard Bronze Company / Founders New York 1899.* **Collection of:** *Columbia University; gift.*

# J-7 Curl, 1968

**Sculptor:** *Clement Meadmore (1929– ).* **Media and size:** *Cor-Ten steel painted black, 12 feet high.* **Location:** *Columbia University, Abrams Plaza, in front of the Business School.*

Clement Meadmore is known for his huge half-twists of painted metal. In this work, as in the others, he tempers mass with grace and curves with straight edges. The hollow squared tube suggests a giant twisting loop that gently unfolds as its ends rise upward. For this Australian-born artist, the problem of making sculpture is not one of modeling but is "a matter of finding another vocabulary, as it were, which could also be used in the way modeling was to create expressive forms." By combining a quarter circle tilted at an angle with different lengths of straight sections, Meadmore has created numerous variations on a theme; and though assembled from numerous components, his characteristically buoyant and upbeat sculptures retain an inviolable wholeness.

*Curl* is the first monumental sculpture that Meadmore sold. When Dean Brown of the Columbia Business School saw Meadmore's *Upstart I* (1967) in the city's 1967 Sculpture in Environment show, he contacted the artist to ask about acquiring it for the plaza in front of the new Business School. The architects of the building argued that the vertical orientation of *Upstart I* would not harmonize with the horizontal, low configuration of the architecture, so Meadmore suggested this piece. As do most sculptures by Meadmore, *Curl* respects the size of the viewer. "I have a reason for that," Meadmore explains. "One of the things I feel about public sculpture is that it should act as a sort of bridge between human scale and architectural scale."

A more recent sculpture by Meadmore, *Switchback* (1981), can be seen in the lobby of 1180 Avenue of the Americas.

**Collection of:** *Columbia University; gift of Percy Uris.*

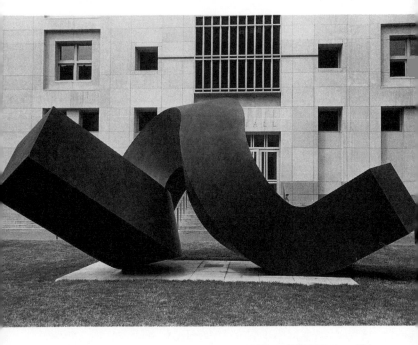

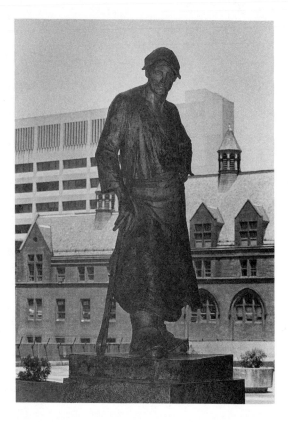

## J-8 Le Marteleur, 1886

**Sculptor:** *Constantin-Emile Meunier (1831–1905).* **Media and size:**
*Bronze statue, over life-size; granite pedestal.* **Location:** *Columbia
University, at the entrance to the Engineering Building.*

In the wake of industrialism, socially conscious late–19th-century artists
began depicting the modern laborer. A form of political protest, their
paintings and sculptures drew attention to the plight of the worker. One of
the first sculptors to celebrate the heroism of labor was the Belgian artist
Constantin Meunier, whose 1886 *Marteleur,* a hammerman or metalsmith,
was one of his earliest sculptures on this theme.

Proud and defiant, the laborer depicted in this bronze statue stands in an
assured *contrapposto* with his weight on his left leg. He balances pincers, used
in pouring molten metal, on the ground next to him and places his left hand
on his raised left hip. *Le Marteleur* wears a leather apron over his open shirt
that clings to the sweat of his body. Calf and foot coverings and a piece of
leather over his head provide meager additional protection from the sparks of
the forge. Using minimal detail, Meunier emphasizes the figure's simple,
volumetric forms and strong gestural lines. An image of the noble worker, the
statue's generalized, handsome features make it clear that *Le Marteleur*
represents a type, not an individual.

**Foundry mark:** *FonderieVerbeysi / Bruxelles.* **Collection of:** *Columbia
University; gift of the class of 1889, presented at the 1914 commencement;
purchased from an exhibition of Meunier's work held at Columbia in 1914.*

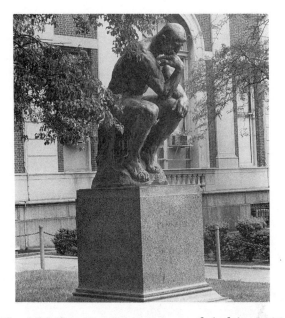

## J-9 The Thinker (Le Penseur), modeled in 1880

**Sculptor:** *Auguste Rodin (1840–1917).* **Media and size:** *Bronze statue, over life-size; granite pedestal.* **Location:** *Columbia University, in front of the Philosophy Building.*

In 1880 the French government commissioned the 40-year-old sculptor Auguste Rodin to create an intricate, even phantasmagoric, design to frame the portal to the Museum of Decorative Arts in Paris. Using as his theme Dante's *Inferno*, he entitled it *The Gates of Hell.* Rodin envisioned Dante as a small figure lost in thought to be placed atop the doorway. For this he modeled a nude man, a poet-artist musing over the tragic human condition. Although he never finished the *Gates of Hell* project, Rodin continued to work on several figures conceived for it, including that of Dante. In 1902 he had the small figure enlarged, and in 1906 Parisians saw it unveiled in its first public location, in front of their national shrine, the Pantheon.

This brawny, brooding figure is Rodin's best-known sculpture. It is recognized universally, but its meaning is enigmatic. Rodin, himself, later viewed *Le Penseur (The Thinker)* as more than the poet-artist. When questioned about the statue's significance at the time of its public installation, the celebrated sculptor called it "a social symbol," emblematic of "the fertile thought of those humble people of the soil." As Albert Elsen has argued so cogently in his book *Rodin's Thinker and the Dilemmas of Modern Public Sculpture,* in Paris of 1906 the sculpture was intended and perceived as a monument to the laborer. Since replicated many times, *The Thinker* appears on university campuses and in front of museums and government buildings. Because of its impressive but unspecific presence, it has become a popular icon, lending itself to many interpretations. Here, in front of the Philosophy Building, this sculpture, cast in 1930, suggests the contemplative philosopher.

**Signed:** *A Rodin.* **Foundry mark:** *Alexis Rudier / Fondeur Paris.* **Collection of:** *Columbia University.*

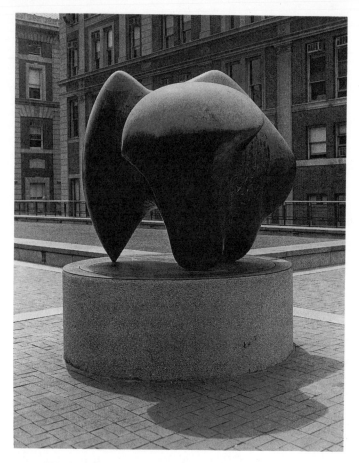

## J-10 Three-Way Piece: Points, 1967

**Sculptor:** *Henry Moore (1898–1986).* **Media and size:** *Bronze sculpture, 7 feet high; circular granite pedestal.* **Location:** *Columbia University, on the overpass across Amsterdam Avenue at 117th Street.*

This compact, elegant, buoyant abstract bronze rises from its base at three points. An example of the celebrated English sculptor Henry Moore's later work, it is totally non-objective and bears little resemblance to the reclining figure, a recurrent theme in his art (see I-9). Rather, it swells and contracts, forming modules which suggest rocks. Gouges and giant hatchmarks give it an earthy quality.

**Dedicated:** *October 3, 1973.* **Signed:** *Moore 2/3.* **Foundry mark:** *H. Noack Berlin.* **Collection of:** *Columbia University; gift of Miriam and Ira D. Wallach.*

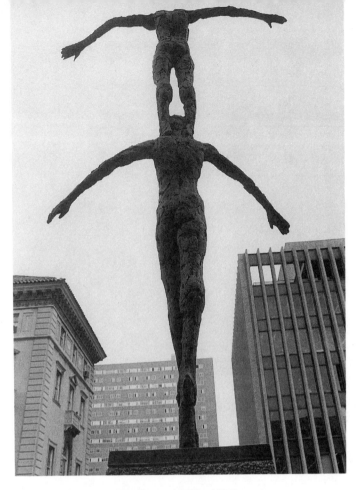

## J-11 Tightrope Walker, 1973–1979

**Sculptor:** *Kees Verkade (1941– ).* **Media and size:** *Bronze, 14 feet 3 inches high.* **Location:** *Columbia University, on Revson Plaza near the overpass across Amsterdam Avenue at 117th Street.*

Colleagues and friends presented this sculpture as a tribute to Gen. William Donovan (1883–1959), an alumnus of Columbia College and Columbia Law School and a veteran of World War I. Nicknamed "Wild Bill" for his valor in leading New York's 69th Regiment, he later rose to prominence as a lawyer and public servant.

Instead of a likeness of Donovan, Verkade created an allegorical sculpture, alluding to Donovan's courage and daring. He shows two acrobatic figures, one balanced on the shoulders of the other, with their arms outstretched as they walk a tightrope. The attenuated forms, modeled from loose wads of clay, retain the spontaneity of a maquette.

One can not only walk around this unusual sculpture but beneath it. However, finding it may be difficult. It is on an upper-level brick plaza, just north of the law school on the east side of Amsterdam Avenue, and can be reached by the bridge across the avenue. The stainless-steel sculpture *Flight* (1981) by Gertrude Schweitzer (1911– ) is nearby.

**Dedicated:** *October 9, 1981.* **Collection of:** *Columbia University; gift.*

## J-12 Bellerophon Taming Pegasus, 1964–1967

**Sculptor:** *Jacques Lipchitz (1891–1973).* **Media and size:** *Bronze group, 40 feet high.* **Location:** *Columbia University, over the entrance to the law school.*

An allegory for the triumph of reason over passion, civilization over nature, this monumental group interprets the Greek myth of Bellerophon and the winged horse Pegasus. The King of Corinth's son, Bellerophon, easily tamed Pegasus by using the golden bridle given to him by Athena. Lipchitz, however, shows a fierce struggle, as Bellerophon attempts to pull the spirited horse down from the heavens. For Lipchitz, "Pegasus is the wild force of nature. Bellerophon is man harnessing these forces, bending them to his use. In codified form, these forces become man's laws."

Standing on a small platform, the stocky figure of Bellerophon braces himself as he puts a heavy rope around Pegasus' neck. The horse's head, with mouth opened and eyes bulging, twists violently around as the enraged Pegasus beats his wings and hooves. The massive, intertwined, rounded forms create a dramatic pattern of light and dark and the group convulses with emotional energy. Commissioned by Columbia University for this site, *Bellerophon Taming Pegasus* dominates the law school building's façade; even though it is free-standing, it looks flattened out, more like a high relief than sculpture in the round.

*Bellerophon Taming Pegasus* is one of Lipchitz's last works. The Russian-born sculptor achieved recognition in the 1910s and 1920s for his Cubist sculptures. By the 1930s he began modeling expressionist figurative works, often based on mythological themes.

**Dedicated:** *November 28, 1977.* **Collection of:** *Columbia University; gift of alumni to law school.*

*J-13 Photo, ca. 1915*

## J-13 Carl Schurz Monument, 1909–1913

**Sculptor:** *Karl Bitter (1867–1915).* **Exedra by:** *Henry Bacon.* **Media and size:** *Bronze statue, over life-size; two granite reliefs, 4 feet high by 9 feet wide by 2 inches deep; one granite relief, 4 feet high by 3 feet wide by 2 inches deep.* **Location:** *Upper Morningside Drive and 116th Street.*

Karl Bitter believed that "monuments must show larger and deeper roots of thought and execution," whereas exhibition pieces "may appeal to the tastes of the day." The important *Carl Schurz Monument,* a probing bronze full-length portrait statue crowning the apex of a semicircular granite exedra, embodies this artistic philosophy.

Bitter's monument honoring Carl Schurz (1829–1906), German-American reformer, Civil War brigadier-general, orator, and journalist, unites sculpture with architecture, reflecting the Beaux Arts ideal. It is a total design that artfully combines drama with utility. The memorial occupies a semicircular platform 50 feet in diameter, with steps and benches projecting from the cliff overlooking the treetops of Morningside Park. A sweeping stairway approaches the platform and seating area from the south and links the monument to the park below.

Bitter received this commission shortly after Schurz died in 1906, and by 1909 had selected the dramatic location on Morningside Drive and devised a scheme for a figure in front of a simple, low semicircular wall. Architect Henry Bacon, famed for his Washington, D.C., *Lincoln Memorial,* designed the exedra and very probably the entire foundation and stairway as well.

In its overall form and decorative details the *Carl Schurz Monument* is an essay in simplicity. The severe folds of a long military greatcoat and cape enfold the gaunt figure of Schurz. Bitter's portrait, based on a death mask, photographs, and his own recollection of Schurz, is a powerful likeness of the fiery orator. The directness of the centrally placed statue is carried through in the three granite archaic-type reliefs, positioned below the statue and at the far ends of the exedra. Articulated as flat planes decorated with incised lines, sharply raised against the background, these reliefs reflect the influence of Greek archaic sculpture, and are among the earliest examples of that influence on American sculpture. Bitter's travels to Vienna in 1909 and 1910 exposed him to the severe, architectonic style of Secessionist art and architecture, while his trip to Greece in 1910 impressed him with the beauty of archaic Greek sculpture.

Schurz's activities as a reformer, as a foe of slavery and an advocate of

fairness to American Indians, provide the theme of the reliefs. Illustrating the inscription in the central panel, a male figure raises a sword in defense of liberty and a female figure extends her hand in friendship. In the right panel Liberty beckons to the people, and in the left panel a Greek warrior breaks the chains of slavery as a female figure gestures to an American Indian to join the group.

**Dedicated:** *May 10, 1913.* **Signed and dated:** *Karl Bitter Sculptor 1912 [statue]; Karl Bitter–Sculptor [right relief].* **Foundry mark:** *JNO Williams. Incorporated / Bronze Foundry, New York.* **Collection of:** *City of New York; gift of the Carl Schurz Memorial Fund.*

J-14 Photo, ca. 1915

## J-14 Seligman Fountain (Bear and Faun Fountain), ca. 1910

**Sculptor:** *Edgar Walter (1877–1938).* **Media and size:** *Bronze group, 8 feet high.* **Location:** *Morningside Park, 116th Street and Morningside Avenue, at the foot of the stairway.*

Placed on actual rocks, this unusual bronze group harmonizes with its surroundings in the lower level of Morningside Park. A faun sits with knees up in the hollow of a bronze boulder, apparently hiding from the bear, which sprawls on top of the rock, its head and paw hanging over the edge. Musical pipes, lying near the faun's left hand, evoke the mythical Pan.

The National Highways Protective Society presented the fountain sculpture in memory of its former vice-president, Alfred Lincoln Seligman, who died in 1912 in an early automobile accident.

**Dedicated:** *1914.* **Signed:** *Edgar Walter.* **Foundry mark:** *Roman Bronze Works.* **Collection of:** *City of New York; gift of friends of Alfred L. Seligman and Roman Bronze Works.*

*J-15 Photo, 1935*

## J-15 Lafayette and Washington, 1890

**Sculptor:** *Frédéric-Auguste Bartholdi (1834–1904).* **Media and size:** *Bronze group, over life-size; marble pedestal.* **Location:** *114th Street and Manhattan Avenue, at Morningside Avenue.*

Frédéric-Auguste Bartholdi, sculptor of the *Statue of Liberty,* here depicts Washington greeting Lafayette. They reach out to one another, clasping hands. Behind them is a background of intertwined French and American flags held by Lafayette. The work's heavy-handed symbolism and composition, even the unnaturally short and portly figure of Washington, neutralize the sculpture's serious message.

If the sculpture is somewhat less than interesting, it has an unexpected history. Joseph Pulitzer, publisher of the *New York World,* played a principal role in raising money for the pedestal of the *Statue of Liberty* when other efforts had faltered. After *Liberty's* unveiling, he commissioned Bartholdi to execute a statue of Lafayette and Washington for Paris. It was dedicated in the Place des Etats-Unis in 1895. Prior to that when it was displayed at the 1893 Columbian Exposition in Chicago, critics derisively called it "the handshake." The mayor of Chicago endorsed a public subscription for a replica of the statue for Chicago, but the *New York Times* panned the work, impeding the subscription. New York's replica of this Bartholdi work, standing at Morningside Drive and 114th Street, was given at the turn of the century by a flamboyant New York merchant, Charles Broadway Rouss. His name can still be made out in large letters across the front of a ten-story cast-iron building at 555 Broadway in Soho, his former department store.

**Dedicated:** *April 19, 1900.* **Signed:** *A. Bartholdi, 1890.* **Foundry mark:** *F. Barbedienne, Foundeur Paris.* **Collection of:** *City of New York; gift of Charles Broadway Rouss.*

## J-16 General Winfield Scott Hancock, 1891

**Sculptor:** *James Wilson Alexander MacDonald (1824–1908).* **Media and size:** *Bronze bust, over life-size; granite pedestal.* **Location:** *Hancock Square, at the confluence of Manhattan and St. Nicholas Avenues at 124th Street.*

An experienced sculptor of Civil War heroes, James Wilson Alexander MacDonald, often referred to as J. Wilson MacDonald, here portrays an American seldom mentioned today, but who was so popular in 1880 that he was almost elected president of the United States. Hancock was one of the Union's most successful generals, credited with helping turn the tide at Gettysburg, and in a race for the presidency he lost to James Garfield by only a slim margin. The oversize bronze bust in its primly fenced little park was funded in his memory by veterans of the Hancock Post 259 and public subscription.

MacDonald took a plaster mask of Hancock the year he ran for office and this portrait is probably based on it. Another cast is in the collection of the Metropolitan Museum of Art. Its accuracy is supported by a contemporary description of General Hancock by J. B. McClure which said in part: "A soldierly moustache, white as snow, finds a broad resting place on his upper lip. His face is large and good. It inspires confidence. His eyes are a light or bluish gray, and set wide apart. . . . His stature and his tread make him a commanding person wherever he may be." The block-like torso cut off sharply at the shoulders is bare except for a wide ribbon across the left shoulder, denoting military honor. The sober naturalism of this work is marked by bold contours yet subtle modeling in the detailing of moustache and hair.

**Dedicated:** *December 30, 1893.* **Signed and dated:** *1891 / Wilson MacDonald Sculptor.* **Collection of:** *City of New York; gift from Hancock Post 259.*

# J-17 Harlem Hybrid, ca. 1973

**Sculptor:** *Richard Hunt (1935– )*. **Media and size:** *Welded bronze plate, 10 feet high*. **Location:** *Roosevelt Square Park, at 125th Street and Morningside Avenue*.

This imaginative sculpture fits into its triangular space at the northern edge of Roosevelt Park. The powerful construction that branches out from a snout-like end seems to lurch forward like a giant animal. From some angles its sweeping curves and sloping planes simulate rock formations, inviting an onlooker to explore. They also invite local youths to add graffiti. Roosevelt Park has many fine trees and if this portion of it were restored this interesting abstract sculpture would be greately enhanced.

A master of welded metal, Chicago-born Richard Hunt rose quickly to public prominence. Art critic Hilton Kramer wrote of the artist, then not yet 30: "I think that Hunt is one of the most gifted and assured artists working in the direct metal, open-form medium—and I mean not only in his own country and generation, but anywhere in the world."

Hunt welded his earliest sculptures from discarded machine-made parts. Many of these pieces have a calligraphic quality, recalling the linear constructions of Julio Gonzalez. Gradually Hunt evolved denser, more massive forms, suited to the large-scale outdoor works which he began doing in 1967. Plant life, the human figure, and geological formations have all been sources for the artist.

**Collection of:** *City of New York; gift of the Mildred Andrews Fund.*

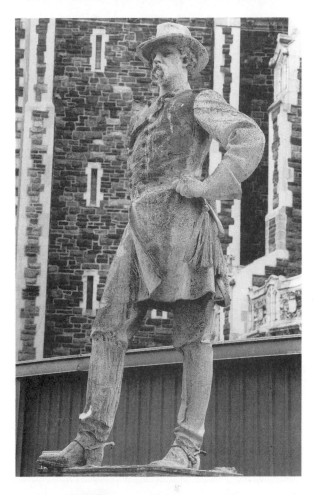

## J-18 Alexander Stewart Webb, 1917

**Sculptor:** *John Massey Rhind (1860–1936).* **Media and size:** *Bronze statue, over life-size; granite pedestal.* **Location:** *City College, on Convent Avenue between 138th and 139th Streets.*

The soldier and educator Alexander Stewart Webb (1835–1911) fought for the Union, rising through the ranks to major-general. After the Civil War he left the military and became president of City College, a position he held for 33 years, from 1869 to 1902.

This statue is a replica of the bronze statue erected on the battlefield at Gettysburg, where Webb achieved his greatest distinction, winning the Congressional Medal of Honor for "distinguished personal gallantry." His brigade met Pickett's charge, successfully repulsing it. In this bronze likeness Rhind seeks to capture the moment when Webb confronted Pickett, showing the indomitable fighter poised for action, his left hand on his hip and his right holding a sword (now missing). The pedestal bears Gothic details to harmonize with City College buildings.

**Dedicated:** *May 7, 1917.* **Signed:** *J. Massey Rhind Sculptor.* **Foundry mark:** *John Williams, Incorporated, Foundry.* **Collection of:** *City of New York; gift of alumni of the College of the City of New York.*

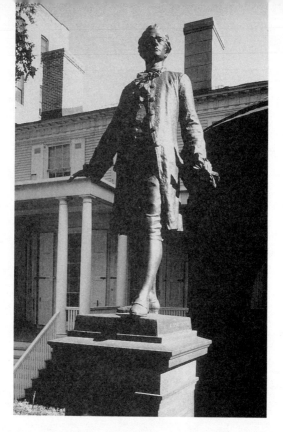

## J-19 Alexander Hamilton, 1892

**Sculptor:** *William Ordway Partridge (1861–1930).* **Media and size:** *Bronze statue, over life-size; granite pedestal.* **Location:** *Hamilton Grange, 287 Convent Avenue, between West 141st and 142nd Streets.*

Poet, actor, lecturer, author, critic, the versatile William Ordway Partridge made his debut as a sculptor at the 1893 Columbian Exposition. A model for this statue of Alexander Hamilton (1757–1804) was among the ten works he exhibited there. It was his first large-scale work. The dynamic portrait of *Hamilton* reflects the influence of the École des Beaux-Arts and also of Partridge's own experience as a public speaker and actor. Partridge depicts Hamilton at the New York Convention during the speech in which he eloquently defended the Constitution. As one critic noted, the "face expresses clear, resolute reasoning; the bearing shows strong feelings and passions controlled by a still stronger intelligent will. . . ." In his 1894 book *Renaissance and Modern Art,* William H. Goodyear went so far as to call this statue an encapsulation of an entire epoch, an embodiment of the "colonial spirit."

The Hamilton Club of Brooklyn commissioned the statue which stood in front of its clubhouse at the corner of Clinton and Remsen Streets until 1936. Then it was moved to its present location in front of Hamilton's 1801 New York country house, "The Grange," in upper Manhattan by the American Scenic and Historic Preservation Society.

**Dedicated:** *October 4, 1893.* **Signed:** *William Ordway Partridge.* **Collection:** *National Park Service.*

# J-20 Sculptures at Bethune Tower, 1968

**Sculptors:** *Melvin Edwards (1937– ); Todd Williams (1939– ); Daniel Larue Johnson (1938– ).* **Architect:** *James Stewart Polshek & Associates.* **Location:** *Bethune Tower, 650 Lenox Avenue at the southeast corner of Lenox Avenue and 143rd Street.*

Three playful abstract sculptures enliven the street at the corner of this Mitchell-Lama, middle-income housing project built by the New York City Housing and Development Administration and sponsored by Kreisler Borg Florman, a private construction company. This was the first housing project which the company embellished with public sculpture. Later it commissioned Ernest Trova's work at its Heywood Tower (see I-17). A Museum of Modern Art curator, Kynaston McShine, helped select black sculptors Daniel Larue Johnson, Melvin Edwards, and Todd Williams, choosing artists with the community in mind.

*Double Circles* (1968) by Mel Edwards is a lighthearted participatory piece. Eight feet high, it consists of two pairs of red eight-foot-tall steel circles set on edge, one behind the other and stabilized at the sidewalk with a connecting metal bar. Positioned in a straight line and large enough to walk through, they invite youthful play. Edwards is known for his quite different, politically charged art made from materials such as chain link and barbed-wire.

Marking the very corner of the project at Lenox and 143rd Street, a few yards from *Double Circles,* is the burgundy-painted *Ligion* (ca. 1970) by Todd Williams. Over five feet high, it could be a jigsaw puzzle on a grand scale. Composed of three blocky elements that look like they might fit together, the cluster provides a popular seat for teenagers, climbing children, or at other times for elderly people in the sun. It is an all-around successful piece.

Near the entrance to Bethune Tower stands a slender metal wedge-shaped

form 15 feet tall by Daniel Larue Johnson. Entitled *Ornette Coleman Force No. 1*, it honors the jazz musician and composer and was originally painted with stripes of color. Johnson explains that jazz is a "motivating spirit that makes my mind see changing patterns of color." Probably vandalism has led to the metal shape being repainted more than once, so now the original stripes have disappeared under coats of gray paint. This is a metal version of similar works in enameled wood by Johnson in which he combines the wedge form with stripes of color.

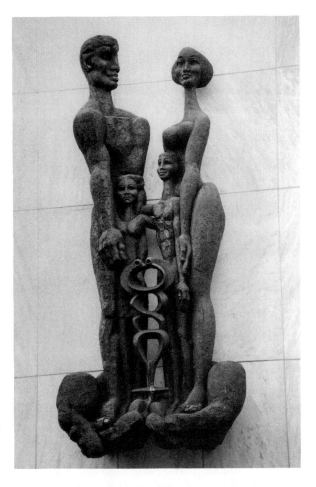

## J-21 The Family, 1966–1969

**Sculptor:** *John Rhoden (1918– ).* **Media and size:** *Bronze group, 22 feet high.* **Location:** *Harlem Hospital, over the main entrance on Lenox Avenue between 135th and 136th Streets.*

Like an icon, this figurative bronze relief "conceived as a universal image of the family" marks the entrance to Harlem Hospital. The rigid figures form a hierarchical composition, the parents framing two children nestled between them. They stand in the palms of two giant hands behind a caduceus, the emblem of the medical profession. Clearly the sculpture suggests that when you enter the hospital you are now in its protective hands.

Sculptor John Rhoden, a world traveler who has studied the arts and culture of numerous peoples, incorporates various sculptural traditions in his work. The figures in *The Family* smile the archaic smile of Greek kouros figures, projecting an inner spirit, yet anatomical distortions such as the mother's elongated neck and oversized breasts and hips recall African tribal art. The caduceus, too, resembles an African sculpture.

**Collection of:** *City of New York; commissioned by the Health and Hospitals Corporation.*

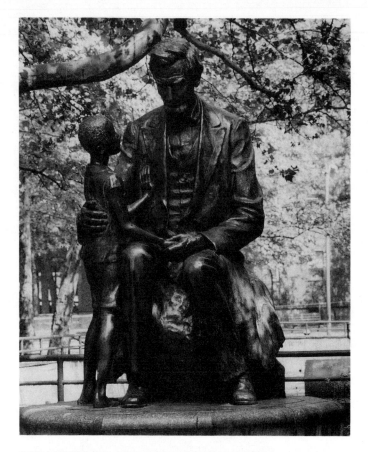

## J-22 Abraham Lincoln *and* Child, 1948

**Sculptor:** *Charles Keck (1875–1951)*. **Media and size:** *Bronze group, over life-size; circular granite pedestal*. **Location:** *Madison Avenue near 133d Street*.

This informal portrait of Abraham Lincoln shows him as a humanitarian and friend of children. Seated on a simple stool Lincoln draws close the small black boy with whom he is talking. Perhaps sculptor Charles Keck was inspired by his teacher, Augustus Saint-Gaudens' statue of the seated Lincoln, unveiled in Chicago in 1926. Keck, however, reinterprets the theme, portraying Lincoln in a more personal light.

**Signed and dated:** *C. Keck '48*. **Foundry mark:** *Roman Bronze Work*. **Collection of:** *New York City Housing Authority*.

## J-23 Growth, 1984–1985

**Sculptor:** *Jorge Luis Rodriguez (1944– ).* **Media and size:** *Steel sculpture painted magenta, 14 feet high.* **Location:** *East Harlem Artpark, Sylvan Place, between 120th and 121st Streets and Lexington and Third Avenues.*

A note of whimsy in the newly designed East Harlem Artpark adjacent to a housing complex, *Growth* suggests trees, plants, or maybe a fantastic bird. Sculptor Rodriguez purposefully included recognizable imagery, because he knew that that was what the neighborhood would prefer. Rodriguez said: "If I had made something completely abstract, I think that would have caused a violent reaction in the community. I took into account that people would want to understand the piece, which is semi-abstract. It could be a flower, a bird, or a seed growing from the earth." In its organic references, the sculpture suits its site.

*Growth* was the first artwork to be commissioned through the city's "Percent for Art" program, administered at that time by the Public Art Fund, Inc., under the auspices of the Department of Cultural Affairs. Initiated in 1982, the New York Percent for Art Law stipulates that the city shall allocate 1% for art out of the first $20 million and 0.5% of the next $40 million spent on construction or renovation of an eligible city-owned structure. Modeled on percent programs in other cities, the commissioning process involves art experts and takes into account community needs and aspirations. At the time of this writing, 19 designs are in process. Forthcoming works for sites in Manhattan include Stephen Antonakos' neon light sculpture for the 59th Street Marine Transfer Station, Donna Dennis' sculptural fence for P.S. 234, and Richard Haas and Kit-Yin Snyder's work for the White Street Detention Center.

**Dedicated:** *June 26, 1985.* **Collection of:** *City of New York; commissioned by the Department of Housing Preservation & Development as part of the Department of Cultural Affairs Percent for Art Program.*

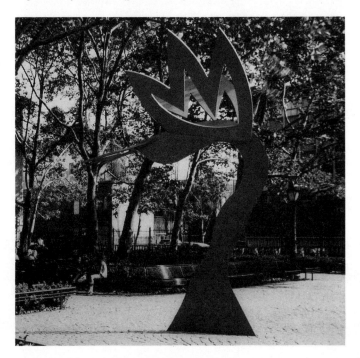

## J-24 Robert F. Wagner Memorial, 1959

**Sculptor:** *Georg John Lober (1892–1961).* **Media and size:** *Bronze bust, over life-size; granite pedestal.* **Location:** *Terrace adjacent to Robert F. Wagner, Sr., Houses, 120th Street and Second Avenue.*

United States senator from New York, Robert F. Wagner (1877–1953) devoted 45 years of his life to illustrious public service, leaving an indelible mark on the New Deal. Responsive to the plight of the unemployed, he drafted legislation to improve worker's rights and was primarily responsible for the National Labor Relations Act, passed July 5, 1936. His son, Robert F. Wagner, Jr., served as the mayor of New York from 1954 to 1965.

**Signed:** *Georg Lober / .19.Sculptor.59.* **Collection of:** *New York City Housing Authority; gift of the International Brotherhood of Electrical Workers of Greater New York.*

## J-25 Sculpture at the Hispanic Society of America, 1927–1943

**Sculptor:** *Anna Vaughn Hyatt Huntington (1876–1973).* **Location:** *156th Street and Broadway.*

Over the course of two decades, noted *animalier* Anna Vaughn Hyatt Huntington created a complex sculptural program unexampled in this country for the sunken court of the Hispanic Society Museum, founded in 1904 by her husband, Archer M. Huntington. Mrs. Huntington explained in a letter of 1954 that ". . . as my husband had directed his life to bringing Spanish culture to this country, his love and enthusiasm for Spain was naturally conveyed to me and gave me the wish to supplement his work by my sculpture."

The dramatic equestrian statue *El Cid Campeador* (1927) dominates the symmetrical plan. It portrays the 11th-century Spanish knight who fought the Moors during the reconquest. Proud and victorious, he stands in his stirrups and holds aloft a pennant. Huntington designed the sculpture to be seen silhouetted against the rear wall. Four seated bronze warriors (1927),

symbols of Spain's Orders of Chivalry, mark the corners of the grandiose pedestal. The original cast of *El Cid* went to Seville, and two years later in 1929 the King of Spain presented Huntington with the Grand Cross of Alfonzo XII.

Flanking *El Cid Campeador* are two limestone high reliefs of extraordinary interest. *Don Quixote* (1942), the imaginary hero of Cervantes' epic book, looks up dreamily as his scrawny horse, Rosinante, grazes. Facing him is *Boabdil* (1943), the last Moorish king of Granada, who turns around for a last look at the Alhambra.

In keeping with the Spanish theme, the decorative animals in bronze and marble in the courtyard's ensemble depict Hispanic fauna. They include a bronze stag (1929), a doe and its fawn (1934), and in marble, four groups of vultures, wild boars, jaguars, and bears (1936). Two heraldic limestone lions (1930) guard the main entrance to the Hispanic Society. The sculptural array and its architectural setting make a grand statement.

**Collection of:** *Hispanic Society of America.*

## J-26 Washington Heights–Inwood War Memorial, 1921

**Sculptor:** *Gertrude Vanderbilt Whitney (1875–1942).* **Pedestal by:** *Delano & Aldrich.* **Media and size:** *Bronze group, over life-size; low circular granite pedestal.* **Location:** *Broadway and Saint Nicholas Avenue, between 167th and 168th Streets.*

In this stirring sculpture Whitney portrays three World War I American fighting men struggling to safety. The central figure holds up a comrade who is collapsing in his arms. The third crawls on his knees as he turns toward the others, his mouth frozen in a grimace. Whitney honors the dead without glorifying their suffering and forces the viewer to confront war's brutality. The New York Society of Architects awarded the *Washington Heights–Inwood War Memorial* a medal for the most meritorious work of 1922.

In 1914 Gertrude Vanderbilt Whitney, sculptor, art patron, and prominent member of a wealthy family, had established a hospital near the front lines at Juilly, France. The alienation, waste, and heroism she witnessed inspired a series of emotionally charged small sculptures depicting battle-worn soldiers. In 1919 she included these works in her exhibition "Impressions of the War," held at the Whitney Studio in Greenwich Village. This war memorial derives from the small bronzes and retains the intensity of the sketches. The critic and painter Guy Pene du Bois summed up the power of Whitney's vivid war sculptures when he wrote ". . . she threw masses of clay together in the shapes of men, men who were not merely men but men at war, men enveloped in the chaos of a mad dream."

During the first three decades of the 20th century, concurrent with her career as a figurative sculptor, Whitney was a leading patron of progressive American art. She supported struggling artists by creating Friends of the Young Artists (1915), and the Whitney Studio Club (1918). Her lasting contribution to the promotion of American art was the Whitney Museum, which she founded in 1929 at 20 West 8th Street. It opened in 1931.

**Dedicated:** *May 30, 1923.* **Collection of:** *City of New York; gift of Washington Heights and Inwood Memorial Association.*

## J-27 3000 A.D. Diffusion Piece, 1974

**Sculptor:** *Terry Fugate-Wilcox (1946– )*. **Media and size:** *Plates of magnesium and aluminum, 40 feet high by 3 feet wide by 1 foot deep.*
**Location:** *Jacob Hood Wright Park Terrace, Fort Washington Avenue between 173rd and 175th Streets, across from the George Washington Bridge.*

For artist Terry Fugate-Wilcox time and nature are collaborating forces. He weds the visible with the invisible, constructing pieces which will substantively reflect the passage of time. In *3000 A.D. Diffusion Piece,* Fugate-Wilcox bolts varying lengths of magnesium and aluminum plates together into a slab which is eight layers thick. "The essence of this type of work," the artist states, "is the fact that the two materials will mix or diffuse together within a determined time span of 3,000 years, at which time I will consider the piece finished."

*3000 A.D. Diffusion Piece,* Fugate-Wilcox's first major public sculpture, evolved out of the Environmental Sculpture Program, organized in the early 1970s by the Public Arts Council, the New York City Department of Cultural Affairs, and the Mayor's Neighborhood Action Program. The program originators conceived a way for the city's communities to participate in the selection and siting of neighborhood sculptures. A committee of neighborhood representatives and art experts chose 12 proposals out of 60 submissions, and then recipient communities reviewed models and plans and voted on them in order of preference.

Fugate-Wilcox himself suggested this site overlooking the Hudson. He then designed the piece to correspond visually to the George Washington Bridge, rising dramatically in the background. A subtle resonance exists between the bolts, so prominent on the sculpture, and the steel frame construction of the bridge.

**Collection of:** *City of New York; purchase by the Public Arts Council and Neighborhood Action Program.*

# Checklist of Other Outdoor Sculpture in Manhattan

## (A) Financial District

**Dewey Memorial, 1973** (medallions are enlarged and recast from 1898 originals). *Sculptor:* Daniel Chester French (1850–1931). *Location:* Battery Park, adjacent to the Admiral George Dewey Promenade.

**The Jerusalem Grove, ca. 1976.** Stone marker and *Cedrus atlantica glauca* trees. *Location:* Battery Park, northwest of Castle Clinton.

**Netherland Memorial Flagpole, 1926.** *Designer:* H. A. Van den Eyden. *Location:* Battery Park, at the Bowling Green entrance to the park.

**Norwegian Monument, ca. 1982.** Natural boulders from Norway. *Location:* Battery Park, northwest of Castle Clinton.

**Wireless Operators' Fountain, ca. 1913.** *Designer:* Hewitt & Bottomley. *Location:* Battery Park, east of *East Coast War Memorial.*

**Bank of Tokyo (American Surety Building) Facade Figures, 1895.** *Sculptor:* John Massey Rhind (1860–1936). *Location:* 100 Broadway at Pine Street.

**Trinity Church Doors, 1891–1893.** *Sculptor:* Karl Bitter (1867–1915). *Location:* Broadway at Wall Street.

## (B) Downtown

**Bowery Savings Bank Pediment, 1894.** *Sculptor:* Frederick MacMonnies (1863–1937). *Location:* 130 Bowery, north of Grand Street.

**Environmental Sculpture, 1985.** *Sculptor:* Ami Shamir (1932– ). *Location:* Courtyard of I. S. 25, 145 Stanton Street.

**The Four Elements** (Replicas of 1917 panels). *Sculptor:* Paul Manship (1885–1966). *Location:* AT&T Building, 195 Broadway.

**The Life of Samuel Dickstein, ca. 1967.** *Sculptor:* Otello Guarducci. *Location:* J.H.S. 56, 220 Henry Street.

**Park Row Building Cupola Figures, 1899.** *Sculptor:* John Massey Rhind (1860–1936). *Location:* 13-21 Park Row.

**Seward Park Fountain, 1895.** *Designer:* Brunner & Tryon. *Location:* Seward Park, Essex Street between Chester and Canal Streets.

**Sullivan Memorial Fountain, ca. 1911.** *Designer:* Thomas Lamb (1871–1942). *Location:* Bowery and Kenmore Street at Delancey Street.

**Unity of the Family, 1954–1955.** *Sculptor:* Oronzio Maldarelli (1892–1963). *Location:* State Insurance Fund Building, 199 Church Street at Reade Street.

## (C) The Villages

**First Houses Playground Sculpture, ca. 1936.** *Sculptor:* Hugo Robus (1885–1964). *Location:* Avenue A at East 3rd Street.

**Little Lady of the Dew, Aspiration, Inspiration, ca. 1920.** *Sculptor:* Solon Borgium (1868–1922). *Location:* St Mark's-in-the-Bouwerie, Second Avenue at East 10th Street.

**Petrus Stuyvesant, 1911.** *Sculptor:* Toon Dupuis (1877–1937). *Location:* St. Mark's-in-the-Bouwerie, Second Avenue and East 10th Street.

**Puck, 1885.** *Sculptor:* Caspar Buberl (1834–1899). *Location:* Puck Building, 295 Lafayette Street at Houston Street.

**Riis Plaza Sculptures, 1966.** *Sculptor:* William Tarr (1925– ). *Location:* Riis Houses, at Avenue D between East 6th and 10th Streets.

**Weathering Concrete Triangle, *1984*.** *Sculptor:* Terry Fugate-Wilcox (1944– ). *Location:* 159 Seventh Avenue South, at Waverly Place.

## (D) Midtown South

**Nursing Activities, ca. 1952.** *Sculptor:* Ivan Mestrovic (1883–1962). *Location:* South wall of Hunter College Nursing School Dormitory, East 26th Street and First Avenue.

**The City of Manhattan, ca. 1965.** *Sculptor:* John Matt. *Location:* J.H.S. 70, 333 West 17th Street, between Ninth and Tenth Avenues.

**Eternal Light Monument, 1924.** *Sculptor:* Paul Wayland Bartlett (1865–1925). *Location:* Madison Square.

**Union Square War Memorial, ca. 1934.** *Sculptor:* Hunt Diedrich (1884–1953). *Location:* Union Square, southeast triangle.

## (E) Midtown East

**"Brick Wall," 1981.** *Sculptor:* Aleksandra Kasuba (1923– ). *Location:* 560 Lexington Avenue, at East 51st Street.

**Dag Hammarskjold Bust, ca. 1981.** *Sculptor:* Carina Ari. *Location:* 240 East 47th Street, near Second Avenue.

**Big Red Swing, 1971.** *Sculptor:* Theodore Ceraldi. *Location:* 777 Third Avenue, between East 48th and 49th Streets.

**Construction Workers, 1930–1932).** *Sculptor:* Elie Nadelman (1882–1946). *Location:* Fuller Building, 41 East 57th Street, near Madison Avenue.

**"Fluorescent Light Installation," 1977.** *Sculptor:* Dan Flavin (1933– ). *Location:* Grand Central Terminal, on commuter train platforms 18-19, 39-40, and 41-42.

**Queensboro Bridge Fountain, ca. 1918.** *Sculptor:* Eli Harvey (1860–1957). *Architect:* Charles Stoughton. *Painter:* Edwin Blashfield. *Location:* Bridgemarket, 413 East 59th Street, at the Queensboro Bridge.

**St. Bartholomew's Episcopal Church Portals, 1904.** *Sculptors:* north portal, Herbert Adams (1858–1945); middle portal and flanking panels, Andrew O'Conner (1874–1941); south portal, Philip Martiny (1858–1927). *Location:* Park Avenue, between East 50th and 51st Streets.

**St. Patrick's Cathedral Doors.** *Sculptor:* John Angel (1881–1960). *Location:* Fifth Avenue, between East 50th and 51st Streets.

**Spirit of Achievement, ca. 1931.** *Sculptor:* Nina Saemondsson (active 1931). *Location:* Waldorf-Astoria, 301 Park Avenue, between East 49th and 50th Streets.

**Spirit of Understanding, 1959–1960).** *Sculptor:* Pierre Bourdelle (1902–1965). *Location:* American Field Service Headquarters, 313 East 43rd Street, between First and Second Avenues.

**Statuary Group and Clock, ca. 1928.** *Sculptor:* Edward McCartan (1879–1947). *Location:* Helmsley Building, facing Park Avenue at East 44th Street.

**Trilogy, 1960.** *Sculptor:* Sidney Gordon. *Location:* 300 East 46th Street.

## (F) Midtown West

**"Flagpole Bases," 1912.** *Designer:* Thomas Hastings. *Executed by:* Raffaele J. Menconi. *Location:* New York Public Library, 42nd Street and Fifth Avenue.

## (G) Central Park

**Central Park Boathouse Dedicatory Sculpture, 1967.** *Sculptor:* Irwin Glusker. *Location:* Central Park Boathouse.

**Levy Memorial Gates, ca. 1957.** *Sculptor:* Walter Baretta. *Location:* Entrance to the Levy Playground, near 79th Street and Fifth Avenue.

**Snow Babies, ca. 1937.** *Sculptor:* Victor Frisch (1876–1939). *Location:* Entrance to Mary Harriman Rumsy Playground.

## (H) Upper East Side

**ASPCA Horses, ca. 1925.** *Sculptor:* Hunt Diedrich (1884–1953). *Location:* ASPCA Headquarters, East 92nd Street between York Avenue and the FDR Drive.

**Itzamna Stella, 1973.** *Sculptor:* Hans Van de Bovenkamp (1938– ). *Location:* 300 East 75th Street, at the southeast corner of Second Avenue.

**Metropolitan Museum of Art Façade Sculptures, 1899.** *Sculptor:* Karl Bitter (1867–1915). *Location:* Metropolitan Museum of Art, Fifth Avenue at 82nd Street.

**Polhymnia, ca. 1896.** *Sculptor:* Giuseppe Moretti (1859–1935). *Location:* Liederkranz Club, 6 East 87th Street, near Fifth Avenue.

**Signal 1 and Clam, 1969–1970.** *Sculptor:* Menashe Kadishman (1932– ). *Location:* Adam's Towers, 351 East 84th Street, at First Avenue.

**Steel Park, 1980.** *Sculptor:* Bernard Rosenthal (1914– ). *Location:* 401 Gracie Mews, at the northeast corner of East 80th Street and First Avenue.

**Symbol Tower.** *Sculptor:* William Tarr (1925– ). *Location:* Vest-pocket park on East 102nd Street between Lexington and Third Avenues.

**Untitled, 1973.** *Sculptor:* Edward Dorson. *Location:* 160 East 65th Street, at Third Avenue.

**Wobbly, 1987.** *Sculptor:* Les Leveque. *Location:* "The America," on the southeast corner of East 85th Street and Second Avenue.

## (I) Upper West Side

**Clark Memorial, 1911.** *Sculptor:* Henry Kirke Bush-Brown (1857–1935). *Location:* Riverside Park and West 82nd Street.

**Hamilton Drinking Fountain, ca. 1905.** *Designers:* Warren & Wetmore. *Location:* Riverside Drive and West 76th Street.

**Seals on New York Coliseum, 1956.** *Sculptor:* Paul Manship (1885–1966). *Location:* New York Coliseum, Columbus Circle, Eighth Avenue and West 59th Street.

**Thomas Gainsborough, A Festival Procession of the Arts, ca. 1910.** *Sculptor:* Isidore Konti (1862–1938). *Location:* 222 West 59th Street, near Columbus Circle.

## (J) Upper Manhattan

**Bears, 1956.** *Sculptor:* Joseph Kiselewski (1901– ). *Location:* Carver Houses, 50-60 East 106th Street, between Park and Madison Avenues.

**George Washington Carver, ca. 1955.** *Sculptor:* Robert Amendola. *Location:* Carver Houses, playground, off 101st Street, between Park and Madison Aves.

**Man with a Cog, 1937.** *Sculptor:* Richmond Barthe (1901– ). *Location:* Harlem River Houses, 151st to 153rd Streets, Macombs Place to Harlem River Drive.

**Martin Luther King, Jr., 1970.** *Sculptor:* Sam Sawyer. *Location:* Esplanade Garden Houses, 147th Street at Lenox Avenue.

**Negro Mother and Child, 1937.** *Sculptor:* Heinz Warneke (1895–1983). *Location:* Harlem River Houses, 151st to 153rd Streets, Macombs Place to Harlem River Drive.

**Morningside Heights, Numbers, and Letters, 1966–1967.** *Sculptor:* William Tarr (1925– ). *Location:* P.S. 36, 123 Morningside Avenue.

# Selected Bibliography

## Surveys and General Sources

Arnason, H. H. *History of Modern Art*. 2nd ed. New York: Harry N. Abrams, 1977.

Armstrong, Tom, et al. *200 Years of American Sculpture*. New York: Whitney Museum of American Art, 1976.

Craven, Wayne. *Sculpture in America*. New and rev. ed. Newark: University of Delaware Press, and New York and London: Cornwall Books, 1984.

Fried, Frederick, and Edmund V. Gillon, Jr., photographer. *New York Civic Sculpture—A Pictorial Guide*. New York: Dover, 1976.

Lederer, Joseph, and Arley Bondarin, photographer. *All Around the Town: A Walking Guide to Outdoor Sculpture in New York City*. New York: Charles Scribner's Sons, 1975.

Proske, Beatrice. *Brookgreen Gardens, Sculpture*. Brookgreen Gardens, S. C., 1968.

Rubinstein, Charlotte Streifer. *American Women Artists*. Boston: G.K. Hall & Co.; New York: Avon Books, 1982.

Taft, Lorado. *The History of American Sculpture*. New York: Macmillan Co., 1903, 1924 (reprint, New York: Arno Press, 1969).

White, Norval, and Elliot Willensky. *The AIA Guide to New York City*. New York: Collier-Macmillan, 1978.

*The W P A Guide to New York City*. Introduction by William H. Whyte. New York: Pantheon, 1982 (reprint of *New York City Guide*, New York: Random House, 1939).

## Specialized Sources

Art Commission of the City of New York. *Catalogue of the Works of Art Belonging to the City of New York*. 2 vols. New York: Art Commission of the City of New York, 1909, 1920.

Barlow, Elizabeth, et al. *The Central Park Book*. New York: The Central Park Task Force, 1977.

Beattie, Susan. *The New Sculpture*. New Haven and London: The Yale University Press, 1983.

Freedman, Doris C. *Walking Tour Guide of Public Art in Lower Manhattan*. New York: Public Arts Council, Municipal Art Society, and Lower Manhattan Cultural Council, 1977.

Karp, Walter. *The Center: A History and Guide to Rockefeller Center*. New York: American Heritage Publishing Co., Inc., 1982.

King, Moses, ed. *King's Handbook of New York City—Thoroughfares and Adornments, Monuments, Statues, Fountains. . . .* New York, 1893.

Port Authority of New York and New Jersey. *Art for the Public.* New York: The Port Authority of New York and New Jersey, 1985.

Read, Benedict. *Victorian Sculpture.* New Haven and London: The Yale University Press, 1982.

Senie, Harriet. "Studies in the Development of Urban Sculpture: 1950–1975." Ph.D. dissertation, New York University, 1981.

Sharp, Lewis I., and David W. Kiehl, eds. *New York Public Sculpture by 19th Century American Artists.* New York: Metropolitan Museum of Art, 1974.

Stokes, Isaac Newton Phelps. *The Iconography of Manhattan Island, 1498–1909.* 6 vols. New York: Robert H. Dodd, 1915 (reprint, New York: Arno Press, 1971).

Trachtenberg, Marvin. *The Statue of Liberty.* New York: Viking Press, 1976.

Wilson, Walter S. "The Statues and Monuments of New York City." Chapter 7 in vol. 4 of *Memorial History of the City of New York,* . . . edited by James G. Wilson. New York, 1892.

## Unpublished Sources

Exhibition and correspondence files of the Art Commission of the City of New York.

# Photo Credits

*Abbreviations: Parks Photo Archive-PPA; United Nations Photo Library-UNPL*

Art Commission of the City of New York, A-2, A-4, A-5, A-12, B-2, B-4, B-8, B-15, C-2, C-3, C-4, C-5, (a,b), C-6, C-12, C-13, C-14, C-15, D-1, D-3, D-4, D-5, D-7, D-9, D-10, D-12, D-14, D-22, F-1, F-5, F-6, F-7, F-12, F-15, F-16, G-2, G-3, G-6, G-8, G-10, G-11, G-12, G-14, G-15, G-20, G-22, G-25, G-26, G-27, G-28, G-30, G-31, G-32, G-33, G-34, G-36, G-37, G-38, G-39, G-40, G-42, G-45, G-48, G-49, G-50, I-1, I-2, I-14, I-19, I-20, I-21, I-22, I-23, I-24, I-26, J-13, J-14, J-16, J-26.

Daniel Dutka, A-3, A-6, A-7, A-8, A-9 (a-d), A-21, A-22, A-23, B-1, B-7, B-9, B-11, B-12, B-13, B-14, B-18, B-19 (a,b), B-20, B-22, B-23, C-9, C-10, C-16, D-2, D-11, D-16, D-17, D-18, D-21, D-25, E-2, E-8, E-14, E-15, E-16, F-2, F-8, F-9, F-10, F-11 (a,b), F-13, F-17, F-36, F-37, F-38, G-1, G-2(a), G-23, G-41, G-44, G-51, H-2, H-4, H-5, H-9, H-10.

Jenny McCloskey, A-10, A-13, B-6, B-17, C-1, D-6, D-20, D-23, E-1, E-9, E-11, F-14, F-22, H-11, I-4, I-5, I-6, I-7, I-15, J-17, J-20 (a,b), J-21, J-22, J-24.

A-1, Brian Feeney, courtesy National Park Service; A-15 courtesy The Pace Gallery; A-16, Arthur Lavine, courtesy The Isamu Noguchi Foundation, Inc.; A-17, Arthur Lavine, courtesy The Pace Gallery; A-18, C. S. Laise, courtesy Federal Hall Memorial Associates; A-19 courtesy The New York Convention and Visitors Bureau, Inc.; A-20 courtesy The Isamu Noguchi Foundation, Inc.; A-24, A-25, A-26, courtesy The Port Authority of New York & New Jersey; A-27, Devin Mann, courtesy Battery Park City Authority; B-3, Mel Finkelstein, courtesy Margot Gayle; B-5, Bob Pfeiffer, courtesy Pace University; B-10, Dan Brinzac, courtesy Borgenicht Gallery; B-16, courtesy Tony Rosenthal; B-21, Richard Guthridge, courtesy PPA; B-24, courtesy the New York City Department of Parks & Recreation, Office of Arts and Antiquities; C-7, Thor Bostrom, courtesy DiLaurenti Gallery; C-8, Alan Sonfist; C-11, Hans Namuth, courtesy Tony Rosenthal; D-8, Rodney McCay Morgan, PPA; D-13, Phyllis Samitz Cohen; D-15, Alajos Schuszler, courtesy PPA; D-19, Travis, courtesy the United Nations International School; D-24, courtesy Robert Cronbach; E-3 courtesy Howard Rubenstein Associates, Inc.; E-4, courtesy Sculpture Placement, LTD of Washington, D.C.; E-5, courtesy Robert Cook; E-6, Janice Jablon Mehlman; E-7, Ivan Dalla Tana, courtesy Xavier Fourcade, Inc.; E-10, Karen Sigel,

courtesy Art Commission of the City of New York; E-12, Noel Rowe Photography, courtesy William King; E-13, courtesy André Emmerich Gallery; E-17, courtesy UNPL; E-18, Milton Grant, courtesy UNPL; E-19, E-20, E-21, E-22, courtesy UNPL; E-23, Yutaka Nagata, courtesy UNPL; E-24, courtesy UNPL; F-3, Judith Weller, courtesy ILGWU; F-4, Alajos Schuszler, courtesy PPA; F-18, courtesy Sculpture Placement, LTD of Washington, D.C.; F-19, courtesy The Association for a Better New York; F-20, Gianfranco Gorgoni; courtesy © The Equitable; F-21, courtesy © The Equitable; F-23, courtesy Phyllis Weil & Company; F-24, Alexandre Georges, courtesy The Isamu Noguchi Foundation, Inc.; F-25, Allan Finkelman, courtesy Sidney Janis Gallery, N.Y.; F-26, courtesy the Port Authority of New York & New Jersey; F-27, Chuck DeLaney, courtesy Joyce B. Schwartz, Ltd., Works of Art for Public Spaces; F-28, Karen Sigel, courtesy Art Commission of the City of New York; F-29, Alajos Schuszler, courtesy PPA; F-30, F-31, F-32, courtesy Rockefeller Center; F-33, Stephen Senigo, courtesy Landmarks Preservation Commission; F-34, courtesy The New York Convention & Visitors Bureau, Inc.; F-35, Stephen Senigo, courtesy Landmarks Preservation Commission; G-4, courtesy David Finn, Ruder Finn & Rotman, Inc.; G-5, Alajos Schuszler, courtesy PPA; G-7, Sarah Cedar Miller, courtesy Central Park Conservancy; G-9, Calvin Wilson, courtesy PPA; G-13, courtesy PPA; G-16, G-17, G-18, G-19, G-21, courtesy PPA; G-24, G-29, courtesy The New York Convention and Visitors Bureau, Inc.; G-35, The New York Times/John Manship Collection supplied to the PPA; G-42a, G-43, courtesy PPA; G-46 Ben Cohen, courtesy PPA; G-47, courtesy PPA; H-1, courtesy Herbert A. Feuerlicht; H-3, Timothy Clarke, courtesy The Twentieth Century Fund, Inc.; H-6, courtesy The Metropolitan Museum of Art, Isamu Noguchi Foundation, Inc. 1981. (1981.131); H-7, Albert Mozell, courtesy The Pace Gallery; H-8, David Watterson, courtesy Museum of the City of New York; I-3, courtesy Forum Gallery, New York; I-8, I-9, Susanne Faulkner Stevens, courtesy Lincoln Center, Inc.; I-11, Walter Karling, courtesy Joan Tucker; I-10 Whitestone Photo, courtesy The Juilliard School; I-12, courtesy the New York City Housing Authority Photography Unit; I-13, courtesy William Tarr; I-16, courtesy the New York City Housing Authority Photography Unit; I-17, courtesy The Pace Gallery, I-18, Alajos Schuszler, courtesy PPA and Riverside Park Fund; I-25, courtesy National Park Service; J-1, Richard Nadel, courtesy Greg Wyatt; J-2, J-3(a,b), J-4, J-5, J-6, J-7, J-8, J-9, J-10, J-11, J-12, Joe Pineiro, courtesy Columbia University; J-15, Alajos Schuszler, courtesy PPA; J-18, Joy Hurwitz, courtesy Art Commission of the City of New York; J-19, Frank Lusk, courtesy National Park Service; J-23, Elliot Fine, courtesy Department of Housing Preservation and Development; J-24, courtesy the New York City Housing Authority Photography Unit; J-25, courtesy The Hispanic Society of America; J-27, Terry Fugate-Wilcox.

# Index

Abdell, Douglas, 247, 259
Abingdon Square, xiii
*Abingdon Square Memorial*, 71
*Abraham De Peyster*, 18
*Abraham Lincoln*, 96
*Abraham Lincoln and Child*, 318
Abramovitz (and Harrison and
    Harris), 164
*Abstract Wall Relief*, 142
*Accord*, 131
*Acrobat in the Ring*, 46
Adams, Herbert, 109, 151, 327
Adamy, George, 17
A.E. Bye Associates, 17
Agam, Yaacov, 273
*Alamo*, xiv, 82, 129
*Albert Bertel Thorvaldsen Self-Portrait*,
    231
Aldrich (and Delano), 323
*Alexander Hamilton*, 227, 256, 299,
    314
*Alexander Lyman Holley*, 73
*Alexander Stewart Webb*, 313
*Alexander von Humboldt*, 245
*Alfred E. Smith Memorial Flagpole
    Base*, 66
*Alfred the Great*, 109
*Alice in Wonderland*, 222
Allen, Frederick Warren, 56
*Alma Mater*, 293, 296
*Ambrose, John Wolfe*, 10
*Amringe, John Howard Van*, 299
Andersen, Hans Christian, 221
Andrada e Silva, José Bonidacio de,
    155
*Andrada* Monument, 145, 155
Angel, John, 327
*Angel of the Waters*, 216
*Antelopes, Birds, Monkeys, Lions, and
    Wolves*, 196
Antonakos, Stephen, 145, 174, 319
Antonson, Michael, 295
Appellate Court, 89
*Appellate Division of the Supreme Court
    Façade Sculpture*, 108–9
Areas, xxi
    Central Park, 187–246, 327; map,
        188–9
    Downtown, 37–68, 325–6; map,
        38–9
    Financial District, 1–35, 325; map,
        2
    Midtown East, 119–44, 326–7;
        map, 120
    Midtown South, 89–118, 326;
        map, 90
    Midtown West, 145–86, 327; map,
        146
    Rockefeller Center, 177–8, 185;
        map, 177
    Upper East Side, 247–60, 327–8;
        map, 248
    Upper Manhattan, 293–324, 328;
        map, 294
    Upper West Side, 261–92, 328;
        map, 262
    Villages, 69–88, 326; map, 70
Ari, Carina, 326
Armajani, Siah, 35
Armillary sphere, 130
Arp, Jean, 77
Arrighini, Nicola, 68
*Arthur, Chester Alan*, 107
Artists in the Gardens, xv
*Arts*, 159
*ASPCA Horses*, 327
*Atlas*, 177, 182
*Atlas Clock*, 128
Audubon Terrace, 293
Augustinčić, Antun, 137
*Authority*, 48, 57
Azaz, Henri, 46

Bacon, Henry, 307
Badgeley & Wood, 224
Ball, Thomas, 242
*Balto*, 202
*Bank of Tokyo (American Surety
    Building) Façade Figures*, 325
Barber, Don, 229
Baretta, Walter, 327
Barger, Raymond Granville, 169
Barnard, George Gray, 159, 300
Barthé, Richmond, 328
Bartholdi, Frédéric-Auguste, 3, 97,
    310

Bartlett, Jennifer, 35
Bartlett, Paul Wayland, 26, 157, 326
Batterson, Canfield (& Co.), 242
Batterson, James Goodwin, 104
Battery Park, 1, 325
Battery Park City, xiv, 1
*Bear and Faun Fountain*, 309
Bearer, Henry, 213
*Bears*, 328
*Beauty*, 158
Bedloe's Island, 4
Beer, Friedrich, 98
*Beethoven, Ludwig von*, 213
*Belgium*, 11
*Bellerophon Taming Pegasus*, 306
*Bell Ringers Monument*, 147
*Benjamin Franklin*, 45
*Bennett, James Gordon*, 147, 154
Benton, Thomas Hart, 145, 167
*Bethesda Fountain, Angel of the Waters*, 216
*Bethesda Fountain Terrace*, 215
*Bethune Tower sculptures*, 315–16
*Big Red Swing*, 326
Bissell, George Edwin, 18, 107, 109
Bitter, Karl, 11, 109, 192, 286, 307, 325, 327
Blackall Simonds, George, 244
Blaeser, Gustaf, 245
Blashfield, Edwin, 327
*Boabdil*, 322
*Bolívar, Simón*, 237
*Booth, Edwin*, 100
Borgium, Solon, 326
Borglum, John Gutzon de la Mothe, 292
Bosworth, Willis, 286
Bottomley (and Hewitt), 325
Bourdelle, Pierre, 327
Bovenkamp, Hans Van de, 327
*Bowery Savings Bank Pediment*, 325
Bowling Green, xiii
Brandston, Howard, 17
"Brick Wall," 326
Brisbane, Arthur, 230
*Brotherhood of Man*, 46
Brown, Henry Kirke, xiii, 91–2, 96
Brun, Napoleon Le, 204
Brunner & Tryon, 325
Bryant Park, 145, 150, 151, 153, 154, 155
*Bryant, William Cullen*, 145, 151–2
Buberi, Caspar, 326
*Buffalo Hunt*, 64
*Bunche, Ralph* (sculpture), 136
Bunshaft, Gordon, 27
Burnett, Frances Hodgson, 233
*Burnett Memorial Fountain*, 233
*Burns, Robert*, 206
Burton, Scott, 35, 145, 167, 168
Bush-Brown, Henry Kirke, 48, 109, 328
*(The) Busted Bike*, 20

*Bust of Sylvette*, 79–80
*Butterfield, Daniel*, 292

Cain, Auguste, 197
Calder, Alexander, xiv, 33, 75, 161, 261, 271
Callery, Mary, 88
Carles, Antonin Jean Paul, 147
*Carl Schurz Monument*, 293, 307–8
Carl Schurz Park, 247
Carrère and Hastings, 230
*Carroll, Lewis*, 20
Carson and Lundin, 171
*(The) Castle*, 253
*Ceiling and Waterfall for 666 Fifth Avenue*, 171
Central Park, 187–246, 327; map, 188–9
*Central Park Boathouse Dedicatory Sculpture*, 327
Central Park Zoo, 196–200
Ceraldi, Theodore, 326
Chambellan, René Paul, 185
Channel Gardens, 185
*Charles F. Murphy Memorial Flagpole*, 95
*Chase Manhattan Bank Plaza Sunken Garden*, 22–3
Chelsea Park, xiii
*Chelsea Park Memorial*, 70, 118
*Chester Alan Arthur*, 107
Chia, Sandro, 167
*Child*, 318
*(The) Child*, 112
Child, Susan, 35
Chinni, Peter Anthony, 46
*Christopher Columbus*, 204
*Circle World #2*, 269
Cityarts Workshop, xv
City College, 313
*City of Manhattan*, 326
*Cityscape*, 17
*City Spirit*, 268
*Civic Fame*, 37, 58–9
*Civic Virtue*, 37
Civiletti, Pasquale, 278
Clarke & Rapuano, 236
Clarke, Gilmore D., 261
Clarke, Rapuano and Holleran, 235
Clarke, Thomas Shields, 109
*Clark Memorial*, 328
"Cleopatra's Needle," 187, 226
*Clinton, DeWitt*, 256
*Coast Guard Memorial*, 9
Cogswell, Henry D., 85
*Cohan, George M.*, 163
*Coliseum seals*, 328
Columbia University, 293, 297–306
*Columbus, Christopher*, 204
Columbus Circle, 263
*Columbus Monument*, 263–4
*Comet*, 20
*(The) Commuters*, 172

Companions, 119, 132
Confucius, 62, 109
Conkling, Roscoe, 101
Conrads, Carl, 227
Construction Workers, 326
Continuum, 134
Contrappunto, 133
Cook, Robert, 125
Cooper, Alexander, 35
Cooper, Peter, 69, 83
Corbett, Harrison & MacMurray, 176
Corbett, Harvey Wiley, 176, 177
Corchia, de Harak, Inc., 17, 20
Cornelius Vanderbilt, 119, 122
Couper, William, 109
Couton, Jules-Félix, 119, 121
Cox, Samuel, 84
Creative Time, xv
Creeft, José de, 222
Cremer, Fritz, 140
Cronbach, Robert M., 117
Crovello, William, 166, 175
Cubed Curve, 166, 175
Curl, 301

Dag Hammarskjold Bust, 326
Dancing Goat, 199
Daniel Butterfield, 292
Daniel Webster, 242–3
Dante Alighieri, 265
Daumas, Louis Joseph, 235
Da Verrazzano, Giovanni, 7
Davidson, Jo, 67
De Andrada e Silva, José Bonidacio, 155
De Bovenkamp, Hans Van, 327
De Creeft, José, 222
De Francisci, Anthony, 95
De Harak, Rudolph, 20
Delacorte Clock, 198
Delano & Aldrich, 323
Den Eyden, H.A. van, 325
Dennis, Donna, 319
Denmark, 11
Department of Transportation, xv
De Peyster, Abraham, 18
De Rivera, José, 134
De San Martín, José, 235
Descent from the Cross, 113
DeStuckle, H.W., 97
De Vitoria, Francisco, 138
Dewey Memorial, 325
DeWitt Clinton, 256
Dickstein, Samuel, 325
"Die Aufsteigende," 140
Diedrich, Hunt, 326, 327
Dinoceras, 125
Dixey, John, 44
Dr. James Marion Sims, 232
Dodge, Edwin S., 100
Dodge, William Earl, 145, 153, 154
Donndorf, Karl Adolph, 94
Donnelly, John, 121

Donnelly and Ricci, 159
Donoghue, John Talbott, 109
Donovan, William, 305
Don Quixote, 322
Doris C. Freedman Plaza, xv
Dorson, Edward, 328
Double Check, 28
Double Circles, 315
Downtown, 37–68, 325–6; map, 38–9
Doyle, Alexander, 115
Duarte, Juan Pablo, 68
DuBoy, Paul E.M., 282
Dubuffet, Jean, 1, 24
Duffy, Francis P., 162
Duffy Square, 163
Duncan, John, 290
Dupuis, Toon, 326

Eagles and Prey, 211
Eaphae-Aekyad #2, 259–60
East Coast Memorial, 8
East Harlem Artpark, 293, 319
Eckstut, Stanton, 35
Edwards, Melvin, 315
Edwin Booth as Hamlet, 100
Eggers and Higgins, 65, 67
Egyptian Obelisk, "Cleopatra's Needle," 187, 226
Eiffel, Gustave, 3
El Cid Campeador, 321
Elwell, Frank Edwin, 11
Embrace, 249
Embury, Aymar (II), 10, 146, 225, 228, 232, 233
Embury, Edward Coe, 198
England, 11
Environmental Sculpture, 325
Equitable Center, 145, 167
Ericsson, John, 5
Eternal Light Monument, 326
Eyden, H.A. van den, 325
Eye of Fashion, 117

(The) Fables of La Fontaine, 88
(The) Falconer, 187, 244
(The) Family, 111, 317
Fantasy Fountain, 100
Farnham, Sally Jane, 237
Farragut Monument, xiii, 89, 105–6
Father Francis P. Duffy, 162
Fellows, William, 14
Felt, James, 275
Ferrandino, John, 14
Feuerlicht, Herbert A., 247, 249
Financial District, 1–35, 325; map, 2
Fiorello Henry La Guardia, 67
Firemen's Memorial, 285
First Houses Playground Sculpture, 326
Fischer, Karl, 153
Fitz-Greene Halleck, 209
Five in One, 60
"Flagpole Bases," 327

Flanagan, Barry, 167
*Flanders Field Memorial*, 176
Flavin, Dan, 326
*Flight*, 305
"*Fluorescent Light Installation*," 326
Fonseca, Gonzalo, 251
*Force*, 108
Fordham University, 261, 266–70
*42nd Street Ballroom*, 145, 173
*42nd Street Neon*, 174
Fouilboux (and Hood, Godley), 177
*Fountainhead Figures*, 185
*Fountain of the Three Dancing
    Maidens*, 234
*The Four Continents*, 12–13
*(The) Four Elements*, 325
*Four Trees*, 1, 24
Frager, Sigurd, 79
Frampton, George James, 230
*France*, 11
Francisci, Anthony de, 95
*Franklin, Benjamin*, 45
*Franz Sigel*, 286
Fraser, James Earle, 279
Fratin, Christophe, 211
Freedman, Doris C., xv
French, Daniel Chester, 12, 109, 218,
    293, 296, 325
Friedberg, M. Paul, 35
*(The) Friendship of France and the
    United States*, 186
Frisch, Victor, 153, 327
Fugate-Wilcox, Terry, 324, 326

*Gainsborough, Thomas*, 328
*Gandhi, Mohandas*, 293
*Garibaldi, Giuseppe*, 76
*(The) Garment Worker*, 149
Gehron and Seltzer, 8
Gelert, Johannes, 11
*General Philip Henry Sheridan*, 72
*General Winfield Scott Hancock*, 311
*Genoa*, 11
*George M. Cohan*, 163
*George III* equestrian statue, xiii
*George Washington*, 25
*George Washington* (equestrian statue),
    xiii, 91–2
*George Washington Carver*, 328
Gilbert, Cass, 11, 12
*Giovanni da Verrazzano*, 7
*Giuseppe Garibaldi*, 76
*Giuseppe Mazzini*, 240
*Giuseppe Verdi*, 278
Glusker, Irwin, 327
Godley (and Hood and Fouilboux),
    176
*Goethe, Johann Volfgang von*, 145, 153
*Golda Meir*, 148
Goldfine, Beatrice, 148
Gordon, Sidney, 327
*Governor Alfred E. Smith Memorial*, 65
Grafly, Charles, 11

Gramercy Park, 100
Grand Army Plaza, 190, 192
Grand Central Terminal, 119, 121,
    122, 326
*Grant's Tomb*, 261, 290–1
*(The) Great God Pan*, 300
*Greece*, 11
*Greeley, Horace*, 47, 115
Gross, Chaim, 46, 266
*Group of Four Trees*, 1, 24
*Growth*, 293, 319
Guarducci, Orello, 325
*Guichet (Le)*, xiv, 271
Gussow, Roy, 53
Guttenberg, Johannes, 45

Haas, Richard, 319
Hafner, Charles Andrew, 258
*Hale, Nathan*, 41–2
*Halleck, Fitz-Greene*, 209
*Hamilton, Alexander*, 227, 256, 299,
    314
*Hamilton Drinking Fountain*, 328
*Hammerskjold, Dag* (memorial
    sculpture), 144
*Hancock, Winfield Scott*, 311
Haneman (and Rogers), 201
*Hans Christian Andersen*, 221
Harak, Rudolph de, 17, 20
*Hare on Bell*, 167
Harlem Hospital, 317
*Harlem Hybrid*, 312
Harris (and Harrison and
    Abramovitz), 164
Harrison (and Corbett and
    Mac-Murray), 177
Harrison, Abramovitz and Harris, 164
Harrison, Wallace K., 177
Hartley, Jonathan Scott, 5, 109
Harvey, Eli, 327
Hastings (and Carrère), 230
Hastings, Thomas, 73, 151, 192,
    229, 327
*Heat Trees*, 17
*Heaven and Earth*, 46
Hebald, Milton, 246, 274
Heber, Carl A., 63
*Hebe* statue, 85–6
Heizer, Michael, 119, 127
*Helix*, 17
Hepworth, Barbara, 144
Herald Square, 147
*Herbert, Victor*, 212
Hewitt & Bottomley, 325
Hewlett, William A., 70
Higgins (and Eggers), 65, 67
Hiltunen (Pietinen), Eila, 141
*Hispanic Society of America Sculpture*,
    321–2
*History*, 159
Hofmann, Hans, 134
Hofmeister (and Reinhard), 177
*Holland*, 11

Holleran (and Clarke and Rapuano), 235
*Holley, Alexander Lyman*, 73
*Homage to Lewis Carroll*, 20
*Honey Bear*, 199
Hood, Raymond, 176
*Horace Greeley*, 47, 115
Horgan and Slattery, 48
Horvall, John, (Janos Horvay), 289
*Humboldt, Alexander von*, 245
Huntington, Anna Vaughn Hyatt, 236, 261, 283, 293, 321
Hunt, Richard Morris, 3, 25, 47, 154, 220, 241, 312
*Hunt, Richard Morris*, 218–19

*Icarus*, 40
*Ideogram*, 31
Illava, Karl, 201
*I. Miller Building Sculptures*, 161
*(The) Immigrants*, 6
*Independence Flagstaff*, 95
*(The) Indian Hunter*, 207–8
*Industries of the British Commonwealth*, 184
*Irving, Washington*, 98
*Italia*, 183
*(The) Italian Immigrant*, 183
*Itzamna Stella*, 327

Jaegers, Albert, 11
*Jagiello*, 225
*James Felt Memorial*, 275
*James Gordon Bennett Memorial*, 147, 154
Janniot, Alfred, 186
*Jefferson, Thomas*, 298
Jennewein, Carl Paul, 184
*(The) Jerusalem Grove*, 325
*Joan of Arc*, 261, 283–4
*Johann Christoph Friedrich von Schiller*, 214
*Johann Volfgang von Goethe*, 153
*John Ericsson*, 5
*John Howard Van Amringe*, 299
John Jay Park, 247
*John Purroy Mitchel Memorial*, 229
Johnson, Burt W., 176
Johnson, Daniel Larue, 136, 315, 316
Johnson, J. Seward (Jr.), 28, 124, 165
*John Wolfe Ambrose*, 10
Jones, Lowell, 123
*José Bonidacio de Andrada e Silva*, 155
*José de San Martín*, 235
*José Martí*, 236
*Josephine Shaw Lowell Memorial Fountain*, 150
*Juan Pablo Duarte*, 68
*Justice*, 37, 43–4, 54, 57, 109
*Justinian*, 109

Kadishman, Menashe, 328
Kapel, Priscilla, 253

Kasuba, Aleksandra, 326
Katzen, Lila, 268
Kaufman, Melvyn, 17
Keck, Charles, 65, 162, 239, 296, 318
Kemegs, Edward, 223
*Kimlau War Memorial*, 61
*King Jagiello*, 225
*King, Martin Luther (Jr.)*, 276–7, 328
King, William, 119, 132
Kiselewski, Joseph, 54, 328
Kodama, Masami, 269
Koenig, Fritz, 29
Konti, Isidore, 328
*Kossuth, Lojas*, 289
*Kryeti-Aekyad #2*, 259–60

*Lafayette and Washington*, 310
*Lafayette, Marquis de*, 97
*La Guardia, Fiorello Henry*, 67
Lamb, Charles Rollinson, 118
Lamb, Thomas, 326
Langmann, Otto F., 221
*Lapstrake*, 170
*Law*, 55
Lawrie, Lee, 179, 182
Lawson, Louise, 84
Lazarus, Emma, 4
Le Brun, Napoleon, 204
Lee, Poy G., 61
*Le Guichet*, xiv, 271
*Lehman Zoo Gates*, 200
Leigh, Douglas, 264
*Le Marteleur*, 293, 302
*Le Penseur*, 303
*Letters*, 297
*Let Us Beat Our Swords into Plowshares*, 143
Leveque, Les, 328
*Levitated Mass*, 119, 127
*Levy Memorial Gates*, 327
Lewitt, Sol, 167
Liberman, Alexander, 131
Lichtenstein, Roy, 167
*(The) Life of Samuel Dickstein*, 325
*Light*, 179
*Ligion*, 315
Lima, José Otavia Correia, 155
*Lincoln, Abraham*, 96, 318
Lincoln Center, xiv, 261, 266–72
*Lincoln Center Reclining Figure*, xiv, 272
*Lions*, 156
Lipchitz, Jacques, 306
*Little Lady of the Dew, Aspiration, Inspiration*, 326
Lober, Georg John, 163, 221, 320
*Loeb, Sophie Irene*, 224
*Lojas Kossuth*, 289
Lomprey, Mary, 20
Lord, James Brown, 107, 108
Lowell, Guy, 56
*Lowell, Josephine Shaw*, 150

Lowell Memorial Fountain, 145
Lower Manhattan Cultural Council, xv
Ludlow & Peabody, 292
Ludwig von Beethoven, 213
Lukeman, Augustus, 11, 109, 287
Lundin (and Carson), 171
Lycyrgus, 109

McCartan, Edward, 327
Macdonald, James Wilson Alexander, 209, 311
McKim, Charles Follen, 190
McKim, Mead and White, 297
MacMonnies, Frederick, 41, 158, 325
MacMurray (and Corbett and Harrison), 177
MacNeil, Herman, 75
Madison Square, xiii, 89, 101–3, 105, 107, 326
Magonigle, H. Van Buren, 239, 285
(The) Maine Monument, 238–9
Maldarelli, Oronzio, 326
Manca, Albino, 8
Manship, Paul, 66, 167, 178, 200, 228, 325, 328
Manu, 109
Man with a Cog, 328
Manzù, Giacomo, 183
Maps
    Central Park, 188–9
    Downtown, 38–9
    Financial District, 2
    Midtown East, 120
    Midtown South, 90
    Midtown West, 146
    Rockefeller Center, 177
    Sculpture Regions, xxi
    Upper East Side, 248
    Upper Manhattan, 294
    Upper West Side, 262
    Villages, 70
Marantz, Irving, 114
Marquis de Lafayette, 97
(Le) Marteleur, 293, 302
Martí, José, 236
Martinelli, Ezio, 142
Martin Luther King, Jr., 328
Martin Luther King, Jr., Memorial, 276–7
Martiny, Philip, xiii, 48, 50, 57, 71, 109, 118, 327
Matriati, F., 240
Matt, John, 326
Mazzini, Giuseppe, 240
Mead (and McKim and White), 297
Meadmore, Clement, 301
Mehlman, Ron, 126
Meir, Golda, 148
Menconi, Raffaele, 327
Menconi, Ralph Joseph, 46
Mestrovic, Ivan, 326
Metropolitan Museum of Art Façade Sculptures, 327

Metzler, Henry Frederick, 128
Meunier, Constantin-Emile, 293, 302
Midtown East, 119–44, 326–7; map, 120
Midtown South, 89–118, 326; map, 90
Midtown West, 145–86, 327; map, 146
Milkowski, Antoni H., 102
Miller (and Noel), 99
Miller, Ferdinand Von (II), 232
Minerva bronze figure, 147
Miss, Mary, 35
Mitchel, John Purroy, 229
Mitochondria, 111
Mohandas Gandhi, 93
Month of June, 17
Moore, Henry, xiv, 195, 261, 272, 304
Moore, Thomas, 194
Moretti, Giuseppe, 327
Morning, Night, Noon, and Evening, 109
Morningside Heights, Numbers and Letters, 328
Morningside Park, 293, 309
Moroles, Jesús Bautista, 170
Morse, Samuel Finley Breese, 210
Moses, 109
Mother Goose, 217
Mother Playing, 266
Mould, Jacob Wrey, 203, 215, 216
MTA's Arts for Transit, xv
Mullins, William H. Co., 44
Murphy, Charles F., 95
Murphy Memorial, 95
Murphy Memorial Flagpole, 89, 95
Myers, Forrest, 81

Nadelman, Elie, 326
Nagare, Masayuki, 30
Nakian, Reuben, 77, 113
Nathan Hale, 41–2
Negro Mother and Child, 328
Neon for 42nd Street, 174
Nesjar, Carl, 79
Netherland Memorial Flagpole, 325
Nevelsen, Louise, 21, 32, 247, 255
"(The) New Colossus," 4
News, 180
New York City Department of Parks and Recreation, xv
New York Coliseum, 328
New York County Courthouse Pedimental Sculpture, 56
New York in Its Infancy, 50
New York in Revolutionary Times, 50
New York Public Library, 156–9, 327
New York Stock Exchange Pediment, 26
New York Vietnam Veterans Memorial, 14–15
Niehaus, Charles Henry, 109
Nierman, Leonardo, 267

*Night Presence IV,* 247, 255
Nivola, Costantino, 257, 280
Noel and Miller, 99
Noguchi, Isamu, 1, 22, 27, 171, 180, 254
*Norwegian Monument,* 325
*Nursing Activities,* 326

*Obelisk to Peace,* 114
O'Conner, Andrew, 327
O'Connor, Andrew (Jr.), 10
Olmsted, Frederick Law, 187, 261, 293
*107th Infantry Memorial,* xiii, 201
*127 John Street,* 20
Organization of Independent Artists, xv
*Oriel,* 111
*Ornette Coleman Force No. 1,* 316
*Osburn, William Church,* 228
Ostrowski, Stanislaw Kazimierz, 225
*Out to Lunch,* 165

*Pace University Sculpture,* 46
*Padre Francisco de Vitoria,* 138
*Pan statue,* 300
*Park Row Building Cupola Figures,* 325
Partridge, William Ordway, 288, 298, 299, 314
Patel, Kantilal B., 93
Peabody (and Ludlow), 292
*Peace,* 119, 137, 267
*Peace Form One,* 136
*Peace Fountain,* 295
Pelli, Cesar, 35
Pelt, John Van, 283
*(Le) Penseur,* 303
Pepper, Beverly, 133
Percent for Art Law, 319
*Performance Machine, Big O's,* 123
*Peter Cooper,* 69, 83
*Peter, Fisher of Men,* 270
*Peter Pan,* 247, 258
*Peter Stuyvesant,* 99
*Peter the Fisherman,* 270
*Petrus Stuyvesant,* 326
Pfaff, Judy, 319
*Phoenica,* 11
Picasso, Pablo, 69, 79
Piccirilli, Attilio, 181, 239, 285
Piccirilli, Getulio, 26
Piccirilli, Orazio, 193
Pickett, Byron M., 210
*(The) Pilgrim,* 220
Plassman, Ernst, 45, 122
Platt, Charles Adams, 150
*Plaza Fountain sphere,* 29
Pollia, Joseph P., 72
Polshek, James Stewart & Associates, 315
*Pomona,* 192–3
Pope, John Russell, 279

"Porcellino," 130
Port Authority of New York and New Jersey, xv, 172, 173
*Portugal,* 11
Post, George B., 26
Potter, Edward Clark, 109, 156
Price, Bruce, 218
*Profile Canto West,* 281
*Prometheus,* 177, 178
Public Art Fund, Inc., xv
*Puck,* 326
*Pulitzer Fountain (Pomona),* 192–3

*Queensboro Bridge Fountain,* 327
Quinn, Edmond T., 100, 212

Ralph Bunch Park, 136
Rapuano (and Clark), 236; (and Clarke and Holleran), 235
Raymond Hood, Godley & Fouilboux, 177
*Rea, Samuel,* 116
*(The) Red Cube,* 27
Reinhard & Hofmeister, 176
*Rejected Skin,* 17
Rhind, John Massey, 290, 313, 325
Rhoads, George, 173
Rhoden, John, 111, 317
Ricci (and Donnelly), 159
*Richard Morris Hunt Memorial,* 218–19
*Richard Tucker,* 274
Richter, C.L. 214
*Riis Plaza Sculptures,* 326
*Rising Man,* 140
Rivera, José de, 134
Riverside Drive and Park, 261
*Robert Burns,* 206
*Robert F. Wagner Memorial,* 320
Robus, Hugo, 326
*Rockefeller Center,* 176–7, 185; map, 177
Rodin, Auguste, 303
Rodriguez, Jorge Luis, 319
Rogers and Haneman, 201
Rogers, Randolph, 103
*Rome,* 11
*Romeo and Juliet,* 246
*Rondo,* 129
Roosevelt Square Park, 312
*Roosevelt, Theodore,* 279
*Roots and Ties for Peace,* 139
Rosati, James, 31
*Roscoe Conkling,* 101
Rosenthal, Bernard (Tony), xiv, 60, 82, 129, 328
Roszak, Theodore, xiv, 110
Roth, Emery (and Sons), 17, 20
Roth, Frederick George Richard, xiv, 10, 196, 199, 202, 217, 224
Ruckstill, Frederick Wellington, 11, 108
Rumsey, Charles Cary, 64

Russo, Gaetano, 263

Saemondsson, Nina, 327
*St. Bartholomew's Episcopal Church Portals*, 327
Saint-Gaudens, Augustus, xiii, 69, 83, 105, 190
St. Gaudens, Louis, 11
*Saint Louis*, 109
*St. Patrick's Cathedral Doors*, 327
*St. Peter Casting a Net*, 270
*Samuel Cox*, 84
*Samuel Finley Breese Morse*, 210
*Samuel J. Tilden*, 288
*Samuel Rea*, 116
Sandys, Edwina, 112
Sanguino, Luis, 6
*San Martin, José de*, 235
Sawyer, Sam, 328
Scallo, Victor, 17
*Schiller, Johann Christoph Friedrich von*, 187, 214
Schott, Walter, 234
*Schurz, Carl*, 247, 293, 307, 308
Schwartzott, Maximillian, 109
Schweitzer, Gertrude, 305
*Science*, 297
*Scott, Walter*, 205
*Sculpture at the Hispanic Society of America*, 321–2
*Sculptured Panels*, 257
*Sculpture on Attic Story of the New York Public Library*, 157
*Sculptures at Bethune Tower*, 315–16
*Sculptures at 77 Water Street*, 16–17
*Seals on New York Coliseum*, 328
Segal, George, 172
*Seligman, Alfred Lincoln*, 309
*Seligman Fountain (Bear and Faun Fountain)*, 309
Seltzer (and Gehron), 8
*Senes*, 175
*Sentinel*, xiv, 110
Serra, Richard, 51
*Seuil Configuration*, 77
*Seventh Regiment Memorial*, 241
*77 Water Street sculptures*, 16–17
*Seward Park Fountain*, 325
*Seward, William H.*, 103
*Shadows and Flags*, 21
*Shakespeare, William*, 203
Shamir, Ami, 325
Sheahan, Dennis B., 194
*Sheridan, Philip Henry*, 72
*(The) Sherman Monument*, 190–1
Shifrin, Roy, 40
Shih, Liu, 62
Shrady, Frederick, 270
*Sibelius*, 141
*Sigel, Franz*, 286
*Signal 1 and Clam*, 328
Silva, Pedro, 290
*Simón Bolívar*, 237

Simonds, George Blackall, 244
*Sims, James Marion*, 145, 232
*Single Form*, 119, 144
*Skagerrak*, 102, 166
*Sky Gate, New York*, 32
Slattery (and Horgan), 48
*Slocum Memorial Fountain*, 87
*Smith, Alfred E.*, 65, 66
Smith, Gary Coke, 95
Smith, Tony, 160, 247, 250
Smyth, Ned, 34
*Snow Babies*, 327
Snyder, Kit-Yin, 319
*Soldiers' and Sailors' Memorial*, 261, 282
*Solon*, 109
Sonfist, Alan, 78
*Sophie Irene Loeb Fountain*, 224
*Sopwith 1919*, 17
*Sound*, 179
Spadini, Andrea, 198
*Spain*, 11
*Sphere for Plaza Fountain*, 29
Spilhaus, Athelstan, 164
*Spirit of Achievement*, 327
*Spirit of Commerce*, 63
*Spirit of Industry*, 63
*Spirit of Understanding*, 327
*Statuary Group and Clock*, 327
*Statue of Liberty*, xiv, 1, 3–4
*Stead, William*, 230
Stebbins, Emma, 216
*Steel Park*, 328
Steell, Sir John, 205, 206
Stein, Richard G. & Associates, 280
*Stephen Wise Towers Playground Sculpture*, 280
Stern, Jan Peter, 135
*Still Hunt*, 223
Stoughton, Arthur A., 282
Stoughton, Charles, 282, 327
Stratton, Joseph, 44
Straus, Ida and Isador, 287
*Straus Memorial*, 287
*Study for Monument to Sibelius*, 141
"Stuff and Guff," 147
*Stuyvesant, Peter*, 99
*Stuyvesant, Petrus*, 326
Stuyvesant Square, 99
*Sullivan Memorial Fountain*, 326
Suñol, Jeronimo, 204
*Sun Triangle*, 164
*Surrogate's Court Façade Sculpture*, 48–9
*Switchback*, 301
*Swords into Plowshares*, 143
*Sylvette*, 69, 79
*Symbol Tower*, 328

Tacca, Pietro, 130
Tarr, William, 17, 275, 276, 326, 328
*Tau*, 247, 250

Taxi, 124
*Temperance Fountain*, 85–6
*(The) Tempest*, 246
Temporary sculptures, xv
Texidor, Fernando, 198, 222
*Theodore Roosevelt Equestrian Statue*, 279
*(The) Thinker (Le Penseur)*, 303
*Thomas Gainsborough, A Festival Procession of the Arts*, 328
*Thomas Jefferson*, 298
Thomas, John Rochester, 48
*Thomas Moore*, 194
Thomas, Norman M., 9
Thorvaldsen, Albert Bertel, 231
*Thorvaldsen, Albert Bertel*, 231
*Three Forms*, 53
*3000 A.D. Diffusion Piece*, 324
*Three Times Three Interplay*, 273
*Three-Way Piece: Points*, 304
*Throwback*, 160
*Tightrope Walker*, 305
*Tigress and Cubs*, 197
*Tilden, Samuel J.*, 288
*Tilted Arc*, 51–2
*Time Landscape*, 78
Toledo, Francisco, 138
Tompkins Square, 69, 85
Tonetti, Mary Lawrence, 11
Tracy, Evarts, 287
*Transition*, 169
*Transportation*, 119, 121
*Triad*, 114
*Trilogy*, 327
*Trinity Church Doors*, 325
*Triumph of Law*, 109
Trova, Ernest, 281
*Truth*, 158
*Tucker, Richard*, 274
Turini, Giovanni, 76, 240
*Two Piece Reclining Figure: Points*, 195

Ulm, d'Augsburg, Yolanda, 139
*Unidentified Object*, 254
Union Square, xiii, 89, 90–7
*Union Square Drinking Fountain*, 94
*Union Square War Memorial*, 326
United Nations, 119, 137–44
*Unity of the Family*, 326
*Untermeyer Fountain (Fountain of the Three Dancing Maidens)*, 234
*Untitled*, 19, 81, 251, 328
*Untitled Abstract Sculpture*, 77
Upjohn, Richard, 91
Upper East Side, 247–60, 327–8; map, 248
Upper Manhattan, 293–324, 328; map, 294
*(The) Upper Room*, 34–5
Upper West Side, 261–92, 328; map, 264
*Urban Plaza North*, 168
*Urban Plaza South*, 168

*U.S. Custom House Cornice Sculptures*, 11

*Van Amringe, John Howard*, 299
Van de Bovenkamp, Hans, 327
Van den Eyden, H.A., 325
*Vanderbilt, Cornelius*, 119, 122
Van Pelt, John V., 283
Varnell, David, 35
Vaux, Calvert, 187, 215, 216
*Venice*, 11
*Venus and Manhattan*, 252
*Verdi, Giuseppe*, 278
Verkade, Kees, 305
*Verrazzano, Giovanni da*, 7
*Victor Herbert*, 212
*Vietnam Veterans Memorial*, 14–15
(The) Villages, 69–88, 326; map, 70
Vitoria, Francisco de, 138
*Von Beethoven, Ludwig*, 213
*Von Goethe, Johann Volfgang*, 153
*Von Humboldt, Alexander*, 245
Von Miller, Ferdinand (II), 232
Vonnoh, Bessie Potter, 233
*Von Schiller, Johann Christoph Friedrich*, 214
Vuchetich, Evgeniy, 143

Waehler, Haines Lundberg, 136
*Wagner, Robert F.*, 320
*Waiting*, 145
Walter, Edgar, 309
*Walter Scott*, 205
Ward, John Quincy Adams, 25, 26, 47, 73, 90, 101, 153, 154, 203, 207, 220, 241
Warneke, Heinz, 328
Warren and Wetmore, 121, 265, 328
*Washington and Lafayette*, 310
*Washington Arch*, 74
*Washington as Commander-in-Chief Accompanied by Fame and Valor*, 75
*Washington as President, Accompanied by Wisdom and Justice*, 75
*Washington, George*, xiii, 25, 75, 91–2, 310
*Washington Heights-Inwood War Memorial*, 323
*Washington Irving*, 98, 145
Washington Square, 69
*Water Trilogy*, 126
*Weathering Concrete Triangle*, 326
*Webb, Alexander Stewart*, 313
*Webster, Daniel*, 242–3
Weinman, Adolph Alexander, 58, 116, 229, 256
Weller, Judith, 149
Wetmore (and Warren), 121, 265, 328
White (and McKim and Mead), 297
White (and Wilder), 288
White, Stanford, 41, 74, 83, 105

Whitney, Gertrude Vanderbilt, 99, 323

*Wild Boar*, 130

Wilder & White, 288

*William Church Osborn Memorial Playground Gateway*, 228

*William Cullen Bryant Memorial*, 145, 151–2

*William Earl Dodge*, 154

*William H. Seward*, 103

*William Shakespeare*, 203

Williams, Todd, 315

Williams, Wheeler, 252

*William T. Stead Memorial*, 230

Wilson, Albert, 20

Wilton, Joseph, xiii

*Windward*, 135

*Winter, Autumn, Summer,* and *Spring*, 109

*Wireless Operators' Fountain*, 325

*Wisdom*, 56, 108, 179

*Wobbly*, 328

*Woman's Health Protective Association Fountain*, 87

World Trade Center, 1

*World Trade Center Plaza Sculpture*, 30

*World Trade Center Stabile*, 33

Wormser, Peter, 14

*Worth, Jenkins*, 104

*Worth Monument*, 104

Wyatt, Gregg, 100, 295

Ximenes, Ettore, 265

Yang, Yu Yu, 19

*Young Elephant*, 167

*Youth Leading Industry*, 181

Yu Yu Yang, 19

Zimm, Bruno Louis, 87

Zorach, William, 55

*Zoroaster*, 109